W9-BUG-700

Henri de TOULOUSE-LAUTREC

Henri de TOULOUSE-LAUTREC

IMAGES OF THE 1890s

Edited by Riva Castleman and Wolfgang Wittrock

THE MUSEUM OF MODERN ART, NEW YORK

Distributed by New York Graphic Society Books

Little, Brown and Company, Boston

The exhibition *Henri de Toulouse-Lautrec*, organized by
guest curator Wolfgang Wittrock, has been made possible by a
generous grant from Mobil Corporation. An indemnity for the
exhibition has been provided by the
Federal Council on the Arts and the Humanities.

Copyright © 1985 by The Museum of Modern Art
All rights reserved
"Henri de Toulouse-Lautrec: A Biography of the Artist"
copyright © 1985 by Julia Frey
"Toulouse-Lautrec and the Art of His Century" copyright
© 1985 by Matthias Arnold
Library of Congress Catalogue Card Number 85-60790
Clothbound ISBN 0-87070-596-2
Paperbound ISBN 0-87070-597-0

Edited by Harriet Schoenholz Bee
Designed by Joseph B. Del Valle
Title lettering by Carole L. Lowenstein
Production by Susan Schoenfeld
Typesetting by Concept Typographic Services, New York
Color separation by Fotolito Gammacolor, Milan
Printed by Arti Grafiche Brugora, Milan /L.S. Graphic Inc., New York
Bound by Torriani & C., Milan

The Museum of Modern Art
11 West 53 Street
New York, New York 10019

Printed in Italy

COVER: *The Clowness at the Moulin Rouge*. 1897. Lithograph,
printed in color, 16⅛ x 12⁹⁄₁₆″ (41 x 32 cm). The Museum of
Modern Art, New York. Gift of Abby Aldrich Rockefeller, 1946

FRONTISPIECE: *Miss Loie Fuller.* 1893. Lithograph, printed in
color, in the original mat, 14½ x 10⁹⁄₁₆″ (36.8 x 26.8 cm).
Bibliothèque Nationale, Paris

Contents

Preface and Acknowledgments

Fifty-three years ago the tenth exhibition of the young Museum of Modern Art was devoted to two French artists of the late nineteenth century, Odilon Redon and Henri de Toulouse-Lautrec. Showing these artists lent a broader aspect to the Museum's program since both had produced notable prints as well as paintings. The exhibition allowed the Museum to show the importance that other mediums, such as lithography, had in the history of the modern movement. Perhaps most significantly, the exhibition demonstrated to one of the Museum's founders, Abby Aldrich Rockefeller, that it was possible and desirable to assemble a collection of Lautrec's prints that would eventually become a particularly valued part of the Museum's holdings.

In subsequent years the Museum continued to show Lautrec's paintings and prints to its growing public, and three more exhibitions of this artist followed, in 1933, 1947, and 1956. Now, three decades later, there are new reasons to reexamine his work. Accepted as the most gifted and innovative printmaker of the late nineteenth century, Lautrec provided the foundation for an unprecedented attention to printmaking by most of the major artists of the twentieth century. Furthermore, there has been increasing recognition of the primacy of printed images within this artist's oeuvre itself. This exhibition has been planned to demonstrate that lithography was of central significance to Lautrec's creative production and to show how the prints relate to his drawings and paintings. In recognizing the increased importance and influence in our culture of works on paper and multiple impressions, this presenta-

tion is also relevant to the Museum's continuing commitment to contemporary art. The work of Lautrec, whose inspiration came from the unconventional side of a swiftly shifting urban society, has echoes today in the great variety of expressions through which contemporary artists interpret our own quickly changing culture.

We are particularly pleased that Mobil Corporation, known for its innovative and discerning sponsorship of cultural projects, has provided the support to make this exhibition possible. On behalf of the trustees and staff of the Museum, I wish to express our deep appreciation to Rawleigh Warner, Jr., Chairman of the Board of Mobil Corporation, and to Allen E. Murray, President. I also wish to extend our very warm thanks to Herbert Schmertz, Vice President, Public Affairs, and to Sandra Ruch, Manager, Cultural Programs and Promotion. Because of their early and perceptive interest, this special view of Henri de Toulouse-Lautrec was given Mobil's enthusiastic support, and we are most grateful for their many valuable contributions to its realization. We also thank Barbara Butt and Janet McClintock of Mobil for their generous assistance in the planning and implementation of related activities.

We were most fortunate five years ago to be approached by Wolfgang Wittrock with the suggestion that the Museum undertake an exhibition of the finest copies of Lautrec's prints. Based on his research for a new, definitive catalogue of the artist's printed work, Mr. Wittrock assured us that the fresh, unbleached, and otherwise unblemished examples that he had seen would constitute a revelation. He claimed

that these prints, together with related paintings, would dazzle the eye anew. As the guest curator of this exhibition, he has fulfilled this claim. Riva Castleman, Director of the Department of Prints and Illustrated Books, who coordinated his work with her staff, joins me in expressing the great appreciation of the Museum for his consummate care, thorough professionalism, and uncompromising connoisseurship.

Complementing Mr. Wittrock's extraordinary knowledge of his field, the authors of the essays for this book, Dr. Matthias Arnold; Phillip Dennis Cate, Director, Jane Voorhees Zimmerli Art Museum at Rutgers University; and Julia B. Frey, Assistant Professor, University of Colorado, have drawn upon their special expertise to illuminate the distinctive character of the artist and his times. We owe them our admiration and gratitude, which are also due the editor of this book, Harriet Schoenholz Bee, and its designer, Joseph B. Del Valle.

There are several truly extraordinary collectors of the prints of Lautrec who have helped to realize this exhibition. Because of the breadth of his interests, one man in particular has been absolutely vital. The quintessential Lautrec collector, Herbert D. Schimmel, has generously made his unique assemblage of letters, documents, photographs, posters, and prints fully accessible for study and exhibition. His assistance has been of inestimable importance, and we are all extremely grateful to him and to his wife. The Museum is also deeply indebted to the many other individuals and institutions, listed on page 260, who parted with precious examples of Lautrec's work for the duration of this exhibition.

In addition to individuals cited elsewhere, the following are owed special mention for their expert advice and support in the planning of the exhibition: William A. Acquavella; Jean Adhémar; Wieland Barthelmess; Laure Beaumont-Maillet, Director, Department of Prints and Photography, Bibliothèque Nationale, Paris; Ernst Beyeler; Suzanne Boorsch, Associate Curator, Prints and Photographs, The Metropolitan Museum of Art, New York; Douglas Druick, Curator of Prints and Drawings, The Art Institute of Chicago; Alexander Dückers, Curator, Staatliche Museen, Preussischer Kulturbesitz, Kup-

ferstichkabinett, Berlin; Jean-Marie Guéhenno, French Cultural Counselor in New York; John and Paul Herring; Sinclair Hitchings, Keeper of Prints, Boston Public Library; Alfred Isselbacher; Colta Feller Ives, Curator in Charge, Prints and Photographs, The Metropolitan Museum of Art; the late Harold Joachim, Curator of Prints and Drawings, The Art Institute of Chicago; Jennifer Josselson, Christie, Manson & Woods International, Inc.; Oskar Matzel; Michel Melot, Director, Bibliothèque Publique de l'Information, Centre National d'Art et de Culture Georges Pompidou; Dr. Nicholas Penny, Keeper of Western Art, Ashmolean Museum, Oxford; Simon de Pury, Curator, Thyssen-Bornemisza Collection; Andrew Robison, Curator of Prints and Drawings, National Gallery of Art, Washington, D.C.; Réne Scharf; Mr. and Mrs. Walther Scharf; Barbara Stern Shapiro, Assistant Curator, Prints, Drawings and Photographs, Museum of Fine Arts, Boston; Bertrand du Vignaud de Villefort; Henri Zerner, Curator, Prints, Fogg Art Museum, Cambridge; Ruth Ziegler, Sotheby's.

Among the Museum's staff, I can only cite here a few of the many individuals who contributed to this exhibition and publication. The unusual number of objects required unusual care; over 300 works were expertly handled and conserved by Eloise Ricciardelli, Registrar, and Antoinette King, Director of the Department of Conservation, and their assistants, Emily Croll and Anne Craddock. Additional conservation of the large posters was done by Florence Hodes. The efficient coordination of the exhibition by Richard L. Palmer and his staff eased many of the more difficult tasks, as did the excellent work of Virginia R. Coleman, Jeanne Collins, Jerry Neuner, Richard L. Tooke, and Susan Schoenfeld. John H. Limpert, Jr., and Charles Tebo secured the happy alliance of exhibition and sponsor. Finally, neither the exhibition nor the publication would have been possible without the remarkably dedicated and comprehensive involvement of Audrey Isselbacher, Assistant Curator in the Department of Prints and Illustrated Books, who supervised most of the essential elements of this project.

Richard E. Oldenburg
Director, The Museum of Modern Art

Introduction

Riva Castleman

Some ideas about people so lend themselves to popularization that the understanding of events and eras is distorted by their continuously attractive appeal. Certainly our image of life in the final decade of the nineteenth century is heavily indebted to the vision of one artist, Henri de Toulouse-Lautrec. It seems that more is remembered about him than about other artists, writers, and statesmen of the period, whether in France or elsewhere. Through his posters and prints, primarily, he has handed down to the twentieth century a view of a very small part of Parisian society that, even more than Marcel Proust's epic examination of the *haute bourgeoisie* of the same period, stands as the model upon which popular opinion of the *fin de siècle* is based. Appropriately, all these posters and prints were done in the brief period between 1891 and 1900. The artist died at the early age of thirty-six, shortly after the popular summation of the nineteenth century, the Paris Exposition of 1900, took place.

While considerable attention has been given to Lautrec's art, and particularly his graphic work, serious examination of its special virtues has been more often cursory than that applied to work of his contemporaries (Paul Cézanne, Paul Gauguin, Vincent van Gogh). Partly owing to the fact that his major oeuvre was in printmaking and that he created more drawings than anything else, it has been simpler to deal with his personality and the people he portrayed than

to study his unique abilities as a composer of memorable images. The several catalogues raisonnés of Lautrec's prints have been useful directories of his accomplishments, from Loÿs Delteil's early accounting of the works in 1920 to Jean Adhémar's listing of 1965. With the recently completed catalogue raisonné by Wolfgang Wittrock we are finally able to draw some firm conclusions about Lautrec's printmaking activities, his methods of arriving at solutions, and his creative gifts. The exhibition which this book accompanies takes advantage of this thorough documentation by presenting with the lithographs examples of drawings, paintings, and working proofs of prints that reveal the special art of Lautrec at its greatest brilliance. Not only is it possible to follow the artist's hand as he moves from quickly sketched motif, full-scale cartoon, and lithographed image *avant-lettre*, to finished poster, but we can examine the variations in color and rhythm that he presents in such works as his vignetted Art Nouveau vision of the dancer Loie Fuller (Cats. 38–43). In the light of our understanding of his methods and intentions, Lautrec, the graphic innovator, astute observer of character, and mirror of an era, emerges as an imaginative and sensitive organizer of form, color, and space.

Lautrec, deft with his sketching pencil, had a graphic sense from a very young age. That he completely understood the nuances of the black line, its power to describe

contour, enhance the energy of movement, and convey the feeling of color and texture was clear before he ever entered the ateliers of Paris' great teachers. In the age of significant developments in black-and-white visual material, from the photograph to the popular illustrated magazine, this artist innately and totally sensed the potency and exploitable qualities of print. Intending to be a painter, he was, nevertheless, equally inclined to the graphic. Assuredly, he created memorable and admirable paintings, but his own drawings after some of them, made for reproduction in the press, distill and translate their distinctive compositions to a point at which the lack of paint, vibrant color, or brushstroked surface is immaterial: the bones are quite as wonderful as the body. Knowledgeable about the techniques of reproduction, he found his bearings for these renderings with a blue pencil, drawing afterwards in black the exact parts of the composition that were to be printed. Unlike painters who expected their paintings to be reproduced by professional engravers, the normal situation for centuries, Lautrec was able to prepare his own version of his works for the mass media.

He experimented with methods of reproduction, tracing, and monotype, before he made his first lithograph. During the second half of the nineteenth century there was considerable interest on the part of engravers and painters in the possibilities of experimentation with printing ink. Some artists altered their engraved plates by modulating and actually composing with the viscous ink placed on the surface of the plate, for example, creating night or stormy effects on an engraved landscape. Edgar Degas made large quantities of monotypes by daubing and smearing the ink on unengraved plates, often taking a second or cognate impression upon which he would continue to form his composition with pastels. While Lautrec's several endeavors in this area are of little importance among his graphic works, one group of compositions of about 1886, depicting an artilleryman and woman, demonstrates his curiosity and persistence in utilizing duplicating methods (Fig. 1). Starting with a sketch, he traced it, then transferred portions which he transformed, in part, before impressing it on paper. It seems that he was searching for a better solution to the woman's figure and placement. He reworked

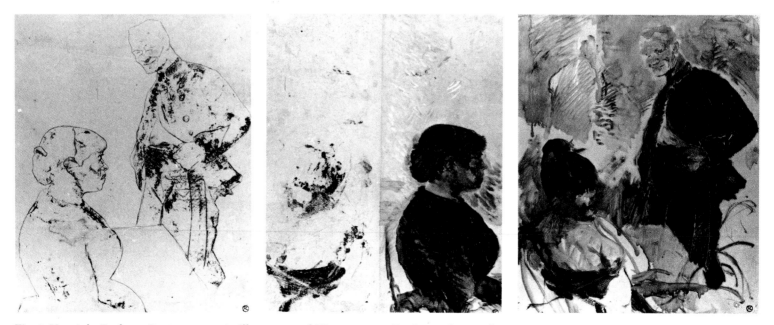

Fig. 1. Henri de Toulouse-Lautrec. LEFT *Artilleryman and Woman.* 1886. Tracing with gouache, 22⅛ x 17¾" (56 x 45 cm). CENTER *The Woman Alone.* 1886. Gouache and transfer, 22⅛ x 17¾" (56 x 45 cm). RIGHT *Artilleryman and Woman.* 1886. Gouache drawing, 22½ x 18⅛" (56 x 46 cm). Musée Toulouse-Lautrec, Albi

and transferred the woman alone, and finally developed, but never completed, the total composition on canvas. Instead of making an entirely new drawing, Lautrec invented his new composition out of the old one, retaining the immediacy of his original sketch.

These early essays show Lautrec's predilection for creating his compositions on one level or plane, rarely altering any area by overpainting or otherwise defacing his original work. Since repairs and revisions were difficult to execute on lithographic stones, it is clear that the artist's tendency to simplify and keep his drawing unencumbered was fundamental to his success as a printmaker. He also understood how colors combined in printing and produced other colors in ways entirely different from painting. The layering of relatively transparent inks or the juxtaposition of dots of ink of various colors were two techniques of creating color prints that became feasible when color theory was popularly understood. Lautrec was no scholar, nor a scientist with prisms and charts. He was, however, a member of a society of painters who played and worked with colors with increasing information about their qualities, components, and interdependencies. The Impressionists had intuitively known how colors could be juxtaposed to emulate the play of light and shadow. In 1888 Paul Signac presented the "chromatic circle" of the physiologist Charles Henry as a lithograph, forming the monogram of the Théâtre Libre on one of its programs. Henry's theories gave plausible meaning to the psychology of color and independent dynamism of line at that time.

The concept of maintaining clear and nearly transparent color was an important element in the success of Lautrec's color lithographs. Having incorporated Jean-François Raffaëlli's method of painting with turpentine-thinned pigments on cardboard, Lautrec had a better idea of the interaction of transparent color and paper than most artists of his time. The fact that the lithographic stone was close to the same tone as the cardboard he had painted upon may have helped him visualize how his colors would transfer into print (remembering, of course, that even when he drew a part of his composition to be printed in color upon the stone it was always with black crayon or black tusche). In his first print, the mammoth poster for the Moulin Rouge (Cats. 247–248), Lautrec used the spatter technique (crachis) for exactly that transparency. The film of spatters, contrasted with the flat, bright colors of the lights and lettering, and the unmodulated black silhouette of the crowd are all borrowed stylistic constructs from the type of Japanese prints that Lautrec often viewed and collected. Although the poster itself is larger than any Japanese printed image Lautrec may have seen, its proportions evoke those of the typical Japanese print, and if reduced to the size of the standard oban it would conform nearly exactly. This first print, too, shows another method of Japanese composition, the use of an outlined drawing, printed in a neutral tone, which then is filled in with unmodulated or unshaded color. This traite, important in early color reproduction so that colors could be filled in by hand or perfectly registered, was the bare-bones drawing of which Lautrec was a master. Prints that were not to be in color often have spatters which, instead of presenting flat color areas, create shadows and atmospheric backgrounds. Together with these transparent clouds of dots, heavy, solidly filled-in areas, and swift crayon jottings (often scraped sideways), Lautrec's repertoire of techniques is cleverly limited in order to provide a clarity lacking in so much printmaking up to his time.

The eye-catching arrangements of bright colors and arresting blacks were some of the properties of Lautrec's posters that propelled him to an unusual degree of success. A few public controversies about his radically concise representations of personalities, such as the performers Aristide Bruant and Yvette Guilbert, only served to increase the growing interest in his popular work. One can see from a photograph of a wall filled with posters how much more compelling and vigorous Lautrec's imagery was, compared with that of others (Fig. 2). He sought the vital elements in his subjects, discarding what he found to be nonessential, and combining this economy with an eye for the characteristic expression, which we too often name caricature, he was capable of making his subjects appear more real than they did in the photographs that he often used as models. He understood the theatrical atmosphere that could create excitement for those who filled the streets of Paris, offering to drabber lives a bit of magic. While much

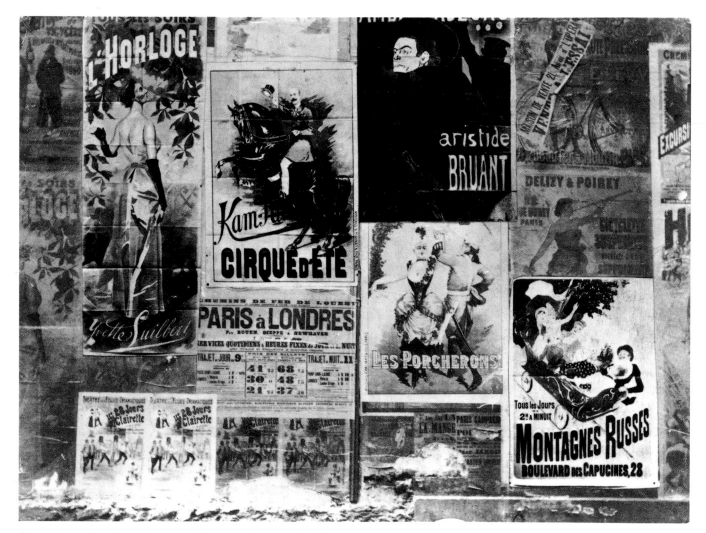

Fig. 2. Postered wall, Paris, c. 1892. Photograph, Warnod Collection

of this came from Lautrec's subject matter (he was so much a part of the Montmartre milieu that his nightlong presence guaranteed him the right to memorialize it), it was also his unique skill at original composition and printing technique that ensured recognition and acclaim.

Lautrec found the nightlife of his Montmartre neighborhood a congenial palette for his inventions. Perhaps because of his own visible infirmity his interest was drawn immediately to those performers in the cafés and dance halls who had physical characteristics that, above and beyond their performing prowess and talent, drew instantaneous attention: La Goulue's twisted-up cockade of bright red hair and pudgy contours; Yvette Guilbert's

sharp features and long, spider-leg, black gloves; Aristide Bruant's common, black corduroy worker's suit setting off a pale face that Edmond de Goncourt found enigmatically androgynous.[1] Of course, these elements appeared in works of other artists as well, but none seemed to understand as well as Lautrec how to rid the composition of bits of extraneous information and concentrate the impact of just those signs that conveyed the essence of the subject. This ability was acquired, in part, by attention to the formal precepts of Japanese composition.

Only two years after his death Lautrec was called "the Utamaro of Montmartre" by a writer who floridly described how Lautrec, with "shameless curiosity...nails

[his subjects] with unheard of mastery of analysis."[2] The choice of Utamaro was an obvious one; after nearly four decades of interest in things Japanese, a few names had become quite common among the cultured classes in France, owing to frequent and exhaustive exhibitions of Japanese prints, particularly in the late 1880s and early 1890s. Utamaro's refined portraiture, dependent upon very clear characteristics, among them flat and dominant areas devoted to the coiffures of his subjects and emphasis on the expression of an exaggeratedly small mouth, seemed to have had an influence on Lautrec. In the balance between flat, unmodulated areas and the finely annotated features of the performers and friends he depicted, Lautrec emulated the Oriental concept of opposites to a greater degree than any of his colleagues. Assuredly, Degas, van Gogh, and others incorporated many Japanese motifs into their compositions, but their Western eyes missed some elements that Lautrec seemed to sense immediately.

While comparisons between specific Japanese prints and Lautrec's prints have been made, what is usually overlooked is the abundance of formal or traditional poses and patterns of interior and exterior representation that Lautrec inserted into his compositions or upon which he based them. The famous poster *Aristide Bruant in His Cabaret* (Cats. 256–257), for example, has been related to Katsukawa Shunsho's famous woodcuts of Ichikawa Danjuro V in the role of Sakata No Kintoki, of about 1781 (Fig. 3),[3] evidently a direct "steal." And in the many figures in Lautrec's prints in which the subject is viewed from the back, one shoulder slightly raised, we see a traditional pose of the Japanese courtesan. (See *The Englishman at the Moulin Rouge*, Cats. 5–11, or *At the Moulin Rouge, La Goulue and Her Sister*, Cats. 2–3.) The framing construct that Degas used so successfully in his theatrical compositions is, for Lautrec, an important feature that organizes and provides a setting for the major subject of the picture, as in the poster of Jane Avril (Cats. 253–254) or in the hypnotic print of Loie Fuller (Cats. 38–43). In both lithographs the head of the contrabass, jutting up from the orchestra, dominates the lower right-hand corner. For *Jane Avril* it forms the lower part of a frame around the dancer, while the haze of dark color, sprinkled with gold dust (in the manner of the Japanese application of mica to woodcuts) in the Loie Fuller print is made more mysterious by the same, now nearly illegible, form, closing off the lower right-hand corner but not making a complete frame (a printed, rather formal, Art Nouveau passepartout was added to each print before it was sold).

Despite all of Lautrec's *Japonismes*, which extended to the point of his arranging his initials, printed on each lithograph, in the form of a seal, he was an artist of a particular time in the history of France. His interest in two areas of nightlife, the cafés and the brothels (often called

Fig. 3. Katsukawa Shunsho. *The Black Danjuro*. 1781. Woodcut, 12½ x 6″ (32 x 15.2 cm). The Art Institute of Chicago. The Clarence Buckingham Collection

Green Houses,[4] borrowing the title of Utamaro's famous printed series on the life of courtesans, *The 12 Hours of the Green Houses*, as a suitable synonym for an establishment that, like its trade, enjoyed a vast dictionary of terms), reflected current curiosity about these institutions. Cafés and how entertainment was purveyed in them experienced rapid changes in the last quarter of the nineteenth century. The lower classes provided entertainment to the burgeoning middle class: more cafés opened, and the fame of the performers spread outside the poor neighborhoods. Respectable people openly went to cafés so that what occurred in them became proper for representation in the popular press and on song sheets, but not in more exclusive art forms. For Lautrec the brothel was the same sort of subject. Degas had made many monotypes capturing the female society of the bordellos (apparently kept to himself but reproduced by Ambroise Vollard well after Degas's death in his 1934 edition of Maupassant's book *La maison Tellier*.[5] Lautrec's print series *Elles* documented the quotidian aspects of the "girls" in these houses (Cats. 139–145, 147–158), just as the Japanese had documented the occupations of the courtesans. With the exception of two plates of the clowness Cha-u-ka-o, the prints of *Elles* are of prostitutes, and yet none shows a completely nude body or a suggestive pose. These were very real people, living unglamorous lives. Real people did not spend their time being totally naked, and there are very few examples in Lautrec's printed oeuvre that show completely nude women. The traditional French artistic subject of the female body, encompassing an unlimited variety of meanings, remained the main event in the popular salons and international exhibitions, but for the modern painter men and women undressed for practical purposes.

Degas is supposed to have drawn his monotypes from memory,[6] or perhaps working from swift sketches that were destroyed (many of the monotypes of brothels were also destroyed after his death).[7] His nudes, except when seen bathing, appear in areas of the brothel where it was unlikely that they would be unclothed. Antedating Lautrec's rendering of the same subject by fifteen years, it is clear that Degas presented a more sensational view of the real, the sort of biased naturalism of Emile Zola's *Nana*, by

embroidering on the life of the brothel. His interest in presenting the nude in several circumstances and poses seems to have arisen from curiosity rather than insight. Of course, the brothel offered an opportunity to observe the nude outside the formal arrangement of the studio, much as the zoo replaced dusty collections of stuffed animals as a place to see how real animals look and move. Lautrec's view of brothel life represented a further change in attitude wherein depicting nude women in natural circumstances was less important than capturing the reality of life in a brothel. Degas visited brothels; Lautrec lived in them.

The rhythm of Lautrec's life was, as befitted the times, often broken by new distractions. His normal life was already unnatural, as he sought his subject matter at night and committed it to lithographic stone or canvas by day. Between 1891 and his death, besides periodic visits to his family home, he went to London eight times, Belgium at least six, made his second and third visits to Spain, and spent a brief moment in Lisbon. He traveled frequently within France, not only into the nearby countryside, but to the shores of Le Havre and Arcachon. The pawn of late nineteenth-century wanderlust and family obligation, Lautrec yearned as much to visit Japan as Gauguin had wanted to go to Polynesia. It was possible for Gauguin to escape his bourgeois responsibilities, but not for Lautrec, who was both physically weak and chained to a tradition-bound society. The freedom he had to journey across the Channel and to the borders of France came from certain improvements in transportation during the nineteenth century, but the overall character of his wanderings was little different from that followed by the nobility for several centuries. Nevertheless, for an artist these peregrinations had substantial impact upon a mind and body already strained by a passion to experience everything possible, from the casual bar to grand opera, from horse and bicycle races to the law courts. He did not bother to record views of foreign landscapes or French shorelines, although these were frequently before his eyes. What drew his attention was a limited group of subjects whose reality he found most compelling.

In 1897, the year he produced most of his last important color prints, he moved to a new home where, he told his

mother, "I hope to end my days in peace."[8] That year he also illustrated a little-known book by Georges Clemenceau, *Au pied du Sinaï* (Cats. 185–186), a series of short stories about Jews. Although we now recall the famous statesman as the designer of the Versailles Treaty ending World War I, he had had a long career before 1918 which, curiously, offers some new insights into the life of Lautrec. The mayor of Montmartre at the time of the Commune (1871), he was later, in 1892, caught in a French financial scandal (which summarily ended the French involvement in the digging of the Panama Canal) and found himself without a job. Still bursting with opinions, he turned all his attention to writing books and contributing to several journals, among them his own *La justice* and *L'Aurore*.

Clemenceau had had a friendly association with the art critic of *La justice*, Gustave Geffroy, which had begun in 1880 when the journal was founded. And it was Geffroy who introduced the hot-headed statesman to many contemporary artists and cemented a longstanding friendship between Clemenceau and Claude Monet. In 1894 Geffroy and Lautrec collaborated on a book about the sensational café singer, Yvette Guilbert. This thin, historic album consisted of Lautrec's lithographs weaving in and out of Geffroy's text, all printed in the olive-green that typified Japanese-influenced sensitivity (Cats. 84–87, 90, 92). After so successful a collaboration, it is likely that Geffroy arranged the commission for Lautrec to illustrate his friend Clemenceau's storybook three years later.

In the summer of 1897 Lautrec wrote to his mother about completing the illustrations for Clemenceau's book.[9] To be sure, what he pictured was less attractive than the cafés of Montmartre or life in the brothels. The subject of the book, character studies of Jews in Poland, at Carlsbad (where Clemenceau took the cure once each year), and in Paris, may have had a momentary popularity at its publication in 1898, as an admittedly anti-Semitic Parisian population looked for the peculiarities of a poorly known people to feed its hatred. It was, in fact, in January of 1898 that Clemenceau's journal *L'Aurore* carried Zola's historic essay, "J'Accuse," which precipitated the retrial of the Jewish officer Alfred Dreyfus. (Dreyfus was accused of treason and sent to Devil's Island in 1895; new information that pointed

to another officer emerged in 1897 and the case was revived.) The temper of the Parisians was inflamed, and into this milieu went Clemenceau's odd book. At the time he wrote *Au pied du Sinaï*, Clemenceau was known to have thought Dreyfus guilty, but his opinion, which later changed, seems to have had nothing to do with Dreyfus's religious faith. The stories, which show a good deal of sympathy for the Jewish people, are predominantly humorous. The book concludes with a plea for understanding and tolerance lest fanatics consolidate and seek to eradicate the Jews ("I hear that their systematic extermination is desired").[10]

Lautrec illustrated this set of six stories with quite literal crayon lithographs which obliquely illuminate his own interests and limitations. In this period of his decline Lautrec's work shows some influence of the more tragic imagery of Francisco Goya. His first design for the cover of Clemenceau's book, an emaciated man crawling up a hill, reaching out to the shining image of an eagle, was discarded. Probably a reference to the final words in the book: "What the Christians, who are after all still masters of the world, need above anything else, is to better their own ways; then they will not need to fear the Jews who may be reaching out for the crown of opulence, which has ever been coveted by men of all ages and of all countries,"[11] Lautrec's choice of symbols to interpret the character of Clemenceau's book seems awkward. The final cover shows Moses on Mount Sinai, the smashed Golden Calf at its base.

In the comic story "How I Became Farsighted," the author's baffling encounter with a Jewish oculist, Lautrec's portrait of Clemenceau being fitted with glasses reveals a curious omission (Fig. 4). Although there is a careful mention in the text that the oculist asked to keep his hat on indoors (a definitive sign of an orthodox male Jew), Lautrec shows him bareheaded. Although the mistake may have been due to a cursory reading of the story, it is more probable that the noble son of a count did not recognize the symbolic significance of this passage. Lautrec, despite his bohemian adult life, was a product of a part of society that had an unusually narrow scope of interests and a wide variety of prejudices by which it assiduously retained the

Fig. 4. Henri de Toulouse-Lautrec. *Georges Clemenceau and the Oculist Mayer*. From *Au pied du Sinaï* by Georges Clemenceau. Paris. Henri Floury, 1898. Lithograph, 10⅜ x 8⅛″ (26.4 x 20.4 cm). The Museum of Modern Art, New York. The Louis E. Stern Collection

aura of aristocracy. This inability to deny his heritage is apparent in the absence of Lautrec's signature in an album, *Hommage des artistes à Picquart* (Col. Georges Picquart was the officer who first suspected the miscarriage of justice in the Dreyfus affair and was himself incarcerated by the military in 1898).[12] Among the tens of thousands who signed the protest in the album were some of Lautrec's best friends and associates: Tristan Bernard, Clemenceau, Félix Fénéon, Geffroy, Henri-Gabriel Ibels, the Natansons, Jules Renard, Paul Signac, and Edouard Vuillard.

As his life plummeted to a close, Lautrec's work showed a desperate lack of concentration, dividing itself between humorous, often obscene caricatures and representations of animals. The latter group of prints is dominated by twenty-two lithographs of animals for Renard's *Histoires naturelles* which, after some years of planning, he finally drew at the urging of Maurice Joyant, who hoped this activity might stem the overwhelming decline of his friend

(Cats. 187–188). Several prints, of 1899, depicting horses, the favorite subject of Lautrec's youth, show his unswerving security in capturing the reality of these beasts. Nowhere is there a disinterested, scientific representation; always a characteristic movement or habitual position illuminates the vital essence of each animal. Particularly in the final years of Lautrec's career, a small dog appears to observe the subject of the composition as well as act as an anchor to hold it down. Some of Lautrec's many dogs, Tuck, Derby, or the last one, Pamela, or even Palmyre's bulldog, Bouboule, were his models as well as alter egos for these enchanting *remarques*. It seems clear that the small dogs which jauntily scamper through these late works play roles that are both emotional as well as formal.

Some years after Lautrec's death the English writer, and sometime frequenter of the Parisian cabarets and boulevards of the late nineteenth century, Arthur Symons, reminisced about the man he found so memorable:

To be great, to be a man of genius, to be famous, to be much loved and much hated; to be much praised and much dispraised; to have a passion for creation and a passion for women; to be descended from one of the oldest French families; to be abnormal and inhuman; to have sardonic humour and intense presence of mind; to adore nights more than days—to adore and to detest immensely; to squander much of one's substance in riotous living, to have a terribly direct eye and as direct a force of hand; to be capable of painting certain things which have never yet existed for us on the canvas; to be angry with his material, as his brutal instincts seize hold on him; these, chosen at random, are certain of the distinguishing qualities of Lautrec—certain of his elemental emotions.[13]

In 1920, to refresh his memory of the artist and his subjects, Symons went to the Bibliothèque Nationale in Paris to look at Lautrec's lithographs. As their indelible images evoked successive recollections and impressions for the writer then, so they express to us now some sense of the foundation of our modern age in forms that have an enduring accessibility and magnetism.

1. Edmond [and Jules] de Goncourt. *Journal* (Monaco, 1956), vol. 18, p. 146. March 13, 1892: "sur cette figure un mélange de quelque chose de feminin et d'un mâle voyou, que vous donne un tout d'androgyne énigmatique."

2. Erich Klossowski. *Die Maler von Montmartre* (Berlin, [1903]), p. 52.

3. Colta Feller Ives. *The Great Wave: The Influence of Japanese Woodcuts on French Prints* (New York, 1974), pp. 80–81.

4. Ibid., p. 93.

5. Ambroise Vollard. *Recollections of a Picture Dealer* (Boston, 1936), p. 258.

6. Ibid., p. 258. "Degas executed these monotypes after dinner, at Cadard the printer's."

7. Jean Adhémar and Françoise Cachin. *Degas: The Complete Etchings, Lithographs, and Monotypes* (New York, 1973), p. 84.

8. Lucien Goldschmidt and Herbert Schimmel, *Unpublished Correspondence of Henri de Toulouse-Lautrec* (New York, 1969), p. 191, letter 210.

9. Ibid., p. 192, letter 211.

10. Georges Clemenceau, trans. A.V. Ende (Amelia Kemper von Ende). *At the Foot of Sinai* (New York, 1922), p. 133.

11. Ibid., p. 136.

12. *Hommage des artistes à Picquart* (Paris, 1899).

13. Arthur Symons. *From Toulouse-Lautrec to Rodin* (London, 1929). pp. 15–16.

Henri de Toulouse-Lautrec with his mother at Malromé, c. 1899–1900

Henri de Toulouse-Lautrec: A Biography of the Artist

Julia Frey

Toulouse-Lautrec is one of those painters, like Vincent van Gogh, who has attracted interest not only because of his art but also because of his personal history.[1] He has come to symbolize a whole era in French life, the *fin de siècle*, the Moulin Rouge, the Parisian demimonde, the colorful nightlife of Montmartre. Not only was he an aristocrat, firmly tied to an eccentric, arch-conservative family, but he also lived among music-hall performers, prostitutes, and sideshow figures, who were his companions as well as his models for controversial works of art.

Lautrec's art conveys to many the sense of the texture and the excitement of life in Paris at the turn of the century. He "painted no landscapes, no religious pictures, no abstract conceptions. All his subjects, except for a few representations of animals, were people: real people whose lives were an integral part of his own life."[2] In his paintings of the people and places that moved him, documenting his everyday activities, Lautrec told two stories: his own and that of his generation.

To view a Lautrec exhibition is to take a tour of his private world—a world of contrasting images and characters, of aristocrats and clowns, sportsmen and cancan dancers, bordellos and cafés. His works themselves became artifacts of his time: portraits, posters, and book illustrations. If an archeologist were to dig them out of the ruins of Western civilization some centuries hence, he would stumble upon precise documents of Parisian life between 1880 and 1900. So precise are they, in fact, that studying the details of Lautrec's own life through photographs, family letters, newspaper clippings, and the accounts written by people who knew him personally confirms that his work is almost completely autobiographical and frequently an exact portrayal of places he went to and people he knew, despite sometimes misleading titles. By dating his surviving works, a fairly accurate chronology of Lautrec's changing interests and lifestyle can be established.

Lautrec died in 1901, before he was thirty-seven years old. In his brief lifetime he created some 737 canvases, 275 watercolors, 368 prints and posters, and 5,084 drawings, not including lost works, an occasional sculpture, ceramic, or stained-glass window. To have been so prolific Lautrec had to have been an extremely serious, perhaps driven, artist, who spent most of his time on his art. If these statistics are compared to his reputation as a rich, snobbish barfly who spent all his time in brothels, or to his dwarfism, broken bones, and illness from alcoholism and possibly syphilis, they temper the sometimes accepted theory that Lautrec was an artistic lightweight—that he was usually too drunk or too ill to work. The truth must be that he worked sick or well, wherever he was—a conclusion substantiated by the reports of his contemporaries that he

sketched and drew constantly, even in the cabarets, and by the subject matter of his work, which includes numerous bar and brothel paintings.

If Lautrec's era is called the *belle époque*, it is because between 1880 and the beginning of World War I France enjoyed a long period of relative economic stability. Obviously, the period meant different things to people of different economic classes. In the cities, the upheaval of the industrial revolution, followed by the rise of trade unions, had finally led to improved working conditions and a reduction in working hours. However, the peasant and urban working classes still struggled to find enough food for their families, and there was still social and political dissent, sometimes in the form of anarchist bombings.

It was a time, nonetheless, of widespread optimism, particularly among the economically secure. The family was still the center of existence for all so-called decent people, and provided for and protected its members when they were in need. It also could be fierce in controlling standards of behavior among family members and in trying to dominate those who wished to leave the fold. In its effect on the society at large the middle- and upper-class family (which lived in the same house with its servants, provided charity to the poor as a part of everyday life, and trained its children in "Christian" generosity) played many of the paternal roles now assumed by the state. And, like the state, the bourgeois family tended to believe that the world it inhabited was "the best of all possible worlds" and to be ignorant of those aspects of society it did not control.

For the growing middle class there was enough economic leeway for the subjects of leisure, fashion, and home decor to become pertinent for the first time. For the independently wealthy, art and culture, elegant costumes, beautiful furnishings—in short, matters of taste—took on vast importance, and decisions about how and where to be entertained were considered primary issues. Life was a succession of significant rituals: visiting cards, weddings, funerals, horse shows, the Opéra, the races, charity bazaars, exhibitions, yachting, and country weekends.

By 1880 Paris was a "new city." It had been rebuilt and opened up following the massive plans designed by Baron Georges Haussmann (prefect of the Seine during the Sec-

ond Empire) and by Emperor Napoleon III himself, who personally instructed Haussmann on many of the details. Instead of a congested medieval town with a few impressive palaces, Paris was now an open city crisscrossed by large, tree-lined avenues with classical perspectives. For the first time it could be traversed efficiently (by troops, if necessary), and the wide new streets provided a perfect theater for the elegant comings and goings of the rich.

Haussmann had also seen to the establishment of new water supply and drainage systems, which removed the foul odors from the city. Parks had been constructed or enlarged, both in the center of the city and on its outskirts. The showplace of Paris was the Bois de Boulogne at the end of the Champs-Elysées, the customary destination of the morning parade of the leisure classes through the city.

At the other end of town, the Bois de Vincennes remained the territory of the working classes. One of the major effects of rebuilding the city had been to destroy a number of decaying neighborhoods, forcing the proletariat to move to the outskirts of Paris, where they lived in a squalid zone of shacks and temporary buildings called the "red belt." Although these dreadful slums—the poorest of which were inhabited by the beggars, prostitutes, and artists—were full of disease and suffering, they tended to be viewed by outsiders as having a seductive glamour all their own.

Haussmann, without proclaiming his intentions, had effectively isolated the working classes. But the rest of Paris circulated freely, seeing and being seen. The city was becoming known as the pleasure capital of the world. Citizens of all nations, who had the means and the leisure, gathered there to play. And when the rich grew tired of their own games, by ironic reversal, it was they who would invade the working-class neighborhoods, slumming with the seamstresses and *apaches* in the cabarets and dance halls. The *cafés concerts* and other nightspots became melting pots of the least and the most fashionable, elbow to elbow. Among all social classes the *belle époque* can be measured in terms of conspicuous consumption of material goods and conspicuous satisfaction of the passions. In both low and high society, the most convincing image of success was style.

Lautrec had style. Even in his lifetime he became the hero of a set of legendary anecdotes. He was the author and perpetrator of many of these stories, not only because he behaved extravagantly, dressed in startling costumes, and habitually made ironic and witty comments on situations around him, but because he delighted in retelling incidents that had really happened, embellishing and elaborating them until they bore little relation to the originals.

Curiously, this grandiosity and tendency to mythologize coexisted with his well-known cynicism in his observations of human nature. He made cruelly revealing portraits of people he professed to like and admire. Part of his style was an ability to see beneath surface appearances and to make apparent in his works the psychological realities he sensed in his models. Both the unflattering portraits and the embroidered accounts of his escapades may have represented his attempts to correct truth as perceived by the world at large, replacing it with his own view of reality.

A brief look at Lautrec's life—fact and myth—will help to explain the complexity of his artistic and personal style. He is a surprisingly pure example of philosophical positivism, which had marked French thought during his parents' generation—Hippolyte Taine's determinist theory that an individual is unvaryingly the product of three factors: his heredity, his surroundings, and the historical moment at which he lives.

Henri Marie Raymond de Toulouse-Lautrec Montfa[3] was born before dawn on a stormy morning in late November 1864, exactly seventy-five years after the beginning of the French Revolution. The provincial mansion in Albi from which he first saw the world was called the Hôtel du Bosc, the private townhouse of his family of aristocrats, who were still hoping the rightful king (Henry V, Comte de Chambord) would be returned to the throne of France and who believed that nobility was ordained by birth, not by acts. Lautrec was the eldest son of an eldest son, and from his earliest years knew that it was his legacy to someday be the count of Toulouse-Lautrec.

Albi, a red-brick fortified city not far from Toulouse in southwestern France, would never really be his home. However, his personality in some ways was representative of the character attributed to inhabitants of the region. They are known historically as theatrical, extravagant, loyal, lovers of good stories and wit; they are said to be quick to laugh, to anger, and to make up, but rebellious when confronted, preferring to die before submitting to outside domination.

His family was very wealthy, so wealthy that one of the legends prevalent in his childhood is that the Toulouse-Lautrecs had a "chest full of money" into which they dipped at will. While this may be true, what can be verified is that Lautrec's extended family—parents, grandparents, uncles, and aunts—owned a number of impressive estates, farms, vineyards, and palatial townhouses. Lautrec spent his entire childhood traveling from château to spa, and from hunting lodge to elegant Parisian hotel, usually at the whim of his mother.

Although he had no home as such, Lautrec was not rootless. He had the security of an impressive heritage. His family was descended from a secondary branch of one of the oldest and most prestigious families in France, the Toulouse dynasty, which had ruled the regions of Toulouse and Aquitaine a thousand years before he was born. Like every child, Lautrec was fascinated by tales of knights and ladies, battles in armor, and holy crusades. But in his case, at least according to his parents, they were all true, and his own forebears were the heroes.

One of the first stories that he heard was that one of his ancestors, Comte Raymond IV de Toulouse, had led the almost unbelievable army of one hundred thousand men on the first crusade to take the Holy City of Jerusalem in 1096. Later he learned stories of less revered but equally arresting relatives. Through successive generations his bloodline produced a series of powerful leaders whose physical strength, mental energy, audacity, and violent ambition made one count of Toulouse after another famous throughout the land. These characteristics often created men who believed they themselves were the law. Brothers attacked and killed brothers, warred relentlessly with neighbors, and struggled for continued independence from both king and pope. They conquered, stole, and purchased enough land to make them at one time the absolute rulers of the entire south of France.

By the time of Lautrec's birth, however, his direct

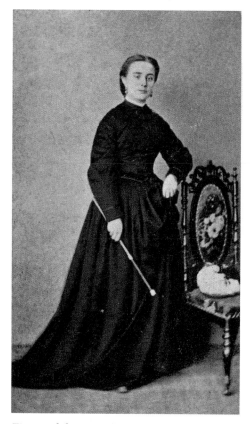

Fig. 1. Adèle Tapié de Céleyran, Comtesse de Toulouse-Lautrec, the artist's mother

aristocratic pedigrees. Lautrec's grandmothers were sisters; his parents were first cousins (Figs. 1, 2). In addition, Lautrec's father's sister married his mother's brother. This aunt and uncle had fourteen children, not counting still-births; three of them were born with birth defects, and at least one of those was a dwarf.[5] In a family proud of its illustrious lineage, the presence of children with birth defects was a humiliation. Nowhere in any of the family correspondence are such birth defects mentioned. The children are always referred to as fragile or sickly if mention of their health problems must be made at all. In the case of Lautrec, the family insisted to the outside world that he showed no signs of handicap until an incompetent doctor set a broken leg badly, somehow stopping his growth.

Although posthumous diagnosis is always risky, it has been convincingly argued that Lautrec suffered from a rare kind of dwarfism called *pyknodysostosis*, in which twenty percent of the cases are born of parents who are from the same family.[6] In this form of dwarfism the most radical symptoms appear at adolescence, when in normal children there is a huge growth spurt. Lautrec's long bones, his arms and legs, did not grow normally. Instead, they became increasingly weak and fragile.

It is fortunate that the major symptoms of his malady did not appear until he was about ten years old. Although, as his mother had already noted when he was three months old, he was "not a very large child,"[7] he was able to spend a relatively normal early childhood (Fig. 3). He was educated at home by his mother and Abbé Peyre, a Catholic priest who lived on his grandmother's estate. His innumerable cousins, who also lived or visited where he happened to be, were his principal playmates. Life in the country was full of horses, farm animals, and dogs. Lautrec's father hunted with falcons, cormorants, and ferrets. His great-grandmother kept parrots and monkeys. Early in life Lautrec learned to love all sorts of animals, and drew them as sympathetically as he did his human models.

His parents got along so badly that, although they never formally separated, they chose to live in different places and crossed paths only a few times a year. His only brother had died in infancy. Consequently, Lautrec's primary fam-

ancestors had been reduced to a life of hunting and managing their provincial estates. They were perhaps even more profoundly snobbish than their forebears, precisely because they could no longer equal their glory. Such country nobles are often called *culs terreux* (literally, "bottoms in the dirt") and are closer in many ways to their farming neighbors than they are to royalty. It is not surprising that Lautrec's father and grandfather maintained a nostalgia for the old life, before the Toulouse-Lautrecs had become subjects of the king of France. "Ah, Monseigneur," Lautrec's father is supposed to have remarked earnestly to an archbishop at dinner one night, "the days are gone when the counts of Toulouse could sodomize a monk and hang him afterwards if it so pleased them."[4]

In this family, intermarriage was common, practically the rule, for it prevented the family fortune from being dispersed and guaranteed that the spouses would have

ily relationship was always with his mother, a long-suffering, pious woman, considered to be an "angel" by others in the family, but whose well-meaning, iron-willed domination of her son became a continual source of conflict for him.

His absent father was a man whose wealth and freedom from accountability permitted him to be an outrageous eccentric. His embarrassing tendency to appear in costume and behave in harmless but exhibitionistic ways may have had its source in a frustrated need to express his aristocratic prowess. A confirmed womanizer and sportsman, he was obsessed with hunting, which he considered to be the only activity worthy of an aristocrat's serious attention. He showed little interest in his son.

Lautrec was a quick, observant child. He was surely marked by the conflict between his parents, particularly since he himself was at times a pawn between them. Early in life he developed a sense of irony and a talent for witty repartee, which remained part of his defensive posture throughout his life.

He went to school for the first time, in Paris, when he was nine years old. He was so small that the other students called him "little man," and it was during his first year in school that his mother began to realize that he was more than just a frail child, that he had serious growth problems. By the time he was ten she decided to place him in the home of M. Verrier in Neuilly, just outside Paris, for treatment of his legs. The young Lautrec stayed there for more than a year. He was kept in bed several hours a day and not allowed to walk farther than the garden. To visit the children's zoo, in the nearby Bois de Boulogne, he rode a large tricycle. His mother lived in Paris and went to Neuilly to see him every day, taking a combination of public omnibus and tram to save money she did not need to save, and perfecting the role of martyred nurse and protector, which would define her relationship with her son for the rest of his life.[8]

Lautrec's father appears to have been little concerned by his son's condition, and almost never visited him. On principle, he was opposed to the treatment. For his bedridden son's second Christmas in Verrier's clinic the count of Toulouse-Lautrec gave him a book on how to hunt with

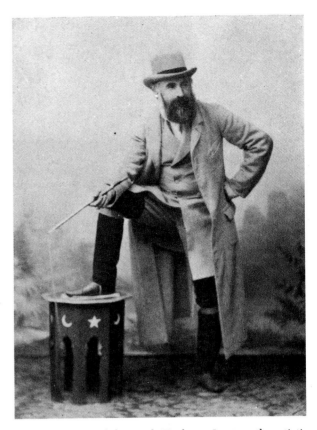

Fig. 2. Le Comte Alphonse de Toulouse-Lautrec, the artist's father

falcons. Inside the front cover he wrote the following insensitive dedication:

Remember, my son, that life in the open air and in the light of the sun is the only healthy life; everything which is deprived of liberty deteriorates and dies quickly.

This little book on falconry will teach you to enjoy the life of the great outdoors, and if, one day, you should experience the bitterness of life, dogs and falcons, and above all, horses, will be your faithful companions and help you to forget a little.[9]

His words reflect the ongoing struggle between Lautrec's parents about what treatment would benefit their son. "To complicate my problems," his mother wrote in 1877, "I'm caught between M. Verrier, who wants Henry at Neuilly, Dr. Raymond, who is opposed, and Alphonse, who wants to get rid of all the doctors and cure his son on horseback!"[10]

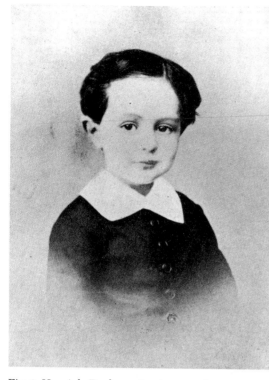

Fig. 3. Henri de Toulouse-Lautrec, age 5

inconsolable at the thought that he had inadvertently been the cause of his son's mishap.[12]

Just over a year later (Fig. 4), while at Barèges, a spa whose waters were supposed to fortify his crippled leg, he fell again, this time into a shallow ditch, and broke his other femur. All long-bone growth stopped; for the rest of his life he was visibly dwarfed, and painfully dragged his crippled legs along with the help of a cane.

Even as a young child he had shown a number of qualities which came to his aid as he faced the agony of uncertainty and then the confirmation that his handicap was permanent. He had always been famous in his family for his sunny disposition and witty sense of humor. Despite his frailty he had been recognized as the ringleader of the games and pranks he invented for his band of younger cousins. Most important, he had a gift for art. Throughout long illnesses and painful operations he some-how was able to remain cheerful and uncomplaining. As he grew used to his new physical limitations, his imagina-tion in inventing amusements, along with his warmth and generosity, helped him to develop a following of close friends, despite his disabilities. And before he was able to do more than walk with a crutch, supported by someone at his side, he was back doing watercolors, finding consola-tion in what was to be his major activity.[13]

Like a great many men of their class and time, Lautrec's father and uncles were amateur artists, and during his childhood he had frequently spent rainy afternoons watch-ing or imitating them as they painted watercolors of hunt scenes or modeled in wax. However, there is little mention of Lautrec's artwork until his years in Paris, when his illness was beginning to dominate his life. His father had become friendly with a deaf-mute painter, René Princeteau, who frequently lived in the same residential hotel the family stayed in when they were in the capital. The count admired Princeteau's conventional, fashionable paintings of hunting and racing scenes, and even took lessons from him. As Princeteau grew to know Lautrec as well, he some-times tried to amuse the child by filling sketchbooks with drawings for him and encouraging him to try art himself. Perhaps his own handicap made him sympathize with the ailing boy.

Lautrec did not improve at Neuilly, and finally his anguished mother, deciding that Verrier was quite possibly a charlatan, took her son on the first of an endless round of visits to health spas, hoping that somehow his worsening condition might be cured. Her letters are full of conflicting emotions: irrational hope, forced optimism, moments of despair. Profoundly religious, she prayed and placed her son's well-being in the hands of god. Lautrec's brief experi-ence with school was completely abandoned, and hence-forth his devoted mother taught him his lessons, occasion-ally hiring a "Miss" to tutor him in English.

The crisis of his malady came at Easter vacation, 1878, when he was thirteen years old. He and his parents were visiting his Uncle Charles and Aunt Emilie in Albi.[11] The doctor had been to see his ailing grandmother that day and came into the salon to say goodbye. In response to his father's abrupt order to come and be introduced to the doctor, Lautrec tried to push himself out of a low chair with the short cane he had been using. It slipped on the waxed floor and he fell, breaking his left thigh. Lautrec's father was

After the accidents in 1878 and 1879, Lautrec turned to drawing to fill the long hours of his convalescences. He sketched everything: caricatures of the people around him, boats in the harbor, and even landscapes, although he observed: "My trees look like spinach, and my sea looks—well, like anything you choose to call it."[14] He covered not only sketchbooks, but all his school books and notebooks with drawings, showing a gift for catching movement and human likeness. For the rest of his life these would be the two subjects that seemed to interest him the most—the varieties of human expression and living things in motion. Images, in fact, interested him far more than his school work, as he demonstrated by having to take his high-school baccalaureate exam twice in 1881 before he was able to pass it. After the first failure, with typical verve, he had calling cards printed that read: "Henri de Toulouse-Lautrec, Reject of Letters." On his second try, however, he succeeded. At that time the baccalaureate was the gentleman's proof of education. He was not expected to go any further.

Although he was not exactly an adult at age seventeen, it was time for him to take stock of where he stood. The first thing he had to recognize was the reality of his physical condition. His growth had stopped at a little over four feet, eleven inches. He had a normal-sized head and torso, but his knock-kneed legs were foreshortened.[15] He had short, stocky arms, massive hands, and clublike fingers. His slope-shouldered body hid fragile but compact bones, lumpy with healed fractures (Fig. 5). He had begun wearing a hat even when indoors. He explained that the turned-down brim of his hat reduced glare, helping him to concentrate his vision,[16] but one of the unvarying symptoms of *pyknodysostosis* is an unknitted anterior fontanel—the classic "soft spot" of newborns. Lautrec's had never closed.[17] Perhaps instinctively, he protected this opening in his skull.

As he reached adulthood, he developed other marks of his rare form of dwarfism: a receding chin, large nostrils, a thickening tongue, abnormally red and bulbous lips, a lisping speech impediment, a characteristic sniffle, and a tendency to drool.[18] The only physical compensation for his unappealing appearance was that he had lovely eyes. His irises were such a dark brown that he seemed to have

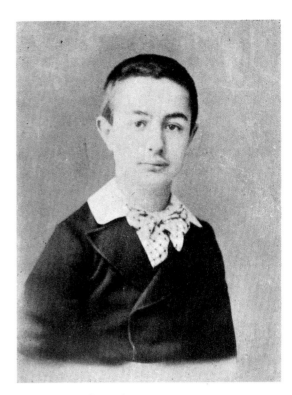

Fig. 4. Henri de Toulouse-Lautrec, age 14

enormous pupils. When he removed his omnipresent pince-nez, his nearsighted gaze was intense and compelling (Fig. 6).

This, then, was the heritage of a man who became one of the most important artists of his period. Not only was he born into a tradition of inherited wealth, but he was handicapped before he reached adulthood, which rendered him unfit for any of the usual occupations of the provincial rich and noble: serving as officers in the army, riding and hunting on horseback, and snobbish exhibitionism such as promenading in the Bois de Boulogne with beautiful and elegant mistresses dressed in the latest fashions. Theirs was a world based on kinds of prowess and beauty with which he could not compete.

Lautrec found other ways to display his prowess. Princeteau and Uncle Charles both agreed that he showed promise as an artist. He had been passionately interested in drawing since about the age of twelve, and it was decided that his desire to pursue this interest would be granted. His parents took him to Paris (Fig. 7) to choose an art school for

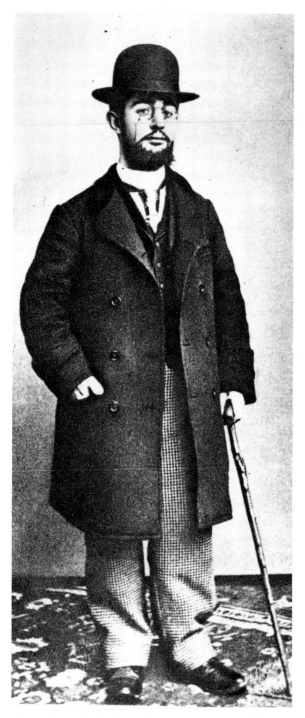

Fig. 5. Henri de Toulouse-Lautrec as a young adult

him. His mother was not nearly so concerned about the quality of instruction he might receive as she was about placing him where there were other boys of good family. Originally she hoped to enroll him in the Ecole des Beaux-Arts because the son of a family friend was already a student there and was considered "a gentleman from every point of view" (although, she observed, "he has had the misfortune to have lost one eye").[19]

She decided her son was to study with Léon Bonnat, a profoundly conservative, academic painter, known as the "favorite of millionaires."[20] She chose Bonnat's atelier largely because the child of acquaintances from Toulouse also worked there and would be able to introduce Lautrec to the right people. Bonnat took an instant dislike to him and, moreover, found his drawing "downright atrocious."[21] However, even in such a constraining circumstance, Lautrec profited from the experience. He seems to have preferred the scathing criticism of Bonnat to the easygoing comments of his other teacher, Fernand Cormon, to whose studio he moved when Bonnat closed shop the next year.

Lautrec used the years of training in both studios to learn anatomy, draftsmanship, the scrupulous analysis of a subject, and classical painting techniques. He was intent on forcing himself to acquire the self-discipline and technical perfection necessary to fully exploit his native artistic energy and facility. He had no illusions about the quality of his work, and was harshly self-critical. The stiff, artificial studies of the atelier years seem greatly inferior to the energetic sketches of his adolescence, but he soon returned to his own highly individualistic style. However, his liveliness had become skilled, his drafting impeccable, and all his work supported by the firm base of conventional academic training.

As they realized the extent of Lautrec's driving commitment to his art and his insistence on pursuing it seriously as a profession, his family grew very distressed. In the nineteenth century, self-respecting nobles lived exclusively from inherited wealth. Although they heartily approved his studying art and even his success as an amateur—for example, his exhibition of paintings at the fashionable Cercle Volney—it was inconceivable to them

that the Lautrec heir work for a living. He had a compli-
cated reaction to their criticism. Despite a monthly allow-
ance from his family, Lautrec considered himself to be a
working artist, not a dilettante. In fact, he went out of his
way to let his family know that he had sold works, and the
prices they commanded. His father, in particular, did not
want the prestigious Toulouse name "misused" by his son,
whose art he never understood or respected. For a few
years, Lautrec attempted to appease him, signing his works
with a variety of names, including Monfa and Tréclau (an
anagram of Lautrec, phonetically pronounced "très clos,"
or, very closed). For the Salon des Incohérents exhibition of
1889, Lautrec even used a "Hungarian" parody of his name:
"Tolau-Segroeg" (address, "Rue Yblas, under the third gas
lamp on the left, pupil of Pubis de Cheval, specialist in
family portraits with a yellow pastel background").[22]
Shortly thereafter, however, he settled on a signature: "H. T.
Lautrec," or often, just his monogram, "HTL." Two years
before he died, a journalist critical of his work was still
chastising him for dragging his family name through the
streets of Paris by daring to sign his "insane" posters, which
were hung everywhere.[23]

To Lautrec's delight, and his family's confusion, he re-
ceived rapid recognition for his work. While he was still
working at Cormon's studio, he was selected along with
another student to assist Cormon in preparing the illustra-
tions for a deluxe edition of Victor Hugo's *La légende des
siècles*. This commission gave the young Lautrec great
excitement and pride, even though his drawings finally
were not used. He began sending his drawings to the
newspapers to be used as illustrations, not so much for the
money as to begin to be known. By the time he was twenty-
six, after nine years in Paris, it can be said that he had
achieved a certain renown. His illustrations in the news-
papers, on sheet music, and in books were beginning to be
recognized, and he had exhibited in a number of salons.
When, in 1891, he made his first poster for the Moulin
Rouge, he became famous overnight (Cats. 247–248).

He was far more successful in public terms, for example,
than Vincent van Gogh, who had also worked briefly at
Cormon's before moving to Arles. The two painters knew
and sympathized with each other, despite the ten-year

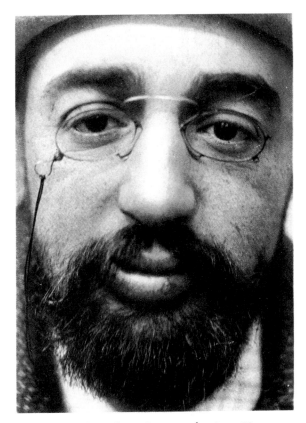

Fig. 6. Henri de Toulouse-Lautrec, about age 30

difference in their ages. The Dutch painter died without
ever selling a painting.

Lautrec was deeply concerned with marketing his work,
exhibiting it in the galleries and salons, publishing his
drawings, and making posters for the cabarets of Paris.
Although his family was disturbed by their son's commer-
cial stance, they were somewhat ambivalent. His mother,
for example, had been proud when the twenty-one-year-
old Lautrec received a 500-franc fee (about $1,500 in 1985)
for his work on the Hugo illustrations. As far as Lautrec was
concerned, his art gave him a sense of purpose and value
that outweighed the pain of familial disapproval. He forced
his family to accept him as an artist on his own terms.

He was far more ambiguous, however, about revealing to
them his changing lifestyle outside the studio. Just as his
mother had feared, in Paris he had fallen among what she
perceived as bad influences. Cormon had suggested that
his students go to sketch models in their normal environ-

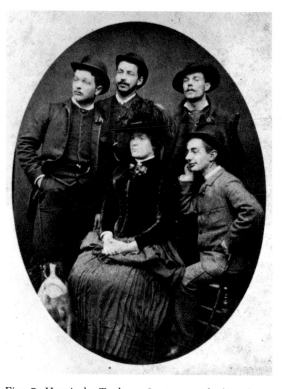

Fig. 7. Henri de Toulouse-Lautrec with friends in Paris, LEFT TO RIGHT René Grenier, M. Rabache, Lucien Métivet, Lily Grenier, and Lautrec

ment of his own social class for another world, the demimonde of Parisian *cafés concerts*, and dance halls, inhabited by what his mother considered to be quasi-criminal types. There snobbery, exhibitionism, and beauty also existed, but they were defined in different ways.

His new territory was Montmartre, the hill where his fellow artists lived, and where he always had his studios. Montmartre was the most accessible bit of countryside near the city. It had vineyards and farmyards, goats, cows, and ramshackle outbuildings that could be rented cheaply by artists (Fig. 8). In the shadow of the scaffolded, unfinished domes of Sacré Coeur basilica, bareheaded, shawl-clad streetwalkers could be had for a few sous, or sometimes just by giving them a place to sleep overnight.

The streets were mostly steep footpaths. At both the top and the bottom of the hill could be found clusters of music halls and *cafés chantants*. There the seamstresses and factory girls would go on Sunday afternoons to meet their beaux at the Moulin de la Galette and the Bal Tabarin, places Lautrec and other artists made famous in their paintings. In the evenings, women who listed their profession as "actress" would dance the cancan and other obscene quadrilles at the Moulin Rouge, high-kicking for an audience that included not only pimps, con artists, and the local representative of the police morals squad, but also artists, musicians, bored aristocrats, and rich bourgeois. The demimondaines who accompanied them added an aura of satin and jewels to their titillating explorations of new vices. Sometimes the evenings would finish at dawn, especially if a famous murderer was to be guillotined in La Roquette prison yard.

It is not surprising that Lautrec's real fame began with his poster for the Moulin Rouge. After the dance hall was built in 1889, it rapidly became a symbol of the excitement of decadent Paris. It was as flashy, glittering, and as full of artifice as the scarlet vanes of its fake windmill, which, outlined with lights, served as a landmark in the night sky. In 1900, a tourist guidebook described the Moulin Rouge at length:

The first view of it is far from commonplace: high and enormous, it looks like a railway station miraculously

ments, so Lautrec took to drawing the figures he saw in the bars and dance halls he went to with his artist friends. Although at the beginning he protested greatly, claiming to find the bars boring and unpleasant, and only going "out of artistic duty,"[24] he rapidly grew used to, and even fond of, his experiences "outside the law," going out every night drinking with his friends during long evenings that frequently ended in rowdiness and public scandal. Even as a child he had shown such unnatural interest in champagne that his mother had felt a need to reprimand him for drinking too much,[25] and despite declarations to the contrary, he later become dependent on alcohol.

Perhaps the change was partly a rebellion against his mother's loving but smothering domination. Although it was unthinkable for him to openly reject her decisions, he nonetheless found a way of establishing his independence. While maintaining the exterior appearance of conforming to his mother's orders, he began to lead a life centered on the one thing that would most horrify her: the abandon-

transformed into a ballroom. The orchestra, big enough for a circus,…sounds the charge for the battalion of *chahuteuses* [quadrille dancers] who leap forward with skirts lifted and legs uncovered. During the intervals in the program of dances, men and women promenade up and down in a double stream as on a railway platform, jostling, rubbing elbows, forming eddies, under a bewildering confusion of hats of all kinds: the women wear huge feathered creations on their heads, while the men are in high silk hats, bowlers, soft felts, and sometimes even caps.

Gay bodices of cerise, green, yellow, white, and blue satin as well as skirts of all colors, provide a feast for the eye and fascinate the observer.

An aroma of tobacco and rice powder envelops you.

To the left, at little tables, sit the *petites dames* who are always thirsty, and who buy drinks for themselves while they are waiting for somebody to buy drinks for them. When that happens, their gratitude is so overpowering that they immediately offer you their hearts—if you are willing to pay the price.

On each side of the room is a raised platform, a broad open gallery from which you can watch the dancing without taking part in it and enjoy a general view of all the women in full regalia, strolling about and parading before you in this veritable marketplace of love.…

The garden is to the left of the entrance; round the bandstand in the center you see a bevy of damsels, trained and paid to maintain at the level of its former glory the divine Parisian *chahut*, sought after and appreciated by people of all nations, who assemble here to enjoy its unconcealed glories.

A few English families…are scandalized by the sight of these women who dance by themselves, without male

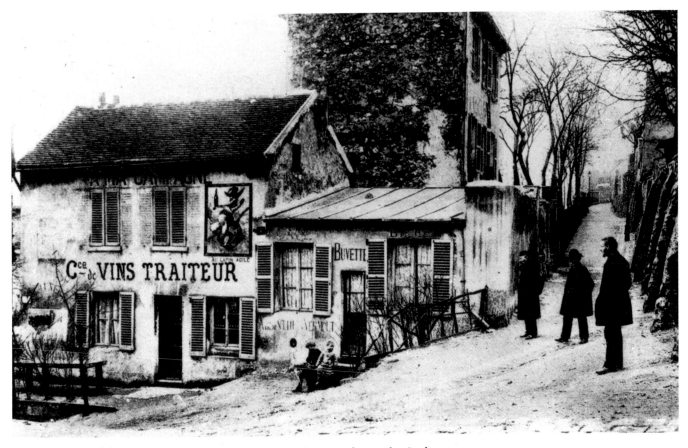

Fig. 8. View of old Montmartre showing the Lapin Agile cabaret on the rue des Saules

partners, and whose muscular elasticity, when they spread their legs wide apart in the *grand écart*, betokens a corresponding elasticity of morals.... Through the lace ruffles of drawers or the transparent gauze of silk stockings you can often catch glimpses of pink or white skin, displayed as samples by these pretty vendors of love.... [26]

Lautrec painted the Moulin Rouge and the rest of his Paris world as obsessively as other artists paint the landscapes of their beloved homelands, but his "landscapes" are almost always interiors. In addition, he himself was a well-known figure in these interiors. He was considered to be practically part of the uninterrupted show in the dance halls, where he watched and drank every evening. He spent much of his time in the brothels, painting as well as paying for pleasure, creating a series of works on the lives of the prostitutes that constitutes one of the most striking sociological portraits of the time.

His own life was peopled with a surprising mixture of types. It should not be thought that he totally abandoned his aristocratic heritage. Not only did he continue to see his mother almost daily, but two of his closest friends were his cousins Louis Pascal and Dr. Gabriel Tapié de Céleyran, both of whom accompanied him on his visits to bohemian haunts. Each cousin in his own way formed a striking visual contrast to the painter. Pascal was handsome and dapper, with flashing blue eyes and a sculptured blond moustache. Unlike Lautrec, Pascal had no sense of purpose in life. "You should find him a rich heiress," Lautrec wrote to his grandmother. "He isn't, I think, good for anything else."[27]

Tapié was five years younger than Lautrec and was probably his closest friend. It has been said that Lautrec totally tyrannized this gentle man, dominating him to such an extent that Tapié, who was something of a clothes horse, even agreed to wear an absurd bottle-green waistcoat Lautrec had ordered for him, specially cut from the felt used to cover billiard tables.

They had been brought up together on the family estates in southwestern France, and in 1891, when Tapié moved to Paris to complete his medical studies, they began going almost everywhere together. "The doctor," as Lautrec's friends called him, was very tall. Lautrec is said to have explained that one reason he liked to be seen with his cousin was that he enjoyed the contrast they made in public. He even painted their divergent profiles into his 1892 canvas, *At the Moulin Rouge* (The Art Institute of Chicago). But he was as likely to go out drinking with the man down the block who ran the livery stable as with fellow artists from Cormon's or his elegant relatives.

Henri Rachou, one of his friends at the Atelier Cormon, later described Lautrec's compelling personal charm:

His most striking characteristics, it seemed to me, were his outstanding intelligence and constant alertness, his abundant good will towards his devoted friends, and his profound understanding of his fellow men. I never knew him to be mistaken in his appraisal of any of our friends. He had remarkable psychological insight, put his trust only in those whose friendship had been tested, and occasionally addressed himself to outsiders with a brusqueness bordering on asperity. Impeccable as was his habitual code of behavior, he was nevertheless able to adapt to any milieu in which he found himself.[28]

One of the men with whom he felt an affinity was the populist cabaret singer, Aristide Bruant. Bruant understood the refusal to prettify or romanticize that characterized Lautrec's work, for he did the same with his songs of the bleakness and depression of the lives of the poorest people of Montmartre. Lautrec illustrated sheet music for Bruant's songs, and beginning about 1885 Bruant hung Lautrec's works in his cabaret, the Mirliton. Lautrec was one of the regulars in the cabaret, joining in the laughter at Bruant's brutal attacks on his clients and, with friends, ordering endless rounds of the tiny glasses of mediocre beer that was the only drink served there. His four posters of Bruant (Cats. 251, 256–258) created an immediate sensation, confirming his reputation as a poster artist.

Lautrec did a great deal of commissioned work—not only posters but book covers and illustrations, stage decors, and covers for sheet music—and no matter what the proposed subject for a work was, he almost invariably used as

models for it either people he actually knew or people who somehow fascinated him. With a kind of malign instinct, he tended to depict them not as they looked at the time but as they one day would be; he somehow was able to get behind their appearances and little vanities to show their true weaknesses and vices.

Not only could it be risky to one's ego to pose for Lautrec, but his well-known passionate infatuations with one person, image, or gesture could be disconcertingly fleeting. As Jean Adhémar pointed out: "His models must often have been bewildered and distressed when, after continually seeking them out, admiring and drawing them, Lautrec would suddenly drop them, announcing that he 'needed a change.'"[29]

Often Lautrec's fascination with a model led him to do numerous works representing that person. He repeatedly sketched his father, with whom he had distant and difficult relations, from memory, although he rarely portrayed him in his finished works. The opposite is true of his mother, whom he adored despite their complicated relationship. He does not seem to have sketched her obsessively, as he did his father, but the portraits he did of her are among his finest and most carefully executed. In each of them, she is depicted in a modest, almost saintly pose, with lowered eyes and a sort of halo of light or color around her head.

It seems that Lautrec always had unstable, complicated relations with women. It would have been difficult, if not unthinkable, for him to make a conventional marriage to a woman of his own class. So far as it is known, Lautrec had no sustained love relationships with women, and he was always extremely discreet about the details of his love life. The women who attracted him were often of a certain type: redheads who had passed their prime, who were beginning to lose their muscle tone. Their images haunt his drawings and paintings. It is almost certain that, like many of his generation, he contracted syphilis. At that time, there was no effective cure for the disease and some twenty-five percent of those suffering from it eventually died of it. It is possible that tertiary syphilis was a contributing cause in Lautrec's own early death.

According to Thadée Natanson, Lautrec accepted a servile and unequal relationship with a number of the women he admired, including Jane Avril, Yvette Guilbert, and Natanson's wife Misia.

As with his intense passions for people, Lautrec developed a series of fascinations with different milieux and art forms. His works identify them and show that they followed a pattern: first he would be obsessed with a place, frequent it and draw it repeatedly, then lose interest and find a new subject. Thus, in turn, he was excited by the backstage scenes of young ballerinas at the Paris Opéra, Bruant's cabaret, and then the working-class Montmartre dance hall, the Moulin de la Galette, where he did his first drawings of La Goulue and Valentin Le Désossé. As he was fascinated by animals (Fig. 9), he was also fascinated by humans who moved with animal vitality, and his drawings of these two dancers, as he followed their careers from cabaret to cabaret, and finally to the Moulin Rouge, confirmed his fame among his contemporaries and recorded theirs for posterity. When La Goulue stopped dancing, he began to do repeated works based on the ritual postures taken by Jane Avril, another dancer, whom he also sketched dancing among the patrons at the Divan Japonais.

Fig. 9. Henri de Toulouse-Lautrec with the family bulldog

Fig. 10. Henri de Toulouse-Lautrec dressed as a choir-boy at a fancy ball, with René and Lily Grenier

muezzin, and as a woman still exist today (Figs. 10, 11).

Lautrec developed a passion for the theater and did paintings and prints of a number of actresses and actors from the Paris stage. He also painted the spectators in their theater boxes. He drew programs for André Antoine's revolutionary Théâtre Libre and for Aurélien-François Lugné-Poë's Théâtre de l'Oeuvre. He went to the *cafés concerts* and the music halls and did perceptive portraits of a whole series of music-hall and *café-concert* singers, among them Yvette Guilbert and May Belfort. He decided that "landscape is nothing and should be nothing but an accessory ... landscape ought only to be used to emphasize the character of the model,"[30] and for a time painted his models in a nearby garden. During a period in 1891, he spent all his Saturdays at the hospital with his medical-student cousin, even scrubbing to enter the operating room so he could watch Dr. Péan, one of the most famous surgeons of the time, operate, with a white linen napkin tied around his neck.

In the early 1890s he began assiduously frequenting brothels. One of his oddest habits was to become an occasional lodger in some of these brothels, where he would convince the madam to rent him a room. On more than one occasion he was known to live this way for brief periods, carrying on business as usual and giving the brothel as his address for business appointments. Thus he resided awhile in the rue des Moulins, near the Opéra, in a luxurious brothel famous for having rooms decorated in different styles, from medieval to Louis XVI, to suit the fantasies of the clients (Fig. 12). There he had a special status, almost like a member of the family. "Monsieur Henri," as they called him, took his meals with the women when they were off duty, and did a number of paintings of interiors of the brothel and its occupants. His scenes of these interiors, of madams and laundrymen, of prostitutes lined up for their medical checkups or sitting vacantly waiting for clients to arrive, are among the most telling portrayals of that life ever to have been done.

In more conventional haunts, Lautrec drank at the bar at the Ambassadeurs and sketched its elegant denizens. He followed Misia Natanson to a skating rink and drew fashionable women gliding or sitting with their lovers at the

At various times he would go repeatedly to the circus, drawing bareback riders, gymnasts, clowns, and trained animals. He liked to go to the masked balls given by the Elysée Montmartre and other nightclubs. He was fascinated by the masked licentiousness at these balls and repeated the theme in a number of works. He also fell in with the fashion for things Japanese, and this influence significantly marked his work.

His family often had photographs taken, and he enlarged his interest in this art, becoming friendly with Paul Sescau, a photographer who lived in his neighborhood. For a time Sescau or another friend took photographs of Lautrec's posed models, and Lautrec would make his final work from the photographs. Photography also became a way of recording occasions with his friends, particularly when they dressed up in costume. As a result, numerous photographs of Lautrec dressed as a choirboy, a Japanese, a

Fig. 11. Henri de Toulouse-Lautrec dressed in Japanese costume, photographed by Maurice Guibert. The Museum of Modern Art, New York. Given anonymously

tiny tables beside the ice. When he went to London, where he was having an exhibition, he may have taken the opportunity to visit the courtroom where the celebrated Oscar Wilde (Cat. 130), whom he had known for several years, was being tried on a charge of sodomy. In 1896, it is said that he went many nights to see Marcelle Lender dance the bolero in the operetta *Chilpéric* at the Variétés, which resulted in a group of paintings and six lithographs (Cats. 101–110). Then he fell in love with bicycle racing and frequented the new Paris velodrome run by Tristan Bernard, where he could watch the racers; he did posters and advertisements for bicycles. As he grew depressed and dependent on alcohol, he went to lesbian bars and tried to catch on paper the intense emotions of the couples there.

Lautrec's works frequently show not only exterior influences at a particular time but also his interior state. Often, repressed and preconscious elements in his personality appear as both imagery and style. This is particularly evident at two times in Lautrec's life. A number of works of 1892–93, when he first developed his addiction to alcohol, are dominated by long shadows, looming in the foregrounds. Two years later, he visited Toulouse to supervise the printing of a poster, *The Hanged Man* (Cat. 270). While there, he remarked to Arthur Huc, editor-in-chief of the local newspaper: "I can paint until I'm forty. After that I intend to dry up."[31] With hindsight, the symbols of a premonition of death seem like obvious signs that Lautrec, no matter what exterior appearances he might have maintained, was finding it painful to think of prolonging an existence he had already begun deadening with alcohol and frenzied living.

By late 1897, when Lautrec was thirty-three years old, all his friends knew that he was in serious emotional trouble and that he was hopelessly addicted to alcohol. His productivity fell off, and he spent more time in the bars. Early the next year he wrote to his mother that he was in "a rare state of lethargy. The least effort is impossible for me. My painting itself is suffering…also no ideas."[32]

From November 1898 until the end of February 1899, few works remain. By this time Lautrec was in an emotional crisis caused by alcoholism and very likely by the appearance of tertiary syphilis. He was almost always drunk and suffered from hallucinations, paranoid fears, amnesia, and uncontrollable shaking. He was aggressive, insomniac, and confused, and he frequently alienated those who might otherwise have tried to help him. One of his last drawings, which he did on a lithographic stone and had printed— dated February 8, 1899—is the most telling. Incomprehensible in logical terms, its uncertain, fragile lines depict a collie, with its tongue hanging out, looking at a parrot on a perch. The parrot is wearing a pince-nez and a tiny hat. It has a pipe in its mouth. In the background, a frail stick figure appears to be trying to stop an oncoming train. Farther down the tracks, in front of the train, is a prancing poodle (Cat. 237). These are images of Lautrec's childhood—animals in costume, dogs, and trains. There were many drawings of parrots in his childhood sketchbooks, and he seems to have returned to this theme during his mental decline.

Fig. 12. "The Moorish Room" in the brothel at 5, rue des Moulins, 1890s

Family documents reveal that shortly after he made this drawing Lautrec suffered a mental breakdown and, at the beginning of March, was committed to a private mental hospital.[33] Once he was hospitalized and unable to drink, Lautrec improved rapidly and wanted to be released. However, his family was terrified that he had gone permanently insane or, at least, that he would start drinking again. The doctors in the posh hospital were in no particular hurry to lose a wealthy guest either. However, Lautrec was too well-known in Paris, both as an artist and as a fashionable Montmartre regular. The newspapers exploited the story, creating a scandal that made the doctors at the asylum, not

to mention Lautrec's family, most uncomfortable. In addition, Lautrec decided that the way to secure his release was to do a series of drawings from memory, thus proving not only that he was able to do work but also that his amnesia was gone.

The series of circus drawings that he produced in the hospital, using colored pencil on paper, are very tight and rigid—much more conservative than his usual work. But the figures in them are recognizable from circus acts Lautrec had seen in Paris some five years earlier; the doctors were either convinced he was well or afraid of further scandal, and they released him after less than three months in the asylum.

Lautrec left Paris and went to one of his family homes, the Château du Bosc, fifty miles from Albi. After a brief stay there, which reassured his family immeasurably about his sanity, he traveled slowly back to Paris accompanied by a friend, Paul Viaud, whom his mother had hired to assist Lautrec on his journey and to see that he did not drink. But his new resolution, even with his friend for moral support, did not last long, and when he began drinking again his symptoms immediately returned. He left Paris again after several months, working his way down the Atlantic coast, again with Viaud, and spending the winter in Bordeaux, still painting, although far less productively than before.

His palette had changed; from the clear, bright colors characteristic of most of his previous work, his art turned dark and heavy, marked by dense brushstrokes and impasto. The canvases seem to reflect the depression and hopelessness of a man who is slowly killing himself and somehow unable or unwilling to stop. In August 1901, at the coastal resort Taussaut, Lautrec suffered a stroke and was taken to his mother's estate at Malromé, not far from Bordeaux. He fell into a coma and died on September 9. At the time, a rumor spread among his Paris friends, which Jules Renard quoted in his journal: "Paris, October, 1901. Toulouse-Lautrec was lying on his bed, dying, when his father, an old eccentric, came to see him and began killing flies. Lautrec said, 'Old fool!' and died."[34]

Consciously or unconsciously, Lautrec's work reflects not only the painful realities of his life but also his self-image. Beneath its bitter humor can be seen profound

melancholy. His uncanny ability to catch the essence of personality came from his consciousness of human flaws, whether visible like his own or lying just under the surface. Even his obsessive rendering of rapid movement, particularly of dancing, riding, and gymnastics, points out his longing for freedom from his physical handicaps. After painting one serious self-portrait at age sixteen, he generally represented himself in his work by numerous caricatural self-images that exaggerated his smallness and his deformities, as if he could fend off unkind remarks by pointing out his deficiencies himself. Such drawings became so much a part of his self-presentation that he sometimes used a self-caricature as a signature, drawn into the corner of a work. His self-irony was both majestically proud and symbolically self-destructive. By making himself "smaller than life" he discounted his own human value. Once he had demeaned himself in his art, his death by self-destruction was a logical conclusion.

1. This text is based in part on lectures given at the Institute for the Humanities, New York University, December 6, 1983, and at the Israel Museum, Jerusalem, May 14, 1984.

2. Gerstle Mack, *Toulouse-Lautrec* (New York, 1938), p.v.

3. "Montfa" is the spelling that appears on Lautrec's birth certificate. It is also the only spelling used by his family. His father used the Château de Montfa as a hunting lodge from 1866 until his death. The commonly accepted spelling, "Monfa," was used by Lautrec to sign a number of drawings done about 1882, at a time when his family did not want him to sign his work with his real name.

4. Henri Perruchot, *Toulouse-Lautrec*, trans. Humphrey Hare (Cleveland and New York, 1960), p. 28.

5. Probably Lautrec's cousin Fides Tapié de Céleyran. From a conversation with Marc Tapié de Céleyran, August 15, 1983.

6. Pierre Maroteaux, M.D., and Maurice Lamy, M.D., "The Malady of Toulouse-Lautrec," *Journal of the American Medical Association*, vol. 191, no. 9, March 1, 1965, pp. 715–717.

7. "Ce n'est pas un très gros enfant." ALS [Autograph letter, signed] (Lake Collection, University of Texas, Austin): Adèle de Toulouse-Lautrec to her mother, Louise Tapié de Céleyran, February 22, 1865. This and all letters cited from the Lake Collection are the property of the Humanities Research Center, University of Texas, Austin. The author would like to thank the center for granting access to this rich collection of unpublished material, and for permission to quote from its documents.

8. Cf. ALS (Lake): Adèle de Toulouse-Lautrec to her mother, Paris, January 23, and February 4, 1875.

9. Mack, *Toulouse-Lautrec*, p. 24 (trans. Mack).

10. ALS (Lake): Adèle de Toulouse-Lautrec to her mother, Paris, Wednesday, March 21, 1877.

11. Georges Beaute, *Lautrec, Témoignages inédits* (Lausanne, 1984), p. 25.

12. ALS (Lake): Adèle de Toulouse-Lautrec to her sister-in-law, Alix Tapié de Céleyran, May 15, 1878; see also Beaute, *Lautrec*, p. 25.

13. Beaute, *Lautrec*, p. 25.

14. Lawrence and Elisabeth Hanson, *The Tragic Life of Toulouse-Lautrec* (New York, 1956), p. 30.

15. Pierre Devoisins, "Henri de Toulouse-Lautrec, Essai d'étude clinique: ses maladies, sa mort," (Diss., Montpellier, France, 1858), p. 55.

16. Beaute, *Lautrec*, p. 69.

17. Maroteaux and Lamy, "The Malady of Toulouse-Lautrec," p. 717.

18. Thadée Natanson, *Un Henri de Toulouse-Lautrec* (Geneva, 1951), p. 17.

19. ALS (Lake): Adèle de Toulouse-Lautrec to her mother, May 18, 1881.

20. Mack, *Toulouse-Lautrec*, p. 50.

21. He maintained his opinion of his pupil even after Lautrec's death. When the Friends of the Luxembourg Museum acquired one of Lautrec's portraits, *Léon Delaporte at the Jardin de Paris*, Bonnat was instrumental in getting the French National Museum Council to reject the donation. Another member of the council later wrote: "Bonnat exhibited a kind of personal hatred for Lautrec: whenever his name was mentioned...Bonnat flew into a rage." Quoted in Maurice Joyant, *Henri de Toulouse-Lautrec: Peintre* (Paris, 1926), p. 142. The portrait is now in the Carlsberg Glypotek, Copenhagen.

22. Perruchot, *Toulouse-Lautrec*, p. 130.

23. Cf. Edmond Lepelletier, "Le secret du bonheur," *L'Echo de Paris*, March 28, 1899.

24. Charles F. Stuckey, *Toulouse-Lautrec: Paintings* (Chicago, 1979), p. 121.

25. Cf. ALS (Lake): Adèle de Toulouse-Lautrec to her mother, Paris, June 9, 1875: "J'ai fort recommandé la sobriété a Maître Henry qui boirait volontiers un peu trop à la santé de son amie Louise...." (I strongly recommended sobriety to Master Henry who would gladly drink a little too often to the health of his friend Louise.)

26. "Guide des plaisirs à Paris," quoted in Mack, *Toulouse-Lautrec*, pp. 128–130.

27. Lucien Goldschmidt and Herbert Schimmel, *Henri de Toulouse-Lautrec: Lettres 1871–1901* (Paris, 1969), p. 91.

28. Quoted in Philippe Huisman and M. G. Dortu, *Lautrec by Lautrec*, trans. Corinne Bellow (Lausanne, 1964), p. 44.

29. Jean Adhémar, *Toulouse-Lautrec: His Complete Lithographs and Drypoints* (New York, 1965), p. vii.

30. Joyant, *Peintre*, p. 192.

31. Homodei [Arthur Huc], "Toulouse-Lautrec," *La dépêche de Toulouse*, March 23, 1899.

32. Lucien Goldschmidt and Herbert Schimmel, *Unpublished Correspondence of Henri de Toulouse-Lautrec* (New York, 1969), pp. 194–195.

33. A number of these documents are reproduced in Goldschmidt and Schimmel, *Unpublished Correspondence*.

34. Jules Renard, *Journal*, ed. and trans. Bogan and Roget (New York, 1964), p. 138. A more elaborate version of this story explains that Lautrec's father was shooting the flies with the elastic bands he used as boot laces.

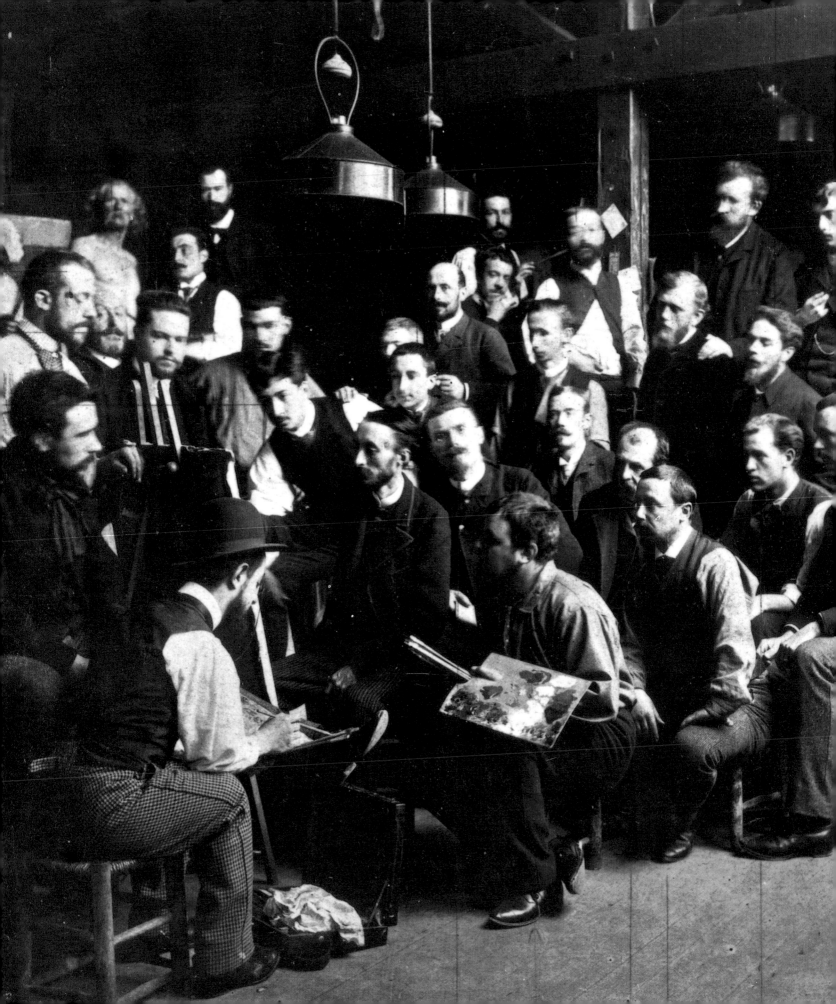

Toulouse-Lautrec and the Art of His Century

Matthias Arnold

Artists throughout history have not existed alone. Even the greatest talents have to be seen in terms of the traditions they inherited and in the context of artistic developments among their contemporaries. Henri de Toulouse-Lautrec (1864–1901), one of the most original and independent draftsmen and painters of his time, was artistically indebted to several old masters—especially Piero della Francesca, Vittore Carpaccio, Frans Hals, Rembrandt van Rijn, and Francisco Goya[1]—and was strongly connected with a number of contemporary or slightly older artists active during the last quarter of the nineteenth century. Generally, his most intensive involvement was with the art of his century and his country. The officially sanctioned academic art of nineteenth-century France exerted very little influence on Lautrec's work while the so-called trivial, applied, avant-garde art of his time did so in profound measure. It is in the great illustrators and caricaturists of the time—Doré, Gavarni, Daumier, and Guys—that we can see Lautrec's immediate forerunners. Lautrec's own talent for illustration and caricature was both challenged and confirmed by the work of these older contemporaries.

Gustave Doré (1832–1883), the historian and visionary, produced many graphic artworks and series during his lifetime. The most relevant aspect of Doré's work for Lautrec was the older artist's role as a caricaturist and critic of society who captured human life in certain illustrations,[2] using a graphic handwriting technique that at times came very close to Lautrec's later style—spontaneous strokes and hachures encircling and defining the subject matter in a network of lines that exposes, as it were, inner and outer movement. Of course, the same can be said of all the great expressive artists, starting with Dürer and Rembrandt, and culminating, at the beginning of the nineteenth century, with Goya. Whereas the painters of official art, regimented and benumbed by classicism, had eradicated any trace of the spontaneous artistic creative process, artists of the trivial took up precisely this execution, which gave the appearance of incompleteness, and developed it into a deliberately usable stylistic means. What in this genre was unacceptable in "great" art was consumed by the general public. Consequently, popular graphic arts helped pave the way for the acceptance of Impressionism and Expressionism.

Paul Gavarni (1804–1866) was a graphic artist who devoted himself principally to the world of elegance but who also depicted the demimonde and the proletariat. He was not so much a caricaturist as a portraitist of types. Lautrec's preference for festivities, for descriptions of women, for the unadorned depiction of people is already sharply defined by Gavarni. Like this predecessor Lautrec later produced portraits of actors and prostitutes, and even

erotica. The fact that Gavarni titled one of his graphic series *Masks and Faces* shows him to be a forerunner of Lautrec, who particularly loved disguises and masked balls. Finally, Gavarni's *Scenes from the Intimate Life* also finds a parallel in Lautrec's *Elles* album (Cats. 139–145, 147–158). In his illustrations for a book by Honoré Balzac, Gavarni records the Human Comedy. In the sum of his work Lautrec presents the Theater of Life.

In Gavarni's lithographs, as in those of Daumier, the artist's caption is meant to be an integral part of the work. Later, with Lautrec, this changed decisively, freeing the graphic arts from a secondary role as a form of commercial art. In Lautrec's work, lithography gained autonomy in art and was able to speak for itself. Thus Lautrec said with regard to captions: "One doesn't need an explanation, find your own!"[3]

Although a social critic, Gavarni was not as involved in daily political affairs as was his great colleague Daumier. And it was for this very reason that Lautrec's friend Vincent van Gogh is said to have preferred Gavarni at times to Daumier.[4] Yet Daumier is one of the most important of Lautrec's forerunners—and not just as a graphic artist.

Honoré Daumier (1808–1879), born, as was Lautrec, in the south of France, played an exceptional role in his time and in art altogether. As stated by a much later painter: "Daumier, with his early and therefore inexplicably mysterious appearance, is a benediction, the starting point for new paths, and it seems as if all subsequent art had only to come into being in order to illuminate and interpret his own condensed work."[5] Lautrec was probably Daumier's most gifted successor because he did not imitate the older master, but reflected his spirit, extended their kinship, and added his own personality. It is likely that Lautrec was very familiar with Daumier's lithographs. Three critics from Lautrec's circle, who later wrote about him as well, took an interest in Daumier: Gustave Geffroy and Arsène Alexandre wrote about the caricaturist, as did Roger Marx, who even collected his works. Alexandre's 1888 monograph on Daumier (the very first!) was certainly known to Lautrec.[6]

Daumier was, as Lautrec would later be, an artist who concerned himself exclusively with the depiction of figures. Each artist captured in his work the many facets of life in his time. Nevertheless, there are significant differences between them. Lautrec did not devote himself to political caricature—not being as much of a devoted republican as Daumier—and, in fact, the younger artist's more important works do not necessarily fall within the scope of caricature at all. Although there are many caricatures in Lautrec's extensive works—in early notebooks, sketchbooks, etc., and also later in his graphic works—they are indicative of more casual by-products of his fantasy. The opposite is true in Daumier, for whom caricature embodies the principal creative means. This subtle but nevertheless important difference between Lautrec's and Daumier's lithographs was perceived as early as 1924 by Gotthard Jedlicka when he wrote about Lautrec's lithographic drawings:

> Even today such drawings, and similar ones, are seen as caricatures. The counterevidence is supplied by comparing them to real caricatures. The caricaturist (for example, Daumier) exaggerates his figures only up to the point where they acquire a character and where their attributes are arranged around a determined, but not always clearly definable, center. Daumier presents a whole person with certain traits that render him ridiculous. Lautrec presents a whole person with certain traits that render him substantial.[7]

Moreover, a stronger narrative tendency prevails in Daumier; Lautrec offers glimpses of the moment—snapshots—while Daumier tells stories and creates settings for them. This is also the most important reason why Lautrec can largely dispense with captions, whereas in Gavarni and Daumier the explanation or point is often to be found in the caption itself. Daumier's caricatures were directed at the public through popular newspapers and magazines. Lautrec's true caricatures were intended, almost without exception, for the artist's private sphere. There was, for example, the menu of 1896 (Cat. 167) on which Lautrec memorialized an adventurous trip to Blois in a humorous manner. Lautrec's friends rob the naked Maria Medici. Maurice Guibert grabs hold of her while Maurice Joyant, as a crocodile, and Dr. Gabriel Tapié de Céleyran, as a hovering dragon, survey the action. Lautrec depicts himself sit-

ting on a milking stool as he draws the scene.

Daumier produced about 4,000 lithographs; Lautrec made 364. Along with Lautrec, Daumier is the most eminent French graphic artist of the nineteenth century. Although his ultimate goal was painting, he could not devote enough effort to it because of his time-consuming and continuous production of graphic artwork. Lautrec's situation was the opposite; for him painting served primarily as a preliminary step, as a training for lithography. In painting Lautrec experimented chiefly with technique: nuance, color value, transition. The two artists are related in the quality of their black-and-white lithographs. There has been no one else, before or since, who could produce such varied gray tones or who was such a master of the spontaneous line so that it neither could nor needed to be corrected on the lithography stone. This freedom and accuracy, which became stronger through the years, was carried over by Daumier into his later painting, in particular, which is quite revolutionary owing to his vehemence and extremely loose "handwriting." Daumier's *Pierrot Playing the Mandolin* (Collection O. Reinhart, Winterthur) and *Woman with Child* (Collection E. G. Bührle, Zurich), both of 1873, are examples of an unprecedented boldness that not only anticipated Lautrec's arabesquelike, lively calligraphy, but also pointed the way far into the twentieth century. With this spontaneous technique Daumier, for the first time since Hals and a few old masters, achieved a significant impact, a suggestion of movement, which in Lautrec's hands was heightened and refined.

Both Daumier and Lautrec show a marked sense of humor, at times caustic, at other times laconic. However, it is not the same kind of humor; Daumier lays a sharp finger on the wounds of society while Lautrec exhibits the cheeky, droll, and amusing aspects of only certain strata of society, primarily the world of pleasure. Daumier's criticism of the petite bourgeoisie does not resemble Lautrec's. Also, we do not find Daumier's misogyny[8] in Lautrec, although the latter's relationship to women was not entirely without problems. Both artists were moralists, but each in a different way; Daumier sought to change man and the world as a missionary, Lautrec broke through conventional taboos, showed what caught his eye, what amused him,

Fig. 1. Honoré Daumier. *The Muse at the Brasserie.* 1864. Lithograph, 7¾ x 10″ (19.8 x 25.3 cm). Collection Wolfgang Wittrock, Düsseldorf

and what he discovered in hidden places. For both artists this included the depiction of the ugly and repulsive. Daumier used a moralizing forefinger to point this out to the viewer. Lautrec, on the other hand, attempted to extract something even from the unattractive: "Everywhere and at all times, ugliness has its enchanting aspects, as well. It is exciting to come across it where no one has ever discovered it before."[9] This was the spirit of the French naturalists, whose impact was reconfirmed by Käthe Kollwitz when she referred, within the context of her own artistic proposals, to Emile Zola's words: "The beautiful is what is ugly."[10]

Daumier created a special kind of modern genre painting (Fig. 1). For him, as for Lautrec, man's surroundings—cityscape, landscape, interiors—are only lightly demarcated by a few lines; what is seen and experienced undergoes a suggestive intensification. As Goncourt put it: "In Daumier, bourgeois reality has such intensity that it passes over into the realm of fantasy."[11] This is an aspect which later took on importance for Lautrec and van Gogh. The true realists are fantasts, those who exaggerate reality. Reality can be shown in a succinct, pointed, more pregnant manner by distorting it. This principle extends throughout

Fig. 2. Honoré Daumier. *The Washerwoman*. 1852. Oil on wood, 10⅝ x 8⅜″ (27 x 21.3 cm). Museum Boymans–van Beuningen, Rotterdam

Fig. 3. Henri de Toulouse-Lautrec. *The Washerwoman*. 1888. Charcoal on paper, 25⅝ x 19¾″ (65 x 50 cm). Musée Toulouse-Lautrec, Albi

the art of the twentieth century and overlaps into other artistic disciplines as well. Filmmaker Federico Fellini, with his grandiose exaggeration, provides the best example of artificiality as an allegory of nature.

Although much divides Lautrec and Daumier in their views on art, the world, and humor, they have much in common iconographically. Many of Daumier's themes—indeed, the most important ones—also became Lautrec's themes. Daumier's characteristic Don Quixote figure appears like a quotation in one of Lautrec's graphic works (Cat. 194). Daumier's washerwoman theme (Fig. 2) was carried on in the works of Degas, Lautrec (Fig. 3), and Steinlen (Fig. 4). His courtroom scenes are echoed in some of Lautrec's lithographs, for example, the witty *Animal Tamer before the Court* (Cat. 244), in which La Goulue appears before the court as an animal tamer. The former

dancer whips Lautrec's monogram, which lies on the floor; she is portrayed as someone who has become more prudish as her figure has grown rounder and who appears before the court to testify against excessive public display of flesh, something which, as everyone knows, she did quite liberally a few years earlier. Lautrec's four courtroom lithographs of 1896, whose themes concern two famous trials of his time, occupy a special position in his oeuvre (Cats. 133–134). His painting of 1901, *A Medical Exam* (Musée Toulouse-Lautrec, Albi), is, in a sense, like a courtroom scene. A precursor of this picture, Daumier's *Two Men at a Table* (c. 1856–60; Collection E. G. Bührle, Zurich), is very similar in form, while expressing a different content.

Daumier also occasionally portrayed doctors, as for example, in various versions of the Hypochondriac. In 1891

Lautrec sketched and painted the famous surgeon Dr. Péan performing surgery in more than thirty drawings and such works as *An Operation* (Francine and Sterling Clark Art Institute, Williamstown, Mass.) and *An Operation by Dr. Péan of the International Hospital* (Private collection). The fact that this theme was important for Lautrec is confirmed by his own statement: "If I were not a painter, I would want to be a doctor or a surgeon."[12]

Much of Daumier's work was devoted to depicting entertainers—among them musicians, jugglers, and clowns. Lautrec preferred them too, and concerned himself even more intensely with the world of the circus and the cabaret; furthermore, he enlarged and made more specific the areas of representation. Both artists were uncommonly captivated by the world of the theater in various respects. Each of them portrayed actors in individual portraits and showed them performing on stage, as well, and they both loved to show the audience watching the show. They viewed the spectators watching, studied their reactions and gestures, their facial expressions and cries; they became the voyeurs of voyeurs. Both artists even went so far as to show the audience leaving the theater. In penetrating psychological studies they analyzed pose and farce, and this is one of the strongest points of contact between these two portrayers of humanity. Carnivals, masked balls, and other festivities were also bountiful hunting grounds for the caricaturist and draftsman of types. Lautrec's feeling for travesty and parody is stronger and more refined than that of Daumier. Daumier's esprit occasionally insults and unmasks, while Lautrec's is more polished and amusing.[13]

In the early 1860s Charles Baudelaire wrote a long and important essay called "The Painter of Modern Life," using Constantin Guys (1802–1892) as a model.[14] In the title of his essay Baudelaire supplied the keyword for all subsequent progressive painting in France in the latter part of the century. The poet cited Balzac, Daumier, and Gavarni, but also lesser-known commercial artists like Louis-Philippe Trimolet and Charles J. Traviès. These portrayers of mores were all precursors of Lautrec.

Guys figures significantly among these forerunners, not only because of his iconography but also because of his technique. Lautrec shared with him a predilection for fluid techniques, that is, for methods permitting rapid and spontaneous handling. Guys gained notoriety chiefly through his lightly executed watercolors. The cutting, pointed impact of these works must have made a strong impression on Lautrec, although we know nothing concrete about his relationship to Guys.[15] However, the evidence provided by the works of both artists is clear enough. Guys's tendency toward exaggeration and overstatement, a tendency already discussed by Baudelaire,[16] is a stylistic means that was meant, as it was in Lautrec, to capture the spontaneous instant. Baudelaire calls this "extracting the eternal from the transitory,"[17] and he elevates this temporality to the status of a new subject matter: "Modernity is transitory, the fleeting, the contingent; it makes up one half of art, whose other half is the eternal and immutable."[18]

Fig. 4. Théophile-Alexandre Steinlen. *Laundresses Carrying Back Their Work.* c. 1898. Color drypoint, aquatint, and line etching. Norma Bartman Collection

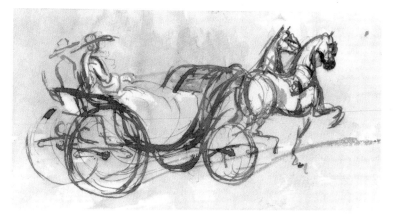

Fig. 5. Constantin Guys. *Equipage*. n.d. Pen and ink with wash, 5½ x 10″ (13.9 x 25.4 cm). Private collection

The transient, from which the timeless is extracted, is, in the first instance, man himself, who figured—for Guys as well as for Lautrec—as the center of creative work. Baudelaire made comments about Guys that can be applied to Lautrec just as easily, without omitting a word: "The crowd is his domain, as air is for the bird and water for the fish. His passion and his vocation is *to become a part of the crowd*. It is an immense pleasure for the perfect flaneur, for the passionate observer, to take up his abode in the multitude, in the undulating and moving, in the fugitive and the infinite."[19] One is reminded of Lautrec's ballroom and dancing scenes, in which this throng, containing life in all its facets, is captured.

The representation of the transitory is perhaps what constitutes the truly modern in painters from Guys to Lautrec and beyond. The chapter headings of Baudelaire's essay, at the same time, name the major themes of the painter of modern life: Coaches, Dandies, Women and Girls, and Moral Sketches. The themes relating to Guys are also Lautrec's themes. Like the older artist (Fig. 5), Lautrec drew and painted—especially in his earlier work—horses, soldiers, jockeys, and coaches, most of them in a comparably loose style. Baudelaire wrote: "Monsieur Guys knows not only about the horse in general, but is just as successful in expressing the personal beauty of the individual horse."[20] The same may be said of Lautrec, who grew up around horses, loved them and knew them as well as anyone, so that, next to Degas, he was one of the first

painters to accurately reproduce the movements of these creatures.[21] Another thematic area treated by both Guys and Lautrec is that of dance halls, *cafés concerts*, and theaters. Both artists portrayed the singers and dancers, actors and spectators, as did Daumier. In their pictures of the loge, these painters, and others such as Manet, Renoir, Degas, and Mary Cassatt, showed variations of the same subject: the audience with all its emotions and reactions.

The third thematic grouping shared by Guys and Lautrec is derived from the second: the world of bars and brothels. It is mainly in his later work that Guys devoted himself to this area. He showed how the courtesans of the Second Empire passed their time, lasciviously dressed, in the ante-rooms of lust. This is one source—perhaps the chief one—for Lautrec's brothel pictures.

Guys and Lautrec showed woman as woman in ever-changing variations. With these and other painters, like Manet, Degas, Renoir, and Matisse, one can almost speak of a cult of the woman. The theoretical foundation for this was again supplied by Baudelaire's treatise. He devoted an entire chapter to *la femme*. This cult of the woman in art reached its peak in the nineteenth century. Just as the depiction of man clearly took precedence in the Renaissance and in Mannerism, the theme of the woman began to dominate in the Baroque and Rococo periods. Men were rendered as effeminate and, accordingly, lost something of their status as the natural counterpart of women. Jean-Dominique Ingres and Eugène Delacroix carried this tradition still further, and Henri Matisse later attempted to revive it with his decorative odalisques. In the period of Romanticism, the woman was revered as the representative of society, as muse and refined companion. Only with the so-called painters of modern life did new aspects enter into the artistic conception of women, which took into account the gradually changing conditions of society. A woman was no longer an ornament or appendage of a man but was a sexual being in her own right. Guys, Manet, Degas, and Lautrec plumbed the depths of this theme as had no one else.

Baudelaire, who wrote enthusiastically of Daumier and Guys, in his later years befriended the young Edouard Manet (1832–1883), to whom he gave his moral and the-

oretical support. While Guys mainly portrayed the "modern life" of the Second Empire in graphic works, Manet carried these themes to painting.[22] We have little concrete information about Lautrec's relationship to Manet, but we can infer from certain anecdotes that he admired the older artist.[23] Manet's courtesan *Olympia* (1863; Musée du Louvre, Paris) is related to such earlier works as Titian's *Venus of Urbino* (c. 1538; Uffizi, Florence) and Ingres's *Odalisque* (1814; Musée du Louvre, Paris). Yet *Olympia* already evokes *Nana* (Fig. 6), that other work by Manet which was subsequently of great importance for Lautrec's iconography. Goya's *Naked Maja* (c. 1800; Prado, Madrid), a picture studied in the original by both artists, who admired its creator, falls somewhere between Titian's gods in the form of men and Lautrec's frivolous human animals. In his later years, Lautrec's female nude increasingly became a bearer of symbols as well. How far removed is the melancholic, resigned mood of futility in Lautrec's *Nude before a Mirror* (1897; Private collection, New York) from Manet's lustily triumphant *Olympia*! On the other hand Manet's *Nana* is more "modern" in that it expresses the modern world of Paris, described by the naturalist writers Emile Zola, Edmond and Jules de Goncourt, Joris-Karl Huysmans, and Guy de Maupassant. Manet portrayed the elegant whore of the world while Lautrec was already depicting the trivial world of the whore, the nameless inmates of the brothel whom he found more natural than the pretentious women of luxury. In his portraits and his figure paintings Manet depicted upper-class courtesans and mistresses (for example, Baudelaire's "dark-skinned lover"). Already weakened by illness in 1881–82, Manet made good use of the pastel portrait for an often fashionable and sweet depiction of these demimondaines.

In about 1878 Manet painted female toilette scenes which helped pave the way for Lautrec's own versions of that subject; yet these, like the nudes, are already altered in content and richer in meaning. An Impressionist theme— the elegantly dressed woman with parasol, sitting on a bench—can be found in Manet (*In the Greenhouse*, 1879; Staatliche Museen–Nationalgalerie, West Berlin) and in Lautrec as well, particularly in his early works.[24] Although both Manet and Lautrec clearly preferred female models,

they did produce some significant portraits of men, choosing to depict men of the world—dandies, artists, critics, intellectuals—their close friends. Manet portrayed Constantin Guys and Stéphane Mallarmé; Lautrec depicted Emile Bernard, Vincent van Gogh, and Oscar Wilde. Some of Manet's figures, like those in Lautrec's late works, are frozen as if in a trance, introverted, resignedly contemplative. Like Manet, Lautrec cultivated the "vocational" portrait and the genre portrait.[25] The latter type shows men and women engaged in some activity or action; in the former they are provided with attributes. In this regard, particular emphasis must be accorded the modern portrait of the actor, which can be traced from Edouard Manet to Max Slevogt and early Matisse via Lautrec. In accordance with their naturalist convictions, both painters observed life and people outside the studio. Those portrayed inter-

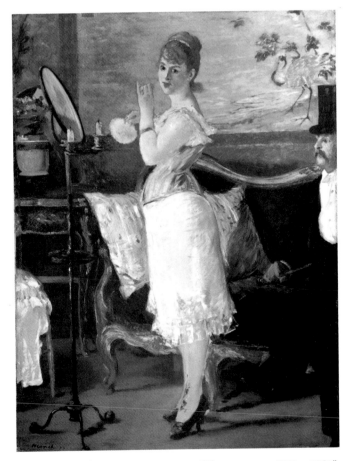

Fig. 6. Edouard Manet. *Nana*. 1877. Oil on canvas, 36¼ x 26¾" (92 x 68 cm). Kunsthalle, Hamburg

rupted their activities for them only briefly, and in the case of Lautrec, sometimes not at all.[26] The "slice of life" became their preferred theme.

Manet and Lautrec usually found such "slices" in places of entertainment. But neither was willing or ready to depict the misery, particularly of the lower classes, with a socially critical attitude. Zola had already introduced this into his novels, but only with van Gogh, Steinlen, Picasso, and Kollwitz would this realm appear in great art. And yet, throughout their work, Manet and Lautrec showed something of a depressing, fatalistic world, as in Manet's late brasserie pictures and in *The Bar at the Folies-Bergère* (1881; Courtauld Institute, London) or in Lautrec's *A la mie* (Fig. 7). For them, life was a theater; and where could one observe it better—in a double refraction—than in the theater itself? Daumier, Manet, and Lautrec never tired of depicting actors and their audiences. The loge was a kind of sideshow where real, unadorned life took place. At festive gatherings of every sort, Manet and Lautrec were able to observe people in every manner of behavior. In 1873 Manet depicted the opera ball; Lautrec, in 1896, portrayed his friend Maxime Dethomas in front of the masks of that same event. While Manet was still concerned with the total spectacle, Lautrec described an individual mood, an electrifying, moving moment. People in cafés were also depicted in different ways by Manet and Lautrec,[27] especially the lonely woman at a café table (no one has captured this subject more suggestively than these painters and, later, Picasso). Fashionable gathering places, such as the racetrack, were also represented by Manet, Lautrec, Degas, and Forain.

Manet's teacher, Thomas Couture, condescendingly told his pupil: "Go on, my poor friend, you will never be anything more than the Daumier of your time."[28] This sounds to us as much like praise as Degas's remark about Lautrec, also intended disparagingly at the time, that the latter would be "the Gavarni of his time."[29] How wrong these artists were in one way, how right they proved in another, positive sense they did not intend! Mallarmé once said of Manet: "The eye...a hand."[30] Lautrec said of himself: "I have always been a pencil."[31] Thus, these artists, as well as their open-minded contemporaries, were fully aware of the ingenious spontaneity of their work.

Matisse said: "Manet was the first painter to transfer his feelings directly into the picture; he accordingly simplified the art of painting....He expressed only what acted directly upon his senses."[32] Manet and Lautrec did not paint what they knew, but what they saw. When Couture corrected Manet one day by saying: "You will never make up your mind to paint what you see!" the student replied: "I paint what I see and not what others prefer to see."[33] This was a direct attack on convention. Through a deliberately loose technique, Manet, the Impressionists, the Post-Impressionists, and especially Lautrec created a new type of painting, which appeared to conventionally trained observers incomplete and sketchy. Of those who judged his pictures to be unfinished, Lautrec once said to his cousin: "These people annoy me. They want me to finish things. But I see them in such a way and paint them accordingly. Look, it is so easy to finish things. I can easily paint you a Bastien-Lepage....Nothing is simpler than to complete pictures in a superficial sense. Never does one lie so cleverly as then!"[34] Manet's friend Mallarmé said, in the same spirit: "What can 'unfinished' mean when all the elements of the painting are in harmony, when it possesses an attraction which could be lost by one additional brushstroke?"[35] Apropos of his enthusiastic involvement with the spontaneous brushstroke of Hals, whom Manet and Lautrec also admired, van Gogh spoke of the *premier coup*, the first stroke, which, once made, should not be altered. He referred ironically to its opposite as "this forced 'finishing up' " and as "brushing smooth." (Letter 427)

Many painters of the *fin de siècle* sought a tepid compromise between academic idealism and impressionistic realism; René Huyghe called this bastard style "conventional realism."[36] But those painters of limited, half-hearted solutions are forgotten today. What has not been forgotten is the personal perspective and representation of things in the works of Manet and Lautrec. These artists are more significant than the strict Impressionists precisely because they refused to be limited by any consistent formula and always attempted to do what was meaningful in terms of form and what was appropriate to the subject matter. The brushstroke for them always meant "the living formula for

that which is being depicted."[37] With artistic refinement they adapted themselves to the particular object to be represented. Above all, it is the stylistic simplicity of Manet, and Lautrec even more, that must be underscored: to achieve much with "nothing," to discard the unimportant and stress the essential was their motto. To Degas, Manet wrote:

Brevity in art is necessary and elegant. A concise artist stimulates thought, a long-winded one is tiring. Always try to express yourself as concisely as possible...pay attention in the figure to strong light and strong shadow; the rest will come of itself, and there isn't much more anyway. And then train your memory, for, at bottom, nature offers you only hints. It is like a safety net that keeps you from stumbling into the abyss of the banal.[38]

And herein lies the difference, even the conflict, between figure painting and Impressionism. The typical Impressionist was a painter of landscapes, used to working outdoors in front of the motif. But this was not true of the so-called Impressionists Manet and Degas. And Renoir is a special case: he sacrificed the individuality of his figures to achieve schematic, insubstantial forms. Individual characterization should always be integral to portraiture. Even a portrait that has a snapshotlike quality, if it is any good, transcends the transitory moment. This has been strikingly demonstrated by Hals and Rembrandt, Manet and Degas, and not least by Lautrec.

Edgar Degas (1834–1917) was unquestionably Lautrec's most important artistic idol, and this is confirmed by numerous formal and iconographic similarities. There are also some biographical parallels. Like his model and senior by thirty years, Lautrec remained unmarried—although for a different reason than Degas. The latter was decried in private life as a misogynist, although in his art he portrayed women primarily. Degas became a solitary eccentric capable of malicious derision and merciless criticism. Lautrec had a more positive, though not unclouded, relationship with women. Unlike Degas, it was not a voluntary seclusion in devotion to work that deterred him from family life, but, rather, his physical misfortune.

Lautrec feared loneliness and found diversion in sociability and amusement. Degas expressed himself clearly on this subject: "A painter has no private life...it seems that one must gather fresh force in solitude if one seriously devotes oneself to art these days....I must be alone with my mission.... There is love and there is work, but we have only one heart."[39] Degas decided in favor of work. Lautrec had only his work, but he, like van Gogh, and some other privately unhappy artists, regarded "real life" (as van Gogh called it) above a life for art. In order to avoid isolation, Lautrec developed an entertaining esprit that made him popular with friends and acquaintances. Francis Jourdain characterized the spiritual and, accordingly, also the artistic difference between the two painters in this pithy remark: "Degas finds nothing amusing; Lautrec finds amusement in nothing."[40]

Both Lautrec and Degas were financially independent from the start and could, therefore, calmly devote themselves to their education and art. As a young man, Degas was friendly with a number of fellow art students who later succeeded as respected academics: Alexandre Cabanel, Léon Gerôme, Léon Bonnat, and Fernand Cormon.[41] Two of them, Bonnat and Cormon, later became Lautrec's instructors. Cabanel was also briefly considered as a possible teacher.[42] When Degas turned to Manet and the Impressionists, these early friendships were relinquished.

Lautrec was introduced to Degas by his friends and relatives, the three Dihau siblings—Désiré, Henri, and Marie—who occupied the same house in Montmartre (rue Fontaine) as did Degas and, for a time, also Lautrec. This must have been a great experience for Lautrec, in addition to the awareness of living in such proximity to the studio of his esteemed master. But this love was probably one-sided. Degas treated Lautrec condescendingly, as he usually did other artists. Most of the anecdotes from this time concerning Degas and Lautrec are told at the expense of the younger artist. Degas's remarks on such occasions are ambivalent, to be taken as either serious or ironic. But when one considers that Degas criticized almost everyone—particularly artists—his attitude toward Lautrec might almost be called benevolent. For example, his advice to the young Lautrec a short time after they first met was:

"You must draw, draw, and draw again."[43] This remark is very similar to the advice Degas himself had received from his own great idol. Ingres once had told him: "Draw lines, young man, many lines, from nature and from memory!"[44] In September 1891, by which time he had already produced masterpieces although barely twenty-seven years old, Lautrec wrote to his mother: "Degas has encouraged me by saying that my work from this summer is not bad. How I would like to believe that!"[45] One day at the Dihaus' when one of Lautrec's drawings was shown to Degas, the painter of dancers said: "To think that a young man made this while we have worked so hard all of our lives!"[46] Evidently, Degas gradually came to realize that this artist, who portrayed similar subject matter and employed similar artistic means, was becoming a competitor; from this point onward, his attitude toward Lautrec seems more marked by irony and sarcasm.[47]

On the occasion of his first major exhibition, in 1893, at the Goupil Gallery—an exhibition shared with the graphic artist Charles Maurin—Lautrec sent an invitation to Degas. It is reported that Degas showed up one evening shortly before the gallery was to close and studied the works attentively while quietly humming a song to himself. Then it looked as though he would leave without a word. After he had reached the stairs he turned around and said to the anxious Lautrec: "One can see, Lautrec, that you know the ropes."[48] Degas's advice to a friend shortly after viewing the exhibition shows that he had intended the remark as a half-hearted platitude rather than the compliment the artist took it to be: "Buy Maurin. Lautrec is talented, to be sure, but he is bound to his own time; he will become the Gavarni of his time. For me there are only two painters worthy of consideration: Ingres and Maurin."[49]

The ambivalent character of Degas's remarks to Lautrec is shown again by the following anecdote. One day, in the company of Anquetin and some other friends, Lautrec met Degas on the street. Degas said to him: "I'm pleased to see you! I am just coming from Durand-Ruel. They showed me your things. Really quite excellent. You have your own tone and character, yes, you have character. My warmest congratulations. I am delighted to have seen it. Marvelous. Do carry on. You are uncommonly talented." Degas then hur-

ried away. The friends walked on in silence, Lautrec with tears in his eyes. Finally he asked Anquetin: "Do you think he really meant it?" Anquetin's tactless reply was: "What! Did you really not notice that he was making fun of you?"[50] Two subsequent remarks by Degas concerning Lautrec seem to confirm Anquetin's opinion. Degas once said to Suzanne Valadon: "He wears my clothes, but they are tailored to his size."[51] This unkind allusion to Lautrec's small stature is only surpassed by another remark made by Degas in 1916, a year before his death, concerning the works of Lautrec: "It all stinks of syphilis."[52] Such a verdict, of course, ignores the fact that Degas had also depicted prostitutes and brothels—before Lautrec. Nevertheless, the import of Degas's aloofness is clear: Degas denounced not only the naturalistic subject matter of Lautrec's work, but also its caricatural quality and the exaggeration of form. Although these two painters share many motifs, such as the café concert, the circus, the theater, the female nude, and the dancer, there are also subtle differences within these themes. Degas mainly painted ballet dancers, while Lautrec painted cabaret dancers who lacked the delicate bearing and the makeup and costumes of the former. Degas portrayed creatures of art; Lautrec's women are flesh and blood. When Lautrec did paint ballet dancers—in his early days and probably as a tribute to Degas—the result was lifeless, almost like a parody.

Nevertheless, Degas's work is fundamental for Lautrec's iconography, and one might use the term "real Parisian life" to describe themes they shared (Figs. 7, 8), that sphere about which Baudelaire wrote: "Paris life is full of poetic and wondrous subjects. The wondrous envelops us like the atmosphere, we simply do not see it."[53] In this respect, Degas and Lautrec owed much to the French naturalists, especially Zola and Edmond and Jules de Goncourt, who wanted to eliminate what they called the "stupid conventions."[54] In contrast to Manet, Degas was, despite his bourgeois background, surprisingly unconventional— even progressive. One need only look at the Impressionists' exhibitions where Degas was the driving force. His subjects, such as Rape (c. 1874; Philadelphia Museum of Art), unmistakably breathe the spirit of Zola, and others, like brothel monotypes, that of Maupassant. Degas was person-

ally acquainted with Alphonse Daudet, Zola, Huysmans, Maupassant, and the Goncourts, although, like Manet, he had his own reservations about writers.[55] Lautrec, the well-read creator of various book illustrations (among them are even some watercolors for Edmond de Goncourt's *La fille Elisa*), likewise avoided an overly literary, symbolist approach, although his illustrations of theater scenes can definitely be labeled literary in a broad sense, just as some of his pictures, especially later ones, embody symbolic elements.

As the younger of the two, it was not without knowledge of Degas's example that Lautrec chose some concrete subjects to fashion in his own way. A favorite motif of Degas, *At the Milliner's* (Fig. 9), appears again and again in Lautrec's work in lithographs, drawings, and in that forceful late painting *The Milliner* (Fig. 10).[56] Some related scenes are that of the washerwoman and the woman ironing. While within the sphere of the theater Degas depicted mainly ballet scenes and Lautrec the spectacle and the cabaret, both artists had a preference for portraying the audience in the loge. One of Degas's earliest works relating to the theater

is *The Opera Orchestra* (Fig. 11), actually a portrait of his friend Désiré Dihau, the bassoonist in the orchestra. Here for the first time ballet dancers appeared in the background along with another element that became a favorite stylistic means for Degas (Fig. 12) and for Lautrec later: the diagonally held neck of a contrabass with the ornamental snail at the upper end.[57] Marie Dihau was one of the few women whom Degas held in tender regard. In 1869 he portrayed her at the piano as she turned from playing (Fig. 13).[58] Decades later, in 1890 and 1898, Lautrec also depicted Mademoiselle Dihau playing the piano in two paintings, the earlier of which showed Degas's painting of that pianist in the background (Fig. 14 and *The Singing Lesson*, 1898; Museum of Modern Art, Cairo). An amusing anecdote attests to Lautrec's high regard for these works by Degas which were in the possession of the Dihau family. One evening, after entertaining his guests—only the dessert had not been served—Lautrec led them into the apartment of the Dihau family, placed them in front of the paintings by Degas, saying: "This is my dessert!"[59] "Let's go see Dihau" meant for him, primarily, "Let's go see Degas's pictures."[60]

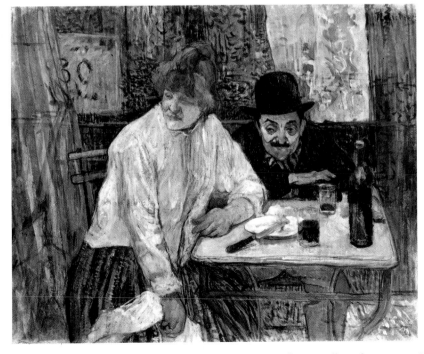

Fig. 7. Henri de Toulouse-Lautrec. *A la mie*. 1891. Oil on cardboard, 21 x 26¾" (53 x 68 cm). Museum of Fine Arts, Boston

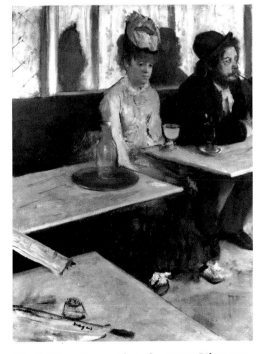

Fig. 8. Edgar Degas. *Absinthe*. 1876. Oil on canvas, 37 x 27½" (94 x 69.8 cm). Musée du Louvre, Paris

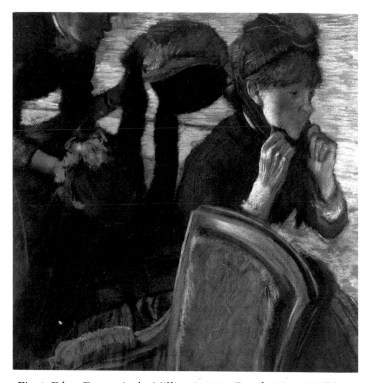

Fig. 9. Edgar Degas. *At the Milliner's*. 1882. Pastel, 27⅝ x 27¾″ (70.2 x 70.5 cm). The Museum of Modern Art, New York. Gift of Mrs. David M. Levy

Fig. 10. Henri de Toulouse-Lautrec. *The Milliner*. 1900. Oil on wood, 24 x 19¾″ (61 x 49.3 cm). Musée Toulouse-Lautrec, Albi

Lautrec also loved Degas's compositionally willful painting *Miss Lala in the Cirque Fernando* (1879; National Gallery, London) and responded to this work, so clearly influenced by Japanese art, with his first great masterpiece, *In the Cirque Fernando: The Ringmaster* (Fig. 15), which was also inspired by Japanese art. Within the circus milieu, Lautrec was principally attracted to the clowns and brought his own persona to his depictions of them.

Degas was the first to sense the pictorial merit of the *café concert*, as we have seen, and was followed in this by Manet and Renoir, and especially by Lautrec. His depictions of brothels (Fig. 16) were, at first, responded to only by Bernard, van Gogh, and Lautrec (Figs. 17, 18), although later this theme would be treated by painters such as Munch, Rouault, and Picasso. After Degas's death Ambroise Vollard used his brothel monotypes to illustrate Maupassant's novella *La maison Tellier*.[61] Reading this work, it is as if one were meeting Lautrec's prostitutes.

Degas was not the first French artist to treat the theme of the female toilette, but the manner in which this painter depicted woman attending to her body was entirely new and shocking for its time. In these pictures, beginning in 1880, Degas showed his models in intimate, often less than graceful, positions—in sharp contrast to his dancers. Degas commented on the woman he portrayed in this manner: "She is a 'human beast' who tends to herself like a cat licking itself clean. Until now, nudes have been shown as poses calculated for the public. But my women are simple, honest creatures who give themselves up only to physical occupations. Here is another, she is washing her feet, you see her as through a keyhole."[62]

Lautrec also showed the animalism that Degas saw in these women, but with a shifted emphasis. What is remarkable is the preference shared by both artists for representing people and animals almost exclusively. Both artists found a common subject in the investigation of the "human

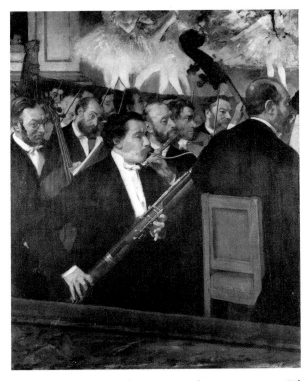

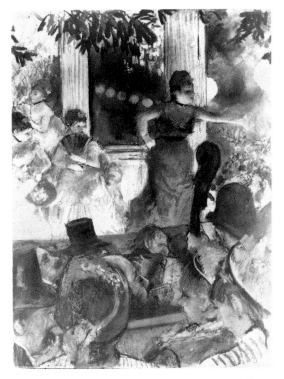

Fig. 11. Edgar Degas. *The Opera Orchestra.* 1868–69. Oil on canvas, 20⅞ x 17¾″ (53 x 45 cm). Musée du Louvre, Paris

Fig. 12. Edgar Degas. *The Café Concert, Les Ambassadeurs.* 1876–77. Pastel, 14¾ x 10¾″ (37 x 27 cm). Musée des Beaux-Arts, Lyon

beast." Not by accident, this term also figured as the title of a Zola novel. Degas said of his models: "Perhaps I have seen woman too much as an animal. I show her without coquetry, in the state of an animal cleaning itself."[63] Degas pushed nineteenth-century woman from her pedestal and took away her pretentious halo, not so much in antipathy as in a spirit of truthfulness, of discovery through the eye of the artist. This attitude opened new paths for Lautrec. To overstate the case, one may say Degas painted women like horses and horses like women. Something of this odd equation also motivated Lautrec, who spoke affectionately of his prostitute models: "They loll about on the sofas like animals."[64]

Degas, as well as Lautrec, painted horses at the racetrack with an almost scientific precision, in contrast to Théodore Géricault and Edouard Manet, for example, who did not accurately depict the movements of these animals. (Degas's early *Horse and Dog,* 1862, indicated the subject matter

preferred by Lautrec, particularly in his early years.) Lautrec's first teacher René Princeteau, a painter of animals, and his friend John Lewis Brown contributed their share to his absorption in this theme.

Both Degas and Lautrec were strictly painters of figures, yet Degas—who, in his own words, was seized by a "boredom in front of nature"[65]—produced a series of pastel landscapes and monotypes that he himself referred to as "dreams."[66] These extraordinary nature scenes call to mind Odilon Redon's pastel drawings. In a vehement philippic against landscape painting Lautrec referred to these works by Degas, which he allowed as exceptions:

Only the figure exists, the landscape is only and cannot be anything but an ingredient; the strict landscape painter is an imbecile. The landscape only serves for the better understanding of the character of a figure. Corot is only great for his figures, and this holds true for Millet,

Renoir, Manet, and Whistler as well. When painters of figures do landscape, they treat it as a face; Degas's landscapes are incredible, because they are dream landscapes; Carrière's are like human masks! Monet gave up on the figure, he could have done so much![67]

Degas had exhibited some of his landscapes in 1893, and it is probable that Lautrec saw them.[68]

Lautrec also learned much from Degas about form. Both loved to experiment with artistic techniques and genres, and produced lithographs, etchings, and pastels. We also know of four monotypes by Lautrec that were possibly inspired by Degas. The compositional peculiarities of Degas and Lautrec, though not always similar, nevertheless resulted from a common source, namely, their involvement with Japanese art and the colored woodcut in particular. Lautrec, especially, integrated into his style the surprising cropping and unusual interaction of the image with the edge of the picture that occur in Degas's work. Degas once noted to himself: "A painter must know how to do much cutting away!"[69] Such a method is basically photographic or even filmic. The filmmaker Fellini acknowledged Lautrec as having "anticipated the cutting and cropping of film even before it was invented by the Lumière brothers."[70] Degas and Lautrec used photography in their work to assist their memory.[71] Both produced "snapshots" of modern life in their work.[72] Although the snapshot discards the artificial pose, nevertheless the spontaneity—especially for Degas—was shrewdly planned, accident largely eliminated. "No art is less spontaneous than mine," said Degas. "My works are the result of reflection and the study of the great masters. I know nothing of inspiration, spontaneity, temperament. The same subject must be rendered ten, even a hundred times. Nothing in art may resemble an accident, not even movement."[73] Lautrec, too, drew one subject again and again, often using all kinds of painting and drawing techniques, but he succeeded in preserving the spontaneity of the first moment in the final product. His posters

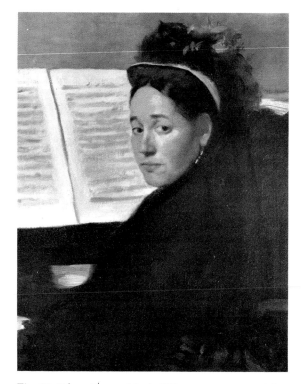

Fig. 13. Edgar Degas. *Marie Dihau*. c. 1869–72. Oil on canvas, 15⅜ x 12⅝" (39 x 32 cm). Musée du Louvre, Paris

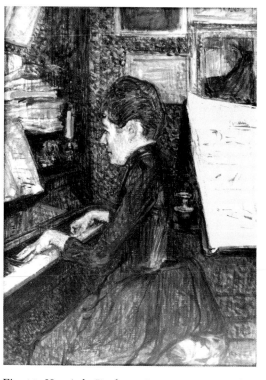

Fig. 14. Henri de Toulouse-Lautrec. *Marie Dihau at the Piano*. 1890. Oil on cardboard, 27⅛ x 19¼" (69 x 49 cm). Musée Toulouse-Lautrec, Albi

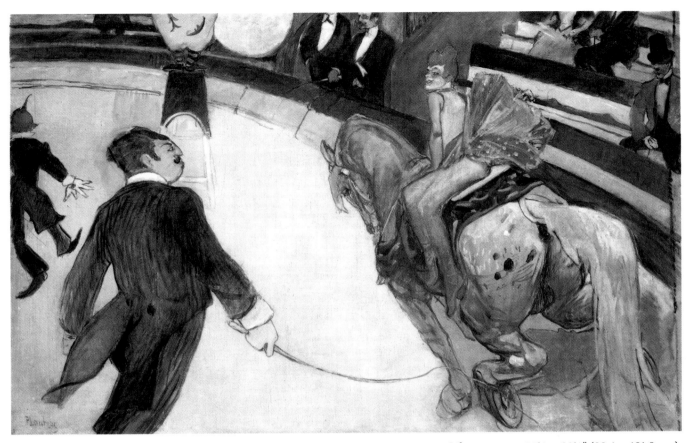

Fig. 15. Henri de Toulouse-Lautrec. *In the Cirque Fernando: The Ringmaster.* 1888. Oil on canvas, 38¾ x 63½″ (98.4 x 161.3 cm). The Art Institute of Chicago. Joseph Winterbotham Collection

constitute an exception; they demanded schematization and simplification because they served a different purpose. Degas and Lautrec each possessed an extraordinary power of observation, a trained eye, and an almost photographic memory.

Degas's work is generally more decorative than that of Lautrec, one reason why subsequent painters like Matisse followed his lead. Lautrec inclined toward expressiveness, which can also detract from a harmonious composition. The pictures of dancers, which established Degas's reputation, are actually his weakest works; their scenes are more often interchangeable, less specific than moments portrayed by Lautrec in comparable pictures. Degas's portraits and milieu pictures are much more powerful than the ballet scenes. Yet it seems astonishing today that neither Degas's nor Lautrec's pictures were fully appreciated by the naturalist writers. Huysmans wrote devastating critiques of

Degas's works. Edmond de Goncourt, outside of frequent praise, also noted some reservations in his diary: "This Degas is an original, he is a sick man, a neurotic, and his eyes are so bad that he is afraid of losing his vision. But that is precisely why he is so oversensitive and can see beyond the external, behind things. He is the one painter who, by copying modern life, has best captured the soul of this life. Will he now achieve perfection? I do not know. He seems to me quite a restless spirit."[74]

Lautrec does not stand in the shadow of Degas. Each impressively complements the other: there is much that overlaps but other qualities that disclose unbridgeable gaps. Degas was a more refined, more cultivated, more disciplined artist than Lautrec. The decorativeness of the older artist contrasts with the expressiveness of the younger. Cézanne's verdict, when asked about Degas, was astonishing and unexpected: "I prefer Lautrec."[75]

The "strict" Impressionists, among whom Degas cannot be counted, were less suited as models for Lautrec, since they were predominantly landscape painters. Only Pierre-Auguste Renoir (1841–1919) played a part in this respect—although a minor one—chiefly in the area of iconography. Renoir's large picture *Dancing at the Moulin de la Galette* (Musée du Louvre, Paris), painted in 1876, is at least thematically a forerunner of Lautrec's various representations of this dance hall. Although Lautrec depicted the interior of the establishment, as opposed to Renoir's view of the garden, he reassumes even the compositional principles of the earlier painting and develops them. In other respects, Lautrec, who met Renoir, among others, at the home of Thadée and Misia Natanson, probably found Renoir's figures too standardized and insubstantial. Lautrec's figures express a pointed individuality and are the opposite of Renoir's impersonal "ideal beings."[76]

Forain and Rafaëlli are two more artists from the Impressionist circle who stimulated Lautrec. Jean-Louis Forain (1852–1931) was a friend of Lautrec's father, as well as of Princeteau and Degas. His father, Count Alphonse, and Degas both thought highly of Forain's art, examples of which they owned. Forain, like Lautrec, admired Degas and adopted most of his Paris themes (Fig. 19). Like Lautrec, he painted *café-concert* scenes, dandies, representations of the theater and the courtroom, and horses at the racetrack. Lautrec cherished a watercolor portrait of Count Alphonse painted by Forain.[77] Forain imitated Degas's delicate technique but was sarcastic and polemical in his works. In this sense he was closer to Lautrec than to Degas, although, at times, he went further than Lautrec in the direction of Steinlen's social criticism. This is brought out most clearly in the biting titles of his pictures. At the same time, it shows that Forain was more narrative, more anecdotal than either Degas or Lautrec.[78]

Jean-François Raffaëlli (1850–1924) is another lesser-known but by no means uninteresting Parisian artist, who portrayed the mores of the *fin de siècle* (Fig. 20). He is responsible for depictions of the man in the street, the boulevards, *cafés concerts*, and theaters, which may have inspired Lautrec as well as van Gogh and probably also Anquetin and Bernard, the founders of *cloisonnisme* and

fellow students of Lautrec in the Atelier Cormon.[79]

Louis Anquetin (1861–1932), only a few years older than Lautrec and also financially independent, was in his youth an imaginative, creative, and innovative painter. The ties that bound him to his fellow student Lautrec were not only artistic but amicable as well, as can be seen from some photographs that have been preserved from the time showing the two painters, who were so unalike physically.[80] In 1886 Anquetin made an oil portrait of Lautrec—in the Impressionist style—as well as drawings of him.[81] In 1887 he painted two pictures that became the key works of the style later called *cloisonnisme*, which was influenced by Japanese woodcuts and aspects of arts and crafts: *Avenue de Clichy: Five o'Clock in the Afternoon* (Wadsworth Atheneum, Hartford, Conn.) and *Mower at Noon: Summer* (Private collection, Paris).[82] The former, in particular, may have influenced Lautrec's own planar style, ascertainable from around 1888 (*Cirque Fernando*), in terms of form. But also in terms of content, this boulevard scene by gaslight is indebted to the themes of modern life in Paris begun by Manet, Degas, Forain, Raffaëlli, and others. Soon afterward, Anquetin also shared very specific themes with Lautrec, reflected, for example, in a pastel portrait, *La Goulue* (Private collection, Paris), of 1890,[83] which is, however, closer in style to Beardsley, or in a large work, *The Dance Hall at the Moulin Rouge* (1893; Private collection, Switzerland).[84] The latter, a pastiche combining several works of Lautrec—primarily the Jane Avril poster (Cats. 253–254) and the painting *Ball at the Moulin Rouge* (1890; Collection Henry P. McIlhenny, Philadelphia)—with its stylistic plagiarism, marked the decline of the artist Anquetin, who produced nothing more of any significance.[85]

This fate was also shared by Emile Bernard (1868–1941), the youngest member of the Atelier Cormon.. In October 1884, at the age of sixteen, he entered the atelier, where he met Anquetin and Lautrec. Two years later, before van Gogh had appeared among the members of this group, the rebellious youth had to leave at Cormon's insistence. Shortly thereafter, Bernard reached what was to be his artistic peak and even became, for some years, the head of the artistic avant-garde of the time, only to lapse into meaningless imitative painting later on.

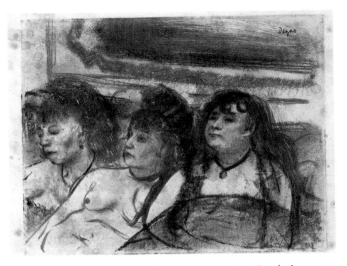

ABOVE Fig. 16. Edgar Degas. *Three Prostitutes in a Brothel*. C. 1879. Monotype and pastel, 6¼ x 8⅝" (16 x 22 cm). Rijksmuseum, Amsterdam

RIGHT Fig. 17. Emile Bernard. *The Women in the Salon* (from the album *In the Brothel*). 1888. Pen and ink with wash, 12 x 7¾" (30.5 x 19.7 cm). Rijksmuseum Vincent van Gogh, Amsterdam

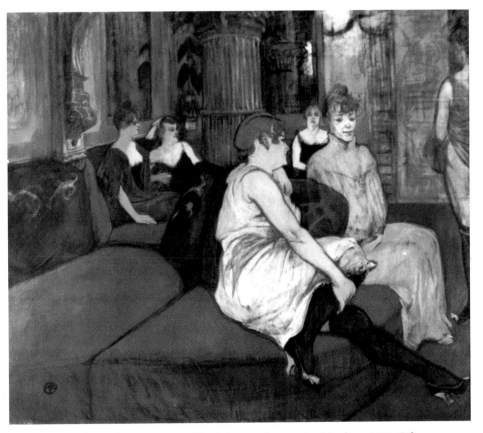

Fig. 18. Henri de Toulouse-Lautrec. *The Salon on the rue des Moulins*. 1894. Oil on canvas, 43¾ x 52⅛" (111.5 x 132.5 cm). Musée Toulouse-Lautrec, Albi

ABOVE Fig. 19. Jean-Louis Forain. *Café Scene.* 1878. Gouache, 12½ x 8″ (31.7 x 20.3 cm). The Brooklyn Museum, New York

RIGHT Fig. 20. Jean-François Raffaëlli. *The Milliner.* c. 1885. Pastel, 23⅝ x 10½″ (60 x 26.5 cm). Private collection

The fact that Bernard and Lautrec worked with one another or, at least occasionally, in one another's company, is substantiated by two caricatures by Bernard that show Lautrec standing before an easel and painting a picture while seated.[86] In the winter of 1885–86, Lautrec painted an oil portrait of Bernard, who later wrote of the extraordinary effort made by his friend: "He spent twenty sessions without succeeding in bringing the background into harmony with the face."[87] This portrait, now in The Tate Gallery, London, reveals nothing of these difficulties; it is an early masterpiece in which Lautrec, with his great art of characterization, represented the precocious seventeen-year-old so full of ideas. About his efforts with Anquetin in painting, Bernard said: "Toulouse-Lautrec highly approved of our studies."[88] This can only refer to the development of *cloisonnisme.* Lautrec, of course, was not a cloisonist: his technique and his style were much too different and spontaneous. The simplification and synthesis of *cloisonnisme* inevitably led to a style suggestive of arts and crafts. Only Lautrec's posters could have been partially indebted to this mode of contours and surfaces. The Nabis, on the other hand, profited much more from this short-lived but influential Post-Impressionist style.

About 1885–87, Bernard produced a large and unfortunately little known pastel drawing titled *The Hour of Flesh* (Private collection, Paris). Its subject, a brothel scene in which one perceives couples in the darkness, was probably influenced by Baudelaire.[89] Bernard treated this theme again in 1888 in an album which he called *In the Brothel* (see Fig. 17), consisting of a dozen watercolors which he sent to his friend van Gogh in Arles. This inspired the Dutch painter, his senior by sixteen years, to do two paintings with a similar theme.[90] Degas's brothel monotypes of 1876 and these works by Bernard were probably the most influential in Lautrec's employment of this theme, which began in 1893 (in the 1880s, Lautrec had not yet produced any brothel scenes). Bernard seems to have profited, in turn, from Lautrec's cabaret and *café-concert* scenes of that time. There is some doubt concerning the date 1886 (probably added later) on a signed pen-and-ink drawing (Fig. 21), allegedly depicting La Goulue in a cabaret. A more likely date would be 1888 or 1889 (in which case it might show

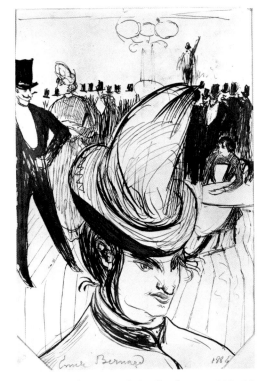

Fig. 21. Emile Bernard. *La Goulue.* c. 1886–89. Pen and ink, 11½ x 7¾" (29.2 x 19.8 cm). Private collection

Authentic sources are sparse, and one can only form a rough picture of the nature of their friendship.

Lautrec supposedly met van Gogh in February 1886 or somewhat later, when, shortly after his arrival in Paris, van Gogh entered the Atelier Cormon, where Lautrec, then twenty-two years old, had been studying since 1882. Despite his physical handicap, this scion of nobility with his witty, open manner embodied the opposite of the deeply earnest thirty-three-year-old Dutch Calvinist. Nevertheless, the two artists seem to have become friends immediately. François Gauzi, a fellow student at the Atelier Cormon, wrote:

> As he was about to leave after visiting my house one day, Vincent glanced at a volume of Balzac which lay on my table; it was *César Birotteau.* "You are reading Balzac," he said to me, "That is good. What an astounding author! Everyone should know him by heart." I gave the incident no further thought until, a few days later, Lautrec confided to me: "Do you know that van Gogh regards you very highly since he discovered that Balzac is your favorite author?"[92]

the Moulin Rouge, which opened at that time), for the style corresponds to that of the brothel watercolors and some other works by Bernard sent to van Gogh in 1888.[91] What is certain is that the drawing is older than Lautrec's Moulin Rouge poster of 1891 (Cats. 247–248) and, accordingly, represents an important precursor to this momentous poster in its spaciousness and silhouetted audience. All these drawings by Bernard show a summary, often only sketchy, outline of the figures, but with an occasional spontaneity and vigor that has an attraction all its own. Despite van Gogh's criticism, that some of these *croquis stupides*—as Bernard himself called the pages of the brothel album—were not elaborated, they nevertheless constitute an important iconographical and formal bridge to Lautrec.

About Lautrec's relationship with Vincent van Gogh (1853–1890) one usually reads only that these two very different artists were friends and that, up to van Gogh's premature death, this friendship remained unclouded.

In view of the differences in their backgrounds and styles, it must have been chiefly the fact that they were both outsiders that brought Lautrec and van Gogh together. Lautrec, who had always possessed a fine sense for recognizing unusual talent, was probably especially impressed by the uncompromising honesty in van Gogh's art, which also expressed itself in a choice of themes that were modern, fresh, and inspired by the French naturalists. Herein lay their bond. But in terms of physique, character, temperament, and background one can imagine no greater contrast than that between these two painters. After his isolation in Holland and Belgium, van Gogh enjoyed being in Paris among friends who wanted, as he did, to renew art. Lautrec's friends soon became van Gogh's friends as well, especially Anquetin and Bernard.

We know, from a letter that van Gogh wrote in the summer of 1886 to his brother Theo, who had just spent his holiday in Holland, that he had friendly contact with Lautrec during his first year in Paris. The succinct reference

RIGHT Fig. 22. Vincent van Gogh. *Dancing Women (Dance Hall in Antwerp)*. 1885. Crayon, 3⅝ x 6½" (9.3 x 16.4 cm). Rijksmuseum Vincent van Gogh, Amsterdam

BELOW Fig. 23. Vincent van Gogh. *The Dance Hall*. 1888. Oil on canvas, 25⅝ x 31⅞" (65 x 81 cm). Musée du Louvre, Paris

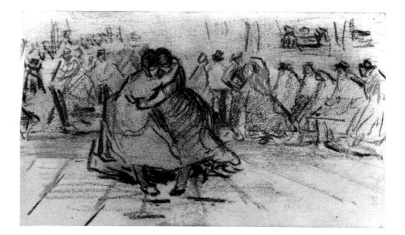

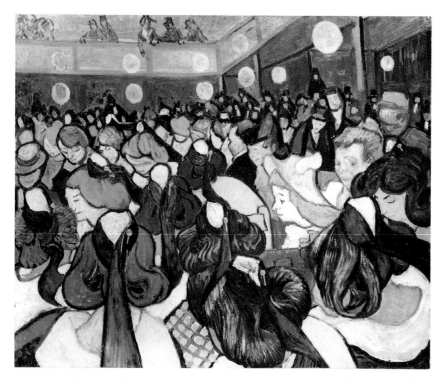

reads: "Today I was with Lautrec; he sold a picture. Through Portier, I believe."[93] It is only natural that the fellow students of the Atelier Cormon sought to exhibit and sell their pictures together. At the initiative of van Gogh, an exhibition was put together at the Tambourin, the café whose Italian proprietress, La Segatori, was for a time involved with van Gogh. Several comparable works by Lautrec and van Gogh showing women sitting in a café or restaurant should be viewed against this background;

for example, van Gogh's *La Segatori at the Tambourin* (1887; Rijksmuseum Vincent van Gogh, Amsterdam)[94] or Lautrec's *Rice Powder* (Fig. 25). It was perhaps at Lautrec's suggestion that van Gogh went to the Paris *cafés concerts*, where he produced a series of sketches which, owing to their heaviness, entirely lack the spirit, ease, and pointedness of Lautrec's later works in this genre.[95] However, the proof that such subject matter at one time corresponded to van Gogh's artistic intentions is supplied by several dance-

hall studies in crayon produced in Antwerp (Fig. 22). Also, later in Arles, van Gogh painted *The Dance Hall* (1888; Musée du Louvre, Paris) which was influenced by Lautrec and Bernard (Fig. 23).

After completing the portrait of Bernard in 1885–86, Lautrec also made a masterful portrait of van Gogh (Fig. 24), presumably in 1887. This large-format colored pastel drawing reveals, as does no other portrait, the inner state of the Dutch artist, who sits at his table in some café like a wild animal ready to leap. The young Lautrec, already a remarkable judge of human nature, captured here the psychological state of van Gogh—in a word, the phenomenon van Gogh. (This work seems prophetic of certain early portraits by Oskar Kokoschka, his so-called "x-ray" portraits.)

There is no doubt that through van Gogh, Bernard and Anquetin became fervently interested in Japanese woodcuts, and Lautrec's predilection for this art may have been at least reinforced by him.[96] The works of both Lautrec and van Gogh show numerous signs of this involvement. It is probably the main source for the inclination of both painters toward contour lines and the occasional ornamental effect of forms in harmony with them. Lautrec planned to travel to Japan many times, but he never made this journey. For van Gogh, whose financial means never would have allowed such a costly enterprise, there could be no question of anything but a substitute. Significantly, it was Lautrec who advised him to go to the south of France to continue his search for color and light.

In February 1888 van Gogh departed for Provence. From Arles he announced to his brother on March 17: "On Sunday I shall write Bernard and Lautrec, because I solemnly promised to, and shall send you those letters as well." (Letter 469) On the very next day he wrote: "I enclose a few lines for Bernard and Lautrec—I solemnly promised to write them. I am sending it to you so that you can give it to them when convenient, there is no hurry at all; and then you also could find out what they are doing and listen to what they say, if you would." (Letter 470) Unfortunately, van Gogh's letter to Lautrec has not been recovered,[97] but his letter to Bernard has been preserved, and on the basis of its scope and contents it is possible to roughly reconstruct the one for Lautrec. Beneath a sketch of the drawbridge at

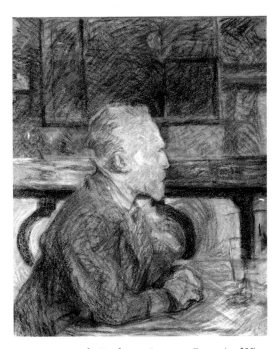

Fig. 24. Henri de Toulouse-Lautrec. *Portrait of Vincent van Gogh.* c. 1887. Pastel, 21¼ x 17¾″ (54 x 45 cm). Rijksmuseum Vincent van Gogh, Amsterdam

Arles, van Gogh wrote: "Since I promised to write to you, I want to tell you, first of all, that this country with its transparently clear air and its bright play of colors seems to me as beautiful as Japan." (Letter B 2) This important piece of artistic information was almost certainly also imparted to Lautrec.

In contrast to van Gogh's rapidly developing exchange of letters with Bernard there was, for unknown reasons, no further correspondence between van Gogh and Lautrec. Lautrec was not as talented at letter-writing as his two friends, and his existing notes to others are mostly brief and factual, like those of Cézanne. Lautrec's forte lay in verbal *bons mots* and *aperçus* rather than in lengthy prose. But one should not conclude from the absence of a written exchange of thoughts that the two friends thereafter became indifferent to one another. Undoubtedly, Lautrec informed himself from time to time through Theo as to Vincent's new works and progress. That van Gogh did not forget Lautrec and his work while in the south of France can be seen from his letters. In April he inquired of Theo:

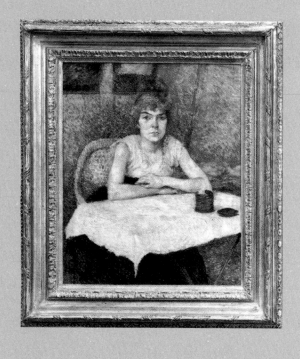

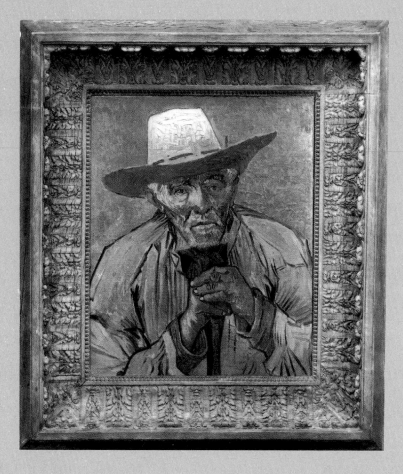

Fig. 25. LEFT Henri de Toulouse-Lautrec. *Rice Powder*. 1888. Oil on cardboard, 22 x 18⅛" (56 x 46 cm). Stedelijk Museum, Amsterdam. RIGHT Vincent van Gogh. *Portrait of Patience Escalier*. 1888. Oil on canvas, 27⅛ x 22" (69 x 56 cm). Private collection

"Has Lautrec finished his picture, the one of the woman with her arms propped on the little café table?" (Letter 476) The reference is to *Rice Powder* (Fig. 25) which van Gogh had apparently seen and probably approved of in its initial stages before his departure for Arles. This work may show Suzanne Valadon: a young woman is seated at a table facing the viewer with a tin of powder before her. Theo eventually purchased this work for his private collection.[98] Impressionistic in terms of technique, this restrained work still differs fundamentally from Lautrec's later works, beginning in the same year with *In the Cirque Fernando: The*

Ringmaster (Fig. 15). It appears that 1888 brought decisive artistic changes for Lautrec as well as for van Gogh, Bernard, and Paul Gauguin. In Arles, van Gogh sensed how far he had removed himself from the Impressionists whom he had approached experimentally for a time in Paris.[99] He also distanced himself from his comrades at the Atelier Cormon in a sense when he wrote to Theo on June 23: "Anquetin and Lautrec will probably not approve of my current work." (Letter 500)

On July 15 van Gogh reported to his brother: "The Lautrecs have just arrived, I find them beautiful." (Letter

505) It cannot be established with complete certainty to which works van Gogh is here referring. Theo, who had taken some Lautrecs on commission for the Goupil Gallery, could have sent his brother photographs of these works or—what is more probable—two copies of the journal *Paris illustré*, published by Goupil, which contained illustrations based on Lautrec's drawings.[100] There is no question of these being original graphic works by Lautrec, since Lautrec, then twenty-four years old, had not yet begun to produce them at all.

On August 11 van Gogh again referred to Lautrec's picture *Rice Powder*—perhaps Theo had just told him of his purchase—in comparing it to his *Portrait of Patience Escalier* (Fig. 25), which he had just completed: "I do not think that my peasant would do any harm to the Lautrec in your possession if they were hung side by side, and I am even bold enough to hope the Lautrec would appear even more distinguished by the mutual contrast, and that on the other hand my picture would gain by the odd juxtaposition, because that sunsteeped, sunburned quality, tanned and air-swept, would show up still more effectively beside all that rice powder and elegant toilette." (Letter 520) This unusual comparison of two radically different works—all that is common to them is that the model looks out of the picture—reveals the artistic tolerance of which van Gogh was capable despite his own very different development.[101]

On June 18, 1889, van Gogh wrote from Saint-Rémy about the more distinguished, pointed pictorial themes of the Parisian painters: "And, finally, when the 'Chat Noir' and especially Forain draw women for us so masterfully in their own style, one simply does what one can in a less Parisian manner—but without loving Paris and its elegance any the less for that reason—and tries to prove that there are other things aside from that." (Letter 595) The *Portrait of Patience Escalier* serves as an illuminating example of this point. Van Gogh fully acknowledged the "Parisian" genre, but he chose to go his own way.

Both van Gogh and Lautrec participated in the exhibitions of the Belgian group of avant-garde artists called *Les Vingts* which took place in Brussels at the beginning of each year. Lautrec first exhibited there in 1888, van Gogh in

1890. In 1889 Theo kept his brother informed of exhibitions in which Lautrec participated. At first, Theo had confirmed Vincent's participation in the exhibition organized by the Gauguin circle at the café Volpini on the periphery of the Paris World's Fair, but then withdrew it because the project did not appear to him sufficiently serious. On June 16, 1889, he gave Vincent an account of this exhibition and concluded with the remark: "Lautrec was not permitted to take part because he exhibited at a club." (Letter T 11) Thus it came to pass that two of the principal Post-Impressionists did not take part in an exhibition that would later be regarded as one of the most important of this movement.

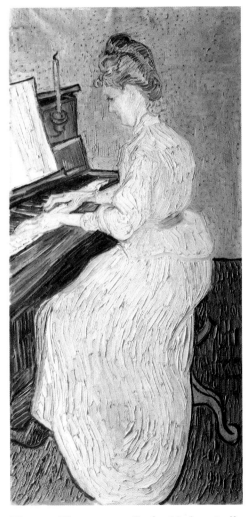

Fig. 26. Vincent van Gogh. *Mademoiselle Gachet at the Piano*. 1890. Oil on canvas, 40⅛ x 19¾" (102.5 x 50 cm). Kunstmuseum, Basel

On September 5, amid an account of the exhibition of the Indépendants, Theo wrote: "Then there are the Lautrecs, which are doing very well: among others, a ball in the Moulin de la Galette which is very good." (Letter T 16) Theo is here referring to Lautrec's picture *Dance at the Moulin de la Galette* (1889; The Art Institute of Chicago). Lautrec also exhibited two other works.[102]

At the end of 1889 van Gogh was asked to exhibit at the start of the following year with *Les Vingts* in Brussels. On November 16 Theo wrote to Vincent: "This year they have invited Puvis de Chavannes, Bartholmé, Cézanne, Dubois, Pillot, Forain, Signac, L. Pissarro, Hayet, Renoir, Sisley and Lautrec and you." (Letter T 20) For the Dutch painter it undoubtedly meant a first sign of recognition to be exhibited along with more noted artists like Pierre Puvis de Chavannes, Jean-Louis Forain, Pierre-Auguste Renoir, and Alfred Sisley, but also with Paul Cézanne, Paul Signac, and Lautrec, who were being admired more and more by insiders.[103] At the opening of this exhibition an unpleasant scene occurred when the Belgian painter Henry de Groux declared that:

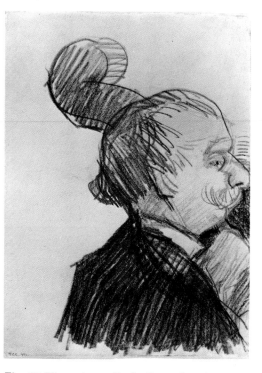

Fig. 27. Vincent van Gogh. *Contrabassist*. 1886–87. Crayon, 13¾ x 10¼" (35 x 26 cm). Rijksmuseum Vincent van Gogh, Amsterdam

He was withdrawing his own works since he did not want them to be shown in the same room with the "abominable *Pot of Sunflowers* by Monsieur Vincent or any other *agent provocateur*." Two days later, however, de Groux participated in the banquet which officially celebrated the opening of the show. Among the guests were Toulouse-Lautrec and Signac who had come from Paris especially for the occasion. During the dinner de Groux once more loudly railed against van Gogh and according to Gustave Maus's recollections, called him "an ignoramus and a charlatan." At the other end of the table Lautrec suddenly bounced up, with his arms in the air, and shouted that it was an outrage to criticize so great an artist. De Groux retorted. Tumult. Seconds were appointed. Signac announced coldly that if Lautrec were killed he would assume the quarrel himself.[104]

Although this incident is also amusing in a way, it says much for Lautrec and Signac that they defended their friend van Gogh precisely in his hour of need; for the Dutch painter was at that moment in the mental hospital at Saint-Rémy.

Regarding the new exhibition of the Indépendants, Theo informed his brother on March 19, 1890, among other things, that "Lautrec has an exquisite portrait of a woman at the piano and a large picture that is very effective. In spite of its delicate subject matter it is first-rate." (Letter T29)[105] When on his journey from Saint-Rémy to Auvers in mid-May 1890 van Gogh stopped for three days in Paris to stay with his brother and sister-in-law, he might also have seen Lautrec. Johanna van Gogh–Bonger recalled: "He went out alone to buy olives, which he was in the habit of eating every day.... He also received many visits."[106] One of these visitors may have been Lautrec, who lived close by. Since the statements of Theo's widow are not always reliable, it is certainly conceivable that van Gogh also visited Lautrec in

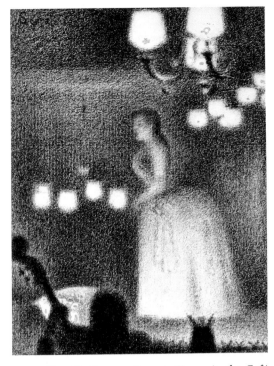

ABOVE Fig. 28. Georges Seurat. *Singer in the Café Concert.* 1887. Conté crayon and gouache, 11⅞ x 9″ (29.7 x 22.9 cm). Rijksmuseum Vincent van Gogh, Amsterdam

RIGHT Fig. 29. Georges Seurat. *The Circus.* 1890–91. Oil on canvas, 73 x 59⅛″ (185 x 150 cm). Musée du Louvre, Paris

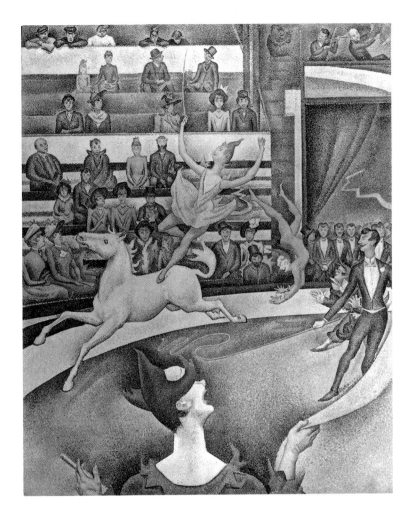

his atelier, to which the picture of *Marie Dihau at the Piano* must have been moved, since the exhibition of the Indé-pendants had closed on April 27. On the other hand, even if van Gogh did *not* see this picture during his brief visit, he may have been inspired by it—at least indirectly through Theo's mention of it in his letter and possibly through a verbal description during the meeting in Paris—to treat the same subject some weeks later (late June) in Auvers, in *Mademoiselle Gachet at the Piano* (Fig. 26)—was it influence or coincidence?

During his last stay in Paris in early July 1890, three weeks before his death, van Gogh definitely saw Lautrec again—for the last time. His sister-in-law reported: "There were also constant visitors for Vincent, among them… Lautrec, who stayed for luncheon and greatly amused him-self with Vincent over a pallbearer they had encountered

on the stairs."[107] A macabre joke near the end of the artist's life!

It was during this final meeting, then, at the very latest, that van Gogh saw Lautrec's picture *Marie Dihau at the Piano,* presumably in Lautrec's atelier.[108] But by the end of June, in Auvers, he had already painted his own picture of a pianist. After returning from Paris he wrote on July 9: "The picture by Lautrec, Portrait of a Musician, is quite amazing, it deeply moved me." (Letter 649) His emotions may have been sparked not only by the quality of Lautrec's picture, but just as well by the discovery that, despite all private and artistic difficulties, there were still painters with intentions similar to his own.[109]

For years after van Gogh's death their friendship seems to have had a lasting effect on Lautrec. It is well known that van Gogh advised Bernard to study the old Dutch masters.

He undoubtedly expressed something similar to Lautrec, who, in fact, made two trips to Holland in the 1890s—once with Anquetin in order to attend "a fine eight-day lesson with professors Rembrandt, Hals, etc."[110] The fact that Lautrec emphasized particularly these Dutch masters whom the Dutchman van Gogh so greatly admired may be seen as the result of his friend's advice to him; it is, at any rate, certainly the result of the two painters' related views on art. Despite any personal differences, there was an overriding mutual artistic accord between Lautrec and van Gogh; both of them strove, in an uncompromising and unconventional way, to express the truth. Seen in this light, the relationship between the two artists—both of whom went far beyond Impressionism—is more significant than had been previously thought.

Although Lautrec experimented in the 1880s with Impressionism and sporadically also with pointillist technique, his link with Georges Seurat (1859–1891) is to be found mainly in the area of iconography, in which their works appear to have had a reciprocal effect. Like Degas, Seurat also portrayed *cafés concerts*. He even used the neck of the contrabass as an important diagonal compositional element before Lautrec took over this feature, which was used also by Degas, as we have seen, and van Gogh as well (Figs. 27, 28).[111] In 1888, the same year that Lautrec produced his large circus picture, Seurat completed the well-known *Invitation to the Sideshow (La Parade)*, 1887–88 (The Metropolitan Museum of Art, New York). But it is only Seurat's last picture, *The Circus* (Fig. 29), that appears to bear directly on Lautrec's masterpiece *In the Cirque*

Fig. 30. Pierre Bonnard. *France-Champagne*. 1891. Poster: lithograph, 30⅛ x 23″ (76.5 x 58.4 cm). The Museum of Modern Art, New York

Fig. 31. Jules Chéret. *Bal au Moulin Rouge*. 1889. Poster: lithograph, printed in color, 23½ x 16½″ (59.7 x 41.9 cm). Jane Voorhees Zimmerli Art Museum, New Brunswick, New Jersey

Fernando: The Ringmaster, which was being exhibited at that time in the foyer of the Moulin Rouge. Seurat also depicted a bareback rider in the ring, along with clowns and a whip-snapping ringmaster. But how different this vertical pointillist painting is from Lautrec's earlier, rectangular work with its flat handling! Yet the Japanese influence, in both cases, seems evident.

Among artists of the cloisonists' generation with whom Lautrec was in contact were Bonnard and Vuillard, the principal representatives of the group known as the Nabis. Their relationship was characterized by lively artistic activity and by friendly contact with the circle of the journal *La revue blanche*. Like Lautrec and the cloisonists, the Nabis were also greatly influenced, in terms of form, by Japanese woodcuts. It is sometimes very difficult to

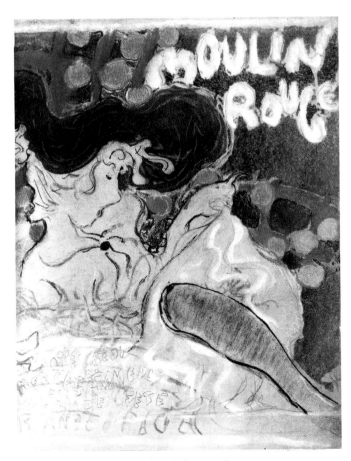

Fig. 32. Pierre Bonnard. Sketch for Moulin Rouge poster. 1892. Pen and ink and pastel. Whereabouts unknown

untangle the web of relationships among these groups: What did the Nabis learn directly from the Japanese? What filtered down to them through the cloisonists? What did they learn from Lautrec? Nevertheless, an attempt must be made to disprove an assertion, which repeatedly crops up in literature on the subject, that Lautrec's lithographic and poster art was influenced by, and even initiated by, the Nabis.

Pierre Bonnard (1867–1947), in particular, is assigned a key function in this alleged relationship, which he probably never performed.[112] His poster *France-Champagne* (Fig. 30), published in 1891, is often cited as the initial impulse for Lautrec's poster work, especially his first creation in this genre, *Moulin Rouge* (Cats. 247–248). Thadée Natanson tells us that Lautrec tried to meet the creator of the unsigned *France-Champagne* poster, printed by Edw. Ancourt & Cie.[113] Ancourt also printed Lautrec's Moulin Rouge poster in the same year, 1891. It is difficult to find any correspondences or similarities in comparing the two works. Although Bonnard's does already show certain stylizations and formal simplifications, these are not really as bold and original as Lautrec's. Bonnard's poster still stands within the tradition of Chéret's fashionable exaltations.

From the 1870s to the 1890s Jules Chéret (1836–1932) was the leading poster artist in Paris. In his effective works he brought to light the world of beautiful make-believe, the superficial pleasures of self-indulgent men and women in affected poses. His confettilike atmospheres had a great deal in common with the late Baroque apotheosis of Tiepolo, in style and composition. (Indeed, this was historically a second Baroque and Rococo period—in everything from commercial art to architecture.) Still, Chéret must be regarded as the founder of the newer kind of poster art, which Lautrec and the Nabis subsequently provided with unconventional impulses. It is characteristic for the relationships among these younger artists that they sometimes even worked for the same client as Chéret, who created posters for Yvette Guilbert, Loie Fuller and, the Jardin de Paris, as well as the first Moulin Rouge poster (Fig. 31). Lautrec also designed posters for most of these clients. There is a photograph, probably taken in 1891, that shows Lautrec standing in the garden of the Moulin Rouge in front

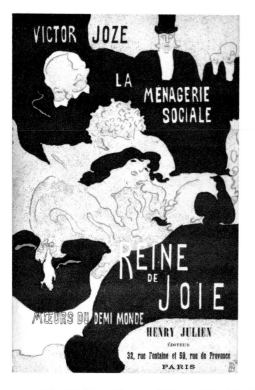

ABOVE Fig. 33. Pierre Bonnard. Front of book jacket for *Reine de joie*. 1892. Lithograph, printed in color, 7½ x 5⅛″ (19 x 13 cm). Collection Mr. and Mrs. Herbert D. Schimmel, New York

BELOW Fig. 34. Pierre Bonnard. *Seated Woman Holding a Glass*. Early 1890s. Watercolor, 12¼ x 7⅛″ (31 x 18 cm). Private collection

of Chéret's poster, hat in hand. This is a deliberate homage to his predecessor, whose work Lautrec could only surpass through a radically different treatment of theme and form; and in this he succeeded brilliantly. In 1892 Chéret himself, regarding Lautrec as his successor and heir, exclaimed: "Lautrec is a master!"[114] Neither Chéret's poster, which shows a dancer riding past a windmill on a donkey, nor Bonnard's sweetly decorative champagne poster is similar to Lautrec's Moulin Rouge poster. The inspiration for it was derived, rather, from the Japanese and the cloisonists.[115]

In Lautrec's poster the violet-gray silhouette of La Goulue's partner, Valentin Le Désossé, in the foreground, La Goulue rendered with contours and intense color in the middle distance, the black silhouette of the audience in the background, and the yellow globes of light scattered irregularly over the sheet in abstract formation all have little to do with French or European pictorial conventions. This work is no lifeless derivative of a formal legacy from the East but the original masterpiece by a young artist. This was immediately sensed by the public of the time; for these large-scale posters, plastered on the walls of Paris, made Lautrec famous overnight.[116] There is nothing in the works of the Nabis until 1891 to compare with this unusual pictorial solution by Lautrec. It appears much more likely that these somewhat younger artists attempted to benefit from Lautrec's success by submitting similar works for the same employer or others like him. It is a little-known fact, for example, that Bonnard also planned a poster for the Moulin Rouge in 1892; that is, one year after Lautrec's great success. There are at least two preliminary studies for this work executed in pastel (Fig. 32).[117] Done in quite a colorful manner, they show a cancan dancer with a large, curvaceous hat who raises her skirt to expose a dancer's leg in a dark stocking. To this day, nothing is known about the circumstances surrounding this poster project. We do not know whether this poster was an official commission and was simply not executed, or whether the sketches are merely private studies—proposals, perhaps, with which Bonnard hoped to solicit such a commission. Stylistically, these rough sketches still bear the imprint of Chéret and *France-Champagne*. This would seem to disprove that Bonnard was already more artistically advanced at this

time than Lautrec. By 1891 Bonnard had completed approximately twenty paintings; Lautrec, his senior by only three years, had already painted more than four hundred. Thus, precisely the opposite state of affairs must be conceded: that the Nabis, and Bonnard in particular, are indebted to Lautrec.

In 1892 the two painters worked on the same project when Lautrec designed the poster (Cats. 249–250) and Bonnard the book jacket for Victor Joze's novel *Reine de joie*. Bonnard's black, yellow, red, and gray jacket (Fig. 33) produced a strong impression of surface in the manner of the Japanese: "The very oriental graphic style, as well as the use of *crachis* reminds one of Lautrec's art."[118] Two of Bonnard's brush-and-ink drawings, which assimilated Japanese and cloisonist influences in their technique, also date from this time: *Seated Woman Holding a Glass* (Fig. 34), a poster sketch with vertical format, and a city scene titled *The Rendezvous*.[119]

Both Lautrec's and Bonnard's first lithographs date from 1891. In 1894 the poster *La revue blanche* (Fig. 35), Bonnard's first masterpiece in this genre, made its appearance. In this case it really was the other way around: Lautrec's poster *La revue blanche* (Cats. 272–273), designed a year later, though original and daring in its way, could not attain the quality of Bonnard's suggestive work. Bonnard's picture shows a Parisian (a cocotte?) accompanied by a street urchin, leaving a newspaper stand where she has just bought a copy of *La revue blanche*. The iconography in Lautrec's work is only loosely connected with the product it was supposed to promote: only insiders were able to identify the ice-skating lady as Misia Natanson, the publisher's sister-in-law. Bonnard's poster does more justice to the genre; with its flat, decorative structure, it is animated by an artful composition and, not least, by graphics that not only stabilize the picture, but which were revolutionary for their time. *Japonisme* and *cloisonnisme* contributed to this artistic solution in which Art Nouveau had begun to proclaim itself.[120]

Bonnard was now at his height of creativity in printed graphic arts. In 1895 he designed the black-gray cover for the *Album de La revue blanche*, which derives somewhat from his poster of the previous year. It shows a woman with

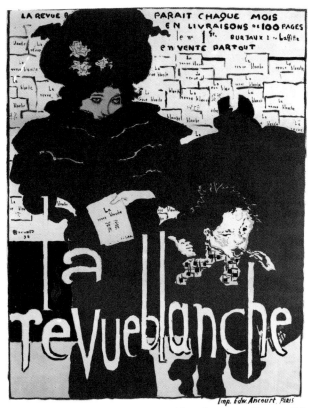

Fig. 35. Pierre Bonnard. *La revue blanche*. 1894. Poster: lithograph, printed in color, 30½ x 23¼" (77.3 x 58.9 cm). The Museum of Modern Art, New York. Abby Aldrich Rockefeller Fund

Fig. 36. Pierre Bonnard. *The Little Laundress*. 1896. Lithograph, printed in color, 11½ x 7⅞" (29.2 x 20 cm). Collection Wolfgang Wittrock, Düsseldorf

Fig. 37. Pierre Bonnard. *Circus Rider*. 1894. Oil on panel, 10¾ x 13½" (27.3 x 34.3 cm). The Phillips Collection, Washington, D.C.

Fig. 38. Edouard Vuillard. *Portrait of Henri de Toulouse-Lautrec*. 1897. Oil on canvas, 15⅜ x 11¾" (39 x 30 cm). Musée Toulouse-Lautrec, Albi

a dog surrounded by the letters of the title. For this album, which was filled with the prints of various artists within the review's circle, Bonnard also designed a separate sheet, the *Woman with Umbrella*, a delicate woman preparing to mount stairs which are only suggested in the picture. The black lithograph shows one pink accent. Such pointed use of two colors is presumably derived from Lautrec's contribution to this album—*Carnival*, a lithograph which he had produced in 1894 (Cat. 80). Lautrec used a second stone for this work in order to bring out the bright red lips of the costumed woman. This radically new effect must have made a strong impression on Bonnard. In addition to *Parisian*, a black-and-white illustration for *La revue blanche*, in April 1895 *NIB Carnavalesque*, a carnival supplement to the review illustrated by Bonnard, was also published. Lautrec, who in January 1895 inaugurated this special supplement—a lively mixture of humorous texts and equally unrestrained caricaturelike drawings—with his own contribution (Cats. 93–94), is said to have been very taken with Bonnard's *NIB*, a cheerful arrangement of masks and dancing in crayon and brush-and-ink drawings.[121]

In 1896 Bonnard designed two posters: one, in brown and yellow-green, done in a flat manner, was entered in the *Exposition des Peintres Graveurs* held at Vollard's gallery, in which both Bonnard and Lautrec participated. It shows a woman holding a print in her hand. This subject is comparable to—and probably also inspired by—Lautrec's cover for *L'estampe originale* done in 1893 (Cats. 14–15), which shows Jane Avril as she checks a proof at the Ancourt printing shop. The second of Bonnard's posters of 1896 was intended for the Salon des Cent and showed a woman with a dog. Lautrec's color lithograph, *The Passenger from Cabin 54* (Cats. 281–284), also done that year, served as an alternative poster for the same exhibition. The subject matter in these works is even further removed from the actual purpose of the poster than it is in the previously mentioned works. Its sole function was to catch the eye. In 1897 Bonnard designed a poster for *L'Estampe et l'affiche*, as well as the colored cover for the second *Album D'Estampe originale de la Galerie Vollard: Peintres-graveurs*. A cat plays with a ball of yarn amid prints spread out on a table. Among the works of other artists, Bon-

nard's color lithograph *The Little Laundress* is also found in this album (Fig. 36). This work, whose form relies on the Japanese, the cloisonists, and Lautrec, represents a subject inspired by the naturalists, which first appeared in works by Daumier and then, repeatedly, in variations by Degas, Lautrec, Steinlen, and others.

Bonnard's work revolved around the Moulin Rouge not only in his poster sketches of 1892 but also in several depictions of the exterior and interior of this cabaret, such as an undated brush-and-ink drawing, probably done in the early 1890s, *The Life of the Painter*, in which he shows himself strolling on the place Blanche in front of the Moulin Rouge accompanied by Lautrec, Ker-Xavier Roussel, Maurice Denis, and Vuillard. This was followed, around 1895, by a painting of the façade of this cabaret and then by a triptych, of 1896, titled *The Moulin Rouge* (Collection Wright Ludington, Santa Barbara, California); in the same year he made both interior and exterior views of the Jardin de Paris.[122] In 1894 Bonnard had painted a theme (Fig. 37) to which Lautrec had already given a masterful treatment in 1888: the bareback rider in the circus.[123]

Like Lautrec, Bonnard also designed some book illustrations. In 1898 Peter Nansen's *Marie* was published by *La revue blanche* with illustrations by Bonnard. In 1900 Bonnard produced 109 lithographs for Paul Verlaine's *Parallèlement*. These figurative drawings were stylistically influenced by Lautrec's 1896 *Elles* album (Cats. 139–145, 147–158). In 1902 Bonnard made 151 Renoir-like lithographs for *Daphnis and Chloë* and in 1904 illustrated *Histoires naturelles* by Jules Renard, for which Lautrec had done illustrations in 1897 (Cats. 187–188). However, Bonnard's brush drawings could not measure up to Lautrec's masterful parade of individual animals.[124] Other Lautrec themes echoed in Bonnard's work for years afterward, such as in the painting *After the Theater* (1902) or *The Milliner in Profile* (1903–4).[125]

Bonnard undoubtedly learned much from the Japanese, the cloisonists, and Lautrec with respect to form. In terms of his iconography, he was influenced primarily by Lautrec. In painting they are linked chiefly through their choice of themes. Certainly, in Lautrec's late pictures, one sees a reflection of the more painterly and flat handling

Fig. 39. Edouard Vuillard. *Woman with a Large Hat.* c. 1890. Pastel, 9 x 8⅞" (23 x 22.7 cm). Private collection

typical of the Nabis. What always remained alien to Lautrec, on the other hand, was the tapestrylike, ornamental ingredient characteristic of the Nabis and often more predominant in their work than the description of form. Of course, there is also formal abstraction in Lautrec's work, but it is always subordinated to the content and is not a structural end in itself, as it so often is in the Nabis's works. It thus becomes almost self-evident that the Nabis placed more value on a decorativeness devoid of meaning than on a literary or anecdotal content. In Bonnard's work the lack of psychological insight and characterization is most apparent. In the figures of the Nabis—as in those of Renoir and, to some extent, Degas—the individual is hardly developed. In painting, the Nabis owe a great debt to Renoir and Degas, while in the graphic arts they are more indebted to Lautrec than the other way round.[126]

Edouard Vuillard (1868–1940) has stood since the nineteenth century, unjustly, in Bonnard's shadow. In his later years he recalled: "Bonnard and I had a little studio in the rue Pigalle. The *Revue blanche* brought us all together—painters, critics, singers, writers—the whole Montmarte group."[127]

The publisher of *La revue blanche*, Alexandre Natanson, and his brothers maintained a friendly private contact with the so-called Montmarte group, who were all more or less actively involved in this cultural review. Thadée Natanson and his young wife, Misia, received Lautrec, Bonnard, Vuillard, Félix Vallotton, Roussel, Mallarmé, and others, from 1895 on, in their country home "La Grangette" in Valvins-sur-Seine—a former barn that Vuillard depicted several times—and later in their country house "Le Relais" in Villeneuve-sur-Yonne.[128] Many portraits of the members of this circle were painted during the summer months of these years.

Vuillard's personal relationship with Lautrec seems to have started at the beginning of the 1890s. Vuillard had portrayed Lautrec as early as about 1895 in the painting *Toulouse-Lautrec in the Aisle* (Private collection, Paris), and a pen-and-ink drawing, *Lautrec in Profile—Caricature* (Private collection).[129] In 1897 Vuillard painted two great late Impressionist paintings of Lautrec: a figure portrait showing Lautrec at work in his yellow painting outfit (Fig. 38) and a profile.[130] Around the time these pictures were done, Vuillard wrote from Villeneuve-sur-Yonne on July 20, 1897, to his friend Vallotton about Lautrec, who was already afflicted with alcoholism: "Lautrec is here and is beginning to calm down, although certainly not without difficulty. But there is no need to worry; he has his good moments and he is really very attached to Thadée and his wife."[131]

Vuillard probably learned more from Lautrec than did Bonnard. In his old age, Vuillard said: "I was always moved by the way in which Lautrec changed his tone when art was discussed. He who was so cynical and so foulmouthed on all other occasions became completely serious. It was a matter of faith with him."[132] Vuillard's serious artistic production commenced, as it did for Bonnard, around 1890. The early 1890s saw pastel drawings such as *Woman with a Large Hat* (Fig. 39), and *The Loge* and *White Blouse* (both 1893; formerly Kunsthandel Sabine Helms, Munich), which show themes from the world of Degas and Lautrec but whose form had already reached a surprisingly abstract stage.[133] The surfaces and strong contours of *Woman with a Large Hat* are reminiscent of the cloisonists, of Bonnard's

two poster sketches for the Moulin Rouge, and to some extent of Lautrec's sketch for an Art Nouveau–style window for Louis Comfort Tiffany, *At the Nouveau Cirque* (1891; Philadelphia Museum of Art). Although it is only a sketch, the abstract form of *The Loge* points far into the twentieth century, toward Oskar Schlemmer, for instance.

Vuillard's color lithographs were inspired by Degas and Lautrec, as well as by the Japanese; see, for example, *The Dressmaker* (1895).[134] A series of watercolors, *Coquelin Cadet*, painted by Vuillard in 1892, is also very Japanese. Here, as in Bonnard, one recognizes the different ways in which Japanese prints affected many Post-Impressionists. The similarities among these artists did not necessarily come about through the influence of one artist on another, but through the artistic models they had in common. Thus, Vuillard frequently structured the backgrounds of his pictures and graphic works with decorative ornaments. This peculiarity, inherited from the Japanese and leading the way for Art Nouveau, can be found earlier in Lautrec, for example, in the background of *Marie Dihau at the Piano*. Vuillard may have seen this painting in 1890 at the exhibition of the Indépendants. Lautrec later returned to these patterned backgrounds in works such as the *Bust of Mademoiselle Marcelle Lender* (Cats. 102–106). Lautrec was Vuillard-like even before Vuillard himself.

In the mid-1890s, Vuillard was very occupied as a commercial artist, among other things with the production of illustrated theater programs for the small avant-garde Théâtre de l'Oeuvre, led by his friend Aurélien-François Lugné-Poë. Vuillard had already provided a sketch for a brush-and-ink drawing with wash, inspired by the cloisonists, for the 1890–91 season of the Théâtre Libre (Fig. 40). As with *Woman with a Large Hat* from the same period, this also announces the kind of decorativeness later to be seen in Art Nouveau.[135] In 1898 he painted a sketchy, fluid oil portrait of the singer May Belfort, whom Lautrec had already depicted in several works in 1895. In the picture, the singer, at right in her famous costume, a nightgown and cap, stands in front of a confettilike background on the stage before the silhouettes of the spectators.[136] In 1899, about 1906, and in 1918–19, Vuillard did several portraits of Lautrec's friend Romain Coolus, a writer for *La*

revue blanche. Lautrec portrayed his friend in 1899 "in the manner of Greco," as he declared to Coolus.[137]

Vuillard's *The Loge* (c. 1900; Private collection), is an ingeniously sketchlike pastel done in sparkling colors, comparable to works by Degas and Lautrec.[138] Other works, such as the *Café Scene* (Neue Pinakothek, Munich) or the green atelier interior, *Model in the Studio* (Fig. 41), are also linked to Lautrec's works: the last-named picture is an almost literal quotation of the woman undoing her corset from *Elles* (Cat. 157).[139] It was not only the Nabis who profited from this album, but whole generations of subsequent artists, among them the Norwegian Munch.

Edvard Munch (1863–1944), who was almost the same age as Lautrec, after a short visit to Paris in 1885, lived primarily in Paris and the south of France from 1889 to 1892; between 1895 and 1897, he lived in Paris where he encountered the decisive influences of his artistic development. He first studied for four months with Lautrec's former teacher Bonnat at the Académie des Beaux-Arts in 1889.[140] But the more important school was probably Paris itself, the circles of young artists of the 1890s, and the private galleries and various exhibitions where Munch was able to see the newest in art. It is possible that he visited the exhibition of the Indépendants in 1889, where works by van Gogh, Seurat, and Lautrec were being shown. The themes of Raffaëlli's works may also have had a strong effect on Munch.[141] *At the Variété* (c. 1889; Munch Museum, Oslo) demonstrates Munch's early use of subject matter associated with those artists: in the background, a bright stage with a singer; in the foreground, tables with men in top hats. Munch also visited subsequent exhibitions of the Indépendants, where he saw works by van Gogh, Seurat, and Lautrec, among them Seurat's *The Circus* and Lautrec's *A la mie* and two works titled *Woman Combing Her Hair* (1891; Musée du Louvre, Paris, and Private collection, Winterthur). These works are clearly reflected in Munch's quite Impressionistic painting *Woman Combing Her Hair* (1892; Collection Rasmus Meyers, Bergen), which is reminiscent not only of Lautrec, but definitely of Degas as well.[142] A surprising section of the picture has a long strand of hair occupying the central vertical area of the composition; the figure is at the very edge of the picture.

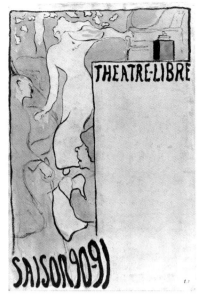

Fig. 40. Edouard Vuillard. Sketch of a program for the Théâtre Libre. 1890. Watercolor and black ink, 11⅞ x 8″ (30 x 20.5 cm). Private collection

Fig. 41. Edouard Vuillard. *Model in the Studio.* 1904–6. Oil on cardboard, mounted on panel, 24⅜ x 33⅜″ (62 x 84.7 cm). Kimball Art Museum, Fort Worth, Texas

Fig. 42. Edvard Munch. *Tingel-Tangel*. 1895. Lithograph, hand-colored, 18⅜ x 25¼″ (46.5 x 64.3 cm). Private collection

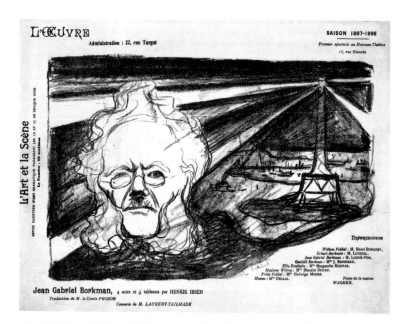

Fig. 43. Edvard Munch. *Ibsen with Lighthouse* (Program for *Jean Gabriel Borkman*). 1896–97. Lithograph, printed in black, 8¼ x 12⅝″ (21 x 32.1 cm). The Museum of Modern Art, New York

Degas's borrowings from Japanese art and Lautrec's further development of this innovation were assimilated here by Munch. Woman, the subject depicted by these Frenchmen in a predominantly positive way, was reinterpreted by Munch in a Nordic, brooding, and symbolic manner that became increasingly demonic. Thus, in a drawing of 1894, Munch represented a winged woman as a *Harpy* (Munch Museum, Oslo)[143] who has buried her claws in the prostrate body of a man. One is reminded of Lautrec's unusual title page for Goya's *Disasters of War* showing a vulture on the corpse of a soldier (Cat. 56).

Nevertheless, in the 1890s Munch also depicted the world of superficial pleasures. The lithograph *Tingel-Tangel* (Fig. 42) shows a cancan dancer on a cabaret stage on which other dancers are sitting; spectators and orchestra are in the foreground and a demimondaine with voluptuous bosom and rounded facial features is at the bottom left edge of the picture. Works by Degas, Raffaëlli, Bernard, and Lautrec are all equally the sources for this imagery.[144] Following Lautrec's brothel scenes of 1893–94, Munch, who in the meantime had certainly come into personal contact with the *Revue blanche* circle, came up with his own works in this genre. In 1894 he painted *Rose and Amélie* (Akers Collection, Oslo), depicting two prostitutes playing cards at a table—a theme that had appeared in 1893 in a similar manner in Lautrec. In Munch, one finds schematic, stereotypical faces as well as a flat, summary handling reminiscent of Bernard. This applies also to a picture of 1894–95 titled *Brothel* (Munch Museum, Oslo), in which prostitutes sit at tables waiting for customers. A painting such as this actually presupposed Lautrec's great composition *The Salon on the rue des Moulins* (see Fig. 18).[145] This theme finds its culminating point in Lautrec's album *Elles*. Munch owned a copy of this album, which he purchased at Vollard's right after it first appeared.[146] These sheets must have greatly affected the Norwegian painter, not only in their theme but through their mastery of technique as well. A comparison of Munch's painting *The Day After* (1886–94; Nasjonalgalleriet, Oslo)[147] with the sheet *Reclining Woman* (Cat. 158) from *Elles* shows how close these two painters were at a time when neither one knew anything about the other. In both instances, a girl is

depicted lying motionless on a bed. It is possible that both pictures are derived from an etching of 1879 by Rops, the *Little Model*.[148]

Thadée and Misia Natanson became acquainted with the dramatist Henrik Ibsen and with Munch's art in 1894 on their sojourn in Norway. In 1895 Natanson published an article on Munch in *La revue blanche*. In the same year Munch's lithograph *The Cry* was reproduced in the journal, and in 1896 an article was published there on Munch's exhibition at the Bing Gallery in Paris by no less a personage than August Strindberg.[149] Munch's lithograph portrait of Strindberg evolved in the same year. Certainly by the time of the appearance of these issues of *La revue blanche* Lautrec must have been aware of Munch.

Like Lautrec and Vuillard, Munch also designed some theater programs for the Théâtre de l'Oeuvre. In the program for Ibsen's *Jean Gabriel Borkman* (Fig. 43) Munch shows the playwright's head in the foreground and a lighthouse in the background radiating beams of light diagonally across the picture. The dominant diagonal line is a compositional element which had earlier been employed by the Japanese and was frequently used by Degas. In 1887 van Gogh and Bernard used the diagonal line in their pictures of bridges in Asnières as a counterformation to the horizontals and verticals in these architectonic structures. Lautrec had also begun relatively early to use them in such works as *Dance at the Moulin de la Galette* (1889; The Art Institute of Chicago). For these three Post-Impressionists the diagonal served to guide the eye toward the central pictorial event. Munch employed this means as early as 1891 in his painting *Rue Lafayette* (Nasjonalgalleriet, Oslo). But in his later work the diagonal led past the primary subject, often right out of the picture, as in *Despair* (1892; Thielska Galleriet, Stockholm), *The Cry* (1893; Nasjonalgalleriet, Oslo), the various versions of *Girls on the Bridge* (1899–1900; best version: Nasjonalgalleriet, Oslo), and the portrait of Friedrich Wilhelm Nietzsche painted in 1906 (Thielska Galleriet, Stockholm). In a variety of changing forms the diagonal also appears in Lautrec's lithographs.[150]

The *Little Model* by Félicien Rops (1833–1898) has already been mentioned. But there are other works by this Belgian graphic artist that also merit consideration for comparison with pictures by Lautrec, for example, *The Examination*, a sheet that depicts a novice prostitute who has undressed and must now demonstrate her charms before the madame and her future colleagues and so prove her vocational aptitude. This is crasser than Lautrec's more intimate renderings, which are not as clear-cut and lascivious as much of Rops's erotica. Very much in demand at the time, most of Rops's erotic works appear somewhat commercial today and seem less the artistic products of a sensitive eye than do Lautrec's works. A link between Rops and Lautrec existed in the person of Gustave Pellet, the publisher of *Elles*, whose son-in-law, Maurice Exsteens, assembled the catalogue of Rops's works. Pellet, who had a profitable business in Rops prints, probably anticipated a similar success with *Elles*. However, he was deceived in this, for the Lautrec album proved to be too artistic for Pellet's more pornographically inclined clientele, and it was still not sold out decades later.[151]

Other artists of Lautrec's time, such as Willette and Steinlen, applied themselves to the borderline areas of frivolous erotica, the portrayal of mores, and social criticism. Léon-Adolphe Willette (1857–1926), whose enormous picture *Parc Domine*—a mediocre piece of decoration which loses itself in an attempt to imitate Chéret—adorned one wall of the Chat Noir cabaret, was no more than an ordinary illustrator and commercial artist. His best works were akin to those of Steinlen or Heinrich Zille, his worst to those of countless fashionable graphic artists who are no longer remembered today. In his otherwise very garrulous autobiography, Willette does not once mention Lautrec, with whom he was personally acquainted.[152]

Théophile-Alexandre Steinlen (1859–1923), in contrast, produced work of a much higher caliber. He also moved through Lautrec's Montmartre milieu around the Chat Noir and with Aristide Bruant, whose journal *Le mirliton* contained his illustrations along with those of Willette and Lautrec. Steinlen is most powerful and suggestive in his social-critical works; for example, the innumerable laundress pictures derivative of Daumier, Degas, and Lautrec (see Fig. 4). The social criticism that was suggested in the works of these artistic models is very much stressed in Steinlen. In general, he continued on a path that began in

Fig. 44. Egon Schiele. *Nude with Violet Stockings*. 1912. Watercolor, brush and ink, pencil, 12⅝ x 18⅝" (32.1 x 47.3 cm). The Museum of Modern Art, New York. Mr. and Mrs. Donald B. Straus Fund

Daumier's caricatures but was less developed in Lautrec's work: the depiction of the proletariat and the petite bourgeoisie.

Certain themes treated by Steinlen were undoubtedly inspired by Lautrec, such as those dealing with the world of the theater, in the broadest sense, and with restaurants and places of entertainment. His color lithograph *The Ball of Bassière*, 1898, and his poster *L'Assommoir* are comparable to Lautrec's *Moulin de la Galette, A la mie* (Fig. 7), and *Elysée Montmartre*. Just as Lautrec captured the *chanteuse* Yvette Guilbert in lithographs and drawings, so did Steinlen in his posters of this artist. A poster of Guilbert planned by Lautrec, however, was never realized.[153] The themes of the brothel and the prostitute were also treated by Steinlen. However, he did not represent the women individually, as did Lautrec, but instead showed them hard at work with their clients or employers (*Prostitute and Procurer*, 1898). Here again, the interest is in the social process. The figure lying on the bed in Steinlen's lithograph *Robbery and Murder* falls within the sphere of Rops's *Little Model*, Munch's *The Day After*, and Lautrec's *Reclining Woman*, although this is not an erotic scene but the depiction of a crime. Steinlen, through the formal and social-

critical components of his art, influenced such subsequent artists as Pablo Picasso, Käthe Kollwitz, Otto Dix, George Grosz, Josef Scharl, and Max Beckmann.

A discussion of European art of the *fin de siècle* can hardly be completed without mention of Art Nouveau. Lautrec had contact with England and Belgium, where this decorative artistic movement was beginning to grow and blossom in the 1890s, knew of the trends and innovations of William Morris,[154] and had personal contact with the ingenious English illustrator Aubrey Beardsley (1872–1898), who lived for a time in Paris, as did Oscar Wilde. There seems to be no bridge connecting the works of Beardsley and Lautrec, at least with respect to form. In the works of the bourgeois Englishman, noble decadence and mannerism prevail; with the nobleman Lautrec, art descends to the level of the common man and his sources of amusement. Beardsley systematized Japanese line/plane compositions, whereas Lautrec always, even in his most stylized posters, retained a personal spontaneous element that saved his work from a boring rigidity. There are, of course, certain thematic points of contact to be found, principally in the depiction of the erotic—although the emphasis is different. Both artists also treated identically titled subjects, as in the Messalina theme or *In the Café*.[155] When Beardsley died, *La revue blanche* published an obituary, which was surely read by Lautrec.[156]

The expressive Austrian Art Nouveau style, known as Jugendstil, with its chief representatives in Gustav Klimt, Schiele, and, to some extent, Oskar Kokoschka, owed much to the frank depiction of mores and eroticism that was imported from France and Belgium. In particular, the nudes of Egon Schiele (1890–1918), considered outrageous at the time, with their mannered, contorted positions (Fig. 44), would scarcely have been imaginable without Rops and Lautrec. Even the sculptor Auguste Rodin may have profited from these trends in his similarly frank late drawings and watercolors.

Lautrec's other principal successors were Picasso (especially in his early work), the Fauves (Georges Rouault, Matisse, and Kees van Dongen), and the German Expressionists (Ernst Ludwig Kirchner and Max Beckmann). In our own time the young generation of expressive painters

(especially the German group known as *Neue Wilde*) shows Lautrec-like aspects in terms of spontaneous technique and a willingness to break those erotic taboos that still exist in our society. Thus, one can see Lautrec's effective influence in today's art as well as in that of the past.

In his brief lifetime Lautrec's influential radicalism was accomplished in silence. It was a radicalism without bluster, self-evident, and indisputable. In his art the apparent contradiction between an artist of reactionary origins and progressive artistic intentions was effectively reconciled. Lautrec expressed the idea when he said: "A thing is never beautiful only because it is new…what is new is seldom what is essential. There is always only one thing that matters: to make something better from what is essential in it."[157]

Translated by Dan and Sonja Cooper

1. See Matthias Arnold, "Toulouse-Lautrec und die alten Meister," *Weltkunst* 1985; Idem., "Das Theater des Lebens: Zur Ikonographie bei Henri de Toulouse-Lautrec," *Weltkunst* 4, 1982, pp. 302–306; Idem., *Henri de Toulouse-Lautrec* (Hamburg, 1982), pp. 89ff.

 In the notes, works by Lautrec not illustrated or listed in the catalogue of the exhibition are designated by the abbreviations D (or P, Ic, M); W (or WP); Del., which refer to the following catalogues raisonnés of Lautrec's work: M. G. Dortu, *Toulouse-Lautrec et son oeuvre*, 6 vols. (New York, 1971); Wolfgang Wittrock, *Toulouse-Lautrec: The Complete Prints* (London, 1985); Loÿs Delteil, *Henri de Toulouse-Lautrec: Le peintre-graveur illustré*, vols. 10, 11 (Paris, 1920).

 For references to the van Gogh correspondence, see *The Complete Letters of Vincent van Gogh* (Greenwich, Conn., 1958).

2. Honoré Balzac, *Contes drolatiques* (1855); Miguel de Cervantes, *Don Quixote* (1863); Jean de La Fontaine, *Fables* (1867).

3. Maurice Joyant, *Henri de Toulouse-Lautrec: Dessins-estampes-affiches* (Paris, 1927), p. 74.

4. Matthias Arnold, "Van Gogh und die Karikatur," *Weltkunst* 10, 1980, p. 1419.

5. Tomáš Vlček, *Honoré Daumier* (Bayreuth, 1981), p. 76.

6. Arsène Alexandre, *Honoré Daumier: L'Homme et l'oeuvre* (Paris, 1888).

7. Gotthard Jedlicka, "Toulouse-Lautrec," *Das Graphische Kabinett 2* (Winterthur), 1924, pp. 15ff.

8. Cf. "Die Frauenbewegung," in *Honoré Daumier 1808–1879: Bildwitz und Zeitkritik* (Münster and Bonn, 1978–79), pp. 166ff.; also *Honoré Daumier: Die Blaustrümpfe und die sozialistischen Frauen* (Berlin, n.d.).

9. Douglas Cooper, *Henri de Toulouse-Lautrec* (Stuttgart, 1955), p. 12.

10. Käthe Kollwitz, *Ich sah die Welt mit liebevollen Blicken* (Hannover, 1968), p. 312.

11. Vlček, *Daumier*, p. 62.

12. Maurice Joyant, *Henri de Toulouse-Lautrec: Peintre* (Paris, 1926), p. 132.

13. Examples of Daumier's theater depictions are *Spectators in the Theater* (1863; National Gallery of Art, Washington, D.C.); *The Drama* (c. 1860; Neue Pinakothek, Munich); *Comedian on the Scene* (1858–62; Musée du Louvre, Paris); *Scapin and Sylvester* (1863–65; Musée du Louvre, Paris).

14. This essay was begun in January 1860 and published in December 1863.

15. Lautrec must have been familiar with the article on Constantin Guys written by Thadée Natanson and published in *La revue blanche 8*, 1895, pp. 377ff.

16. Charles Baudelaire, "Le peintre de la vie moderne," in *Ecrits sur l'art*, vol. 2 (Paris, 1971), p. 155.

17. Ibid., p. 150.

18. Ibid.

19. Ibid., p. 146.

20. Ibid., p. 191.

21. Cf. Jules Vert, "Toulouse-Lautrec et le cheval" (Diss., Lyon, 1959).

22. Both Manet and Lautrec made various trips to Spain and Holland, which had a lasting effect on their art.

23. Cf. Paul Leclercq, *Autor de Toulouse-Lautrec* (Paris, 1921), p. 16; Henri Perruchot, *Manet* (Munich and Esslingen, 1959), p. 344; Nicholas Wadley, *Manet* (Wiesbaden, 1967), p. 33; Henri Perruchot, *Toulouse-Lautrec* (Esslingen, 1958), pp. 296ff. On Manet's *Nana* cf. Werner Hofmann, *Nana: Mythos und Wirklichkeit* (Cologne, 1974); on Manet's Paris themes see Theodore Reff, *Manet and Modern Paris* (Washington, D.C., 1982).

24. Cf. P180, P190.

25. Cf. Manet's *Portrait of Emile Zola* (1867–68; Musée du Louvre, Paris), *Portrait of Theodore Duret* (1868; Petit Palais, Paris), *Portrait of Albert Wolff* (1877; The Solomon R. Guggenheim Museum, New York); and Lautrec's *Cipa Godebski* (1896; Private collection, Paris); *Maxime Dethomas at the Opera Ball* (1896; National Gallery of Art; Washington, D.C.), or *Maurice Joyant as Duck Hunter* (1900; Musée Toulouse-Lautrec, Albi).

26. Cf. P312 or P591.

27. E.g., Manet's *Plum Brandy* (1877; Collection Paul Mellon, Upperville, Virginia) and Lautrec's *At the Bastille* (1888; The Art Institute of Chicago).

28. Denis Rouart, *Manet* (Paris, 1957), p. 12.

29. Götz Adriani and Wolfgang Wittrock, *Toulouse-Lautrec: Das gesamte graphische Werk* (Cologne, 1976), p. 54.

30. Sandra Orienti, *Edouard Manet: Werkverzeichnis*, 2 vols. (Frankfurt and Berlin, 1981), vol. 2, p. 3.

31. Herbert Asmodi, *Toulouse-Lautrec: Moulin Rouge* (Feldafing, 1956) p. 16.

32. Wadley, *Manet*, p. 26.

33. Hugo von Tschudi, *Edouard Manet* (Berlin, 1910), p. 5.

34. Gotthard Jedlicka, *Henri de Toulouse-Lautrec* (Zurich, 1943), p. 42.

35. Wadley, *Manet*, p. 38.

36. Rouart, *Manet*, p. 80.

37. Tschudi, *Manet*, p. 36.

38. Wadley, *Manet*, p. 26.

39. Pierre Cabanne, *Edgar Degas* (Munich, n.d.), pp. 7, 26.

40. Francis Jourdain and Jean Adhémar, *Toulouse-Lautrec* (Paris, [1952]), p. 28.

41. Cf. Degas's *Portrait of Léon Bonnat* (1863; Musée Bonnat, Bayonne).

42. Arnold, *Henri de Toulouse-Lautrec*, p. 19.

43. François Gauzi, *Lautrec et son temps* (Paris, 1954), p. 144.

44. Cabanne, *Degas*, p. 18.

45. Lucien Goldschmidt and Herbert Schimmel, eds., *Henri de Toulouse-Lautrec: Lettres 1871–1901* (Paris, 1972), p. 152.

46. Perruchot, *Toulouse-Lautrec*, p. 164.

47. As had also been the case at one time with Manet, whom Degas had accused of imitating his *café-concert* pictures.

48. Joyant, *Peintre*, p. 123.

49. Adriani and Wittrock, *Toulouse-Lautrec*, p. 54.

50. Perruchot, *Toulouse-Lautrec*, p. 318.

51. Jean Bouret, *Toulouse-Lautrec: Der Mensch und sein Werk* (Gütersloh, [c. 1965]), p. 103.

52. Perruchot, *Toulouse-Lautrec*, p. 217.

53. Jean Bouret, *Degas: Der Mensch und sein Werk* (Gütersloh, [c. 1965]), p. 98.

54. Ibid., p. 99.

55. Manet once said to Mallarmé: "You poets are terrible and it is often impossible to visualize your fantasies." (Wadley, *Manet*, p. 25). Degas said to Goncourt, Zola, and Daudet: "As a painter, I despise you!" (Cabanne, *Degas*, p. 80).

56. There are also two little-known preliminary studies for this work (P714, P715); cf. also Cats. 16–17, 246.

57. A few examples of the compositional use of the neck of the cello or contrabass are: Degas's *On Stage*, two etchings of 1877 [Jean Adhémar and Françoise Cachin, *Degas: Radierungen, Lithographien, Monotypien* (Munich, 1973), nos. 26, 27]; *The Cellist Pillet* (1868–69; Musée du Louvre, Paris); *At the Ballet* (1872; Städelsches Kunstinstitut, Frankfurt). Seurat used the neck of the contrabass in the drawing *Singer in the Café Concert* (Fig. 28) and in the painting *The Cancan* (1889–90, Rijksmuseum Kröller-Müller, Otterlo); Lautrec in his posters *Divan Japonais* (Cats. 260–261) and *Jane Avril* (Cats. 253–254) as well as in the lithograph *Miss Loie Fuller* (Cats. 38–43; Frontis.) After Lautrec this motif was employed by Kees van Dongen in *The Cellist of the Moulin de la Galette* (1905; Private collection, Switzerland).

58. On Marie Dihau see Cabanne, *Degas*, p. 84.

59. *Toulouse-Lautrec* (New York: Knoedler Gallery, 1950), n.p.; cf. also John Russell, *Edouard Vuillard* (Ontario, 1971), p. 102.

60. Joyant, *Peintre*, p. 130.

61. Published by Vollard in 1934 in Paris.

62. Bouret, *Degas*, pp. 187ff.

63. Cabanne, *Degas*, pp. 41, 15.

64. Thadée Natanson, *Un Henri de Toulouse-Lautrec* (Geneva, 1951), p. 71.

65. Cabanne, *Degas*, p. 47.

66. Ibid., p. 28.

67. Joyant, *Peintre*, p. 192. The fact that Lautrec characterized Degas's landscapes as "dreams," just as Degas had done, leads one to conclude that he heard it from Degas or that he had an extraordinary gift of insight.

68. Bouret, *Degas*, p. 213.

69. Ibid., p. 120.

70. Federico Fellini, *Aufsätze und Notizen* (Zurich, 1974), pp. 75ff.

71. Cf. Cabanne, *Degas*, p. 29; also Françoise Daulte, "Plus vrai que nature," *L'Oeil* 70, 1960, pp. 49–55.

72. For example, Degas's *Café-Concert Singer with Glove* (1878, Fogg Art Museum, Cambridge, Mass.) and Lautrec's *Maxime Dethomas at the Opera Ball* (1896; National Gallery of Art, Washington, D.C.).

73. Bouret, *Degas*, p. 126.

74. Ibid., p. 79.

75. Cabanne, *Degas*, p. 79.

76. For Lautrec's visits to Renoir's atelier, cf. Natanson, *Toulouse-Lautrec*, p. 15.

77. Gauzi, *Lautrec*, p. 145.

78. The style of Lautrec's early works of 1886–88, especially, was influenced by Forain. It is unjust that Forain, in whose work there are, admittedly, great fluctuations in quality, is not familiar to a larger audience.

79. Presumably, Lautrec adopted the technique of painting on cardboard with thinned oil paint from Raffaëlli; cf. *Toulouse-Lautrec: Paintings* (Chicago: The Art Institute of Chicago, 1979), p. 229; Joyant, *Dessins*, p. 66; Mark Edo Tralbaut, *Vincent van Gogh in het caf' conc' of het raakpunt met Raffaëlli* (Amsterdam, 1955).

80. Ill. in Dortu, *Toulouse-Lautrec*, vol. 1, nos. Ic144, Ic147, Ic148, Ic150, Ic154.

81. Painting: *Portrait of Toulouse-Lautrec* (1885–86, Private collection, Paris); drawings: Dortu, *Toulouse-Lautrec*, vol. 1, nos. Ic95, Ic96.

82. Color ills. of both paintings in Bogomilia Welsh-Ovcharov, *Vincent van Gogh and the Birth of Cloisonism* (Toronto, 1981), pls. 2, 4.

83. Ibid., p. 254.

84. Ibid., pl. 30.

85. On Anquetin, see John Rewald, *Post-Impressionism: From van Gogh to Gauguin*, 3rd ed. (New York, 1978), pp. 29ff; Hans Hofstätter, *Geschichte der europäischen Jugendstilmalerei* (Cologne, 1977), pp. 78ff; Matthias Arnold, "Vincent van Gogh und seine französischen Freunde: Der Cloisonnismus als Stil 1886–1891," *Weltkunst* 9, 1981, p. 1320.

86. Dortu, *Toulouse-Lautrec*, vol. 1, nos. Ic93, Ic94.

87. Pierre Mornand, *Emile Bernard et ses amis* (Geneva, 1957), p. 57.

88. Ibid., p. 59.

89. Cf. *Emile Bernard* (Bremen: Kunsthalle, 1967), nos. 68, 6 (*In the Cabaret*, 1887); Welsh-Ovcharov, *Vincent van Gogh*, pp. 268ff.

90. *The Brothel* and *The Dance Hall* in J.-B. de la Faille, *The Works of Vincent van Gogh* (Amsterdam, 1970), nos. F478, F547. For Bernard's brothel album see Matthias Arnold, "Eine Mappe mit Zeichnungen Emile Bernards," *Weltkunst* 4, 1985, pp. 330–334.

91. Ills. in Mark Roskill, *Van Gogh, Gauguin, and the Impressionist Circle* (New York, 1970), nos. 70, 71. There are similar drawings and sketches in an extensive album with pasted-in sheets by Bernard from the 1880s and 1890s preserved in the Kunsthalle, Bremen.

92. Gauzi, *Lautrec*, p. 31.

93. Letter 461. Portier was an art dealer with a shop at 54 rue Lepic, at that time the residence of the van Gogh brothers. He also handled some of van Gogh's works.

94. On this work (F381) cf. Welsh-Ovcharov, *Vincent van Gogh*, p. 118.

95. Ibid., F1244a recto, F1244a verso, F1244b recto, F1244c recto, F1244c verso, F1244d verso. Cf. also Matthias Arnold, "Vincent van Gogh als Porträtist seines Bruders Theo," *Weltkunst* 5, 1980, pp. 548ff; Arnold, "Van Gogh und die Karikatur."

96. A part of the van Goghs' collection of Japanese colored woodcuts is still preserved in the van Gogh museum in Amsterdam. Lautrec loved not only Japanese art, but also the painting and drawing implements and clothing of Japan. Cf. also Arnold, *Henri de Toulouse-Lautrec*, p. 95.

97. Theo must have passed these on. It is still possible, in principle, that documents will one day emerge which link van Gogh with Lautrec.

98. Now in the Stedelijk Museum, Amsterdam.

99. Cf. Letter 520.

100. Issues 10 (March 10, 1888) and 27 (July 7, 1888).

101. Naturally, Lautrec's delicate, finely constructed work is overwhelmed by van Gogh's vividly colored and somewhat larger portrait. This was seen very clearly in the exhibition, *Vincent van Gogh and the Birth of Cloisonism*, shown during 1981 at the Art Gallery of Ontario, Toronto, and the Rijksmuseum Vincent van Gogh, Amsterdam, where these works hung side by side for the first time in public (Fig. 25).

102. One of them is P331.

103. "Dubois" and "Pillot" are presumably the result of a misspelling of the hyphenated name of the pointillist painter Albert Dubois-Pillet.

104. Rewald, *Post-Impressionism*, pp. 346–347. Henry de Groux was the son of the painter Charles de Groux, whom van Gogh admired in his early period. In a letter to Vincent dated October 27, 1888, Theo wrote: "In Brussels, I met the son of de Groux, who is also a painter. Unfortunately this was the last evening of my stay so I wasn't able to see his things." (Letter T 3).

105. The picture mentioned is *Ball at the Moulin Rouge* (1890; Collection Henry P. McIlhenny, Philadelphia).

106. *Vincent van Gogh: Sämtliche Briefe*, vol. 6 (Zurich, 1968), pp. 304ff.

107. Ibid., p. 306. The amusement over this incident must have been provoked by Lautrec, who possessed a subtle sense of such situations.

108. Since the two artists met the pallbearer "on the stairs," it is possible that they had just come from or were about to leave for Lautrec's atelier.

109. Possibly, Lautrec's profile portraits (e.g., P320, P353) also had some influence on comparable works of van Gogh from the Auvers period, such as the so-called *Little Arlesienne* (F518), which must be given the date 1890 and not 1888. Perhaps van Gogh also saw *Portrait of Hélène Vary* (1888; Kunsthalle, Bremen) in Lautrec's atelier. This work may have been a model for van Gogh's three portraits of Adeline Ravoux (F768, F769, F786), painted in Auvers in 1890. It is significant that Lautrec's *Portrait of Vincent van Gogh* (Fig. 24) is also a profile.

110. Goldschmidt and Schimmel, *Toulouse-Lautrec: Lettres*, p. 201.

111. Cf. note 57.

112. Cf. Jean Adhémar, *Toulouse-Lautrec: Das graphische Werk* (Vienna and Munich, 1965), p. 9.

113. In the literature on the subject, one occasionally comes across the unsubstantiated claim that Bonnard had already designed his *France-Champagne* poster in 1889. Natanson, quoted in Claude Roger-Marx, *Bonnard Lithographe* (Monte Carlo, 1952), p. 16.

114. Adhémar, *Toulouse-Lautrec*, p. 9.

115. The motif of the dancer riding on the donkey was also used several times by Lautrec, e.g., in the lithograph *A Costume Ball at the Moulin Rouge* (Cat. 62). On the style of the *Moulin Rouge* poster see Hofstätter, *Jugendstilmalerei*, pp. 80ff.

116. Arnold, *Henri de Toulouse-Lautrec*, p. 73.

117. Color ills. in Charles Terrasse, *Bonnard* (Paris, 1927), near p. 68; also *Dessins et Aquarelles de Bonnard* (Paris: Galerie Sapiro, 1975), p. 10.

118. Roger-Marx, *Bonnard Lithographe*, p. 20.

119. Private collection, West Germany. According to the owner, this work dates from 1890. The date is more likely to be 1892–94.

120. On Lautrec's influence on poster art see Hofstätter, *Jugendstilmalerei*, p. 82.

121. Thadée Natanson, *Peints a leur tour* (c. 1948), p. 271.

122. George Besson, *Bonnard* (Paris, n.d.), no. 3. The pictures of 1895–96 can be found in Jean and Henry Dauberville, *Bonnard: Catalogue raisonné de l'oeuvre peint, 1888–1905* (Paris, 1965), nos. 131, 134, 135.

123. Dauberville, *Bonnard*, no. 80, various replicas of 1897: nos. 151, 152, 153.

124. Jules Renard, *Naturgeschichten*. Illustrations by Bonnard (Zurich, 1960).

125. Dauberville, *Bonnard*, nos. 265, 299.

126. On Lautrec's influence on the Nabis see also John Rewald, *Bonnard* (New York, 1948), p. 26. On the *Revue blanche* circle see Evelyn Nattier-Natanson, *Les amitiés de La revue blanche et quelques autres* (Vincennes, 1959); Fritz Hermann and A.B. Jackson, *La revue blanche (1889–1903)* (Paris, 1960); Annette Vaillant, "Les amitiés de La revue blanche," *Catalogue de l'exposition La revue blanche* (Paris, 1966); Fritz Hermann, "Die 'Revue Blanche' und die Nabis" (Diss., Zurich and Munich, 1959).

127. Russell, *Vuillard*, p. 102.

128. Arthur Gold and Robert Fizdale, *Misia* (Bern and Munich, 1981), pp. 70ff.

129. For the drawing see Dortu, *Toulouse-Lautrec*, vol. 1, no. Ic100.

130. Ibid., nos. Ic74, Ic75; both are in the Musée Toulouse-Lautrec, Albi.

131. Gold and Fizdale, *Misia*, p. 86.

132. Russell, *Vuillard*, p. 105.

133. The author wishes to express his thanks to Mrs. Sabine Helms (Munich) for kindly providing access to these and other works.

134. Claude Roger-Marx, *L'Oeuvre gravé de Vuillard* (Monte Carlo, 1948), no. 13.

135. *Edouard Vuillard und die Nabis: Gemälde, Pastelle, Zeichnungen, Druckgraphik* (Bremen, 1983), no. 6; no. 5 shows another early sketch by Vuillard for the Théâtre Libre. For Vuillard's lithograph theater programs, see Roger-Marx, *Vuillard*, nos. 16–25.

136. Private collection, New York.

137. Natanson, *Un Henri de Toulouse-Lautrec*, p. 177.

138. *Vuillard* (Frankfurt: Kunstverein, 1964), ill. 35, cat. no. 92.

139. Cf. also P617, the painted study for this work.

140. When Bonnat received his new appointment he did not invite Lautrec to come along to the Académie (Arnold, *Henri de Toulouse-Lautrec*, p. 21). It is said that Bonnat especially praised Munch's drawings, as he had those of Lautrec some years earlier [Ingrid Langaard, *Edvard Munch: Modningsår* (Oslo, 1960), p. 438]. On Munch and Bonnat see Matthias Arnold, "Drei Winter in Frankreich," in *Edvard Munch* (Hamburg, 1986).

141. Langaard, *Munch*, p. 438.

142. Ibid., p. 161.

143. In 1900 Munch produced a color lithograph on this theme.

144. Color ill. in Ragna Stang, *Edvard Munch: Der Mensch und der Künstler* (Königstein, 1979), ill. 187.

145. Ill. in Gösta Svenaeus, *Edvard Munch: Das Universum der Melancholie* (Lund, 1968), p. 35.

146. Langaard, *Munch*, p. 312; *Graphik: Zeichnungen 4* (Düsseldorf: Kunsthandel W. Wittrock, 1982), no. 99.

147. The first version (1885–86) was burned; a later version (1894) is in Oslo.

148. Maurice Exsteens, *L'Oeuvre grave et lithographie de Félicien Rops* (Paris, 1928), vol. 2, no. 383.

149. Cf. *La revue blanche* 9, 1895, pp. 477ff, 528; *La revue blanche* 10, 1896, pp. 55ff.

150. Cf. Del. 15; Cats. 28–43, 71, 249–250, 253–255, 260–261, 264–265, 268–269, 275–277, 281–284.

151. Information provided by Wolfgang Wittrock, for whose many constructive suggestions and friendly support the author expresses his special thanks.

152. A. Willette, *Feu Pierrot 1857–19…?* (Paris, 1919). Two of Lautrec's graphic works are related to Willette: the poster *La vache enragée*, 1896 (Cat. 294), for the periodical of the same name published by Willette, and the lithograph *Picnic*, 1898 (Cat. 219), in which certain stylistic and thematic peculiarities of Willette's are paraphrased.

153. Cf. Arnold, *Henri de Toulouse-Lautrec*, p. 41.

154. Ibid., p. 122.

155. Cf. two depictions of Messalina by Beardsley; in 1900 Lautrec painted six pictures based on scenes from the opera *Messalina* by Isidore de Lara (P703–708). Beardsley's *The Fat Woman* (1894, The Tate Gallery, London) is comparable in terms of subject to numerous depictions by Lautrec of women in cafés (e.g., P274, P308, P328).

156. *La revue blanche* 16, 1898, pp. 68ff.

157. Jedlicka, *Henri de Toulouse-Lautrec*, p. 82.

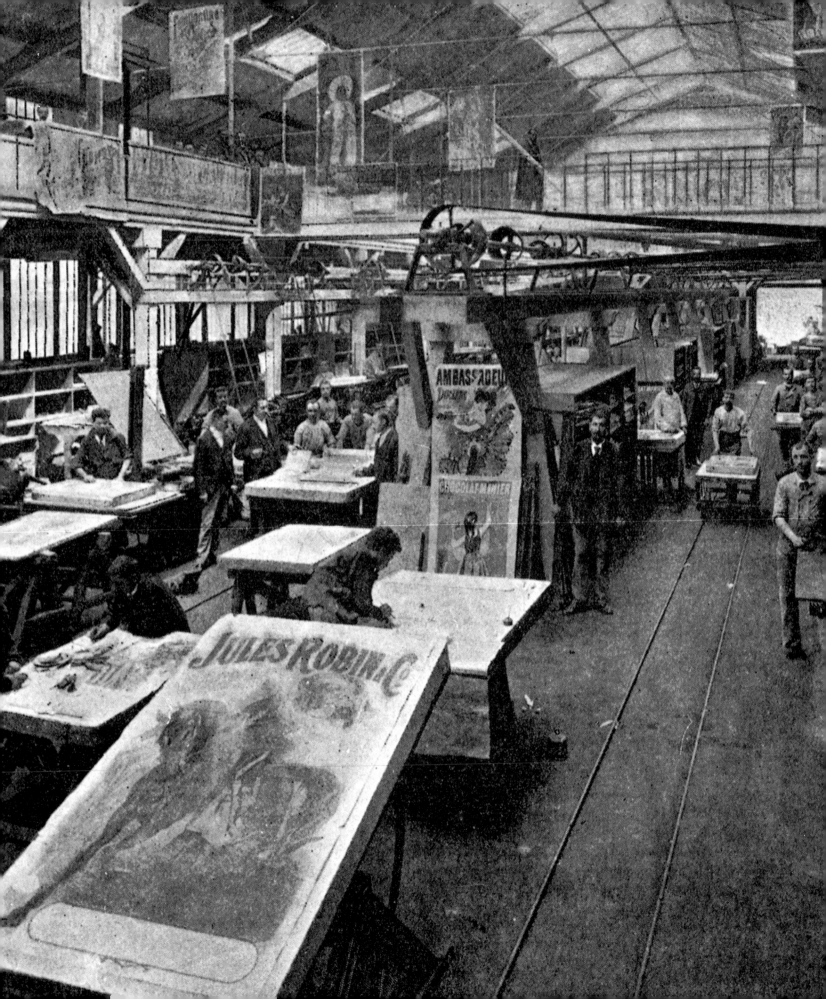

The Popularization of Lautrec

Phillip Dennis Cate

The entrance of Henri de Toulouse-Lautrec in the spring and fall of 1882 into the studio of Léon Bonnat and then into the studio of Fernand Cormon soon established the young artist at the center of the burgeoning bohemian life of Montmartre. His fellow art students, the cabarets and dance halls, and a spirit of independence enticed Lautrec to move, in the summer of 1884, from his father's aristocratic residence at Hôtel Pérey, 5, Cité du Retiro, located off the Faubourg Saint-Honoré and near the place de la Madeleine, to the unpretentious apartment of his friends René and Lily Grenier at 19 bis, rue Fontaine, near the boulevard de Clichy on the southern border of Montmartre. Although the actual distance between the two residences was less than one mile, the sociological and psychological gap was tremendous. The move was a decision that had great significance in Lautrec's life and art. Once ensconced in the artistic community of Montmartre he never left it for long. It meant that he had dissociated himself from the academy and the salon of the Société des Artistes Français, and had taken the route of the independent avant-garde artist.

With the salon—the traditional vehicle for success— closed to Lautrec by his own choice, he, like other young artists of the 1880s, sought visibility by producing illustrations for the new literary and artistic journals that began to proliferate in Paris with the development of inexpensive photomechanical printing processes. Indeed, Lautrec's first publishers were the editors of journals, as his first printed works were photomechanical. The journals of the 1880s that often included the work of young artists were *Le chat noir*, *Le mirliton*, *Figaro illustré*, *Le courrier français*, and *Paris illustré*. Lautrec's first successful attempts as an illustrator were published in 1886 in *Le courrier français* and *Le mirliton*.[1]

Gin Cocktail, a black-and-white illustration, appeared in the September 26, 1886, issue of *Le courrier français* (Fig. 1). On December 29 of that year *Le mirliton* reproduced, as a double-page spread, Lautrec's oil sketch *The Quadrille of the Louis XIII Chair* at the Elysée Montmartre. Both images were reproduced by means of a photorelief printing process, as were his four 1887 cover illustrations for *Le mirliton* and his four drawings of Parisian street scenes used to illustrate Emile Michelet's article "L'Eté à Paris" in the *Paris illustré* issue of July 7, 1888 (Fig. 2).[2] In three of Lautrec's *Paris illustré* works he accommodated his drawing technique to the basic black-and-white contrast requirements of the photorelief printing process by using a *manière noire* approach, working from black to white by scratching away a black background in order to obtain descriptive white masses and lines. The result is that of a roughly cut woodblock print, and indeed, these works are unusual in Lautrec's graphic oeuvre. It was, however, in

Period photograph of the Camis lithographic printing factory, Paris. (From *Les arts et les industries du papier*, Paris 1894)

Gin – Cocktail.

Fig. 1. Henri de Toulouse-Lautrec. *Gin Cocktail.* From *Le courrier français,* September 26, 1886. Collection Mr. and Mrs. Herbert D. Schimmel, New York

three illustrations for *Le mirliton* that he first used color.[3]

Le mirliton began publication in the fall of 1885 under the directorship of Aristide Bruant, the *chansonnier populaire* and owner-manager of the recently established cabaret, the Mirliton. The journal was published irregularly for over ten years and served primarily as a means for disseminating Bruant's songs. Bruant had previously performed at Rodolfe Salis's café, the Chat Noir, where he had gained a reputation and strong following for his abrasive, often insulting, demeanor and his songs of the street people, sung in the argot of the uneducated, the unsavory, and the destitute. Undoubtedly, Lautrec had met Bruant at the Chat Noir where the former was a frequent visitor. The Chat Noir had opened in December 1881 and soon became a favorite meeting place for avant-garde writers and artists, as well as the "in" spot for the upper class and bourgeoisie to vicariously participate in the risqué bohemian life of Montmartre. In January 1882 Salis began publishing the journal *Le chat noir,* a satirical, tongue-in-cheek weekly,

which used the talents of young artists such as Henri Rivière, Léon-Adolphe Willette, Caran d'Ache, and Théophile-Alexandre Steinlen for its witty, often macabre illustrations.[4] In the spring of 1885 the Chat Noir moved from 84, boulevard Rochechouart to larger quarters at 12, rue de Laval (changed in 1887 to rue Victor Massé), and Bruant established his own cabaret and journal at the Chat Noir's old address.

Throughout its existence, the majority of *Le mirliton's* photorelief covers were colored by stencils. Hand-colored illustrations (*pochoirs*) were relatively inexpensive in contrast to printing in color from separate relief plates, a system with which Lautrec was much involved in the 1890s. In both processes the printer, under instructions from the artist, was responsible for making the metallic stencils or plates for each color. *Le mirliton,* with Steinlen as its principal illustrator (Fig. 3), conservatively used from one to three color stencils. Of Lautrec's four cover illustrations of 1887, three are stencil colored. However, unlike the work of Steinlen and others, Lautrec used his limited palette for dramatic compositional purposes rather than solely for local description. For instance, in *Sur le pavé: La dernière goutte* (Fig. 4) the only color added is a bright red for the scarf of the man in the foreground. It is a strong central accent within a simplified composition in which the emphasis is on silhouetted black shapes against a stark white background. In the foreground of *Sur le pavé: Quel âge as-tu, petite?...* (Fig. 5), in which an old man in top hat closely follows and lasciviously eyes a young woman, Lautrec used three colors: blue, yellow, and pink. The color, however, is isolated to the center foreground—on the face and hat of the man and the blouse of the young woman. It serves as an independent element set against a background which is minimally and faintly described by the printed black lines. Finally, in *Le dernier salut* (Fig. 6), a scene depicting a funeral procession, Lautrec again used three colors—purple, yellow, and blue—very economically in the scarf, face, hat, and pants of the man, who is placed dramatically against the frontal plane. Traditional perspective systems are ignored; the background is tilted upward with the black silhouetted figures of the procession running across the white paper as if they were flat figures on a

required the juxtaposition of flat colors and which lent itself to surface decoration rather than painterly realism was to be pertinent to his future work in the medium of color lithography.

The direct relationship of Lautrec's journal illustrations to his early works in color lithography is most apparent in his printed work of 1892. On December 25 Lautrec's illustration *Les redoutes du Casino de Paris—Nouveaux confetti* appeared in *L'Echo de Paris* (Fig. 7), which had only five illustrations in color during 1892. Besides Lautrec's illustration, there were three by Jean-Louis Forain and an anonymous four-color illustration, *Loie Fuller at the Folies-Bergère*. Four stencils were also used in Lautrec's design: pink, yellow, blue, and blue-green. Its decorative two-dimensional quality and its application of color—juxtaposition of flat areas of color—parallel those of his posters and prints of the same year, most specifically, *Reine de joie* (Cats. 249–250) and *The Englishman at the Moulin Rouge* (Cats. 5–11).

Fig. 2. Henri de Toulouse-Lautrec. *The Omnibus Trace Horse (Le côtier des omnibus).* From *Paris illustré,* July 7, 1888. Collection Mr. and Mrs. Herbert D. Schimmel, New York

shadow-play screen. This was Lautrec's most abstract illustration to that date and led directly to the bold and stylistically revolutionary compositional devices of his first color lithographic poster, *Moulin Rouge,* of 1891 (Cats. 247–248).

It is specifically in his illustrations for *Le mirliton* that Lautrec's nascent concern for simplification and functional use of the white paper within the composition first appeared. He explored the photorelief printing process for his own aesthetic experiments. He did not merely produce a drawing for reproduction but, rather, took positive advantage of the limited capabilities of the process by effectively coordinating its three basic elements: the simple black printed line, the white paper, and the stencil colors. This experience with a printing process which, in general,

Fig. 3. Théophile-Alexandre Steinlen. *Ste. Marmite.* Cover for *Le mirliton,* January 15, 1886. Collection Mr. and Mrs. Herbert D. Schimmel, New York

Fig. 4. Henri de Toulouse-Lautrec. *Sur le pavé: La dernière goutte.* Cover for *Le mirliton*, January 1887. Collection Mr. and Mrs. Herbert D. Schimmel, New York

Fig. 5. Henri de Toulouse-Lautrec. *Sur le pavé: Quel âge as-tu, petite?…* Cover for *Le mirliton*, February 1887. Collection Mr. and Mrs. Herbert D. Schimmel, New York

Fig. 6. Henri de Toulouse-Lautrec. *Le dernier salut.* Cover for *Le mirliton*, March 1887. Collection Mr. and Mrs. Herbert D. Schimmel, New York

During the 1890s there were three predominant systems of printing color whether one used a relief process based on photography, a traditional intaglio process such as aquatint, or the planographic process of lithography. First, but not in order of dominance, is a painterly system in which there is a tonal build-up of color by means of superimposing numerous secondary and tertiary colors, sometimes in combination with grays and primary colors. This was most often used commercially for reproducing paintings or watercolors. In Maurias Vachon's *Les arts et les industries du papier en France, 1871–1894*, published in 1894, there is, for instance, an example with nine progressive proofs of a chromotypogravure, a photorelief process, which reproduces with nine tones a watercolor or oil design.[5] Chromotypogravure is a painstaking system of reproduction in which a craftsman must separate the color of the

original design by eye and produce relief zinc plates for each color and tone. The initial plate of the overall design is made photomechanically and is printed in gray to serve as the guide for the production of numerous color plates.

It was not uncommon, however, for artists who sought a degree of realistic representation to use a similarly complex system of superimposition of colors in the creation of lithographs. Alexandre Lunois and Rivière, for example, often built up compositions with numerous colors; the latter used as many as ten. Most of Rivière's lithographs are based on his own highly finished watercolors, and for them this reproductive system was necessary. However, in the end, his best work consisted of prints with a quality of spontaneity rather than facsimile.

A second method of color application is the basic three-color system, first invented in the 1720s by J. C. LeBlon, in

which primary colors are combined to produce intermediate colors. In addition to red, yellow, and blue, black is sometimes incorporated, functioning either as another color or as the outline of the design. This method was also used both commercially and for purely artistic purposes in a variety of printing processes. For instance, Eugène Delâtre, the influential color intaglio printer and son of the great mid-century printer Auguste Delâtre, instructed numerous artists of the 1890s, including Steinlen, Auguste Lepère, and Edgar Chahine. It was a decidedly more economical method of printing color than the painterly system because theoretically it required at the most only four plates to obtain all the colors of the spectrum. Indeed, some of the most colorful and pictorially exciting journals of the 1890s, such as Le rire and Figaro illustré, used the three-color method with the photorelief process. Vachon described this application in his 1894 publication:

The basic drawing of the composition is traced on paper or canvas, in concise lines, in outline, or else in bold, deliberate strokes, intended to form the partitioning and the bed of colors. Photography reduces the drawing, in order to give it more sharpness, and fixes it on the metal plate. From this first plate a proof is pulled, which the artist works into color, following the number of tints which have been settled upon; or sometimes he may abandon himself to his free inspiration and paint the drawing without concern for color printing. In the first instance, the printer's color specialist simply has to transfer to each plate the corresponding color; in the second, he may proceed to an interpretation, made relatively easy by a predetermined use of colors; and he will succeed in rendering, with the almost absolute exactness of a perfect imitation—by fine stippling, by ingenious superimpositions, and by special tricks of the trade—all the subtle nuances and color harmonies of the original work.[6]

Numerous artists, including Steinlen, Félix Vallotton, and Lautrec, were obliged to accommodate themselves to this system of printing as well as adapt the system to their particular aesthetics. Lautrec, in his illustrations for Le rire (Fig. 8), made it work for him better than most artists by taking full advantage of the white paper as an essential compositional element that served to invigorate his designs. His dealer, Edouard Kleinmann, sold signed and numbered color proofs of these illustrations in limited editions just as he often did Steinlen's popular color photorelief illustrations for the journal Gil Blas illustré. This is an indication that Kleinmann saw in these color photorelief prints an art form as valid as that in prints created by traditional mediums.

In 1893 Edouard Duchâtel, master printer for the important lithographic firm of Lemercier, published a treatise on artistic lithography. It was the first treatise on the subject specifically for artists since Godefrey Englemann's work of 1835–40.[7] Its function was to instruct artists on the technical aspects of lithographic printing and to reveal the medium's artistic potential in combination with different papers and inks.

Duchâtel's instructions for creating a color lithograph after a watercolor design are to use four stones, one for each of the three primary colors, and an additional stone for black. The order of printing is yellow, red, blue, and black. This is precisely the procedure used by Lautrec for his first lithographic work, the 1891 poster Moulin Rouge (Cats. 247–248). However, when he overlapped colors such as red and blue to make purple, it was not for the purpose of modeling but, rather, to create broad areas of one color, so that the overall result is a rhythmic pattern of flat colors.

After this first experience with lithography, it became obvious to Lautrec that the three-color method, although in general very practical, was a roundabout way of producing the decorative and exotic color effects that were evolving in his art. At the Moulin Rouge, La Goulue and Her Sister and The Englishman at the Moulin Rouge, both of 1892, Lautrec's first and second lithographs (Cats. 2–3, 5–11) are dramatically different in the creation and application of color from that of his 1891 poster. In these two works and in all future lithographs and posters he rejected the three-color system and proceeded in a much more intuitive manner by juxtaposing, rather than superimposing, a number of solid colors. This became the third and the dominant method of applying lithographic colors in the 1890s.

In *At the Moulin Rouge, La Goulue and Her Sister* there are six colors, one and one half times the number in his first poster. The color proofs of the print at the Bibliothèque Nationale reveal that the final sequence of printing the six stones was olive-green, blue, light green, red, yellow, and salmon-beige. The initial key stone used to produce each subsequent color had been mostly erased in the final printing; olive-green no longer served as the compositional outline but instead was a separate juxtaposed color defining, for instance, the dress and blouse of the sister. In *The Englishman at the Moulin Rouge* Lautrec utilized six colors: olive-green, purple, blue, red, yellow, and black. Unlike that used in Lautrec's 1891 poster, the dominant purple of the print is a premixed ink printed from the stone, as are all his secondary colors, and is not produced by the overlapping of the red and blue stones. As in the photoprinting processes, the artist rarely involved himself in the mechanical act of printing lithographs. Rather, after Lautrec, in this case, drew the image upon the lithographic stones (normally one stone per color) a printer would pull proofs of the print from the press for the artist to correct or approve. Once the proofs were acceptable to the artist the printer would print the full edition. In Lautrec's cover design for *L'Estampe originale*, of 1893 (Cats. 14–15), Le Père Cotelle, master printer for the shop of Edouard Ancourt, is depicted at the lithographic press pulling proofs of a print for the performer Jane Avril.

Lautrec's genius as a printmaker was his ability to control and adapt printmaking techniques for his unique aesthetic goals. Technical conventions had little sway over his use of a particular medium. For instance, in 1898 as he was completing the *Yvette Guilbert* lithographic album (Cats. 212–216) for Bliss, Sands & Co., the British printer, he wrote to W. H. B. Sands and inquired: "As for the cover, how do you want it? In lithography or by the same process as that for the nursery toy book." The nursery book referred to is *The Motograph Moving Picture Book*, of 1898 (Fig. 9), and the process was color photorelief after a drawing by Lautrec specifically commissioned for the cover.[8] It was agreed that the cover of the *Yvette Guilbert* album be done in lithography. Although this was the medium in which Lautrec was most prolific and which he appears to have preferred, it did not diminish in his eyes the status of the photomechanical processes to which he lent his great talents on numerous occasions throughout his brief career and which, indeed, were so fundamental to his artistic development.

By the spring of 1892 it was not only in journals or in the streets that one could view the printed work of Lautrec. In Paris the poster *Moulin Rouge* was exhibited at the eighth Salon des Indépendants, while in Antwerp that and *Reine de joie* were exhibited along with their progressive proofs. That summer, for the first time, Lautrec's posters were available for purchase in the small shop of Edmond Sagot at 18, rue Guénégaud on the left bank. Sagot was the first dealer in Paris to champion the relatively new art of poster-making. As early as 1886 his sale catalogues included posters and emphasized the work of Jules Chéret. In catalogue number 33, of July 1892, Sagot lists (entry 5503) the two most recent productions by Lautrec, *Ambassadeurs: Aristide Bruant* and *Reine de joie* (Cats. 249–250), for sale at 3 and 4 francs, respectively. The dealer annotated this entry with the following words of praise: "These two posters are of an exceptional originality in terms of both drawing and color; this is the only artist, besides Chéret, who is truly personal."[9] By the end of that year Sagot was actively seeking work by Lautrec to include in his catalogues. His desiderata listing for the December 1892 catalogue (number 35) included requests for prints and posters by Félicien Rops, Willette, Chéret, Forain, Henri Fantin-Latour, drawings from the journal *Le chat noir*, and especially posters by Henri-Gabriel Ibels; in addition, Lautrec's drawings, lithographs, and the *Moulin Rouge* poster, in particular, were sought. Throughout the decade Sagot included the work of Lautrec among his vast inventory of prints and posters by established and avant-garde artists.

Sagot was astute in appreciating the artistic activity in printmaking of the 1880s and 1890s. As soon as new graphic works came upon the scene, his catalogues listed them. For instance, his June–July catalogue, of 1893, included Lautrec's posters *Jane Avril* and *Divan Japonais* (Cats. 253–254, 260–261), while his December catalogue (number 39, entry 1797) paid homage to the first-year installment of André Marty's important publication

L'Estampe originale: "L'Estampe originale is destined to assume first place among our published selections of modern printmaking." Sagot was virtually the father of modern print dealers. Yet as Lautrec's reputation grew, other dealers followed, many of whom had an even greater effect upon his career.

Maurice Joyant, Lautrec's boyhood and lifetime friend, had a direct role in the publication of the artist's work and its initial exposure to the public. He had replaced Theo van Gogh in 1890 as the director of the Boussod and Valadon gallery at 18, boulevard Montmartre. By the end of 1893 Joyant had become a full partner in the gallery, whose name was changed to Boussod, Manzi, and Joyant. Jean Adhémar stated that Lautrec's *The Englishman at the Moulin Rouge,* of 1892, had been printed by Ancourt for Boussod. Joyant presented an exhibition of work by Lautrec and Charles Maurin at the gallery from January 30 to February 11, 1893. While it was not the first exhibition in Paris to include Lautrec's posters, it was the first instance in which his works were critically reviewed, and they were done so jubilantly by Thadée Natanson in the February issue of *La revue blanche:*

> The posters that have burst forth upon the walls of Paris recently, or are still adorning them, have surprised, disturbed, and delighted us. The black crowd teeming around the dancer, with her skirts tucked up, and her astonishing partner in the foreground, and the masterful portrait of Aristide Bruant, are equally unforgettable. But it is the last one especially, that makes one thrill: the delicious *Reine de joie,* bright, pretty, and exquisitely perverse....One's eyes delightedly moved, stop in vain at the shop window; in the joyous, carefree coloring of a Chéret, they earnestly seek to rediscover in their troubling memories the exquisite emotion of art that the disquieting intentions of M. Toulouse-Lautrec have made almost painful.[10]

Boussod and Valadon were also the directors of the journal *Figaro illustré,* which in July 1893 published Gustave Geffroy's article, "Le plaisir à Paris: Les restaurants et les cafés-concerts des Champs Elysées."[11] The article

Fig. 7. Henri de Toulouse-Lautrec. *Les redoutes du Casino de Paris—Nouveaux confetti.* From *L'Echo de Paris,* December 25, 1892. Collection Mr. and Mrs. Herbert D. Schimmel, New York

Fig. 8. Henri de Toulouse-Lautrec. *Skating—Professional Beauty.* From *Le rire,* January 11, 1896. Collection Mr. and Mrs. Herbert D. Schimmel, New York

THE MOTOGRAPA
MOVING PICTURE
BOOK

Cover Design by H. de TOULOUSE LAUTREC

LONDON — BLISS, SANDS & CO.

Fig. 9. Henri de Toulouse-Lautrec. Cover for *The Motograph Moving Picture Book*, 1898. Collection Mr. and Mrs. Herbert D. Schimmel, New York

Kleinmann was Lautrec's first official dealer; he not only showed the artist's work at his shop on the right bank at 8, rue de la Victoire but published it as well. Kleinmann's advertisement in the November 15, 1893, special poster issue of *La plume* placed Lautrec with the following artists: Henri Boutet, Steinlen, Ibels, Willette, Forain, Henry Somm, and Chéret. By the spring of 1894 Louis Anquetin, Georges Defeure, Eugène Grasset, Maximillian Luce, Maurin, and Vallotton were represented by Kleinmann. Thirty black-and-white lithographs by Lautrec of performers such as May Belfort and Marcelle Lender were published or distributed by Kleinmann. The dealer also made it a practice, as previously stated, to make available to the public limited editions of color proofs of illustrations for the journal *Le rire* on special paper embossed with Kleinmann's distinctive circular chop.

Both the *café-concert* album and the *Yvette Guilbert* book were published by Marty. From March 1893 to early 1895 Marty, director of *Le journal des arts*, published a series of quarterly albums entitled *L'Estampe originale*. The albums comprised a total of ninety-five prints by twenty-four artists. Marty sought to publish prints by members of the young avant-garde, which included all the Nabis as well as independent artists such as Lautrec. In addition, the albums represented more established yet nonacademic artists such as Pierre Puvis de Chavannes, Odilon Redon, Paul Gauguin, Chéret, and James McNeill Whistler. Lautrec's three prominent contributions to *L'Estampe originale* were the cover for the album of 1893 (Cats. 14–15), *At the Ambassadeurs—Café-Concert Singer*, of 1894 (Cats. 73–79), and the cover for the final album of *L'Estampe originale*, of March 1895 (Cat. 99). Marty also published Lautrec's 1893 color lithograph *Miss Loie Fuller* (Cats. 38–43) and included the artist's *Supper in London* (Cat. 162) in the first installment of *L'Estampe originale*'s 1896 publication *Etudes de Femmes*.[12]

Ibels, an early member of the Nabis, had studied at the Académie Julian along with Pierre Bonnard, Edouard Vuillard, Maurice Denis, and Paul Sérusier; he was also included, along with Lautrec, in La Barc de Boutteville's exhibition, *Impressionist and Symbolist Painters*, in the winter of 1891. When and how the two artists met is not

was accompanied by seven color illustrations photomechanically reproduced after designs specifically created for it by Lautrec. Concurrent with the article was Marty's publication of *The Café Concert*, a series of twenty-two black-and-white lithographs by Lautrec and Ibels (Cats. 44–54). Geffroy collaborated again with Lautrec in 1894 by writing the introduction text of a book on *Yvette Guilbert*, illustrated with seventeen lithographs (Cats. 84–87, 90, 92); in 1895 Lautrec illustrated two more articles in *Figaro illustré* written by Romain Coolus.

Dealers who sold and also published work by Lautrec during the 1890s were Kleinmann, Gustave Pellet, A. Arnould, and Ambroise Vollard. Other important publishers of his work were Marty and *L'Estampe originale*; Georges Ondet, publisher of music sheets; Alexandre Natanson and *La revue blanche*; André Antoine and the Théâtre Libre; Aurélien-François Lugné-Poë and the Théâtre de l'Oeuvre; Léon Deschamps and *La plume*; and Sands, of Bliss, Sands & Co.

known, yet there was ample opportunity from 1888 on because of their mutual acquaintances. Ibels was a consistent link between Lautrec and many of the latter's early commissions. Henri Perruchot stated that it was Ibels who had introduced Lautrec to Georges Ondet, the publisher of sheet music who, under Ibels's influence, commissioned younger artists to illustrate sheet-music covers with lithographic designs.[13] Ondet published songs and music by Désiré Dihau, Maurice Donnay, and others, which were first performed at the Chat Noir.

In 1893 Lautrec created lithographic designs for Ondet's song sheets *The Little Erand-Girl* (Cat. 33) and *Sick Carnot!* (Cat. 30) as well as for the cover and five poems for *The Old Stories* (Cat. 18), also published by Ondet. It was Ibels, along with Henri Rachou, who illustrated the other poems in this volume by Goudezki (Jean Goudey). Throughout the 1890s Lautrec illustrated the sheet music for a number of other publishers such as Paul Dupont (Fig. 10) and Bosc; the composer Désiré Dihau had fourteen of his works illustrated by Lautrec and published by C. Joubert in 1895 (Cats. 120–125). However, in 1900 Lautrec's last lithograph for the sheet-music business was once again published by Ondet. Also in 1893 Lautrec collaborated with Ibels on the series *The Café Concert*, and they both also produced work for the Théâtre Libre and the journal *L'Escarmouche*.

In the spring of 1887 André Antoine opened the Théâtre Libre in Montmartre. This experimental theater—which introduced realism to the French stage with productions by Emile Zola, Henrik Ibsen, and August Strindberg—used the talents of radical young artists to illustrate its programs. Thirty-five programs in black-and-white and in color were issued by the theater during its nine years of existence. From 1888 to 1894, the theater's most active and influential period, programs by Willette, Paul Signac, Vuillard, Ibels, Alexandre Charpentier, Georges Auriol, Rivière, and Lautrec were commissioned. The 1892–93 season was dominated by a series of eight color lithographs by Ibels. In reference to this series Antoine remarked: "I have succeeded in continuing a series of programs which will be unique.... I have even had the pleasure of furnishing a newcomer with an opportunity to show himself in an original way by setting aside eight programs for H.-G. Ibels

last year."[14] During Antoine's final years as director of the Théâtre Libre, Lautrec designed three color lithographic programs (Cats. 34–37, 100).

By 1893, realism had run its course as a movement in the theater. In its place symbolism began to emerge, with Lugné-Poë continuing Antoine's practice of commissioning young artists to illustrate programs. Most of the programs for the Théâtre de l'Oeuvre were produced by members of the Nabis. Lautrec again revealed his theatrical involvement with designs for such plays as *Le Chariot de Terre Cuite* (Cat. 96), by Victor Barrucand, and the combined program for *Raphaël*, by Romain Coolus, and *Salomé*, by Oscar Wilde (Cat. 130). While not all commissioned by these theaters, a number of other lithographs by Lautrec deal with particular personalities, such as Antoine, and with performances of Antoine's Théâtre Libre and Lugné-Poë's Théâtre de l'Oeuvre (Cat. 195). These works reflect once more his intense attraction to the theater, which in a nominal way supported his career.

In November 1893 the writer Georges Darien, in collaboration with the Nabis Anquetin, Bonnard, and Ibels, founded the short-lived weekly *L'Escarmouche*. Although there were only ten issues, Lautrec produced for the journal twelve lithographs of theater and *café-concert* related themes.

As we have seen, the works of the Nabis were often exhibited and published with those of Lautrec. *La revue blanche* was a staunch advocate and supporter of the Nabis and of Lautrec. From July 1893 through December 1894 the journal published one print each month by one of the following: Vuillard, Charles Cottet, Ker-Xavier Roussel, Denis, Paul Ranson, Bonnard, Vallotton, Redon, Ibels, Lautrec (Cat. 80), Sérusier, and Joszef Rippl-Ronai. This culminated at the end of 1894 with a selection of these twelve prints published together as the *Album de La revue blanche*. In 1894 and 1895, Bonnard and Lautrec, respectively, each created a poster (Cats. 272–273) for the journal. In addition, *La revue blanche* published, along with works by other artists, Lautrec's prints of Anna Held and May Belfort; while *NIB*, the journal's supplement which appeared three times, was illustrated by Vallotton, Bonnard, and Lautrec (Cats. 93–94).[15]

Equal to *La revue blanche* in its support and concern for the young avant-garde was *La plume*.[16] The latter was founded in April 1889 by Léon Deschamps, a young poet and writer. His goal was to create an independent review that was not aligned with any one school of literature, philosophy, or art. By 1893 the journal began to emphasize the visual arts as strongly as the literary arts. Its first special issue for an individual artist was that of January 15, 1893; it was dedicated to Ibels. The November 15 issue of that year dealt exclusively with the art of French posters; among the artists applauded were Ibels and Lautrec. In February 1894 *La plume* initiated its Salon des Cent, an important series of monthly exhibitions which continued throughout the remainder of the decade. Ibels was chosen to produce the inaugural poster. A year and a half later Lautrec was given a similar honor. He designed the poster (Cats. 281–284) for *La plume's* six-month long (October 1895–March 1896) changing exhibition of international posters at the journal's gallery at 31, rue Bonaparte. In October the twenty subscribers to the deluxe edition of *La plume* received the first state of Lautrec's poster as a premium. During the last month of the exhibition, which in reality was the twentieth Salon des Cent, Lautrec exhibited his *Elles* series for the first time (Cats. 139–145, 147–158). To promote the series, Lautrec converted its title page into a poster announcing the display of *Elles* at *La plume* (Cats. 141–142). It was also in 1895 that *La plume* published Lautrec's *Chap Book* (Cats. 278–279) poster; printed in its margin is the journal's distinctive identification: "Affiches Artistique de LA PLUME."

While there are a number of interconnecting personalities related to Lautrec's entire career, it is apparent that the early careers of Ibels and Lautrec have significant parallels, which suggests that the former was instrumental and indeed influential in many of Lautrec's commissions during the first half of the 1890s. While in the twentieth century Lautrec's reputation has certainly overshadowed that of Ibels, Steinlen, and Chéret, it is important to note that during the 1890s these artists were, in general, better known than Lautrec, and their work was more fully appreciated and commercially more viable than that of Lautrec.

Until 1900 Lautrec continued to produce posters and prints for a variety of commercial and literary enterprises. A more detailed description of the process of accomplishing these works can be seen with reference to two projects, in particular, for which there exists a collection of correspondence between Lautrec and one of his publishers. This group of forty-seven letters, recently the subject of a monograph, documents in detail the collaboration between Lautrec and the British publisher Sands in the creation of the 1898 *Yvette Guilbert* album (Cats. 212–216) and the series *Portraits of Actors & Actresses—Thirteen Lithographs by H. de Toulouse-Lautrec* (Cats. 198–210). There are numerous revelations derived from these letters which reattribute the identity of a number of the actors and actresses depicted. Most revealing, however, is the fact that the correspondence sheds some light upon the working relationship between Lautrec and Sands and upon the creative process of the former.[17]

The Sands and Lautrec correspondence also imparts information dealing with the economic factors involved in producing the two lithographic albums. The cost factors for these albums are relevant, as well, to the basic production of black-and-white lithographic prints in the 1890s and, therefore, are worth discussing in detail.

The January 1899 issue of Sands's journal *The Paris Magazine*, published in London and Paris, included an ad for the *Yvette Guilbert* album with the following description: "Nine Original Drawings by H. de Toulouse-Lautrec. Printed on the Choisest Hand-made Paper. Text by Arthur Byl. Translated by A. Teixeira De Mattos. Colombier 4to, handsomely bound, with cover design by the artist, satin clasps. Only 350 copies of this edition have been printed. Price 25f. net."[18]

Lautrec's fee from Sands was 100 francs per drawing; the letters confirm payment for the eight primary images but not for the frontispiece or the cover. Byl's fee was 100 francs. Assuming that Lautrec eventually received another 200 francs for his cover and frontispiece designs, the cost for the creation of the drawings and text was 1,000 francs.

Lautrec's printer, Henry Stern, billed Sands 64 francs, 70 centimes for his work, as itemized below:

Fig. 10. Period photograph of the Paul Dupont printing factory, Paris, showing rotary presses used to print color lithographic posters from stones. (From *Les arts et les industries du papier*, Paris 1894)

proofs and preparation of eight stones	40.00
value of the eight stones at 2 francs, 40 centimes	19.20
first packing case	3.90
second packing case	1.60
	64.70

In January 1898, while discussing the series *Portraits of Actors & Actresses*, Lautrec had informed Sands that to print three hundred copies of a lithograph like *Polaire* (Cat. 197) would "cost 33 francs, not including paper." At this rate one may calculate that in an edition of 250 it would cost approximately 38 francs, 50 centimes for each of the ten images which comprise the entire album, for a total of 385 francs. Therefore, the basic cost for the full edition of the *Yvette Guilbert* album, if it had been printed in France (it was printed in London) would have been about 1,450 francs. The paper and the fee to the translator was, of course, additional. If one were to, at least, double the figure of 1,450 francs for deluxe packaging and promotion of the album, an estimate of 8 francs for the total cost of each

album appears legitimate. In relation to the selling price of 25 francs, an 8-franc cost factor agrees with Sands's general three-to-one profit margin, which he outlined for Lautrec in a letter of March 1, 1898.

Sagot's sale catalogues of the 1890s as well as the price listings in *La plume* serve as the most accessible sources for the market value of prints and posters. In addition, advertisements in *La revue blanche* and other art and literary publications such as *Le centaure* offer additional price information.[19] Yet in most cases information on posters dominates that available on prints. It was not until 1897 when André Mellerio inaugurated his important journal, *L'Estampe et l'affiche*, that a regular listing of current prices and edition sizes became available for prints and posters. By referring to these sources, one may more readily evaluate Lautrec's position relative to the Paris art market. There are a number of variables—paper quality, remarques, edition size—which make exact comparisons difficult, but in 1899, one year after Sands published *Yvette Guilbert*, Redon's *L'Apocalypse*, a series of twelve lithographs (edition of 100), sold for 125 francs, as did a suite of six lithographs (edition of 100) by Fantin-Latour.

Black-and-white lithography was obviously much less expensive to produce than color lithography. Pellet's relationship with Lautrec began in 1896 with the publication of *Elles*. Located at 9, quai Voltaire, he published not only Lautrec's work in color but also that by Signac, Luce, and Lunois.[20] It was Lunois, however, the most conservative artist of the lot, who fetched the highest prices for color lithographs. His six-color *Quieto ou les derniers moments de taureau*, of 1897, sold for 60 francs with, and 50 francs without, remarque (*L'Estampe et l'affiche*, March 1897, p. 56). The top price for any of Lautrec's three six-color lithographs announced in 1897 issues of *L'Estampe et l'affiche* is 50 francs. The real discrepancy between the artists' work becomes evident when one compares edition sizes. *The Clowness at the Moulin Rouge* (Cat. 170) and *The Dance at the Moulin Rouge* (Cat. 180) are both in editions of twenty, while *Princely Idyll* (Cat. 171) is in an edition of sixteen. The edition size of Lunois's *Quieto* is one hundred, five times as large as those by Lautrec while the price is the same.

Twenty-five proofs of Lunois's *Quieto* were set aside to be included in his *La corrida* series of eight bullfight subjects. Therefore, only seventy-five of the edition were available as single prints. With this in mind, one final calculation may help to indicate the relative marketability of Lautrec's color lithographs as compared to some of those of his contemporaries. The maximum gross income that Lunois and Lautrec could expect from a print of the same number of colors and approximate size is: Lunois, 4,000 francs, Lautrec, 1,000 francs. Pellet, probably realizing that Lautrec's prints were rather small, limited the edition size. He also may have known that even with such a small edition Lautrec's market could not bear a price higher than that established by Lunois.[21]

Pellet, like the critic Mellerio, was ahead of the market in his appreciation of the work of Lautrec, and each promoted him in his own way. Yet they also saw the validity in the work of the popular Lunois. Mellerio discussed the merits of both artists in his 1898 book *La lithographie originale en couleurs*:

Toulouse-Lautrec demands to be considered first. He has contributed in a powerful way to the creation of original color lithography, both from the point of view of conception and of craftsmanship. His personal taste and circumstances have pushed him to create numerous works.... Toulouse-Lautrec is certainly gifted for prints —we think especially for prints.

We even prefer his prints to his painting, in which he doesn't seem as much at ease, in a medium which is more elaborate, less direct. His remarkable inspiration and procedures, his knowledge that was slowly forged by a training which he evolved himself, have rightly given him a starring role in original color lithography.

Lunois is a practitioner who really knows the stone. Formerly he made reproductions, but he has since, by his numerous and varied works earned himself an important place in original prints—particularly in color lithography.... Lunois's conscientious work, his technical knowledge, and his recent progress point to him as capable of exercising a strong influence on the color

lithography movement, even more so because he produces so much.[22]

Color lithographic posters were far less expensive than prints. For instance, in 1894 Lautrec's *Moulin Rouge* (Cats. 247–248) sold for 15 francs while one could buy his smaller *Divan Japonais* (Cats. 260–261) for 2 francs or 3 francs, 50 centimes, mounted on linen. The primary function of a poster, of course, is to sell a product; the more available and visible, the better the promotion. So not only was it counterproductive to place a high price on posters, it was also unnecessary. Posters were printed in large quantities of one, two, three thousand, or even more. Therefore, the unit production cost was quite low. These costs are detailed in Amadée Meunier's 1898 book *Traité de lithographie*.[23] Below is Meunier's guide to poster formats and the tax for each:[24]

¼ colombier	15½ x 12"	1¢	[6 centimes]
½ colombier	23½ x 15½"	2½¢	[12 centimes]
jesus	27 x 25"	3½¢	[18 centimes]
colombier	23½ x 31"	3½¢	[18 centimes]
grand aigle	44 x 27"	5¢	[24 centimes]
double colombier	49 x 33"	5¢	[24 centimes]
double grand aigle	55 x 44"	5¢	[24 centimes]
quadruple colombier	67 x 49"	5¢	[24 centimes]
quadruple grand aigle	88 x 55"	5¢	[24 centimes]
triple colombier	33 x 67"	5¢	[24 centimes]

The sizes most often used were the double and quadruple colombier. For instance, *Reine de joie, Babylone d'Allemagne*, and *Eldorado: Aristide Bruant* (Cats. 249–251, 262–263) each fit within the dimensions of the double colombier, while *Moulin Rouge* (without the added strip at the top) fits within the quadruple; *Divan Japonais* is simply a colombier. Although there were a number of exceptions, in most cases a tax was charged and a tax stamp was physically placed upon a poster hung outdoors if it included the address of the fabricator of the product.

The cost factors involved in the production of a typical double colombier poster such as *Reine de joie* were as follows: for an *affiche artistique* the artist fee, paper, and press work for one thousand copies was 1,000 francs; for the second thousand copies, add 300 francs for press work, and for each additional thousand copies add another 250 francs.[25] In addition, a tax of 24 centimes (1898) was levied on each poster, and a 15-centime fee for actually pasting it to a wall was charged as well. Therefore, the cost per copy of *Reine de joie* was most likely: 1.39 francs if printed in an edition of one thousand; 1.04 francs if printed in an edition of two thousand; .91 francs if printed in an edition of three thousand. The cost per copy of *Moulin Rouge* was most likely: 2.42 francs, 1.67 francs, and 1.42 francs, respectively.

It is obvious by the number of posters that still exist today that all posters were not glued to walls and thus destroyed. Some were sold directly to art dealers and collectors.[26] As may be seen in the well-known photograph of Lautrec in front of Chéret's *Ball at the Moulin Rouge*, posters were also displayed inside framed glass cases owned by particular companies; in this situation there were additional monthly rental charges but no posting charge.

Poster mania was rampant among collectors in the late 1880s and 1890s.[27] The price of a poster was affected by its rarity, as with Grasset's *Librarie romantique*, of 1887, considered by Sagot in 1894 to be "très rare" and thus valued at 20 francs, or affected by its uniqueness as was Lautrec's *The Hanged Man* (Cat. 270), which Sagot listed in the same catalogue at 25 francs and stated: "Center of poster, without any lettering; veritable print. This is the artist's first poster; it is extremely rare." Proofs before the addition of letters were also at a premium. Lautrec's *La revue blanche* with letters was 2 francs, 50 centimes, and before letters 5 francs, but when it was one of twenty-five proofs without letters, with a remarque, signed and numbered, its price rose to 10 francs. This also occurred with *May Belfort* (Cats. 268–269), in which the special twenty-five proofs included a remarque of a "cat with a ruff and a monocle."

During the last two decades of the nineteenth century and the first decade of the twentieth century, the franc remained stable in relation to other monetary units. From 1884 to 1910 the Baedeker guidebooks to Paris consistently valued one franc at 20 United States cents, 9¾ British pence, and 80 German pfennigs. Indeed, inflation was not a

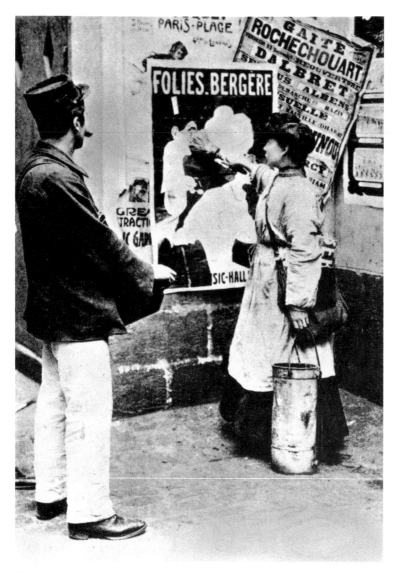

Fig. 11. The first woman bill poster in Paris

about 1894, were able to rent for 800 francs a year, or 160 dollars, an apartment/studio on the left bank off the rue St. André-des-Arts. It cost them 150 francs to furnish it; one student was even able to fill his room with posters by Chéret, Alphonse Mucha, and Steinlen![28] Although Lautrec was not the typical bohemian artist, he did live within a relatively stringent budget. His monthly expenses for the first half of 1893, excluding rent, averaged about 250 francs, or about 50 dollars. In 1894 he rented a new apartment in Montmartre at 27, rue Coulaincourt for 800 francs a year, hired a live-in maid for 40 francs a month, and, in addition, had a studio which he rented across the way at 7, rue Tourlaque.

Salaries, of course, varied greatly; a sample gives some extent of the extremes in *fin-de-siècle* Paris: Yvette Guilbert at the peak of her career received 21,000 francs a month while she performed at the Scala; a lead actor at the Théâtre du Montparnasse earned 100 francs weekly; models for students at the Ecole des Beaux-Arts were paid 30 francs a week whether they were children or adults; while a seamstress received 2 to 2 francs, 50 centimes for a twelve-hour work day.

The humorous journal *Le rire* was 15 centimes. The Chat Noir advertised lunch at 2 francs, 50 centimes and dinner at 3 francs. Admission to the Salon des Cent was one franc, the same as that for the official salons of the Société des Artistes Français and Société Nationale des Beaux-Arts. However, the entrance for varnishing day at the last two exhibitions was 10 francs. The price of a poster was equivalent to an evening of bourgeois entertainment. For an average price of 3 to 5 francs, one could enjoy the *cafés concerts*. While there was no admission fee to these nightspots, drinks were required at premium prices of 75 centimes to 5 francs. For 3 francs, 50 centimes one could attend the Nouveau Cirque, the Cirque Fernando, or indulge in the risqué atmosphere of the Moulin Rouge and the Folies-Bergère.

Those who purchased 50-franc color lithographs could also afford to attend masked balls during Lent at the Opéra from midnight until dawn at a charge of 20 francs for men, 10 francs for women. The best seat at the Opéra was the loge at 17 francs; less desirable seats were available at 2 francs.

problem in France during the 1890s; this is confirmed by the fact that basic prices for restaurants, taxis, and entertainment remained static from the beginning of the decade to the end of the century.

In order to place in perspective the relative monetary value of prints and posters at the end of the century and, therefore, the extent of their accessibility to the general public, it is worthwhile to investigate some aspects of the daily cost of living in Paris for different levels of society. Two young American artists, chronicled in *Bohemian Paris of To-day*, living for four years in Paris beginning

Seats at other legitimate theaters such as the Théâtre Français, Opéra Comique, Odéon, and Théâtre de la Renaissance ranged from 10 to 12 francs and 2 to 3 francs.

If, however, one were very poor, one did not buy posters, much less prints, nor frequent *cafés concerts*, nor climb the Eiffel Tower. Instead, humble workers such as those depicted by Steinlen spent Sunday evenings in Montmartre dancing at the Moulin de la Galette, for which the admission was 50 centimes for men, 25 centimes for women. Yet, as noted previously, even these people were not deprived of an opportunity to view Lautrec's art. The posters by Lautrec and fellow artists of the period were, as critics wrote, the "frescoes of the poor" and the "salon of the street (Fig. 11)."

In photomechanical journal illustrations, posters, and limited-edition lithographs Lautrec's printed work reached a vast and varied audience. His fifteen-year career as illustrator and printmaker reveals an artist in tune with his time. His graphic oeuvre not only epitomizes the exploitation of new print technology by the avant-garde, which expanded the confines of art, but indeed, is also synonymous with *fin-de-siècle* aesthetics.

1. As early as the summer of 1881 Lautrec had created drawings specifically to be used as illustrations. That year his friend, Etienne Devisme, had written the novel *Cocotte*, which he asked Lautrec to illustrate. Still "a painter in embryo," as Lautrec referred to himself in regard to this project, he made twenty-three pen-and-ink drawings in anticipation of the novel's publication; unfortunately for both aspiring writer and artist, the book was not published at that time; rather, it appeared in 1953 and only then because of the reputation of the artist, not that of the author. See Henri Perruchot, *Toulouse-Lautrec*, trans. Humphrey Hare (London, 1962), pp. 60–61.

 Another ill-fated project was initiated in June 1884 by Cormon. Both Henri Rachou and Lautrec were asked by their mentor to create drawings for an illustrated edition of Victor Hugo's *La legende des siècles*. In the spring of that year Lautrec also produced a drawing for *Figaro illustré*, which, again, did not appear. See Lucien Goldschmidt and Herbert Schimmel, *Unpublished Correspondence of Henri de Toulouse-Lautrec* (New York, 1969), p. 81, letter 58, n. 1.

2. For illustrations see Philippe Huisman and M. G. Dortu, *Lautrec by Lautrec* (New York, 1964), p. 253.

3. *Le mirliton*, nos. 31, 33, 34; January, February, March 1887.

4. For a discussion on Bruant, Salis, and their cabarets and journals, see Phillip Dennis Cate and Sinclair Hamilton Hitchings, *The Color Revolution: Color Lithography in France, 1890–1900* (Layton, Utah, and New Brunswick, New Jersey, 1978), pp. 6–7.

5. Maurias Vachon, *Les arts et les industries du papier en France, 1871–1894* (Paris, 1894), pl. after p. 104.

6. Ibid., pp. 108–109 (trans. Cathy Suroweic).

7. Godefrey Engelmann, *Traité théorique et pratique de lithographie* (Mulhouse, 1835–40); Edouard Duchâtel, *Traité de lithographie artistique* (Paris, 1893).

8. Herbert D. Schimmel and Phillip Dennis Cate, *The Henri de Toulouse-Lautrec and W. H. B. Sands Correspondence* (New York, 1983), letter no. 29, pp. 68–69. See *The Motograph Moving Picture Book* (London, 1898) and French edition, *Le motographe album d'images animées* (Paris, 1899).

9. I wish to thank M. Jean-Claude Romand, Director of the Galerie Sagot–Le Garrec, 24, rue du Four, for making available to me the sale catalogues of his great-grandfather.

10. *La revue blanche*, no. 16, February 1893, p. 146.

11. *Figaro illustré*, 2nd series, no. 40, July 1893, pp. 137–140.

12. For more information on *L'Estampe originale* see Donna Stein and Donald H. Karshan, *L'Estampe originale: A Catalogue Raisonné* (New York, 1970).

13. Perruchot, *Toulouse-Lautrec*, p. 175.

14. Quoted in Cate and Hitchings, *The Color Revolution*, p. 18.

15. For more information on *La revue blanche* see Fritz Hermann and A. B. Jackson, *La revue blanche (1889–1903)* (Paris, 1960).

16. For a detailed discussion on *La plume* see Phillip Dennis Cate, "*La plume* and Its Salon des Cent: Promoters of Posters and Prints in the 1890s," *Print Review 8*, 1978, pp. 61–68.

17. Schimmel and Cate, *Toulouse-Lautrec and W. H. B. Sands*.

18. *The Paris Magazine*, vol. 1, no. 2, January 1899, p. ii (pub. Clarke & Co., 225, rue St. Honoré, Paris, and Sands & Co., 12 Burleigh Street, London).

19. The fall 1895 issues of *La revue blanche* advertised its own print and poster publications; *L'Album de la revue blanche* with twelve prints by twelve artists was priced at 25 francs with individual prints at 5 francs. Lautrec's Anna Held and May Belfort prints were 10 francs each, and the two *La revue blanche* posters by Bonnard and Lautrec were 5 francs each.

20. Pellet was in direct competition with his right-bank counterpart Ambroise Vollard, who among other things published in the 1890s the color lithographic albums of Denis, Bonnard, and Vuillard. Lautrec's only collaboration with Vollard occurred in 1897 with the inclusion of his Country Outing (Cats. 191–192) in the group publication *Album D'Estampe originale de la Galerie Vollard: Peintres-graveurs.*

21. This limited market is confirmed by the following letter which Lautrec wrote to Pellet on November 30, 1898: "Dear Sir/On July 8, 1897, you took twenty-five impressions in black (*Interieur de Brasserie*) [Cat. 183] at a net price of ten francs and twelve impressions

of *Femme dans la Loge* [Cat. 169] at twenty francs net. You have sold two imp. of *Brasserie*, making twenty francs, and one impression of *La Loge* at twenty francs. Making a total of forty francs. You advanced me 200 francs on the lot, 160 now outstanding. Therefore I am leaving you eight impressions of *La Loge* on deposit and taking back the rest." (Goldschmidt and Schimmel, *Unpublished Correspondence*, letter 221, p. 198.)

Therefore, within a year and a half, Pellet was only able to sell one copy of the artist's color lithograph (edition of 12) and two of the black-and-white image (edition of 25). One may assume that *The Large Theater Box* (Cat. 169) was sold at the price of his other works in color and that Pellet made 30 francs on each sale. In another letter two years earlier (December 2, 1896) to E. Deman, a publisher in Brussels, Lautrec stated: "I have had a Lender [Cats. 102–106] proof sent to you. For you 30 francs, for the public 50 francs." (Goldschmidt and Schimmel, *Unpublished Correspondence*, letter 209, p. 191.) The edition size of this color lithograph was 111. By 1897 it was apparent that Lautrec and Pellet no longer found it profitable to produce such large editions; however, the same retail price level is maintained.

22. André Mellerio, *La lithographie originale en couleurs pub.* by *L'Estampe et l'affiche* (Paris, 1898). Quoted material comes from the complete translation of Mellerio's book by Margaret Needham, in Cate and Hitchings, *The Color Revolution*, pp. 79–97.

23. See Amadée Meunier, *Traité de lithographie* (Paris, 1898), pp. 142–145.

24. Poster sizes, originally in meters and centimeters, have been converted to inches, using the formula: cm × .39 = in. Taxes, originally in hundredths of a franc, have been converted to original centimes (in 1898 a franc = 20¢, 100 centimes = 1 franc), and then to United States cents.

25. In 1895 Lautrec received from *La plume* a 200-franc artist's fee for *Irish and American Bar, Rue Royale—The Chap Book* (Cats. 278–279). (Goldschmidt and Schimmel, *Unpublished Correspondence*, letter 196, p. 182.)

26. Posters, usually mounted on canvas and sold directly to dealers or collectors, did not have the 15-centime *affichage* charge; in a letter of 1896 to an unidentified individual Lautrec stated: "I have some *Aube* [Cat. 291] posters at your disposal, stamped impressions, at M. Ancourt's, at a price of 50 francs for 50." (Goldschmidt and Schimmel, *Unpublished Correspondence*, letter 208, p. 109.) *L'Aube* fits into the colombier format, and even in an edition of one thousand probably only cost 50 to 75 centimes each to produce.

27. For more information on this period of postermaking and collecting, see Cate and Hitchings, *The Color Revolution*.

28. W. C. Morrow, *Bohemian Paris of To-day* (London, 1899), p. 21.

Catalogue of the Exhibition

Wolfgang Wittrock

For a true understanding of the lithographs of Henri de Toulouse-Lautrec it is necessary to study them in the context of his paintings and drawings. Lautrec was already a highly experienced draftsman when he began making lithographs in 1891. The catalogue raisonné of his work lists more than 3,000 drawings as well as 400 paintings before that year. In all his sketches and drawings Lautrec carefully refined individual images until he arrived at a form appropriate to his expressive intention. He strove to capture the inner soul rather than the surface detail of his subjects, a focus which set him apart from many of the other artists of his time. The sketch served as a visual reminder of the live model while Lautrec worked on a final composition in the printer's workshop.

Lautrec was so gifted that he usually drew single-color lithographs directly on the stone without corrections. For this reason, almost no multiple states of these prints exist. The intense concentration needed to draw directly on the stone (corrections were technically difficult and time-consuming) in most cases resulted in the creation of lithographs of finer quality than his drawings on paper.

When Lautrec received a commission for a color lithograph, he preferred to use an image he had already explored in painting. Before 1896 he still had the ability to transform a somewhat sketchy painting into a complete, finished lithograph. In 1897, however, when alcohol and illness began to take their toll, his creative powers diminished, and he began to rely on more detailed paintings executed earlier as the basis for his color lithographs. In these prints, the compositions more or less duplicate those of the paintings, but it is to the great credit of the artist that they can still be counted among his finest works. Also, after 1897 Lautrec began to use photographs more frequently than sketches to develop his portraits of actors and actresses.

The trial proofs in the exhibition illustrate how Lautrec and his congenial printer, most often Henry Stern, worked on a color lithograph. Technical standards in printing reached their peak during the 1890s; the demands of commercial printing gave rise to tremendous technological advances, and the use of twenty to thirty stones and colors for one print became possible. However, Lautrec and his printers never exploited the entire range of technology available to them. The maximum number of stones they used to print a color lithograph remained a modest eight. It was, instead, Lautrec's powerful imagination and sensitivity combined with a delicately balanced collaboration with his printer that differentiated his lithographs from those of his contemporaries. Alexandre Lunois (1863–1916), for example, enjoyed greater popularity and success than Lautrec. Lunois's more than ten years' experience in professional lithography had familiarized him with the latest technical innovations, but without the aesthetic genius of Lautrec, Lunois's work can merely be characterized as colorful. Lautrec, on the other hand, had the ability to create works of greater brilliance using more limited means. The three series of color trial proofs in the exhibition are excellent examples of how Lautrec achieved these results. Their examination provides us with an imaginary glimpse of the artist at work.

There are more than 260 paintings and drawings directly related to Lautrec's 364 lithographs and posters, not counting the many works which indirectly depict similar subjects. The drawings and paintings included in this exhibition can be classified in the following groups, for which examples are given:

A. Sketches drawn from life: *Head of Yvette Guilbert* (Cat. 88); *Yvette Guilbert Standing, Singing* (Cat. 89).

B. Drawings and paintings on paper or board in which the artist has deliberately formulated his composition for a lithograph: *Father Cotelle* and *Jane Avril Looking at a Proof* (Cats. 12, 13); *Paula Brébion* (Cat. 55); *Jane Avril* (Cat. 297); *Jane Avril Dancing* (Cat. 252); *Le Divan Japonais* (Cat. 259).

C. Previously executed paintings from which the composition for a color lithograph derives: *The Englishman at the Moulin Rouge* (Cat. 4); *The Toilette—Woman Combing Her Hair* (Cat. 138); *At the Moulin Rouge: The Waltzing Couple* (Cat. 179); *The Large Theater Box* (Cat. 168).

D. Paintings very closely related to lithographs, emphasizing the artist's strong interest in a particular subject: *Chilpéric* (Cat. 101); *Miss May Belfort* (Cat. 266); *La Goulue Entering the Moulin Rouge* (Cat. 1).

In the catalogue listings, titles and dates of lithographs conform to those cited in Wolfgang Wittrock, *Toulouse-Lautrec: The Complete Prints* (London, 1985). The medium "lithograph" is used for those works printed in a single color, usually black, olive-green, sanguine, or blue. The paper on which a lithograph is printed is cited only in cases where several kinds of paper were used within the same edition.

Dimensions are given in inches and centimeters, height preceding width. Composition size is given for individual lithographs, and page size for illustrated books.

The following catalogues are referred to in the entries:

Delteil: Loÿs Delteil, *Henri de Toulouse-Lautrec: Le peintre-graveur illustré*, vols. 10, 11 (Paris, 1920).

Dortu: M. G. Dortu, *Toulouse-Lautrec et son oeuvre*, 6 vols. (New York, 1971).

Garvey: Eleanor M. Garvey, *The Artist and the Book: 1860–1960* (Boston and Cambridge, Mass., 1961).

Inscriptions by the artist, usually dedications, are noted. Prints listed as "unpublished" exist in only a few impressions. The number appearing with an illustration refers to the catalogue entry. An asterisk at the end of the catalogue entry indicates that the work is illustrated.

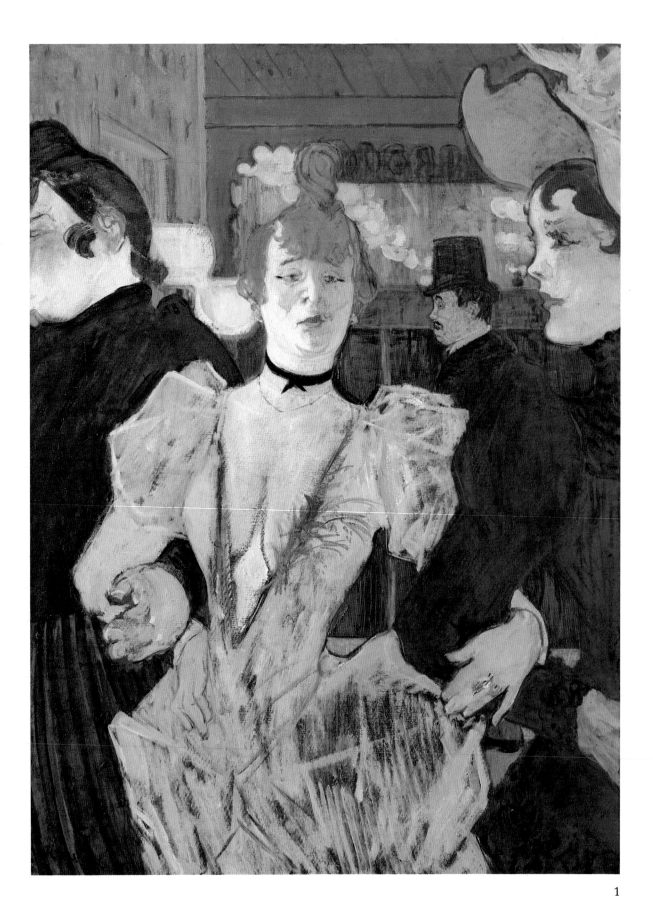

Lithographs, Drawings, and Paintings

1. ***La Goulue Entering the Moulin Rouge*** (La Goulue entrant au Moulin Rouge). 1891.
 Oil on cardboard, 31¼ x 23¼" (79.4 x 59 cm).
 Dortu P423.
 The Museum of Modern Art, New York. Gift of Mrs. David M. Levy, 1957.*

 At the Moulin Rouge, La Goulue and Her Sister (Au Moulin Rouge, La Goulue et sa soeur). 1892.

2. Lithograph, 18³⁄₁₆ x 13¹¹⁄₁₆" (46.2 x 34.8 cm).
 Wittrock 1, first state, proof of key stone. Delteil 11.
 Private collection.

3. Lithograph, printed in color, 18⅛ x 13¹¹⁄₁₆" (46.1 x 34.8 cm).
 Wittrock 1, second state, published edition. Delteil 11.
 The Museum of Modern Art, New York. Gift of Abby Aldrich Rockefeller, 1946.*

 La Goulue (Louise Weber; 1870–1929) was nicknamed after her friend Goulue Chilapanne. She began dancing in 1886, appeared at the Moulin Rouge in 1889, and became the dancing star of Paris. Due to her excessive lifestyle, she had to leave the Moulin Rouge in 1894. She tried belly dancing, animal taming, and after a continual decline died in poverty in 1929. Valentin Le Désossé (The Disjointed; Jacques Renaudin; c. 1845–1906) was for many years the amateur dancing partner of La Goulue (see Cats. 83, 247–248).

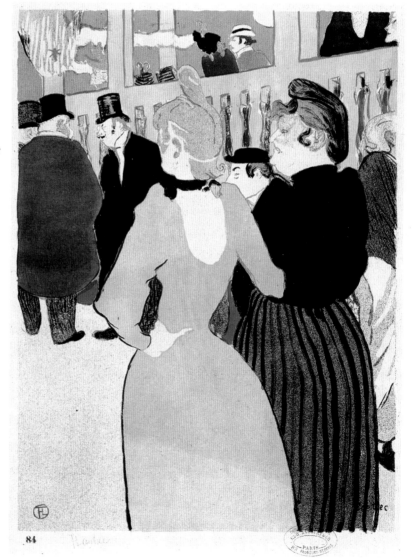

3

4. **The Englishman at the Moulin Rouge** (L'Anglais au Moulin Rouge: M. Warner). 1892.
Oil and gouache on cardboard, 33¾ x 26″ (85.7 x 66 cm).
Dortu P425.
The Metropolitan Museum of Art, New York. Bequest of Miss Adelaide Milton de Groot (1876–1967), 1967.*

The Englishman at the Moulin Rouge (L'Anglais au Moulin Rouge). 1892.

5. Lithograph, 18½ x 14¹¹⁄₁₆″ (47 x 37.3 cm).
Wittrock 2, first state. Delteil 12.
Bibliothèque Nationale, Paris.*

6. Lithograph and watercolor, 18½ x 14¹¹⁄₁₆″ (47 x 37.3 cm).
Wittrock 2, first state. Delteil 12. Dortu A198.
Bibliothèque Nationale, Paris.*

7. Lithograph, 20¾ x 14⁵⁄₁₆″ (52.8 x 36.3 cm).
Wittrock 2, second state, trial proof i. Delteil 12.
Bibliothèque Nationale, Paris.*

8. Lithograph, printed in color, 20¾ x 14⁵⁄₁₆″ (52.8 x 36.3 cm).
Wittrock 2, second state, trial proof ii. Delteil 12.
Bibliothèque Nationale, Paris.*

9. Lithograph, printed in color, 18¹¹⁄₁₆ x 14¹¹⁄₁₆″ (47.4 x 37.3 cm).
Wittrock 2, second state, trial proof iii. Delteil 12.
Bibliothèque Nationale, Paris.

10. Lithograph, printed in color, 18½ x 14¹¹⁄₁₆″ (47 x 37.3 cm).
Wittrock 2, second state. Delteil 12.
Bibliothèque Nationale, Paris.

11. Lithograph, printed in color, 18½ x 14¹¹⁄₁₆″ (47 x 37.3 cm).
Wittrock 2, second state, published edition. Delteil 12.
Collection Nelson Blitz, Jr., New York.*

The Englishman, William Tom Warrener (1861–1934), was a painter and the son of an influential family in Lincoln, England. He moved to Paris in the mid-1880s to study at the Académie Julian, and exhibited at the Salon and the Royal Academy with some success. He met Lautrec in the early 1890s after moving to Montmartre.

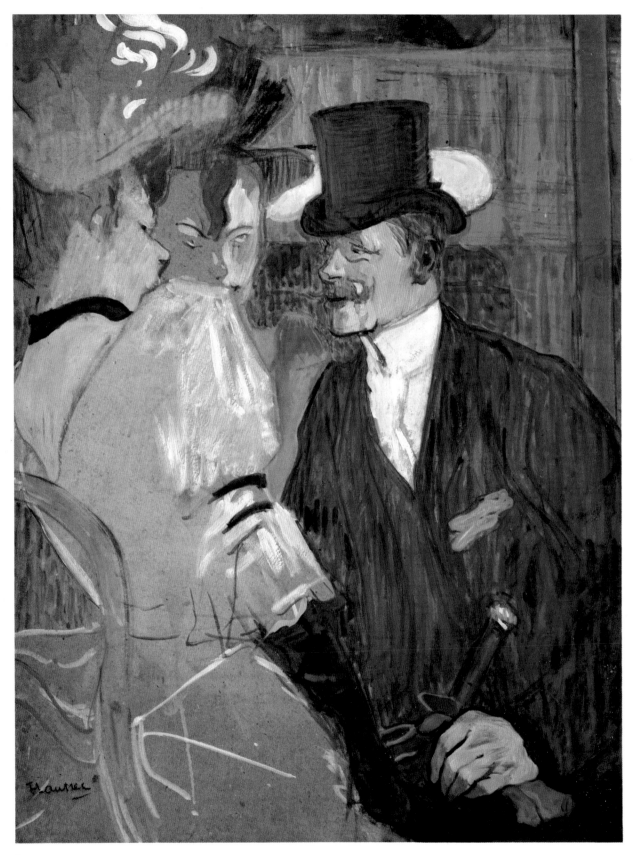

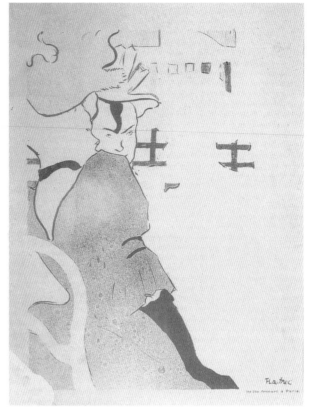

6

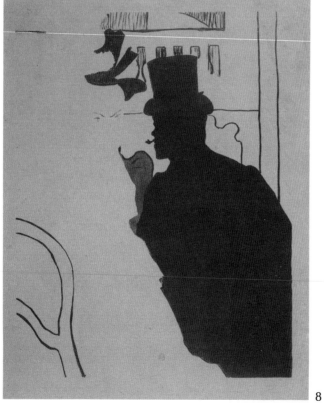

7

8

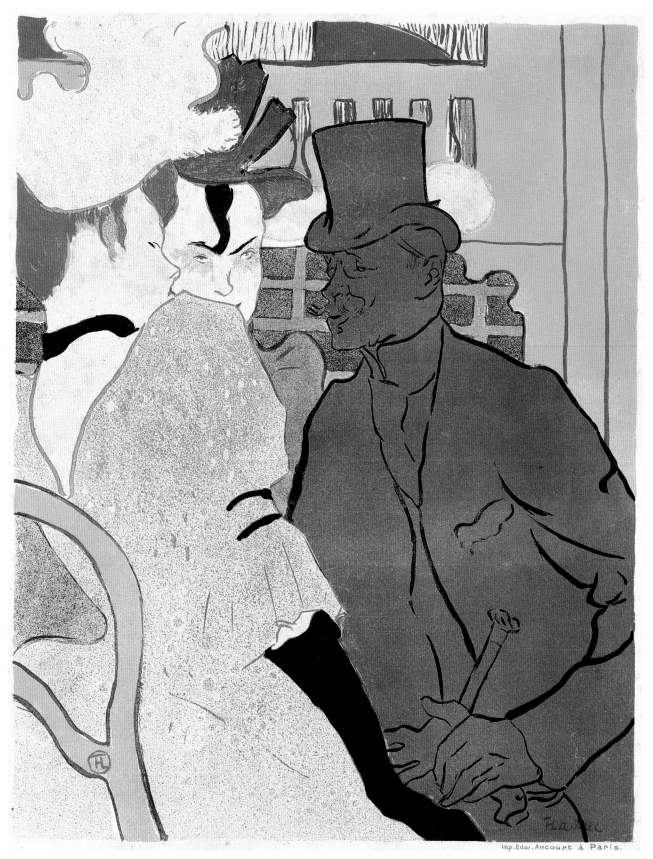

11

Imp.Edw.Ancourt à Paris.

12. **Father Cotelle** (Le Père Cotelle). 1893.
Charcoal and colored crayon on tan wove paper, 20 x 13⅝″ (50.7 x 34.6 cm).
Dortu D3434.
The Art Institute of Chicago. The Mr. and Mrs. Carter H. Harrison Collection.*

13. **Jane Avril Looking at a Proof** (Jane Avril regardant une épreuve). 1893.
Gouache on paper, 20 x 12½″ (51 x 32 cm).
Dortu A206
Collection Henry W. Bloch, Shawnee Mission, Kansas.*

Cover for **L'Estampe originale** (Couverture de L'Estampe originale). 1893.

14. Lithograph, 22¼ x 25¹¹/₁₆″ (56.5 x 65.2 cm).
Wittrock 3, proof of key stone. Delteil 17.
Smith College Museum of Art, Northampton, Massachusetts. Gift of Selma Erving '27, 1978.*

15. Lithograph, printed in color, 22¼ x 25¹¹/₁₆″ (56.5 x 65.2 cm).
Wittrock 3, published edition. Delteil 17.
Private collection.*

Le Père Cotelle was master printer of the Imprimerie Edouard Ancourt & Cie.

Jane Avril (1868–1943), nicknamed "La Mélinite" (an explosive), was discovered in 1891 by Zidler at the Moulin Rouge. She usually danced alone but sometimes danced in the quadrille there and at the Jardin de Paris. In 1897 she performed in London with Mademoiselle Eglantine's troupe, and in 1900 she toured the French provinces. After a month's sojourn in New York in 1901, she returned to Paris, where she performed in musical comedies and revues at the transformed Moulin Rouge. After a short trip to Spain she stopped dancing, married, and had a son. She died destitute in a home for the aged in Paris.

André Marty published L'Estampe originale, a portfolio comprised of original lithographs by various artists. The cover for its first issue depicts Jane Avril examining a proof pulled by Père Cotelle in the workshop of the Ancourt printing firm.

12

13

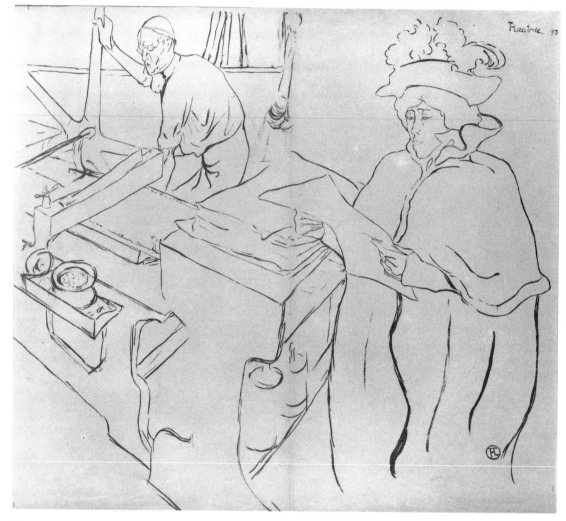

14

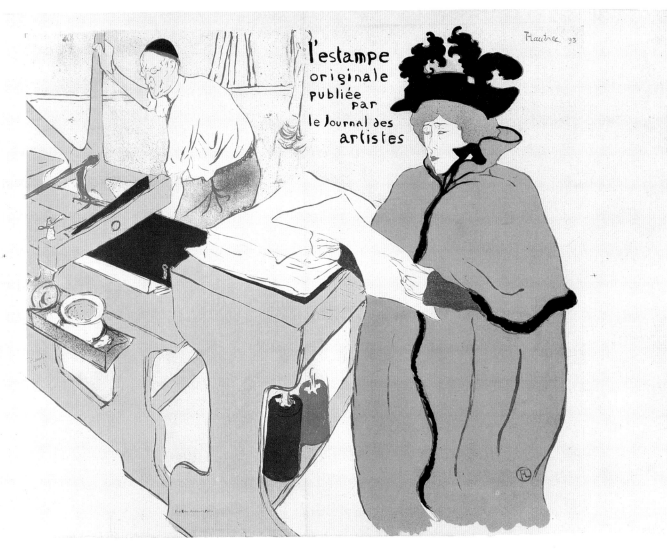

17

The Milliner, Renée Vert (La modiste, Renée Vert). 1893.

16. Lithograph, printed in color, 18⅛ x 11⁷⁄₁₆″ (46 x 29 cm).
Wittrock 4, first state, trial proof i; inscribed *à Kleinmann.*
Delteil 13, second state.
National Gallery of Art, Washington, D.C. Rosenwald
Collection, 1952.

17. Lithograph, printed in color, 17¹⁵⁄₁₆ x 12″ (45.5 x 30.5 cm).
Wittrock 4, second state, published edition; inscribed *à
Kleinmann.* Delteil 13, first state.
National Gallery of Art, Washington, D.C. Rosenwald
Collection, 1952.*

 Renée Vert was a fashion designer and milliner.
 In 1893 she married the painter Joseph Albert.

18. ***The Old Stories,*** Cover-frontispiece (*Les vieilles histoires,*
couverture-frontispice). 1893.
Lithograph, printed in color, 13⅜ x 21¼″ (34 x 54 cm).
Wittrock 5, second state, published edition. Delteil 18,
second state.
The Museum of Modern Art, New York. Gift of Abby
Aldrich Rockefeller, 1946.*

19. ***The Old Stories, Portrait of Désiré Dihau Playing the
Bassoon*** (*Les vieilles histoires,* Portrait de Désiré Dihau
jouant du basson). 1893.
Pencil drawing on paper, 11¼ x 8⅜″ (28.5 x 22 cm).
Dortu D3383.
Collection Mr. and Mrs. Edward M.M. Warburg, New York.*

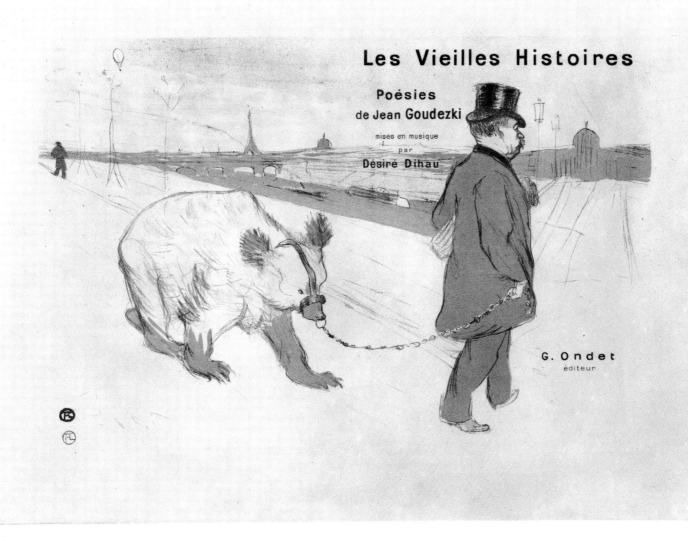

18

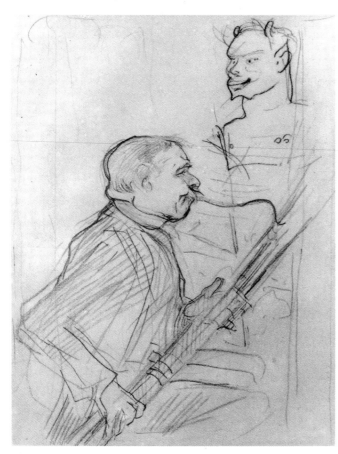

19

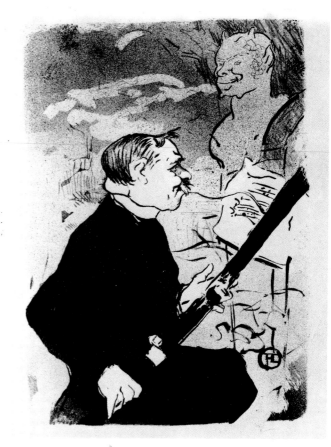

21

For You!... (Pour toi!...). 1893.

20. Lithograph, 10¹³⁄₁₆ x 7¾″ (27.5 x 19.7 cm).
 Wittrock 6, first edition. Delteil 19, first state.
 Impression on imitation Japan paper.
 National Gallery of Art, Washington, D.C. Rosenwald
 Collection, 1952.

21. Lithograph, 10¹³⁄₁₆ x 7¾″ (27.5 x 19.7 cm).
 Wittrock 6, first edition. Delteil 19, first state.
 Impression on mounted wove paper.
 National Gallery of Art, Washington, D.C. Rosenwald
 Collection, 1952.*

22. Lithograph, 10¹³⁄₁₆ x 7¾″ (27.5 x 19.7 cm).
 Wittrock 6, first edition. Delteil 19, first state.
 Impression on wove paper with stencil coloring.
 National Gallery of Art, Washington, D.C. Rosenwald
 Collection, 1952.

23. Lithograph, 10¹³⁄₁₆ x 7¾″ (27.5 x 19.7 cm).

Wittrock 6, song sheet edition. Delteil 19, second state.
Collection Mr. and Mrs. Herbert D. Schimmel, New York.*

24. Lithograph, 10¹³⁄₁₆ x 7¾″ (27.5 x 19.7 cm).
 Wittrock 6, Floury edition. Delteil 19.
 Collection Mr. and Mrs. Herbert D. Schimmel, New York.*
 Désiré Dihau (1825–1909) was a composer and musician
 who played the bassoon in the Paris Opéra. He was a
 close friend of Lautrec and Degas, whom he introduced
 to each other.

25. *Your Mouth* (Ta bouche). 1893.
 Lithograph with stencil coloring, 9¹⁵⁄₁₆ x 6¹⁵⁄₁₆″ (25.3 x
 17.7 cm).
 Wittrock 7, first edition on wove paper. Delteil 21, first state.
 Collection Mr. and Mrs. Herbert D. Schimmel, New York.

26. *Sleepless Night* (Nuit blanche). 1893.
 Lithograph with stencil coloring, 10¼ x 6⅞″ (26 x 17.5 cm).
 Wittrock 8, first edition on wove paper. Delteil 20, first state.
 Collection Mr. and Mrs. Herbert D. Schimmel, New York.

23

24

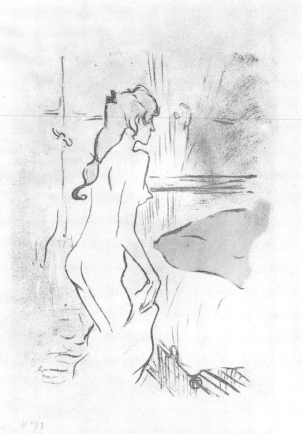

29

27. **Chastity** (Sagesse). 1893.
Lithograph, 10⁷⁄₁₆ x 7¹⁄₁₆″ (26.5 x 18 cm).
Wittrock 9, first edition on mounted wove paper. Delteil 22, first state.
National Gallery of Art, Washington, D.C. Rosenwald Collection, 1952.

28. **Last Ballad** (Ultime ballade). 1893.
Lithograph with stencil coloring, 10⁷⁄₁₆ x 7³⁄₁₆″ (26.5 x 18.2 cm).
Wittrock 10, first edition on wove paper. Delteil 23, first state.
The Museum of Modern Art, New York. Gift of Abby Aldrich Rockefeller, 1946.

29. **Study of Woman** (Etude de femme). 1893.
Lithograph with stencil coloring, 10⁷⁄₁₆ x 7⁷⁄₈″ (26.5 x 20 cm).
Wittrock 11, first edition on wove paper. Delteil 24, first state.
The Museum of Modern Art, New York. Gift of Abby Aldrich Rockefeller, 1946.*

30. **Sick Carnot!** (Carnot malade!). 1893.
Lithograph with stencil coloring, 9⁵⁄₈ x 7⁵⁄₁₆″ (24.4 x 18.6 cm).
Wittrock 12, first edition on wove paper. Delteil 25, first state.
Collection Mr. and Mrs. Herbert D. Schimmel, New York.
 President Sadi Carnot's illness in the summer of 1893 inspired the writing of the monologue *Carnot malade!*, a political satire comparing the state of the government to his physical malady. Carnot recovered from the illness, but was murdered by an anarchist in June 1894.

31. **Poor Streetwalker!** (Pauvre pierreuse!). 1893.
Oil on cardboard, 13 x 10″ (33 x 25.4 cm).
Dortu P492.
Private collection.*

32. **Poor Streetwalker!** (Pauvre pierreuse!). 1893.
Lithograph, 9⁷⁄₁₆ x 6¾″ (24 x 17.2 cm).
Wittrock 13, first edition on imitation Japan paper. Delteil 26, first state.
Museum of Fine Arts, Boston. Bequest of W. G. Russell Allen.*

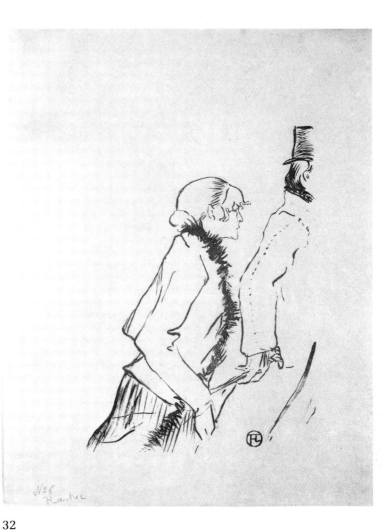

32

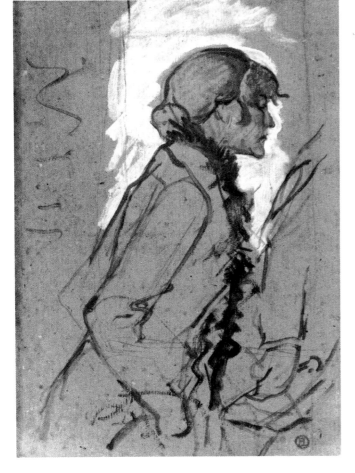

31

33. ***The Little Errand-Girl*** (Le petit trottin). 1893.
Lithograph, 11 x 7½″ (28 x 19 cm).
Wittrock 14, first edition. Delteil 27, first state.
The Brooklyn Museum, New York.*

The Hairdresser—Program for the Théâtre Libre
(Le coiffeur—Programme du Théâtre Libre). 1893.

34. Lithograph, printed in color, 12¹⁵⁄₁₆ x 10″ (33 x 25.5 cm).
Wittrock 15, second state, first edition. Delteil 14, first state.
Boston Public Library. Albert H. Wiggin Collection.*

35. Lithograph, printed in color, 12⅜ x 9⁷⁄₁₆″ (31.5 x 24 cm).
Wittrock 15, theater program edition. Delteil 14,
second state.
Collection Mr. and Mrs. Herbert D. Schimmel, New York.

The Théâtre Libre was founded in 1887 by André
Antoine (1858–1943) for the production of plays by the
new French and foreign naturalist playwrights. Its inno-
vations in directing and acting had a great influence on
contemporary French theater. Owing to financial diffi-
culties, it closed in April 1896.

Je petit trottin
paroles de
Achille Melandri

musique
de
DESIRÉ
DIHAU

33

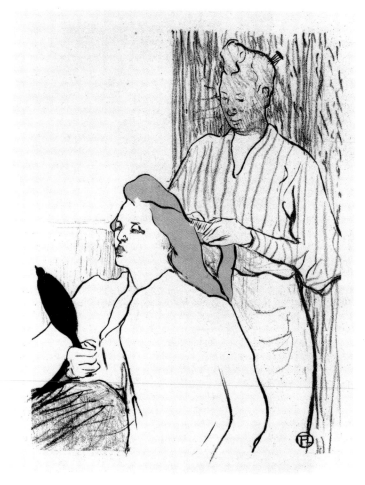

34

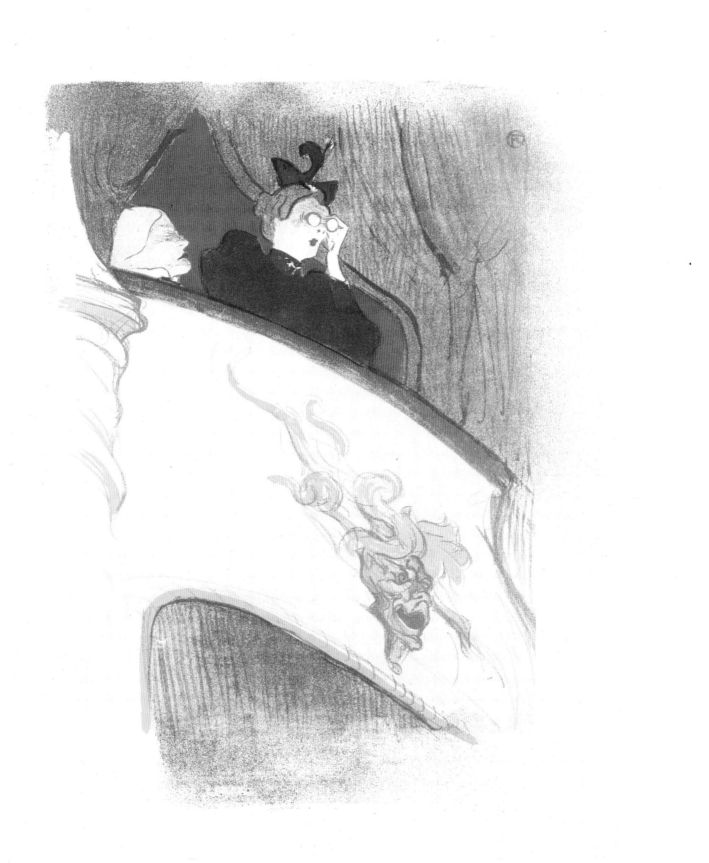

The Loge with the Gilt Mask—Program for the Théâtre Libre (La loge au mascaron doré—Programme du Théâtre Libre). 1893.

36. Lithograph, printed in color, 14⅝ x 12⅞" (37.2 x 32.7 cm).
Wittrock 16, first edition. Delteil 16, first state.
The Metropolitan Museum of Art, New York. Gift of Clifford A. Furst, 1958.*

37. Lithograph, printed in color, 12⅛ x 9⁷⁄₁₆" (30.8 x 24 cm).
Wittrock 16, theater program edition (1894). Delteil 16, second state.
Collection Mr. and Mrs. Herbert D. Schimmel, New York.

Miss Loie Fuller. 1893.

38. Lithograph, 10⁹⁄₁₆ x 6⅜" (26.8 x 16.2 cm).
Wittrock 17, trial proof i. Delteil 39.
Collection Mr. and Mrs. Herbert D. Schimmel, New York.*

39. Lithograph, printed in color, 14½ x 10⁹⁄₁₆" (36.8 x 26.8 cm).
Wittrock 17, published edition; inscribed *à Stern*. Delteil 39.
Boston Public Library. Albert H. Wiggin Collection.*

40. Lithograph, printed in color, 14½ x 10⁹⁄₁₆" (36.8 x 26.8 cm).
Wittrock 17, published edition. Delteil 39.
Boston Public Library. Albert H. Wiggin Collection.*

41. Lithograph, printed in color, 14½ x 10⁹⁄₁₆" (36.8 x 26.8 cm).
Wittrock 17, published edition; inscribed *à R Marx*. Delteil 39.
The Brooklyn Museum, New York.*

42. Lithograph, printed in color, 14½ x 10⁹⁄₁₆" (36.8 x 26.8 cm).
Wittrock 17, published edition. Delteil 39.
National Gallery of Art, Washington, D.C. Rosenwald Collection, 1952.

43. Lithograph, printed in color, in the original mat, 14½ x 10⁹⁄₁₆" (36.8 x 26.8 cm).
Wittrock 17, published edition. Delteil 39.
Bibliothèque Nationale, Paris.*

Loie Fuller (1862–1928) was born in Chicago and began her career at the age of five as a singer. After giving temperance lectures, performing Shakespeare with a touring acting company, and appearing in burlesque in Chicago and New York, she was discovered in Paris at the Folies-Bergère in 1892. She created a sensation with her unique approach to dance: standing immobile, she simulated movement through the manipulation of long veils of flowing drapery attached to her dress. The projection of multicolored electric lights onto her veils created striking visual effects.

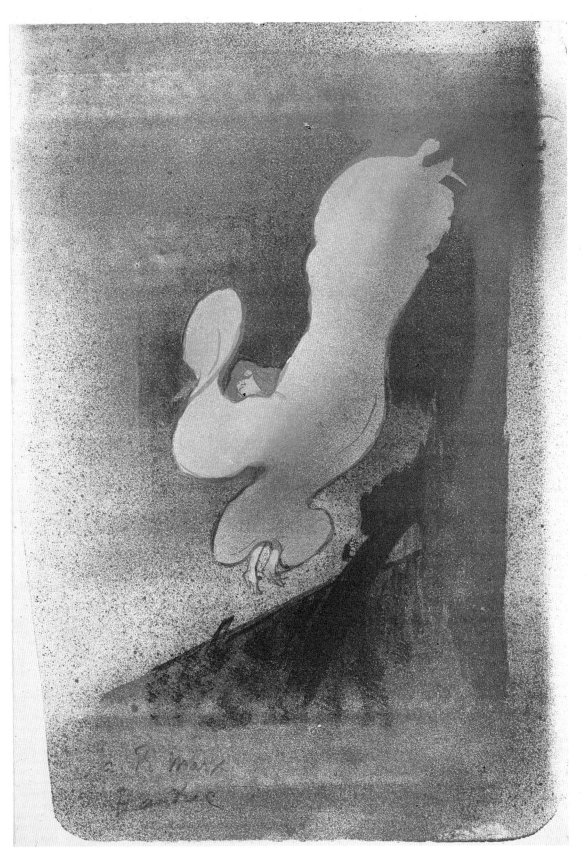

41

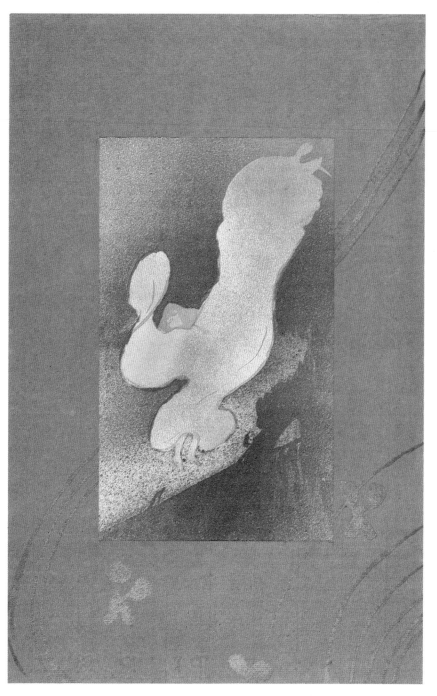

43

The Café Concert (Le café concert). 1893. [44–54.]
A portfolio of 22 lithographs, 11 by Henri-Gabriel Ibels (not in the exhibition) and 11 by Toulouse-Lautrec, with text by Georges Montorgueil.
Published by *L'Estampe originale* (André Marty), Paris.
Deluxe edition on laid Japan paper.
Collection Mr. and Mrs. Gilbert Rothschild.

44. *Jane Avril.*
Lithograph, 10½ x 8⁷⁄₁₆″ (26.6 x 21.5 cm).
Wittrock 18. Delteil 28.*

45. *Yvette Guilbert.*
Lithograph, 9¹⁵⁄₁₆ x 8¾″ (25.3 x 22.3 cm).
Wittrock 19. Delteil 29.
(see Cat. 92)

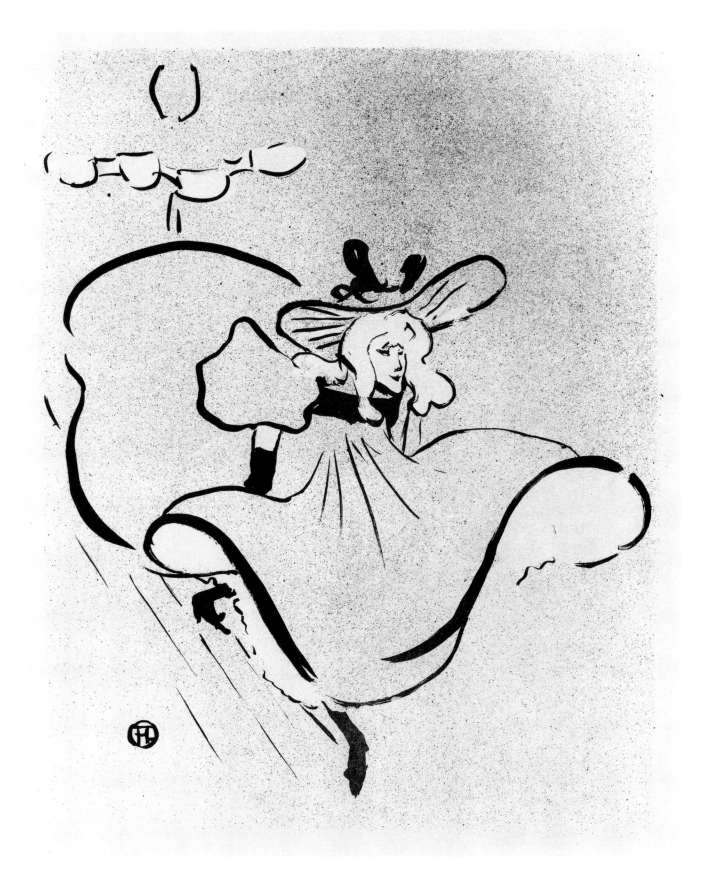

44

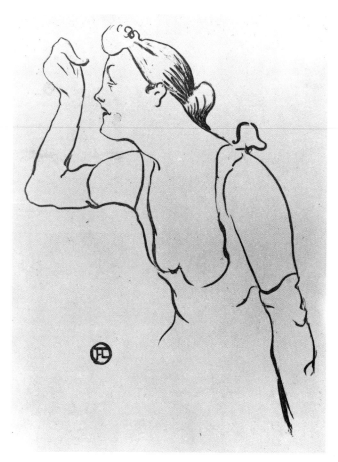

46

46. *Paula Brébion.*
Lithograph, 10⁵⁄₁₆ x 7¾″ (26.2 x 19.7 cm).
Wittrock 20. Delteil 30.*
(see Cat. 55)

47. *Mary Hamilton.*
Lithograph, 10⁹⁄₁₆ x 6⁷⁄₁₆″ (26.8 x 16.3 cm).
Wittrock 21. Delteil 31.

48. *Edmée Lescot.*
Lithograph, 10⅝ x 7½″ (27 x 19 cm).
Wittrock 22. Delteil 32.

49. *Madame Abdala.*
Lithograph, 10⅝ x 7⅞″ (27 x 20 cm).
Wittrock 23. Delteil 33.

50. *Aristide Bruant.*
Lithograph, 10⁹⁄₁₆ x 8⁷⁄₁₆″ (26.8 x 21.5 cm).
Wittrock 24. Delteil 34.*
(see Cat. 251)

51. *Caudieux—Petit Casino.*
Lithograph, 10¹³⁄₁₆ x 8⁹⁄₁₆″ (27.5 x 21.8 cm).
Wittrock 25. Delteil 35.*
(see Cat. 255)

52. *Ducarre at the Ambassadeurs* (Ducarre aux
Ambassadeurs).
Lithograph, 10¼ x 7¹³⁄₁₆″ (26 x 19.9 cm).
Wittrock 26. Delteil 36.

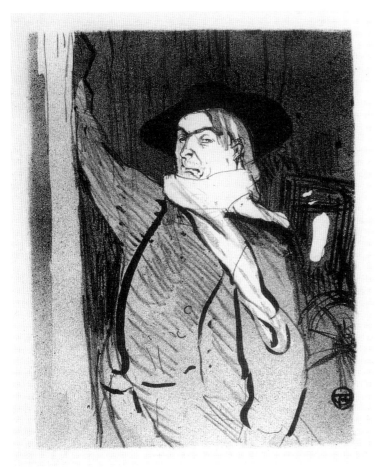

50

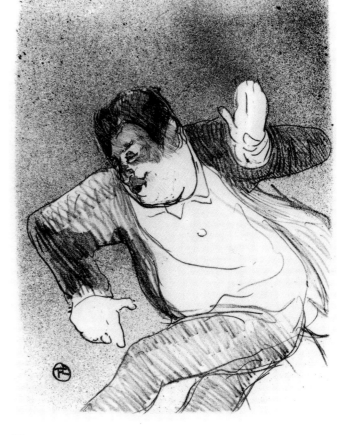

51

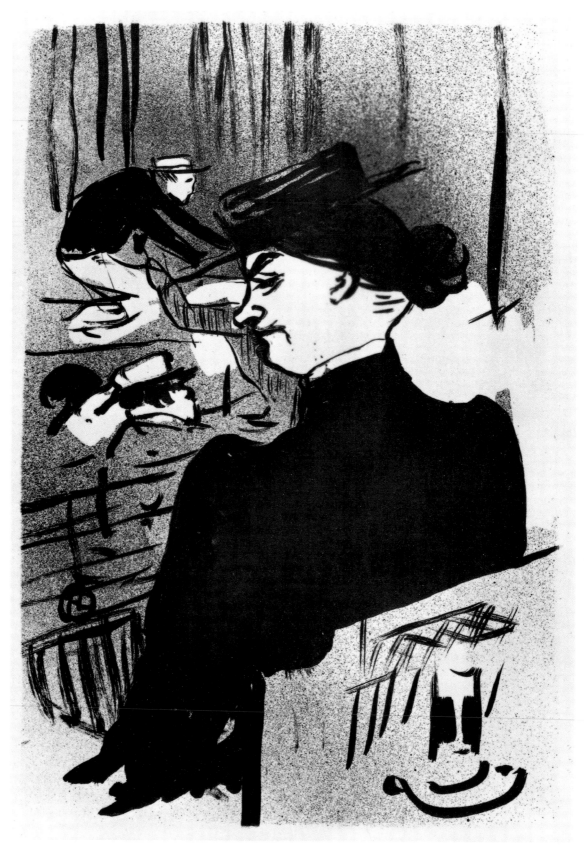

53

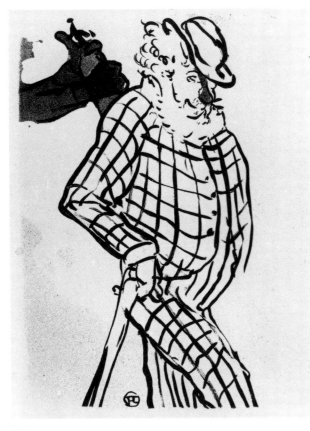

54

53. **A Spectator** (Une spectatrice).
Lithograph, 10⁹⁄₁₆ x 7¼″ (26.9 x 18.5 cm).
Wittrock 27. Delteil 37.*

54. **American Singer** (Chanteur américain).
Lithograph, 10¹⁵⁄₁₆ x 8¹⁄₁₆″ (27.8 x 20.5 cm).
Wittrock 28. Delteil 38.*

The *cafés concerts* were at once places to meet, converse, and smoke as well as places to listen to instrumental and vocal music. Originated in the eighteenth century as cafés with musical entertainment, the first independent *café concert* was the Estaminet Lyrique, which opened in 1848. Its patrons were the workmen and clerks of the neighborhood. This new forum for entertainment, subsequently copied throughout Paris, was called a *beuglant* (from *beugler*, to bellow) and was generally as glamourless as its colloquial name implies. In 1891 the unpretentious *café chantant* became the elegant *café concert*. There were no less than 274 *cafés concerts* in Paris in 1896, presenting 10,000 to 15,000 new songs each year. While many of the female entertainers were originally dressmakers, milliners, or artists' models, at the better establishments they usually had some musical training, and aspired to sing at the Opéra or in musical comedy. The male performers, too, were from all walks of life. The two main *café-concert* districts during Lautrec's time were located on the boulevard de Strasbourg and the boulevard de Sébastopol and on the Champs-Elysées. Only three establishments of importance were located in Montmartre: Divan Japonais (a combination of *café concert* and *cabaret artistique*), Cigale, and Décadents.

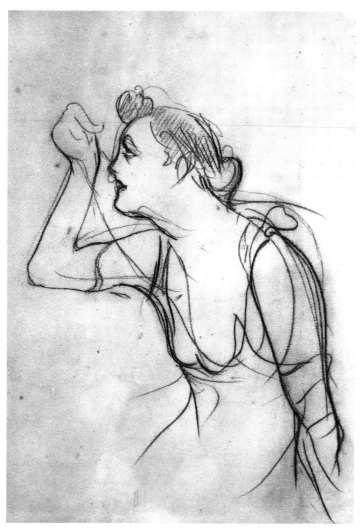

55

55. **Paula Brébion.** 1893.
Black chalk on wove paper, 10 x 7¹¹⁄₁₆″ (25.4 x 19.5 cm).
Not in Dortu.
Museum Boymans–van Beuningen, Rotterdam.*
 Paula Brébion (born 1860) began her career at Scala. She
 sang soldiers' songs while performing contortions at the
 Eldorado and Alcazar.

56. **The Disasters of War** (Los Desastres de la Guerra). 1893.
Lithograph, 11⅛ x 15⅜″ (28.2 x 39.1 cm).
Wittrock 29. Delteil 295. Unpublished.
Private collection.*

57. **Why Not?...Once Is Not a Habit** (Pourquoi pas?...Une fois
n'est pas coutume). 1893.
Lithograph, 13³⁄₁₆ x 10¼″ (33.5 x 26 cm).
Wittrock 30, published edition. Delteil 40.
Collection Mr. and Mrs. Herbert D. Schimmel, New York.*

58. **Dress Rehearsal at the Folies-Bergère** (Répétition générale
aux Folies-Bergère). 1893.
Lithograph, printed with brown tint stone, 14¾ x 10¼″
(37.5 x 26 cm).
Wittrock 34, second state, second edition. Delteil 44.
The Art Institute of Chicago. The Mr. and Mrs. Carter H.
Harrison Collection.*

56

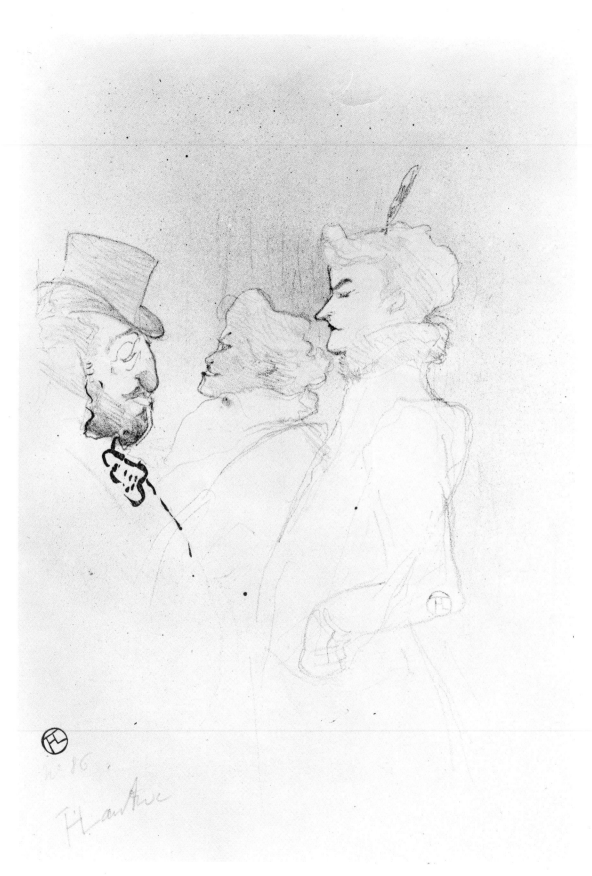

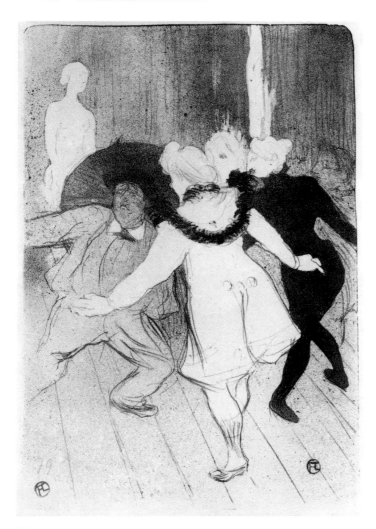

59

59. ***Folies-Bergère: The Censors of Monsieur Prudhomme***
(Folies-Bergère: Les pudeurs de Monsieur Prudhomme).
1893.
Lithograph, 14¾ x 10⅝″ (37.5 x 27 cm).
Wittrock 36, published edition. Delteil 46.
The Museum of Modern Art, New York. Gift of Abby
Aldrich Rockefeller, 1946.*

60. ***At the Renaissance: Sarah Bernhardt in Phèdre*** (A la
Renaissance: Sarah Bernhardt dans *Phèdre*). 1893.
Lithograph, 13¹⁵⁄₁₆ x 9¼″ (35.5 x 23.5 cm).
Wittrock 37, trial proof; inscribed *à Bruant*. Delteil 47.
National Gallery of Art, Washington, D.C. Rosenwald
Collection, 1952.*

> Sarah Bernhardt (1844–1923) was a French actress who
> was also an accomplished painter, sculptress, and author
> of plays and poetry. She began her acting career in 1862
> at the Comédie-Française and during the 1880s directed
> and managed her own theaters. From 1893 to 1898 the
> Théâtre Renaissance was under her management, and
> she played the leading roles there in her own produc-
> tions. She made her New York debut in 1880.

61. ***At the Opéra: Madame Caron in Faust*** (A l'Opéra:
Madame Caron dans *Faust*). 1893.
Lithograph, 14¼ x 10⁷⁄₁₆″ (36.2 x 26.5 cm).
Wittrock 39, proof inscribed *Faust Mme Caron bon à tirer,
50 vert, 50 noir* [crossed out], *5 Japon vert, 5 noir* [crossed
out]. Delteil 49.
The Art Institute of Chicago. The John H. Wrenn Memorial
Collection.*

> Rose Caron (Rose-Lucille Meuniez; 1857–1930) was a
> famous singer of the Paris Opéra. She is shown here in
> the role of Marguerite from Charles-François Gounod's
> *Faust*, which made her a star. This performance coin-
> cided with a subscription to raise funds for a statue of
> Gounod.

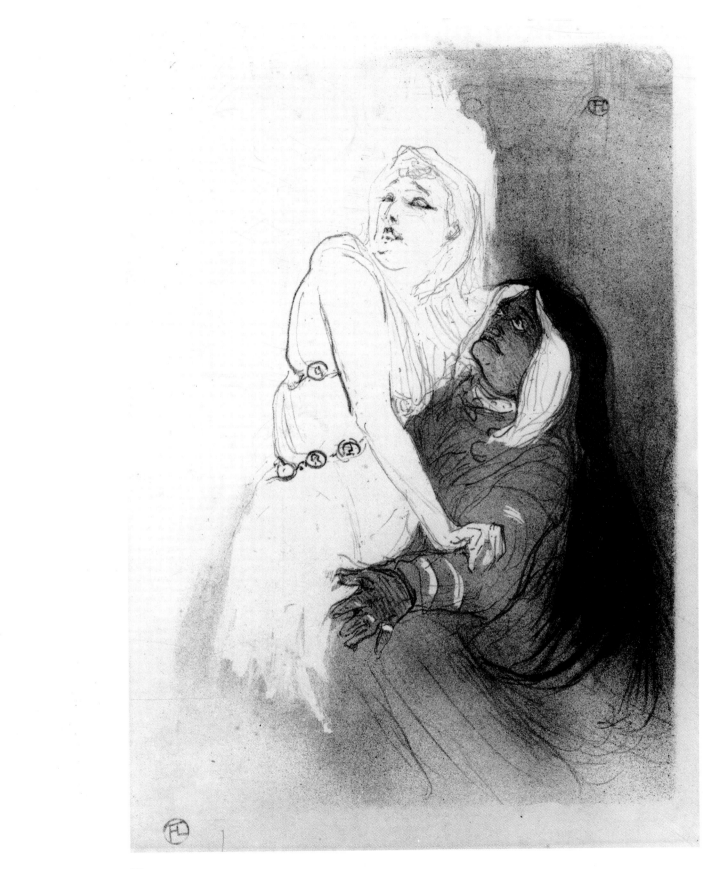

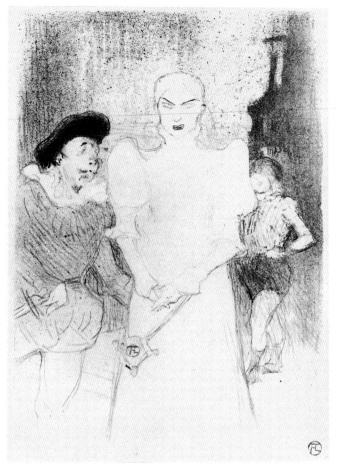

61

62. ***A Costume Ball at the Moulin Rouge*** (Une redoute au Moulin Rouge). 1893.
Lithograph, 11⅝ x 18½″ (29.6 x 47 cm).
Wittrock 42, published edition. Delteil 65.
The Museum of Modern Art, New York. Gift of Abby Aldrich Rockefeller, 1946.*

63. ***Réjane and Galipaux in Madame Sans-Gêne*** (Réjane et Galipaux dans *Madame Sans-Gêne*). 1893.
Lithograph, 12⅜ x 10¼″ (31.5 x 26 cm).
Wittrock 44, published edition. Delteil 52.
Boston Public Library. Albert H. Wiggin Collection.*

Réjane (Gabrielle-Charlotte Réju; 1857–1920) began her career in 1875 at the Théâtre du Vaudeville. She was soon recognized as a leading comedic talent and appeared frequently in many Parisian theaters. In 1906 she opened her own theater. She appeared in *Madame Sans-Gêne* in New York in 1895.

Félix Galipaux (1860–1931) made his debut at the Palais-Royal and later performed at the Renaissance, Vaudeville, and Gymnase. He was renowned for his original monologues, which he called *monomimes*.

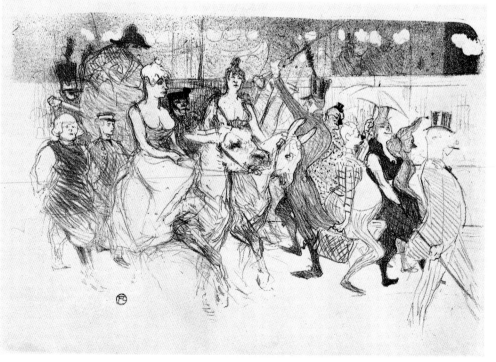

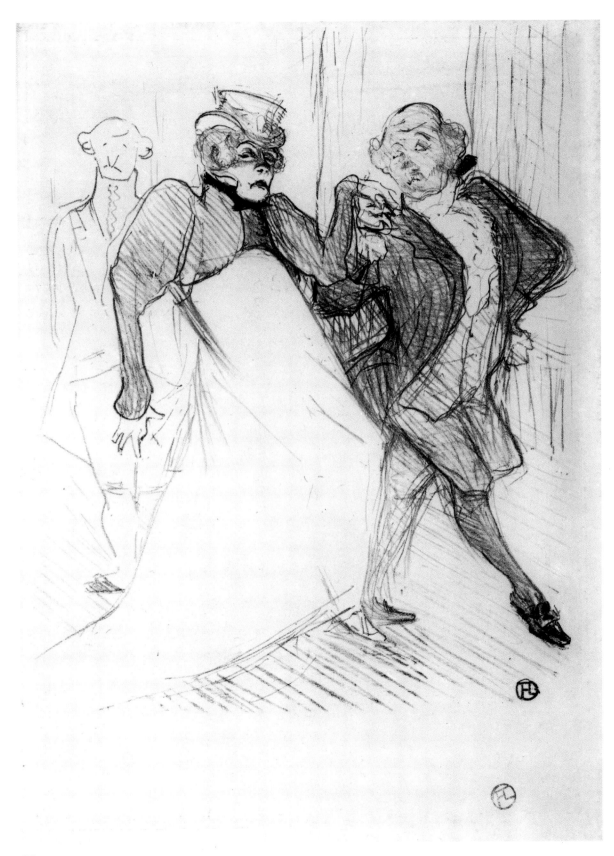

64. ***Truffier and Moreno in Les Femmes Savantes*** (Truffier et Moreno dans *Les Femmes Savantes*). 1893.
Lithograph, 14¾ x 10⁷⁄₁₆″ (37.5 x 26.5 cm).
Wittrock 46, published edition. Delteil 54.
The Metropolitan Museum of Art, New York. The Alfred Stieglitz Collection, 1949.*

Charles-Jules Truffier (1856–1943) joined the Comédie-Française in 1875, where he played in the ancient and modern repertoires.

Marguerite-Monceau Moreno (born 1871) made her acting debut at the Comédie-Française in 1890.

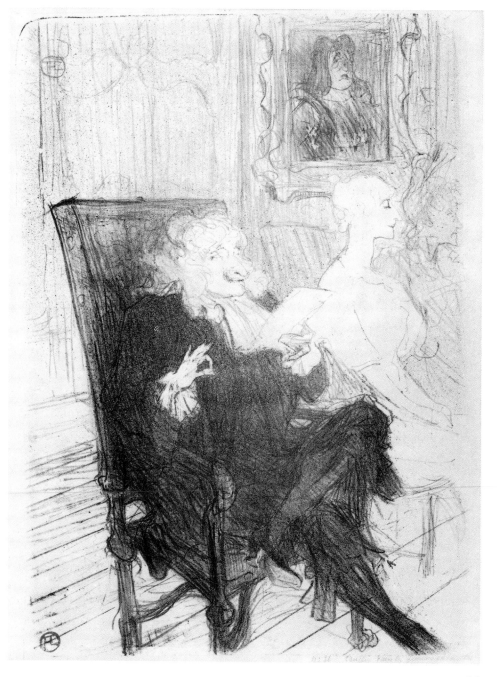

64

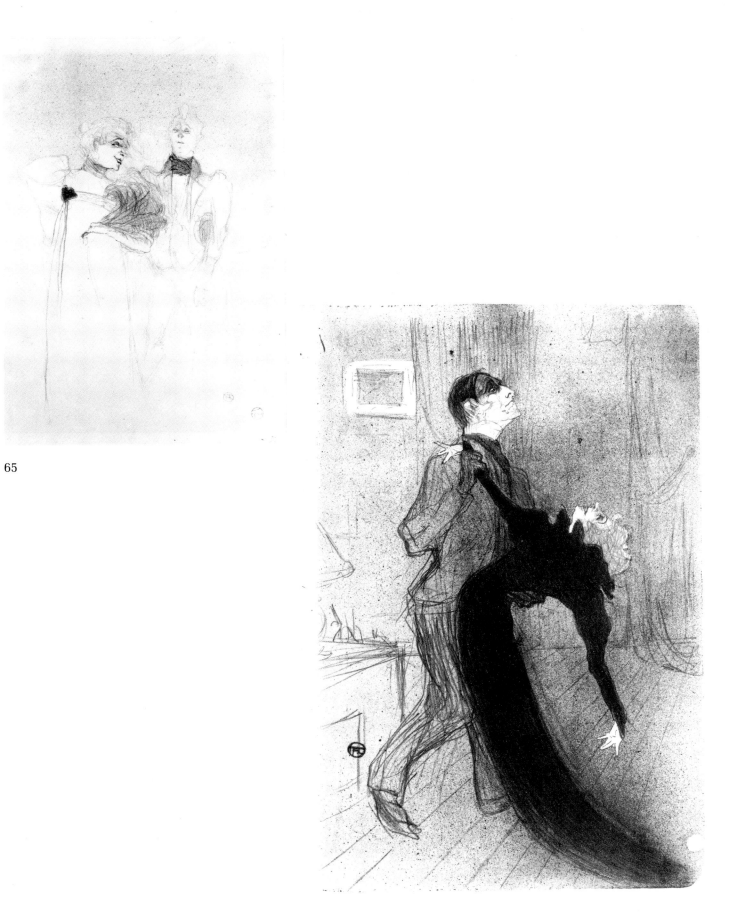

65

67

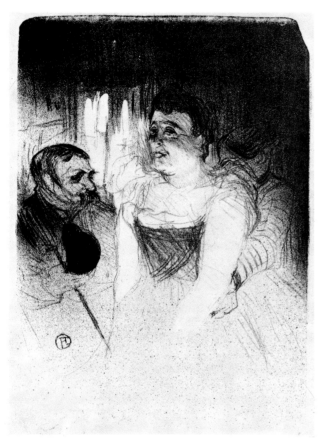

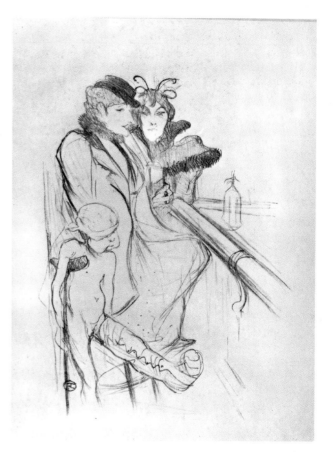

70

71

65. ***Mademoiselle Lender in Madame Satan*** (Mademoiselle Lender dans *Madame Satan*). 1893.
Lithograph, 13¹³⁄₁₆ x 10⅜″ (35.1 x 26.4 cm).
Wittrock 47, proof. Delteil 58, second state.
Collection Mr. and Mrs. Herbert D. Schimmel, New York.*
(see Cat. 101)

66. ***Lugné-Poë in Image*** (Lugné-Poë dans *Image*). 1894.
Lithograph, 12¹⁵⁄₁₆ x 9⁷⁄₁₆″ (32.9 x 24 cm).
Wittrock 49, proof; inscribed *à Lugné Poë*. Delteil 57.
Sterling and Francine Clark Art Institute, Williamstown, Massachusetts.

 Aurélien-François Lugné-Poë (1869–1940) was an actor, director, and theater manager who founded the Théâtre de l'Oeuvre in 1893. He appeared in many of his own productions until 1899. Many Symbolist plays by authors such as André Gide, Henrik Ibsen, Gerhard Hauptmann, Maxim Gorki, Oscar Wilde, and Alfred Jarry *(Ubu Roi)* opened at the Théâtre de l'Oeuvre. Programs were designed by leading avant-garde artists of the day.

67. ***The Swoon*** (L'Evanouissement). 1894.
Lithograph, 14¹⁵⁄₁₆ x 10¼″ (37.9 x 26.1 cm).
Wittrock 50. Delteil 294. Unpublished.
The Art Institute of Chicago. The Clarence Buckingham Collection.*

68. ***Brandès and Le Bargy in Cabotins*** (Brandès et Le Bargy dans *Cabotins*). 1894.
Lithograph, 16⅞ x 12¹⁵⁄₁₆″ (42.8 x 33 cm).
Wittrock 52, published edition. Delteil 61.
Collection Mr. and Mrs. Herbert D. Schimmel, New York.

Judic. 1894.

69. Lithograph, 14¹³⁄₁₆ x 10½″ (37.7 x 26.7 cm).
Wittrock 54, proof in strong light green. Delteil 56.
Boston Public Library. Albert H. Wiggin Collection.

70. Lithograph, 14¹³⁄₁₆ x 10½″ (37.7 x 26.7 cm).
Wittrock 54, published edition on imitation Japan paper. Delteil 56.
Boston Public Library. Albert H. Wiggin Collection.*

 Judic (Anne-Marie Judic) was born in Semur in 1850. She made her debut at the Gymnase in 1867 and per-formed at the Eldorado in 1868 and, later, at the Gaîté, Folies-Bergère, Bouffes, Variétés, and Eden theater.

71. ***Wounded Eros*** (Eros vanné). 1894.
Lithograph, 11⁷⁄₁₆ x 8⅞″ (29 x 22.5 cm).
Wittrock 56, second edition. Delteil 74, second state.
Collection Mr. and Mrs. Herbert D. Schimmel, New York.*

72. ***The Old Gentlemen*** (Les vieux messieurs). 1894.
Lithograph, 9¾ x 6⁹⁄₁₆″ (24.6 x 16.7 cm).
Wittrock 57, song sheet edition. Delteil 75, second state.
Collection Mr. and Mrs. Herbert D. Schimmel, New York.

At the Ambassadeurs—Café-Concert Singer (Aux Ambas-sadeurs—Chanteuse au café concert). 1894.

73. Lithograph, impression of key stone in olive green.
Wittrock 58, trial proof i. Delteil 68.
Bibliothèque Nationale, Paris.*

74. Lithograph, impression of yellow stone.
Wittrock 58, trial proof ii. Delteil 68.
Bibliothèque Nationale, Paris.*

75. Lithograph, impression of yellow and beige-gray stones.
Wittrock 58, trial proof iii. Delteil 68.
Bibliothèque Nationale, Paris.*

76. Lithograph, impression of yellow, beige-gray, and salmon-pink stones.
Wittrock 58, trial proof iv. Delteil 68.
Bibliothèque Nationale, Paris.*

77. Lithograph, impression of yellow, beige-gray, salmon-pink, and black stones.
Wittrock 58, trial proof v. Delteil 68.
Bibliothèque Nationale, Paris.*

78. Lithograph, impression of yellow, beige-gray, salmon-pink, black, and blue stones.
Wittrock 58, trial proof vi. Delteil 68.
Bibliothèque Nationale, Paris.*

79. Lithograph, printed in color, 12 x 9¾″ (30.5 x 24.7 cm).
Wittrock 58, published edition from *L'Estampe originale*. Delteil 68.
Bibliothèque Nationale, Paris.*

 The Ambassadeurs was one of the most elegant outdoor *cafés concerts* on the Champs-Elysées. Founded in the early 1800s, it was directed by Pierre Ducarre in the 1890s.

73

74

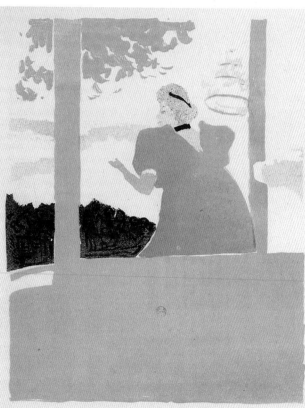

77

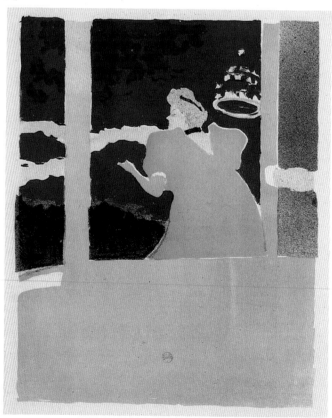

78

75

76

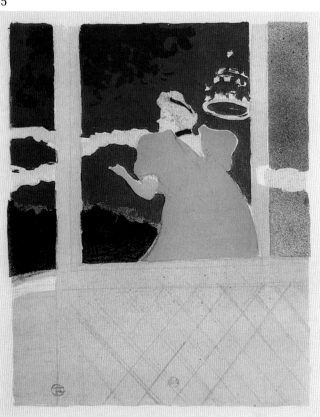

79

80. **Carnival** (Carnaval). 1894.
 Lithograph, 10⅝ x 8¼" (27 x 21 cm).
 Wittrock 61, second state. Delteil 64, undescribed state.
 Boston Public Library. Albert H. Wiggin Collection.

81. **Ida Heath at the Bar** (Ida Heath au bar). 1894.
 Lithograph, 13⅜ x 10" (34 x 25.5 cm).
 Wittrock 62, published edition. Delteil 59.
 The Metropolitan Museum of Art, New York. The Alfred
 Stieglitz Collection, 1949.*

82. **Miss Ida Heath, English Dancer** (Miss Ida Heath, danseuse
 anglaise). 1894.
 Lithograph, 14³⁄₁₆ x 10⅜" (36 x 26.3 cm).
 Wittrock 64, published edition; inscribed à Chéret.
 Delteil 165.
 The Metropolitan Museum of Art, New York. Gift of
 Clifford A. Furst, 1958.*

83. **La Goulue.** 1894.
 Lithograph, 12⅜ x 10⅛" (31.4 x 25.7 cm).
 Wittrock 65, first edition. Delteil 71, first state.
 The Museum of Modern Art, New York. Gift of Abby
 Aldrich Rockefeller, 1946.*

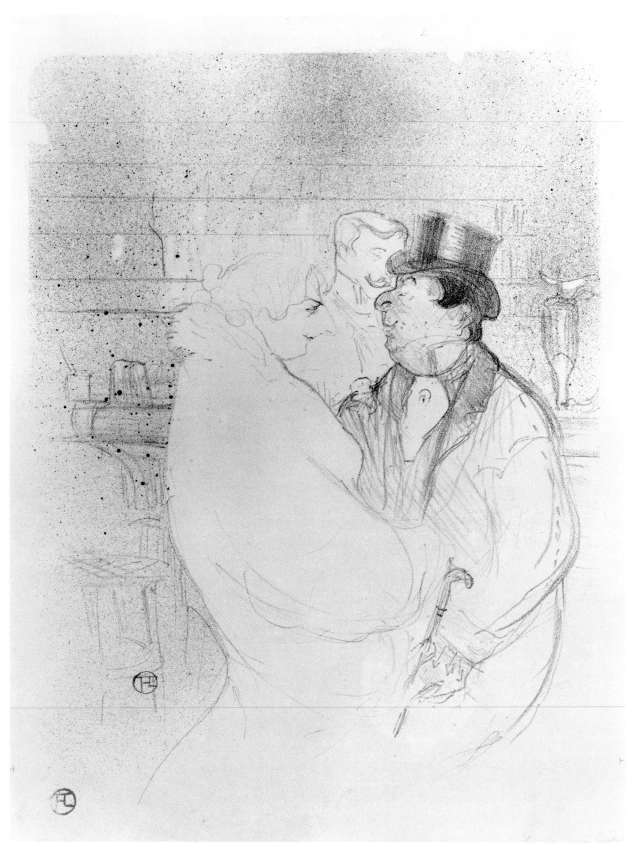

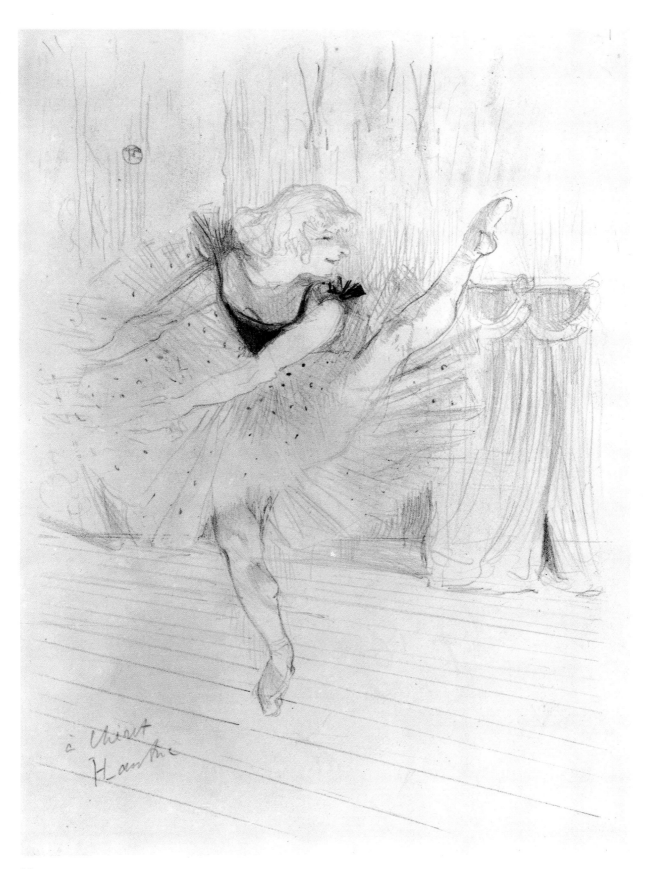

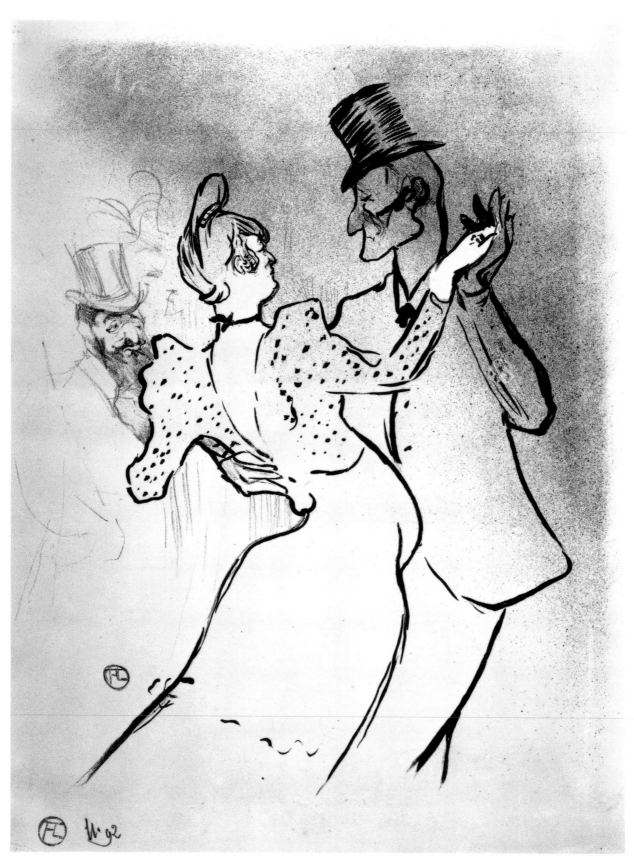

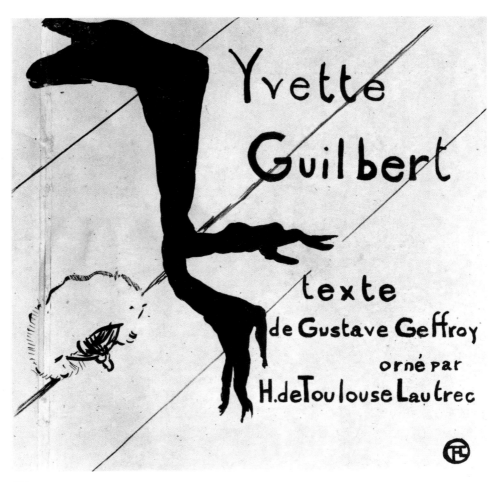

85

84. ***Yvette Guilbert*** by Gustave Geffroy. Paris, L'Estampe originale, 1894. 17 lithographs, 15 x 15″ (38 x 38 cm). Wittrock 69–85. Delteil 79–95. Garvey 301. The Museum of Modern Art, New York. The Louis E. Stern Collection, 1964.

85. Cover for the album ***Yvette Guilbert*** (Couverture de l'album *Yvette Guilbert*). 1894. Lithograph, 15¹⁄₁₆ x 16⅛″ (38.3 x 41 cm). Wittrock 69, published edition. Delteil 79. Boston Public Library. Albert H. Wiggin Collection.*

86. ***Yvette Guilbert.*** 1894. Lithograph, 10⅝ x 7⅛″ (27 x 18.1 cm). Wittrock 70, proof before text. Delteil 80, first state. Smith College Museum of Art, Northampton, Massachusetts. Gift of Selma Erving '27, 1972.*

87. ***Yvette Guilbert.*** 1894. Lithograph, 12½ x 8⁷⁄₁₆″ (31.7 x 21.5 cm). Wittrock 71, proof before text. Delteil 81, first state.

The Art Institute of Chicago. The Mr. and Mrs. Carter H. Harrison Collection.*

88. ***Head of Yvette Guilbert*** (Yvette Guilbert, profil de tête relevée). 1894. Graphite drawing on ivory wove paper, 14 x 9⅛″ (23.2 x 35.7 cm). Dortu D3638, recto of a two-sided drawing (Dortu D3637). The Art Institute of Chicago. Albert H. Wolf Collection.*

89. ***Yvette Guilbert, Standing, Singing*** (Yvette Guilbert, debout, chantant). 1894. Pencil drawing on white wove paper, 13⅜ x 8¼″ (34 x 21 cm). Dortu D3640. Collection Dr. and Mrs. Martin L. Gecht, Chicago.*

90. ***Yvette Guilbert.*** 1894. Lithograph, 13⁷⁄₁₆ x 7¹⁵⁄₁₆″ (34.2 x 20.2 cm). Wittrock 73, proof before text. Delteil 83, first state. Staatliche Museen, Preussischer Kulturbesitz, Kupferstichkabinett, Berlin.*

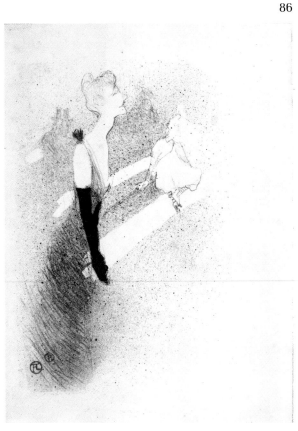

91. ***Yvette Guilbert Taking a Curtain Call*** (Yvette Guilbert saluant). 1894.
Crayon, watercolor, and oil on tracing paper mounted on cardboard, 16⅜ x 9″ (41.6 x 22.8 cm).
Dortu A214.
Museum of Art, Rhode Island School of Design. Gift of Mrs. Murray S. Danforth.*

92. ***Yvette Guilbert.*** 1894.
Lithograph, 13⅜ x 6⁹⁄₁₆″ (34 x 16.7 cm).
Wittrock 85, trial proof. Delteil 95, second state.
Bibliothèque Nationale, Paris.*

Yvette Guilbert (1865–1944) began her career as a singer in 1887. By 1890, at the Divan Japonais, she had invented her distinctive style of recitation and dress—the long black gloves became her trademark and were worn throughout her entire career. She quickly became the outstanding performer of the *café-concert* circuit. In the early 1900s she changed the focus of her repertoire to old French songs. One of her last roles was Mrs. Peachum in Bertolt Brecht's *Threepenny Opera* in 1937.

86

87

88

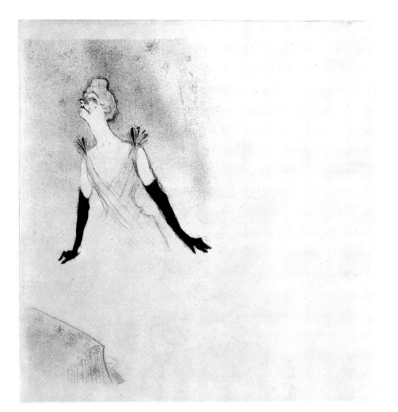

90

89

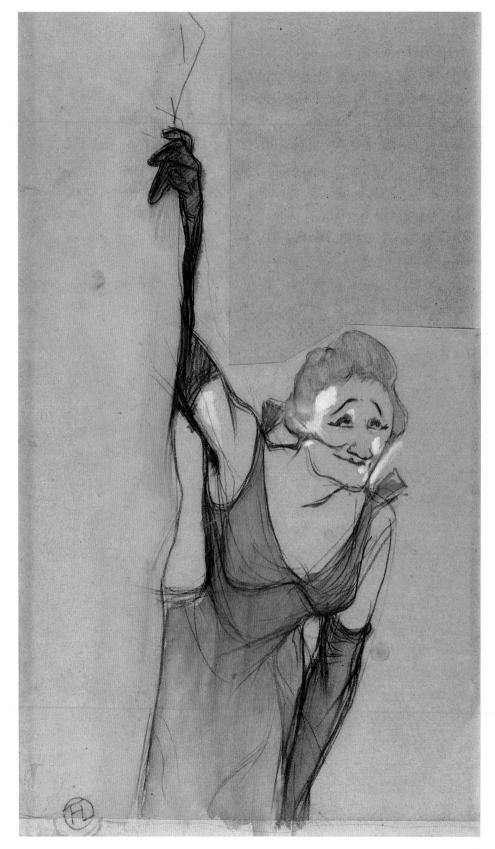

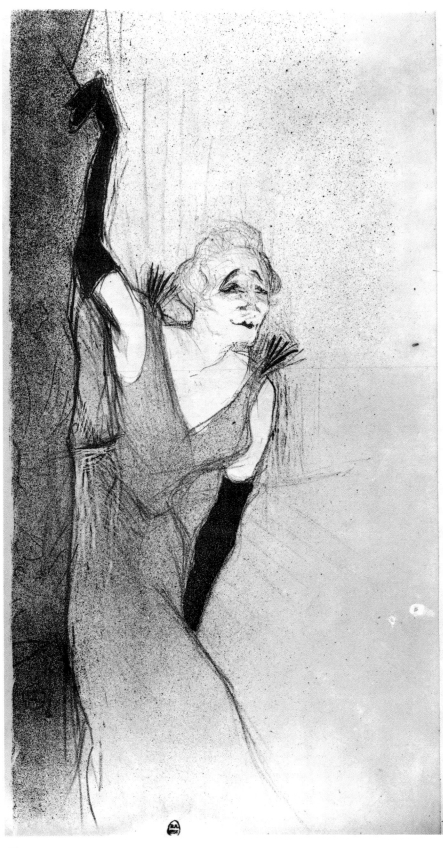

NIB supplement accompanying *La revue blanche,* January 1, 1895. [93–94.]

93. Recto:
The Amateur Photographer (Le photographe-amateur). 1894.
Lithograph, 10³⁄₁₆ x 9⁷⁄₁₆″ (25.9 x 24 cm).
Wittrock 86, regular edition. Delteil 99, second state.*
Footit and Chocolat (Footit et Chocolat). 1894.
Lithograph, 7⁷⁄₈ x 9⁵⁄₈″ (20 x 24.5 cm).
Wittrock 87, regular edition. Delteil 98, second state.
The Art Institute of Chicago. The Charles F. Glore Collection.*

94. Verso:
Anna Held in Toutes ces Dames au Théâtre (Anna Held dans *Toutes ces Dames au Théâtre*). 1894.
Lithograph, 13¹⁄₁₆ x 8⁹⁄₁₆″ (33.2 x 21.8 cm).
Wittrock 88, regular edition. Delteil 100, second state.
The Museum of Modern Art, New York. Gift of Eastman Kodak Company, 1951.*

> Anna Held (1865–1918) was an actress of Polish and French origin who was a leading player in the Yiddish Theater Company in Paris until 1895. She also performed at the Eldorado and at the Scala. In 1896 she moved to New York, where she played mainly in musical comedies. She married Florenz Ziegfeld, the founder of the Ziegfeld Follies.

95. **Footit and Chocolat** (Footit et Chocolat). 1894.
Lithograph, 9⁷⁄₁₆ x 9¾″ (24 x 24.7 cm).
Wittrock 87, trial proof. Delteil 98, first state.
Private collection.*

> George Footit (1864–1921) was an English clown who played at the Nouveau Cirque. His stooge was Chocolat, a black man from Bilbao.

96. **Program for Le Chariot de Terre Cuite** (Programme pour *Le Chariot de Terre Cuite*). 1895.
Lithograph, printed in color, 17⁵⁄₁₆ x 11⅛″ (44 x 28.2 cm).
Wittrock 89, theater program edition. Delteil 77, second state.
Collection Mr. and Mrs. Herbert D. Schimmel, New York.

> *Le Chariot de Terre Cuite* was presented at the Théâtre de l'Oeuvre in 1894. Victor Barrucand wrote a French adaptation of this classic Hindu drama of ancient India, and Lautrec designed the stage set for Act I.

97. ***Mr. and Mrs. Alexandre Natanson Invitation*** (Invitation Mr. and Mrs. Alexandre Natanson). 1895.
Lithograph, 10¹⁄₁₆ x 6⅛″ (25.6 x 15.5 cm).
Wittrock 90, with text. Delteil 101, second state.
Staatliche Museen, Preussischer Kulturbesitz, Kupferstichkabinett, Berlin.*

98. ***Bouillabaisse, Sescau Menu*** (La Bouillabaisse, menu Sescau). 1895.
Lithograph, 9¹⁄₁₆ x 5¹¹⁄₁₆″ (23.1 x 14.5 cm).
Wittrock 94. Delteil 144.
Boston Public Library. Albert H. Wiggin Collection.

99. Cover for ***L'Estampe originale*** (Couverture de *L'Estampe originale*). 1895.
Lithograph, printed in color, 23 x 32⁹⁄₁₆″ (58.5 x 82.7 cm).
Wittrock 96, regular edition. Delteil 127.
The Metropolitan Museum of Art, New York. Rogers Fund, 1922.*

Depicted here is Misia Natanson in a theater box over-looking the backstage curtain of the Théâtre de l'Oeuvre for a performance of *Le Chariot de Terre Cuite.*

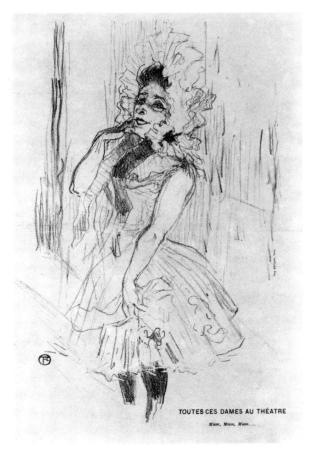

TOUTES CES DAMES AU THÉÂTRE
Miam, Miam, Miam....

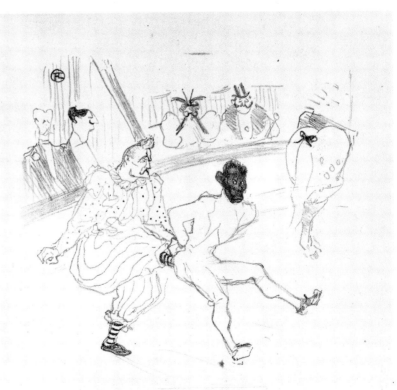

94

95

American

and other drinks

M^r and M^{rs} Alexandre
Natanson will be very
pleased of your company
at 8 h ¼ on the February
1895.

R. S. V. P.

60, Avenue du Bois de Boulogne.

97

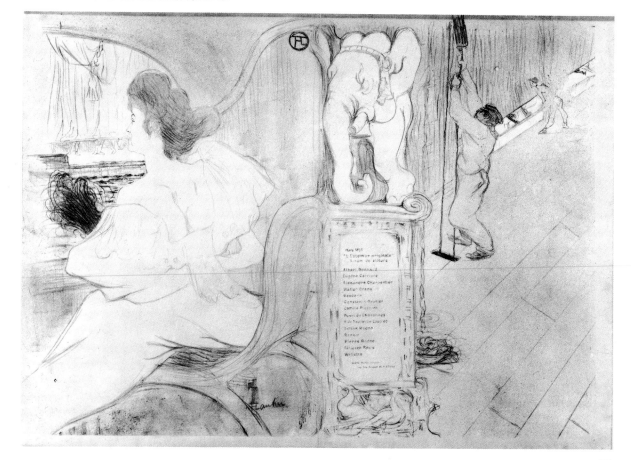

148

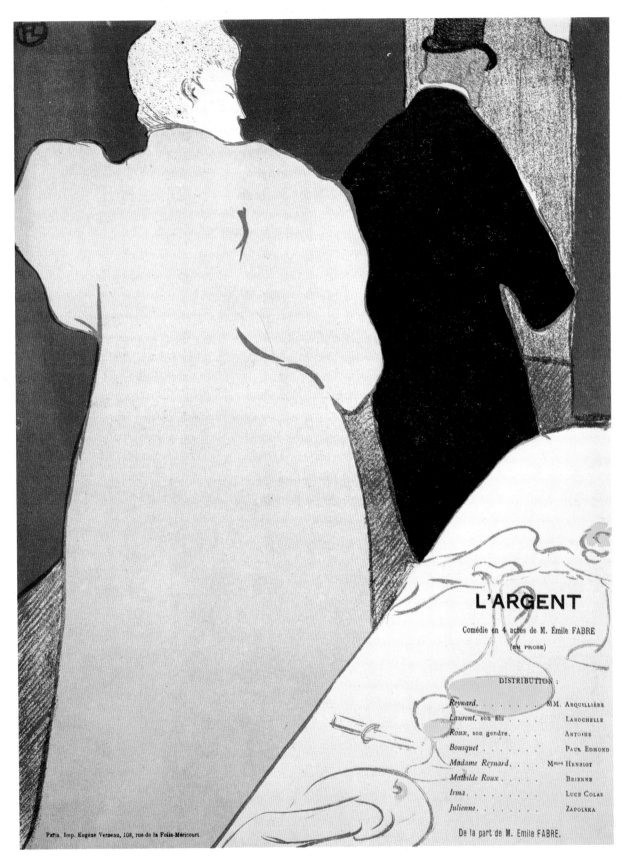

L'ARGENT

Comédie en 4 actes de M. Émile FABRE

(EN PROSE)

DISTRIBUTION :

Reynard. MM. ARQUILLIÈRE
Laurent, son fils LAROCHELLE
Roux, son gendre. ANTOINE
Bousquet PAUL EDMOND
Madame Reynard. M^{mes} HENRIOT
Mathilde Roux BRIENNE
Irma LUCE COLAS
Julienne. ZAPOLSKA

De la part de M. Émile FABRE.

Paris. Imp. Eugène Verneau, 108, rue de la Folie-Méricourt.

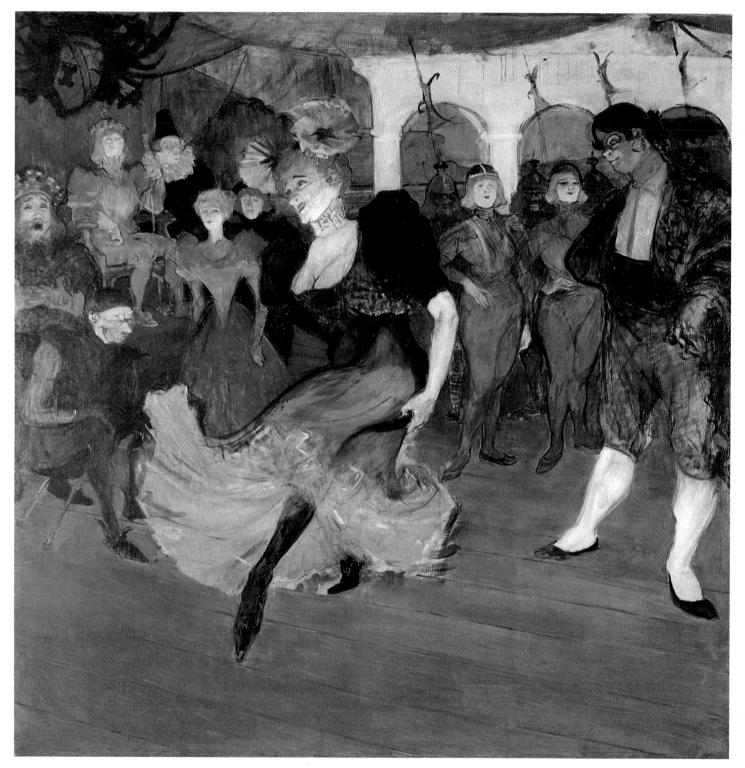

101

100. ***Program for L'Argent*** (Programme pour *L'Argent*). 1895.
 Lithograph, printed in color, 12⁹⁄₁₆ x 9⅜″ (31.9 x 23.9 cm).
 Wittrock 97, theater program edition. Delteil 15,
 second state.
 Boston Public Library. Albert H. Wiggin Collection.*

101. ***Chilpéric.*** 1896.
 Oil on canvas, 57⅛ x 59″ (145 x 150 cm).
 Dortu P627.
 Collection Mrs. John Hay Whitney, New York.*
 Marcelle Lender (Anne-Marie Marcelle Bastien;
 1862–1926) made her debut at the Théâtre Montmartre
 at the age of 16 and then appeared at the Gymnase. Her

greatest success was in 1895 at the Variétés in Hervé's
operetta *Chilpéric*, in which she played the role of
Galswinthe.

Bust of Mademoiselle Marcelle Lender (Mademoiselle
Marcelle Lender, en buste). 1895.

102. Lithograph, 17³⁄₁₆ x 13⅛″ (43.7 x 33.3 cm).
 Wittrock 99, first state. Delteil 102, first state.
 The Metropolitan Museum of Art, New York. Harris
 Brisbane Dick Fund, 1928.

103. Lithograph and watercolor, 17⅛ x 12⁹⁄₁₆″ (43.5 x 32 cm).
 Wittrock 99, first state. Delteil 102, first state. Dortu A231.
 Bibliothèque Nationale, Paris.*

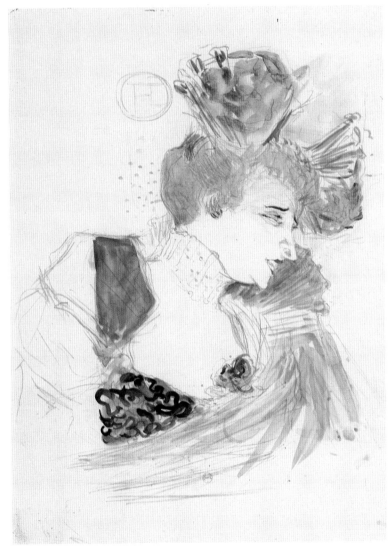

103

104

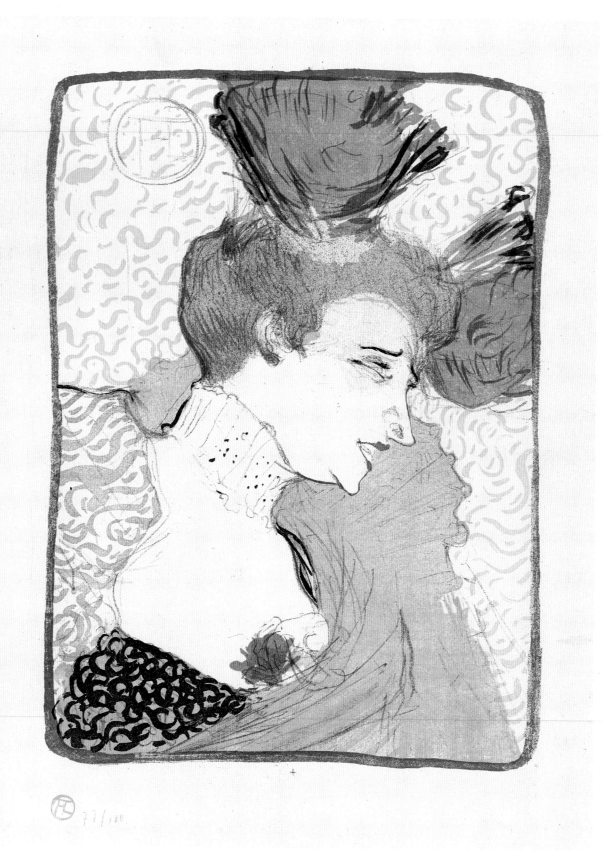

104. Lithograph, 12¹⁵⁄₁₆ x 9½" (32.9 x 24.2 cm).
Wittrock 99, third state. Delteil 102, second state.
National Gallery of Art, Washington, D.C. Rosenwald
Collection, 1947.*

105. Lithograph, printed in color, 12¹⁵⁄₁₆ x 9⅝" (32.9 x 24.4 cm).
Wittrock 99, fourth state, *Pan* French edition.
Delteil 102, third state.
The Museum of Modern Art, New York. Gift of Abby
Aldrich Rockefeller, 1946.*

106. Lithograph, printed in color, 12¹⁵⁄₁₆ x 9⅝" (32.9 x 24.4 cm).
Wittrock 99, fourth state, *Pan* German edition. Delteil 102,
second state.
The Museum of Modern Art, New York. Given anony-
mously, 1960.

107. ***Mademoiselle Marcelle Lender, Standing*** (Mademoiselle
Marcelle Lender, debout). 1895.
Lithograph, printed in color, 14⁷⁄₁₆ x 9⁹⁄₁₆" (36.7 x 24.3 cm).
Wittrock 101, second state, second edition. Delteil 103.
The Museum of Modern Art, New York. Gift of Abby
Aldrich Rockefeller, 1946.

108. ***Lender Dancing the Bolero in Chilpéric*** (Lender dansant
le pas du boléro dans *Chilpéric*). 1895.
Lithograph, 14⁹⁄₁₆ x 10¹⁵⁄₁₆" (37 x 27 cm).
Wittrock 103, proof. Delteil 104.
Bibliothèque Nationale, Paris.*

108

109

109. **Lender from the Back, Dancing the Bolero in Chilpéric**
(Lender de dos, dansant le boléro dans *Chilpéric*). 1895.
Lithograph, 14¾ x 10⁷⁄₁₆″ (37.5 x 26.5 cm).
Wittrock 105, published edition. Delteil 106.
Boston Public Library. Albert H. Wiggin Collection.*

110. **Lender Bowing** (Lender saluant). 1895.
Lithograph, 12⁹⁄₁₆ x 10⅜″ (32 x 26.4 cm).
Wittrock 106, published edition. Delteil 107.
Boston Public Library. Albert H. Wiggin Collection.*

111. **Zimmerman and His Machine** (Zimmerman et sa
machine). 1895.
Lithograph, 9¹⁄₁₆ x 5⅜″ (23 x 13.6 cm).
Wittrock 111, proof. Delteil 145, first state.
Boston Public Library. Albert H. Wiggin Collection.

112. **Le bézigue.** 1895.
Lithograph, oil paint, and watercolor, 12⅛ x 10⁷⁄₁₆″
(30.8 x 26.5 cm).
Wittrock 112. Delteil 115. Dortu A226.
The Art Institute of Chicago. The Clarence Buckingham
Collection.*

> *Le bézigue* was a novella by Romain Coolus (see
> Cat. 130).

113. **Cecy Loftus.** 1895.
Lithograph, 14⁹⁄₁₆ x 9¹³⁄₁₆″ (37 x 25 cm).
Wittrock 113, published edition. Delteil 116.
Staatliche Museen, Preussischer Kulturbesitz,
Kupferstichkabinett, Berlin.*

> Cecy Loftus (Marie Cecilia McCarthy) was born in 1876
> in Glasgow, the daughter of a well-known vaudeville
> performer. Her appearance as a mimic in the Oxford
> Music Hall in 1893 made her a star. In 1899 she went to
> the United States and performed her imitations of well-
> known actresses.

Miss May Belfort, Large Plate (Miss May Belfort, grande
planche). 1895.

114. Lithograph, printed in color, 20¹⁵⁄₁₆ x 16¾″ (53.3 x 42.5 cm).
Wittrock 114, third state, trial proof ii. Delteil 119.
Museum of Fine Arts, Boston. Gift of Mrs. Charles Gaston
Smith's Group.

115. Lithograph, printed in color, 21⅜ x 16¾″ (54.3 x 42.6 cm).
Wittrock 114, third state, second edition. Delteil 119,
first state.
Boston Public Library. Albert H. Wiggin Collection.*

> May Belfort (May Egan) was a singer of Irish origin who
> began her career in London music halls in 1890 and was
> discovered in Paris in 1893. In performance she always
> dressed like a little girl and carried a black kitten. Her
> appearance at the Petit Casino was brief, and afterward
> she disappeared from the Paris stage.

116. **Miss May Belfort Bowing** (Miss May Belfort saluant).
1895.
Lithograph, 14¾ x 10¼″ (37.5 x 26 cm).
Wittrock 115, published edition. Delteil 117.
National Gallery of Art, Washington, D.C. Rosenwald
Collection, 1952.

110

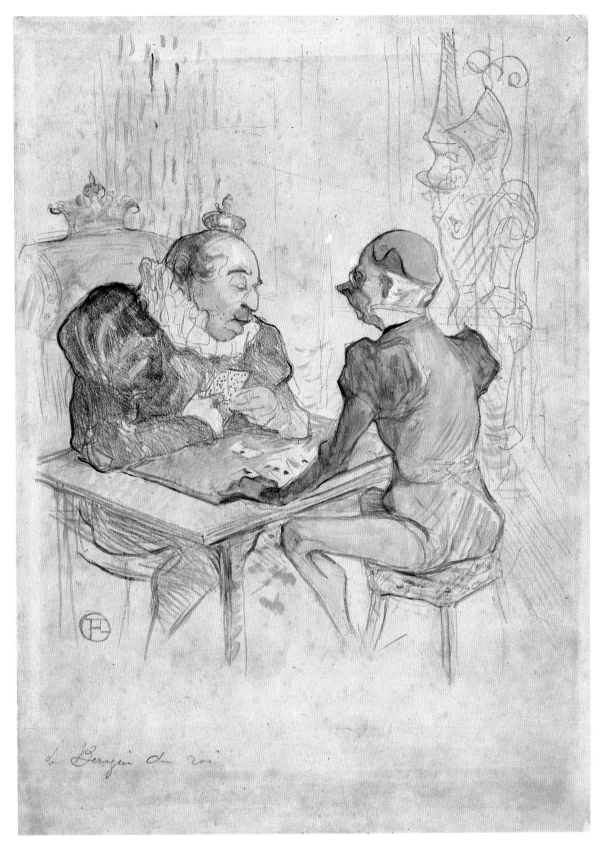

Le Berger du roi

112

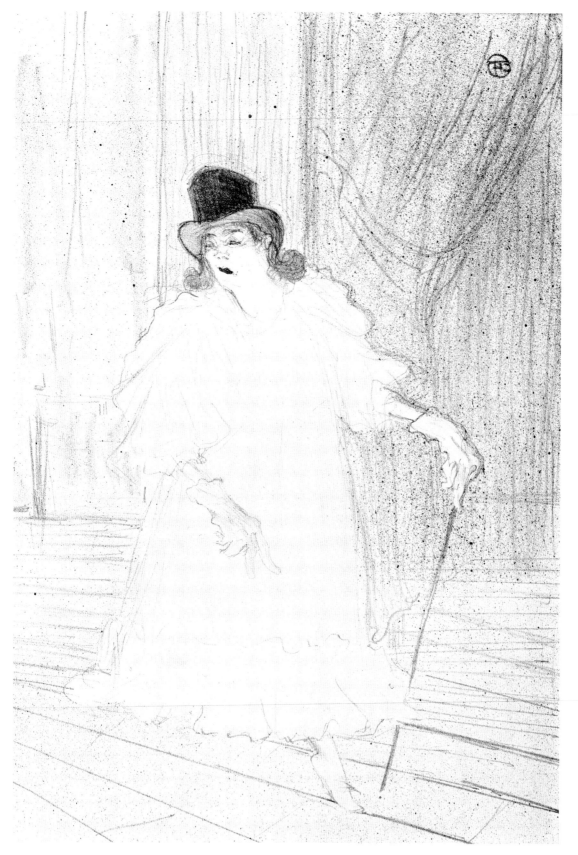

113

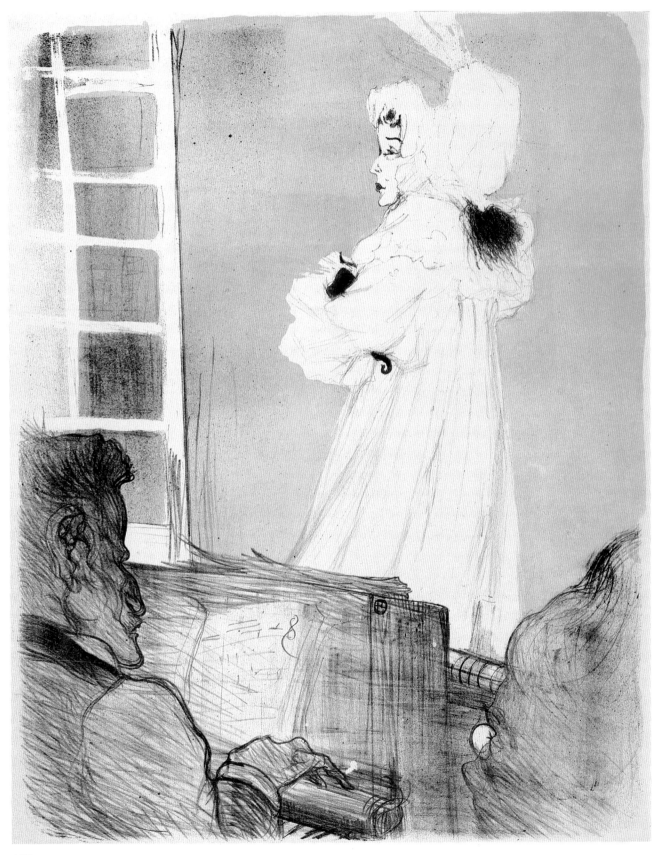

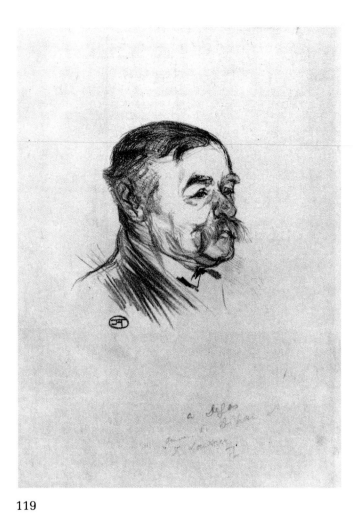

119

120

124

125

117. **Miss May Belfort Bareheaded** (Miss May Belfort en cheveux). 1895.
Lithograph, 12¹¹⁄₁₆ x 8¹¹⁄₁₆″ (32.3 x 22 cm).
Wittrock 116, published edition. Delteil 118.
Boston Public Library. Albert H. Wiggin Collection.

118. **Miss May Belfort at the Achille Bar** (Miss May Belfort au Bar Achille). 1895.
Lithograph, 12¹⁵⁄₁₆ x 10⅜″ (33 x 26.3 cm).
Wittrock 119, published edition. Delteil 123.
The Museum of Modern Art, New York. Gift of Abby Aldrich Rockefeller, 1946.

119. **Désiré Dihau.** 1895.
Lithograph, 5¹¹⁄₁₆ x 5⅝″ (14.4 x 14.3 cm).
Wittrock 123; inscribed à Degas souvenir de Dihau et de Lautrec. Delteil 176.
The Art Institute of Chicago. The Mr. and Mrs. Carter H. Harrison Collection.*

Melodies by Désiré Dihau (Mélodies de Désiré Dihau). 1895. [120–125.]
Six lithographs from a series of 14 created to illustrate song sheets for Désiré Dihau's music with lyrics by Jean Richepin. Twenty impressions of each were printed without text before they were published as song sheets by C. Joubert, Paris. These popular images were reprinted several times, most recently in 1978.

Jean Richepin (1849–1926) was a French poet and dramatist, famous during his own time for his plays, which were an important aspect of his work then, but are now forgotten. They were usually performed at the Comédie-Française. Lautrec's last poster (Cat. 299) announces his play La Gitane at Théâtre Antoine.

120. **Listening to the Rain** (Ce que dit la pluie). 1895.
Lithograph, 6½ x 7⁵⁄₁₆″ (16.6 x 18.6 cm).
Wittrock 126, first edition. Delteil 131, first state.
National Gallery of Art, Washington, D.C. Rosenwald Collection, 1952.*

121. **The Butterflies** (Les papillons). 1895.
Lithograph, 8⅜ x 7⅞″ (21.3 x 20 cm).
Wittrock 128, first edition. Delteil 133, first state.
Collection Mr. and Mrs. Herbert D. Schimmel, New York.

122. **Pickled Herring** (L'Hareng saur). 1895.
Lithograph, 9⅛ x 8⁷⁄₁₆″ (23.2 x 21.4 cm).
Wittrock 129, first edition. Delteil 134, first state.
National Gallery of Art, Washington, D.C. Rosenwald Collection, 1952.

123. **Shooting Stars** (Etoiles filantes). 1895.
Lithograph, 10⁷⁄₁₆ x 8¼″ (26.5 x 20.9 cm).
Wittrock 131, second state, first edition. Delteil 136, second state.
Collection Mr. and Mrs. Herbert D. Schimmel, New York.

124. **Nocturnal Sea** (Oceano Nox). 1895.
Lithograph, 10⅛ x 8⅛″ (25.8 x 20.6 cm).
Wittrock 132, first edition. Delteil 137, first state.
National Gallery of Art, Washington, D.C. Rosenwald Collection, 1952.*

125. **Springtime** (Floréal). 1895.
Lithograph, 8¹⁵⁄₁₆ x 7⁵⁄₁₆″ (22.8 x 18.6 cm).
Wittrock 134, first edition. Delteil 139, first state.
National Gallery of Art, Washington, D.C. Rosenwald
Collection, 1952.*

126. **The Rabbit's Waltz** (La valse des lapins). 1895.
Lithograph, 12½ x 9⁷⁄₁₆″ (31.7 x 24 cm).
Wittrock 138, proof before first edition. Delteil 143.
National Gallery of Art, Washington, D.C. Rosenwald
Collection, 1947.*

127. **Napoléon.** 1895.
Lithograph, printed in color, 23⁵⁄₁₆ x 18⅛″ (59.3 x 46 cm).
Wittrock 140, published edition. Delteil 358.
The Museum of Modern Art, New York. Gift of Abby
Aldrich Rockefeller, 1946.*

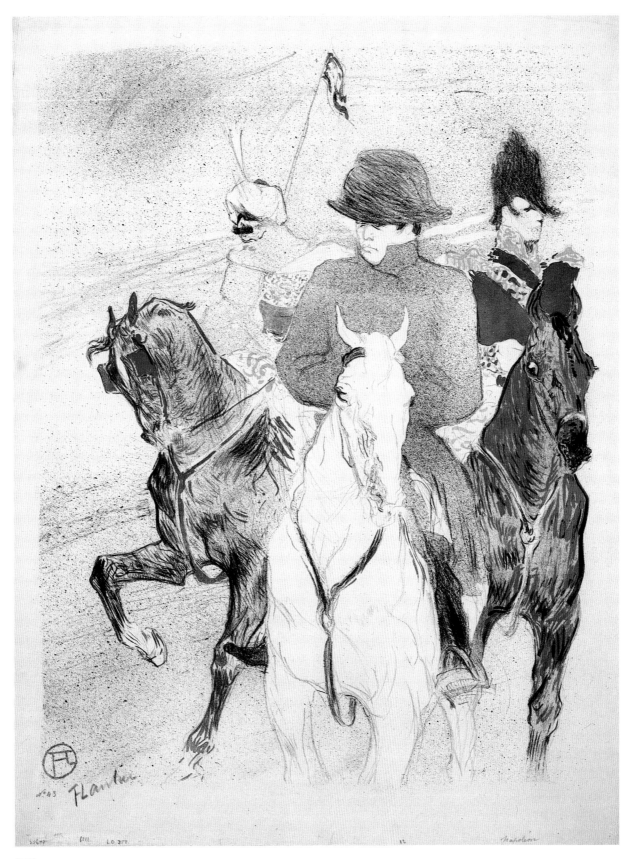

128. **At the Velodrome** (Au vélodrome). 1895.
Lithograph, 13⅜ x 17¹⁵⁄₁₆″ (34 x 45.5 cm).
Wittrock 142. Delteil 147. Unpublished.
Private collection.*

129. **At the Ice Skating Rink** (Au palais de glace). 1895.
Lithograph, 12⁹⁄₁₆ x 9¹⁵⁄₁₆″ (32 x 25.3 cm).
Wittrock 144. Delteil 190. Unpublished.
The Art Institute of Chicago. The Clarence Buckingham
Collection.*

130. **Oscar Wilde and Romain Coolus** (Oscar Wilde et Romain
Coolus). 1896.
Lithograph, 11¹⁵⁄₁₆ x 19⁵⁄₁₆″ (30.3 x 49 cm).
Wittrock 146, theater program edition. Delteil 195,
fourth state.
Collection Mr. and Mrs. Herbert D. Schimmel, New York.*
Oscar Wilde (1854–1900) was an Irish poet, wit,
aesthete, dramatist, and novelist, who went to Paris after
his release from imprisonment on a charge of sodomy.
There he lived under the name Sebastian Melmoth, and
wrote *The Ballad of Reading Gaol.*
Romain Coolus (René Weil; 1868–1952) was a poet
and close friend of Lautrec.

129

130

163

131. ***Leaving the Theater*** (Sortie de théâtre). 1896.
Lithograph, 12⁹⁄₁₆ x 10⁷⁄₁₆″ (32 x 26.5 cm).
Wittrock 147, published edition. Delteil 169.
The Brooklyn Museum, New York.*

132. ***The Theater Box—Faust*** (La loge—*Faust*). 1896.
Lithograph, 14⁵⁄₈ x 10⁹⁄₁₆″ (37.2 x 26.8 cm).
Wittrock 148, published edition. Delteil 166.
The Art Institute of Chicago. The Charles F. Glore
Collection.*

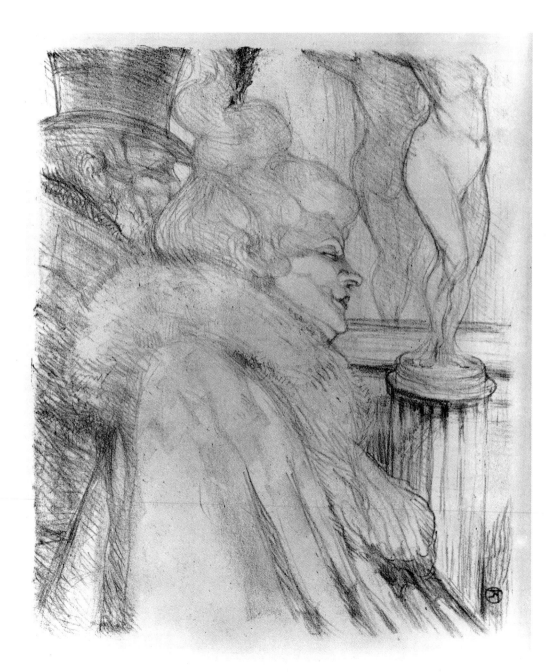

131

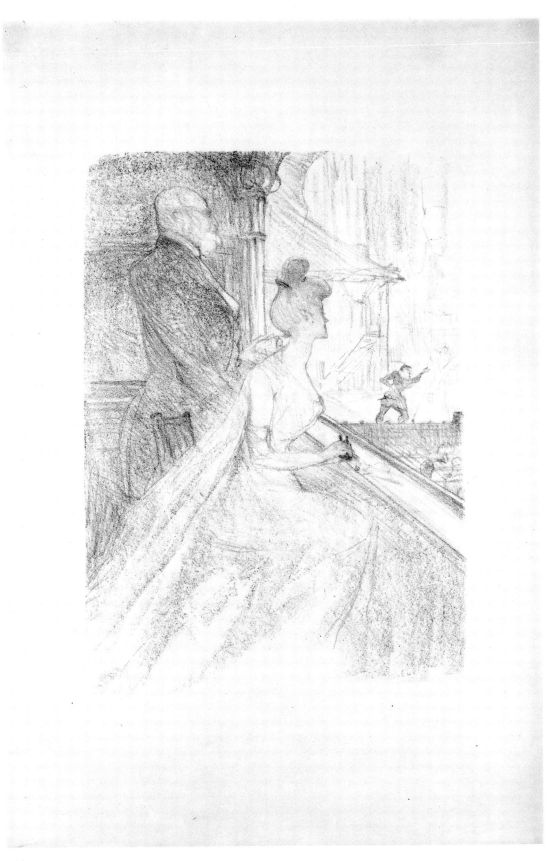

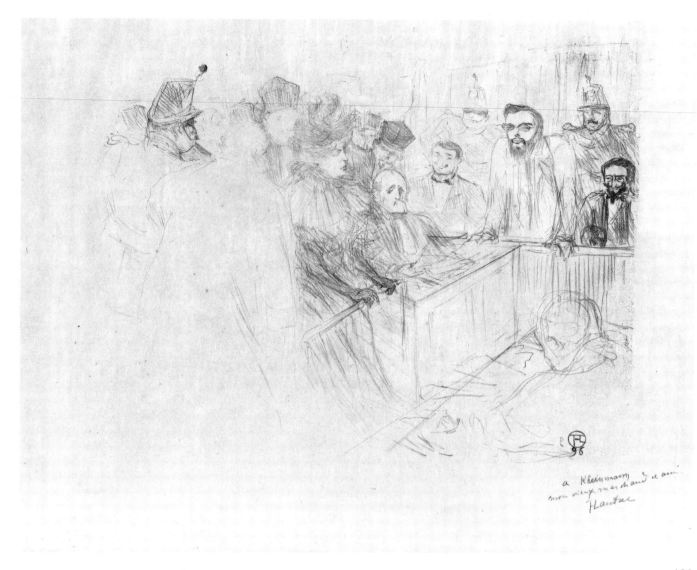

133

Lebaudy Trial, Testimony of Mademoiselle Marsy (Procès Lebaudy, déposition de Mademoiselle Marsy). 1896.

133. Lithograph, 18¹¹⁄₁₆ x 23¹⁵⁄₁₆″ (47.5 x 60.8 cm).
Wittrock 152, first state, first edition; inscribed *à Klein-mann mon vieux marchand et ami*. Delteil 194, first state.
National Gallery of Art, Washington, D.C. Rosenwald Collection, 1952.*

134. Lithograph, 12 x 7½″ (30.5 x 19 cm).
Wittrock 152, third state, third edition. Delteil 194, third state.
National Gallery of Art, Washington, D.C. Rosenwald Collection, 1952.

Max Lebaudy was a rich young man whose associates, after his early death, were accused of blackmailing him.

135. *White and Black* (Blanche et noire). 1896.
Lithograph, 17¹³⁄₁₆ x 11½″ (45.3 x 29.3 cm).
Wittrock 153, published edition. Delteil 171.
The Art Institute of Chicago. The Clarence Buckingham Collection.*

136. *Slumber* (Le sommeil). 1896.
Sanguine drawing on transparent paper, 8 x 10½″ (20.3 x 26.6 cm).
Dortu D4266.
Museum Boymans–van Beuningen, Rotterdam.*

137. *Slumber* (Le sommeil). 1896.
Lithograph, 9¹⁄₁₆ x 12⅝″ (23 x 32.1 cm).
Wittrock 154, published edition. Delteil 170.
The Art Institute of Chicago. The Mr. and Mrs. Carter H. Harrison Collection.*

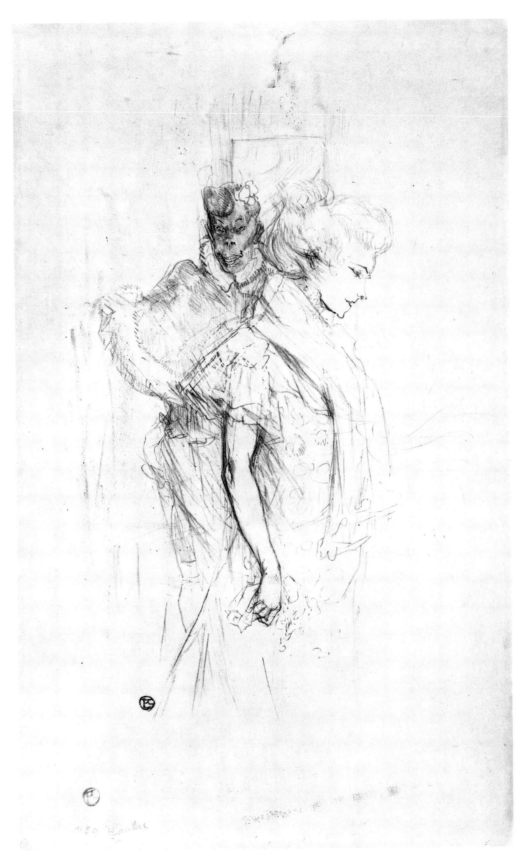

135

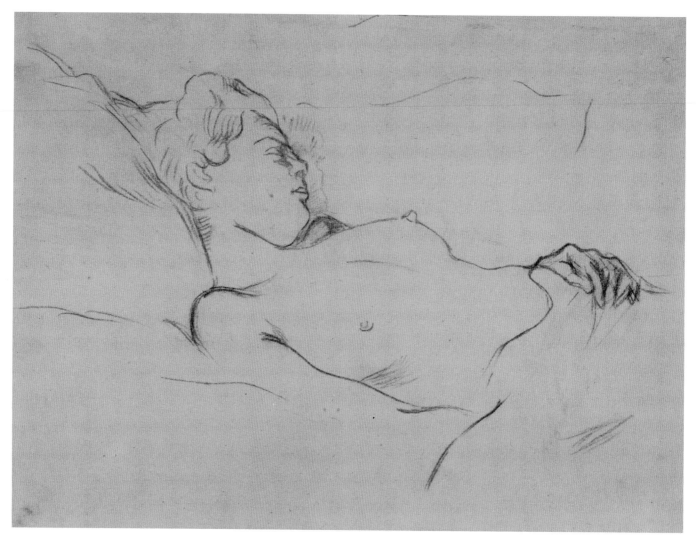

136

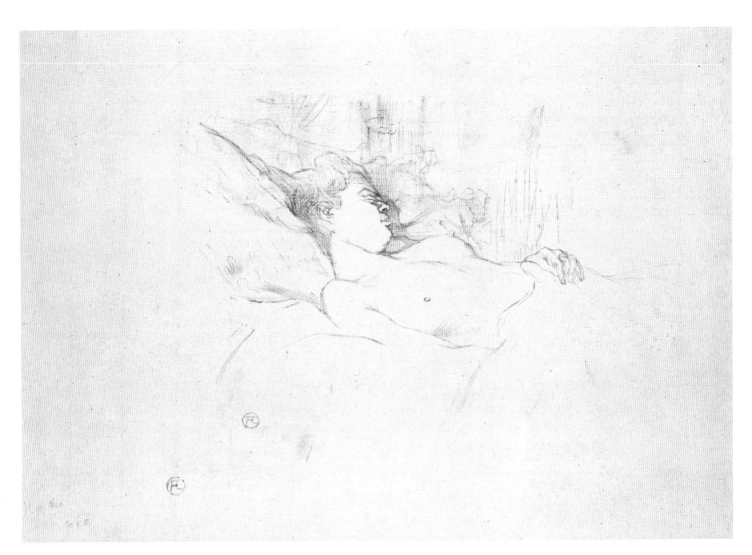

137

Elles. 1896. [139–145; 147–158.]
The *Elles* series consists of a lithographic cover, frontispiece, and ten color lithographs printed on paper with the watermark *G. Pellet/T. Lautrec,* specially made for this portfolio. Published in an edition of 100 by Gustave Pellet, Paris, April 1896.

Lautrec chose this title (which translates literally as them—feminine gender) to refer to the private world of the prostitutes who inhabited the luxurious brothels in Paris. Lautrec periodically lived in these establishments to objectively record the daily lives of the women.

138. *La Toilette—Woman Combing Her Hair* (La toilette—celle qui se peigne). 1891.
Oil on cardboard, 22⅞ x 18¼″ (58 x 46 cm).
Dortu P389.
Visitors of the Ashmolean Museum of Art and Archeology, Oxford.*

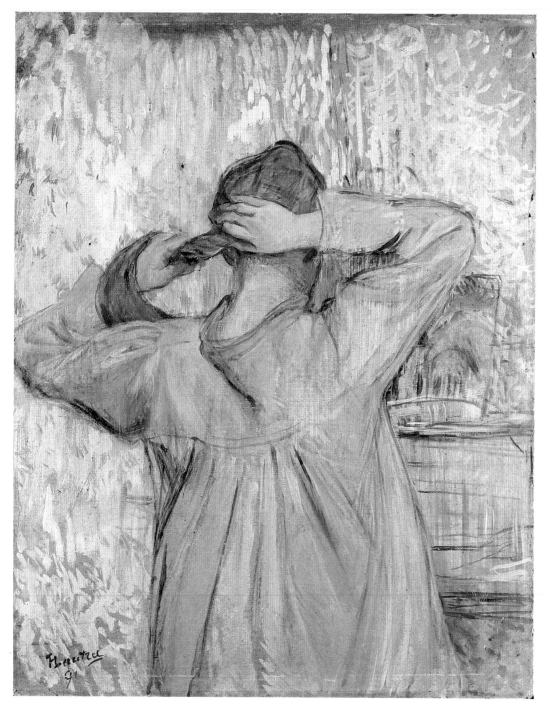

138

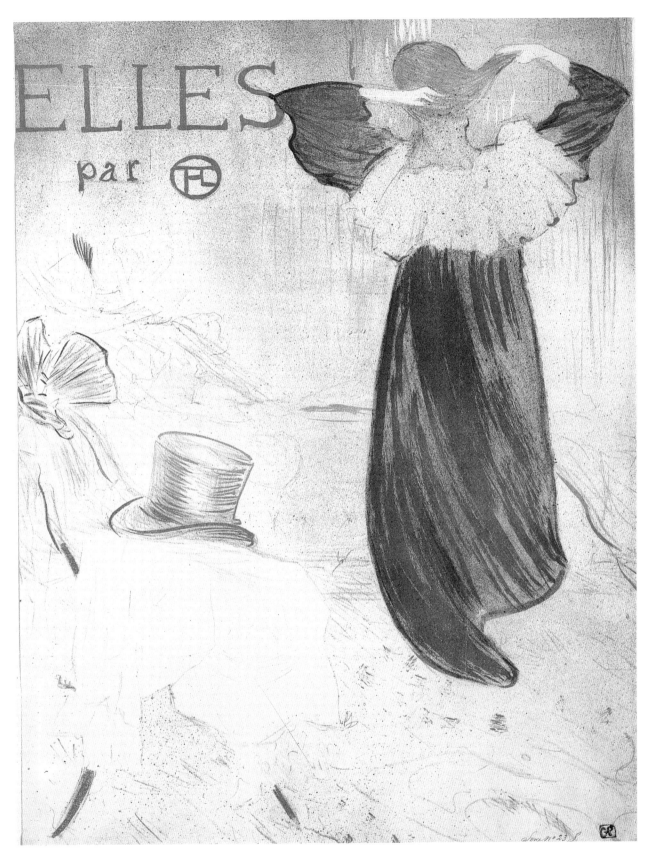

139. Cover for **Elles** (Couverture, *Elles*). 1896.
Lithograph, 22⁹⁄₁₆ x 18⁷⁄₁₆″ (57.3 x 46.8 cm).
Wittrock 155, first state. Delteil 179.
The Museum of Modern Art, New York. Gift of Abby
Aldrich Rockefeller, 1946.

140. Frontispiece for **Elles** (Frontispice, *Elles*). 1896.
Lithograph, printed in color, 20⅝ x 15⅞″ (52.4 x 40.4 cm).
Wittrock 155, second state. Delteil 179.
The Museum of Modern Art, New York. Gift of Abby
Aldrich Rockefeller, 1946.*

Poster for **Elles** (Affiche, *Elles*). 1896.

141. Lithograph, printed in color, 12¹¹⁄₁₆ x 18¼″ (57.7 x 46.3 cm).
Wittrock 155, third state. Delteil 179.
Collection Dr. Henry M. Selby, New York.

142. Second copy: The Museum of Modern Art, New York.
Gift of Mr. and Mrs. Richard Rodgers, 1961.

143. **The Seated Clowness** (Mademoiselle Cha-u-ka-o)
(La clownesse assise). 1896.
Lithograph, printed in color, 20¾ x 15¹⁵⁄₁₆″ (52.7 x 40.5 cm).
Wittrock 156, published edition. Delteil 180.
The Museum of Modern Art, New York. Gift of Abby
Aldrich Rockefeller, 1946.*
(see Cat. 170)

144. **Woman with Tray—Breakfast** (Femme au plateau—Petit
déjeuner). 1896.
Lithograph, 15¹³⁄₁₆ x 20½″ (40.2 x 52 cm).
Wittrock 157, published edition. Delteil 181.

Harvard University Art Museums, Fogg Art Museum,
Cambridge, Massachusetts. Museum Purchase.*

145. **Sleeping Woman—Awakening** (Femme couchée—
Reveil). 1896.
Lithograph, 15¹⁵⁄₁₆ x 20¹¹⁄₁₆″ (40.5 x 52.5 cm).
Wittrock 158, published edition. Delteil 182.
Harvard University Art Museums, Fogg Art Museum,
Cambridge, Massachusetts. Museum Purchase.*

146. **Woman at the Tub** (Femme au tub). 1896.
Sanguine drawing on white wove paper, 15⅜ x 20″
(39 x 50.8 cm).
Dortu D4121.
The Minneapolis Institute of Arts. Bequest of
P. D. McMillan, 1961.*

Woman at the Tub—The Tub (Femme au tub—Le tub).
1896.

147. Lithograph, impression of key stone in olive green.
Wittrock 159, trial proof i. Delteil 183.
Bibliothèque Nationale, Paris.*

148. Lithograph, impression of beige-olive stone.
Wittrock 159, trial proof ii. Delteil 183.
Bibliothèque Nationale, Paris.

149. Lithograph, impression of key stone in olive green plus
five color stones.
Wittrock 159, trial proof iii. Delteil 183.
Bibliothèque Nationale, Paris.

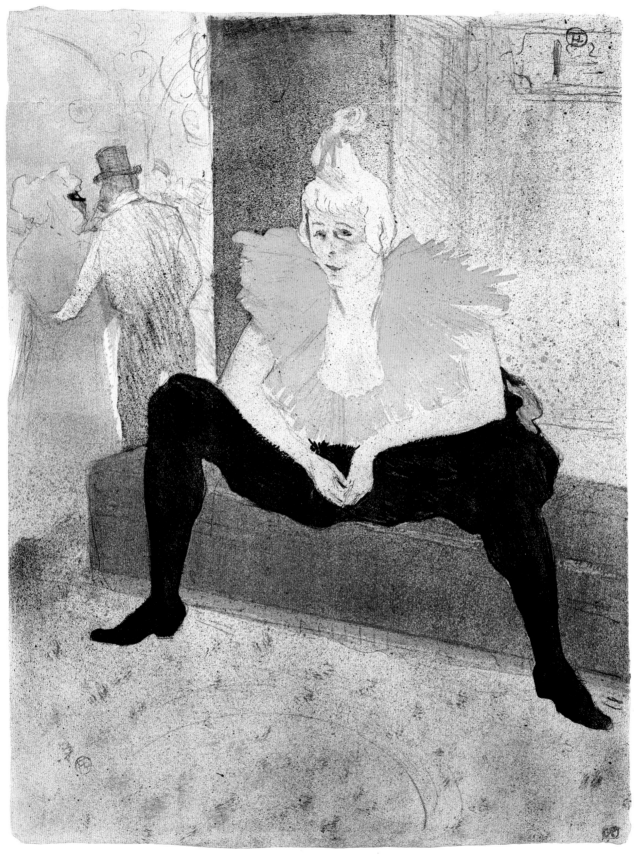

143

144

145

146

147

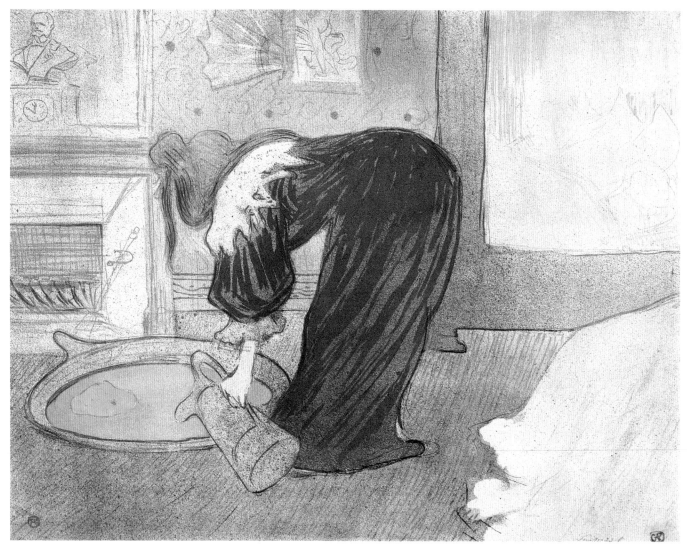

150. Lithograph, impression of key stone in olive green plus four color stones with outlines of woman and picture frame redrawn in crayon and inscribed *à mettre...jaune*. Wittrock 159, trial proof iv. Delteil 183. Kunsthalle, Bremen.

151. Lithograph, impression of key stone in olive green plus five color stones. Wittrock 159, trial proof vi. Delteil 183. Bibliothèque Nationale, Paris.

152. Lithograph, printed in five colors, 15¾ x 20¹¹⁄₁₆″ (40 x 52.5 cm). Wittrock 159, published edition, Delteil 183. Harvard University Art Museums, Fogg Art Museum, Cambridge, Massachusetts. Museum Purchase.*

153. ***Woman Washing Herself—The Toilette*** (Femme qui se lave—La toilette). 1896.

Lithograph, printed in color, 20¹¹⁄₁₆ x 15⅞″ (52.5 x 40.3 cm). Wittrock 160, published edition. Delteil 184. Harvard University Art Museums, Fogg Art Museum, Cambridge, Massachusetts, Museum Purchase.*

154. ***Woman with Mirror—The Hand Mirror*** (Femme à glace—La glace à main). 1896. Lithograph, printed in color, 20⁹⁄₁₆ x 15¾″ (52.2 x 40 cm). Wittrock 161, published edition. Delteil 185. The Museum of Modern Art, New York. Gift of Abby Aldrich Rockefeller, 1946.*

155. ***Woman Combing Her Hair—The Hairdo*** (Femme qui se peigne—La coiffure). 1896. Lithograph, printed in color, 20¹¹⁄₁₆ x 15⅞″ (52.5 x 40.3 cm). Wittrock 162, published edition. Delteil 186. The Museum of Modern Art, New York. Gift of Abby Aldrich Rockefeller, 1946.*

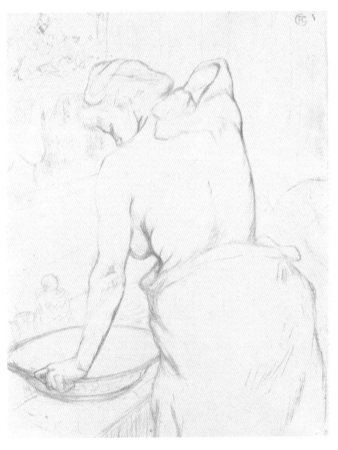

153

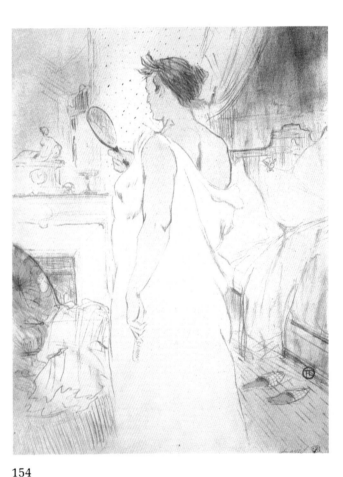

154

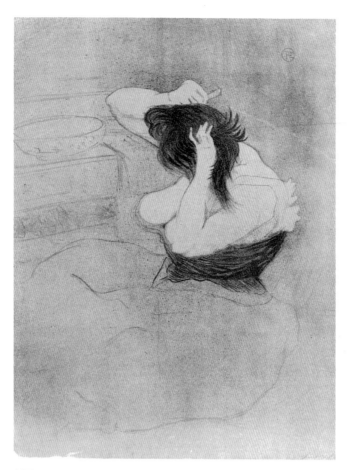

155

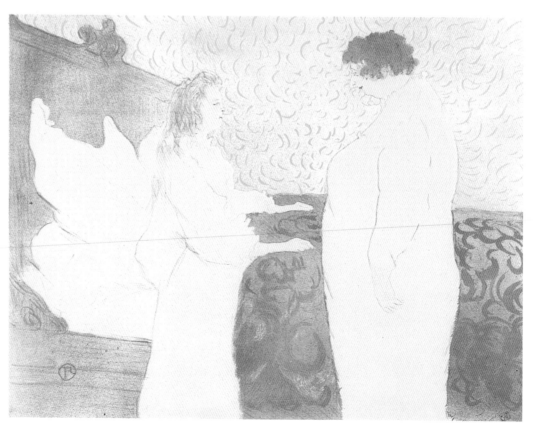

156

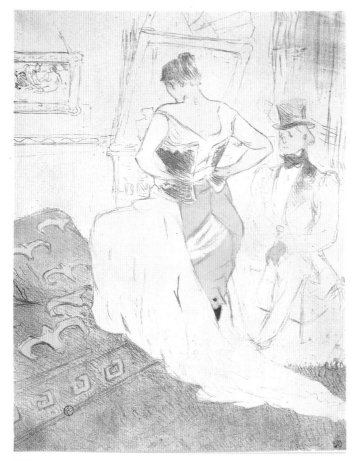

157

158

156. **Woman in Bed, Profile—Awakening** (Femme au lit, profil—Au petit lever). 1896.
Lithograph, printed in color, 15⅞ x 20½" (40.4 x 52 cm).
Wittrock 163, published edition. Delteil 187.
The Museum of Modern Art, New York. Gift of Abby Aldrich Rockefeller, 1946.*

157. **Woman in Corset—Conquest of Passage** (Femme en corset—Conquête de passage). 1896.
Lithograph, printed in color, 20¹¹⁄₁₆ x 15¹⁵⁄₁₆" (52.5 x 40.5 cm).
Wittrock 164, published edition. Delteil 188.
The Museum of Modern Art, New York. Gift of Abby Aldrich Rockefeller, 1946.*

158. **Reclining Woman—Laziness** (Femme sur le dos—Lassitude). 1896.
Lithograph, printed in color, 15¹³⁄₁₆ x 20⁹⁄₁₆" (40.2 x 52.3 cm).
Wittrock 165, published edition. Delteil 189.
The Museum of Modern Art, New York. Gift of Abby Aldrich Rockefeller, 1946.*

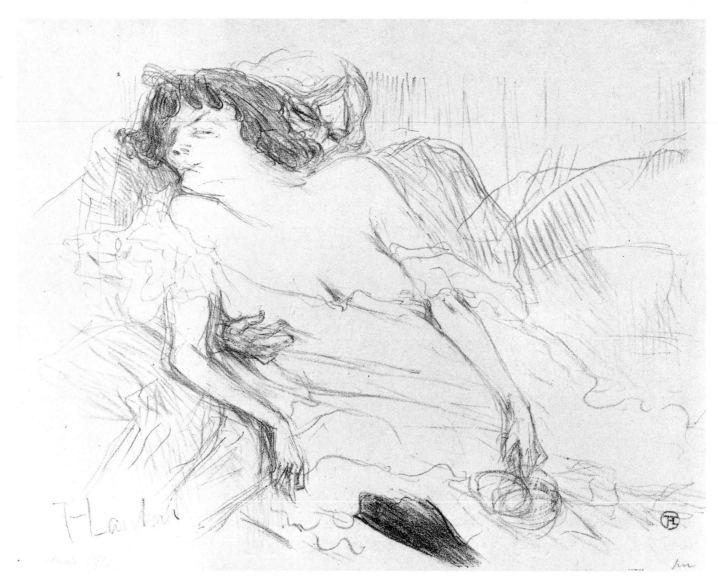

159

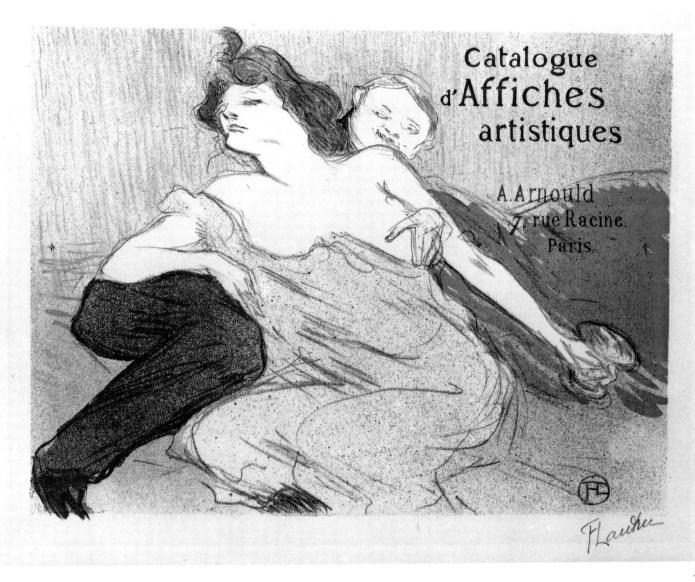

161

159. **Debauchery** (first study) (Débauche, première pensée).
1896.
Lithograph, 9³⁄₁₆ x 12¾" (23.4 x 32.4 cm).
Wittrock 166. Delteil 177. Unpublished.
Private collection.*

Debauchery (second plate) (Débauche, deuxième planche). 1896.

160. Lithograph, printed in color on silk, 9⅝ x 12¹¹⁄₁₆"
(24.4 x 32.3 cm).
Wittrock 167, second state, proof. Delteil 178.

Boston Public Library. Albert H. Wiggin Collection.

161. Lithograph, printed in color, 9⅝ x 12¹¹⁄₁₆" (24.4 x 32.3 cm).
Wittrock 167, second state, second edition. Delteil 178, second state.
Collection Mr. and Mrs. Herbert D. Schimmel, New York.*

162. **Supper in London** (Souper à Londres). 1896.
Lithograph, 12¼ x 14¼" (31.2 x 36.2 cm).
Wittrock 169, published edition. Delteil 167.
National Gallery of Art, Washington, D.C. Rosenwald Collection, 1952.*

163. ***At the Picton Bar, American Bar, rue Scribe*** (Au Bar
Picton, American Bar, rue Scribe). 1896.
Lithograph, 11¾ x 9⁷⁄₁₆″ (29.8 x 24 cm).
Wittrock 170, published edition. Delteil 173.
Boston Public Library. Albert H. Wiggin Collection.*

164. ***Menu for the Tarnais Dinner*** (Menu du dîner des
Tarnais). 1896.
Lithograph, 7⅜ x 7⅜″ (18.8 x 18.8 cm).
Wittrock 172. Delteil 197.
Private collection.*

165. ***A Merry Christmas.*** 1896.
Lithograph, 6¹¹⁄₁₆ x 5″ (17 x 12.8 cm).
Wittrock 173. Delteil 202.
Boston Public Library. Albert H. Wiggin Collection.*

166. ***The Swiss Guard, Menu*** (Le Suisse, menu). 1896.
Lithograph, 14⁹⁄₁₆ x 10⁷⁄₁₆″ (37 x 26.5 cm).
Wittrock 174, with menu text. Delteil 199, second state.
The Art Institute of Chicago. The Mr. and Mrs. Carter
H. Harrison Collection.*

167. ***The Crocodile, Menu*** (Le crocodile, menu). 1896.
Lithograph, 12¹¹⁄₁₆ x 8⅞″ (32.3 x 22.6 cm).
Wittrock 175, first state, with menu text. Delteil 200,
second state.
The Art Institute of Chicago. The Charles F. Glore
Collection.*

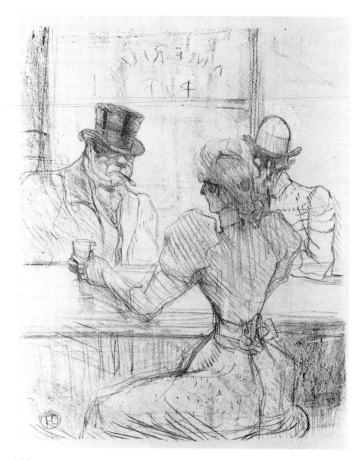

163

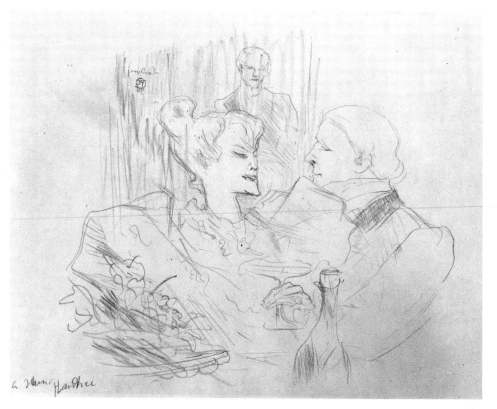

Dîner des Tarnais

164

a merry christmas
and a happy
new year

May Belfort
1896. 97.

165

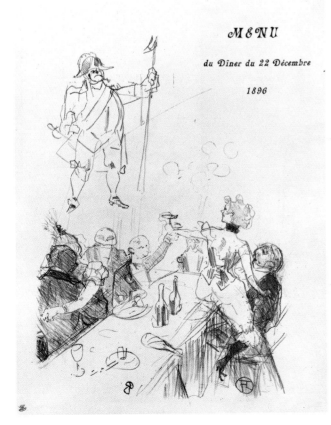

MENU

du Dîner du 22 Décembre

1896

166

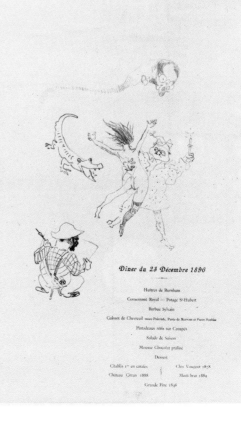

Dîner du 23 Décembre 1896

Huîtres de Burnham
Consommé Royal — Potage S.-Hubert
Barbue Sylvain
Cuissot de Chevreuil sauce Poivrade, Purée de Marrons et Pierre Suchou
Pintadeaux rôtis sur Canapés
Salade de Saison
Mousse Chocolat pralinê
Dessert

Chablis 1.er en caisses Clos Vougeot 1878
Château Citran 1888 Moët brut 1889
Grande Fine 1846

167

168

9/12

168. ***The Large Theater Box*** (La grande loge). 1896.
Oil and gouache on board, 21⅞ x 18¾" (55.5 x 47.5 cm).
Dortu P651.
Private collection.*

> It is probable that this painting was executed in late 1896, as it preceded the lithograph of the same subject which appeared in January 1897.

169. ***The Large Theater Box*** (La grande loge). 1897.
Lithograph, printed in color, 20³⁄₁₆ x 15¾" (51.3 x 40 cm).
Wittrock 177, published edition. Delteil 204.
Thyssen-Bornemisza Collection, Lugano, Switzerland.*

> This work depicts Madame Brazier, manager of the lesbian café the Hanneton, with the actress Emilienne D'Alençon (see Cat. 202). In the adjacent box is Tom, the Rothschilds' coachman.

170. ***The Clowness at the Moulin Rouge*** (La clownesse au Moulin Rouge). 1897.
Lithograph, printed in color, 16⅛ x 12⁹⁄₁₆" (41 x 32 cm).
Wittrock 178, published edition. Delteil 205.
The Museum of Modern Art, New York. Gift of Abby Aldrich Rockefeller, 1946.*

> Cha-u-ka-o was a female clown and acrobat who appeared regularly at the Moulin Rouge and the Nouveau Cirque. Her name is an orientalization of *chahut-chaos*, a dance.

171. ***Princely Idyll*** (Idyll princière). 1897.
Lithograph, printed in color, 14¹⁵⁄₁₆ x 11¼" (38 x 28.5 cm).
Wittrock 179, published edition. Delteil 206.
Kornfeld Collection, Bern, Switzerland.*

> Depicted are Clara Ward, daughter of a Detroit millionaire who married Prince Caraman-Chimay at the age of eighteen, and the gypsy Rigo with whom she ran away after six years of marriage. Ward and Rigo were married in 1904.

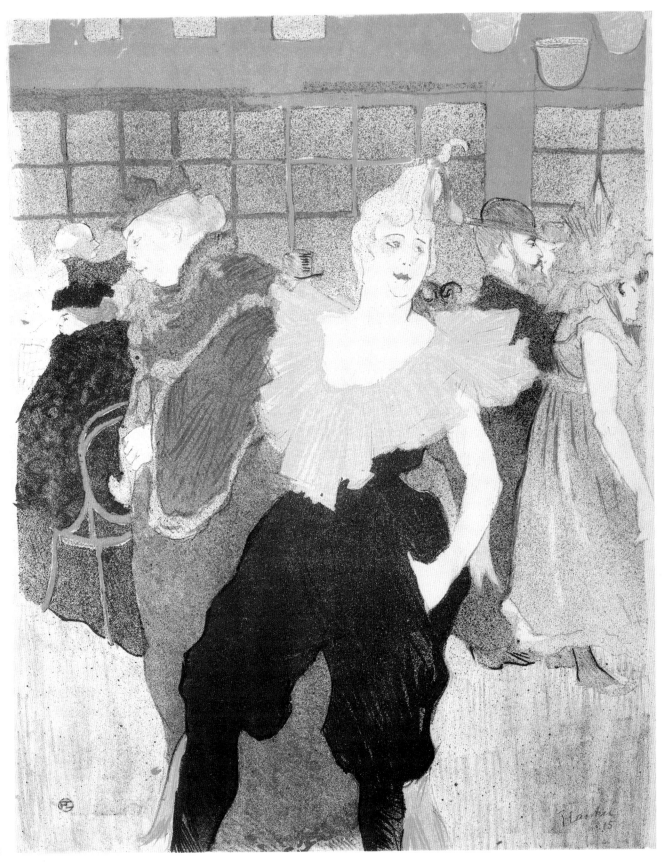

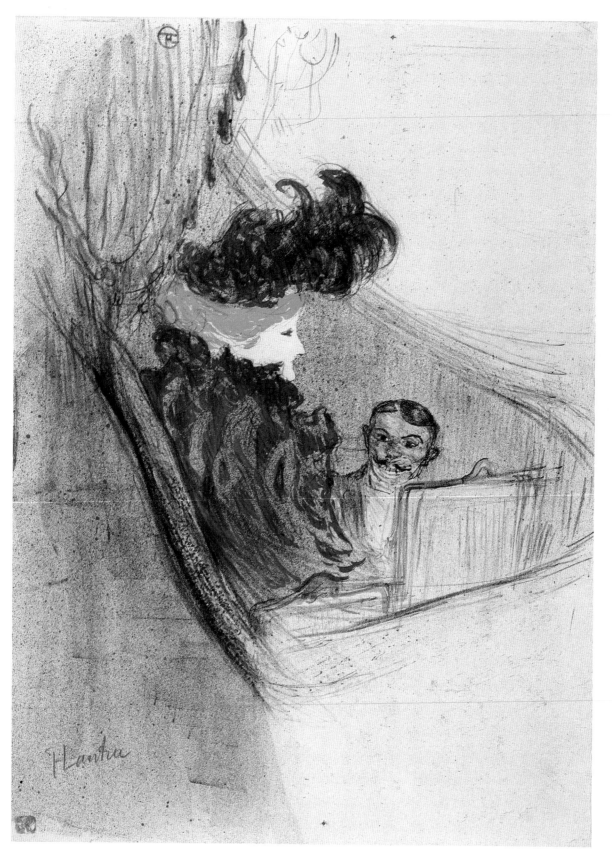

Elsa, Called The Viennese (Elsa, dite La Viennoise). 1897.

172. Lithograph, 19¹³⁄₁₆ x 12½″ (50.3 x 31.8 cm).
Wittrock 180, trial proof i. Delteil 207.
Private collection.*

173. Lithograph, impression of key stone in gray plus color
stones in blue and sanguine with additional lines in
sanguine crayon.
Wittrock 180, trial proof ii. Delteil 207.
Collection Mr. and Mrs. Heinz Friederichs, Frankfurt.*

174. Lithograph, impression of key stone in dark olive green
plus color stones in blue, sanguine, and red.
Wittrock 180, trial proof iii. Delteil 207.
Collection Mr. and Mrs. Heinz Friederichs, Frankfurt.

172

173

176

175. Lithograph, impression of key stone in dark olive green plus blue stone, sanguine stone now printed in grayish-mauve, and red stone.
Wittrock 180, trial proof iv. Delteil 207.
Collection Mr. and Mrs. Heinz Friederichs, Frankfurt.

176. Lithograph, impression of key stone in black plus color stones in blue, grayish-mauve, and red.
Wittrock 180, trial proof v. Delteil 207.
Collection Mr. and Mrs. Heinz Friederichs, Frankfurt.*

177. Lithograph, impression of key stone in black plus color stones in blue, grayish-mauve, and red, the colors more perfectly balanced.
Wittrock 180, trial proof vi. Delteil 207.
Collection Mr. and Mrs. Heinz Friederichs, Frankfurt.

178. Lithograph, printed in color, 22¹³⁄₁₆ x 15¾″ (58 x 40 cm).
Wittrock 180, published edition. Delteil 207.
Thyssen-Bornemisza Collection, Lugano, Switzerland.*
Elsa was a resident of a brothel on the rue des Moulins.

179. *At the Moulin Rouge: The Waltzing Couple* (Au Moulin Rouge: Les deux valseuses). 1892.
Oil and gouache on board, 36⅝ x 31½″ (93 x 80 cm).
Dortu P428.
National Gallery, Prague.*

180. *The Dance at the Moulin Rouge* (La danse au Moulin Rouge). 1897.
Lithograph, printed in color, 17¹⁵⁄₁₆ x 14³⁄₁₆″ (45.5 x 36 cm).
Wittrock 181, published edition. Delteil 208.
Thyssen-Bornemisza Collection, Lugano, Switzerland.*

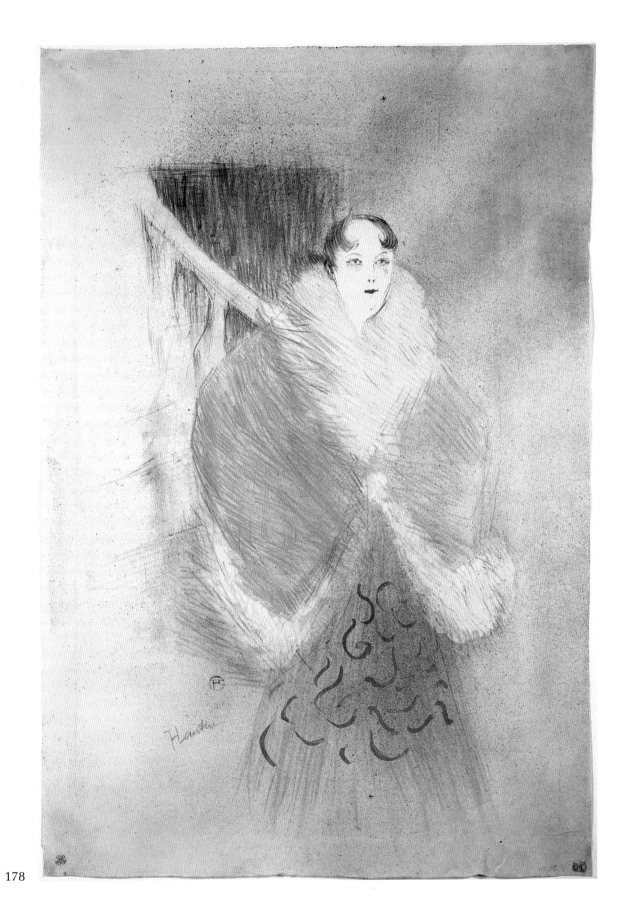

178

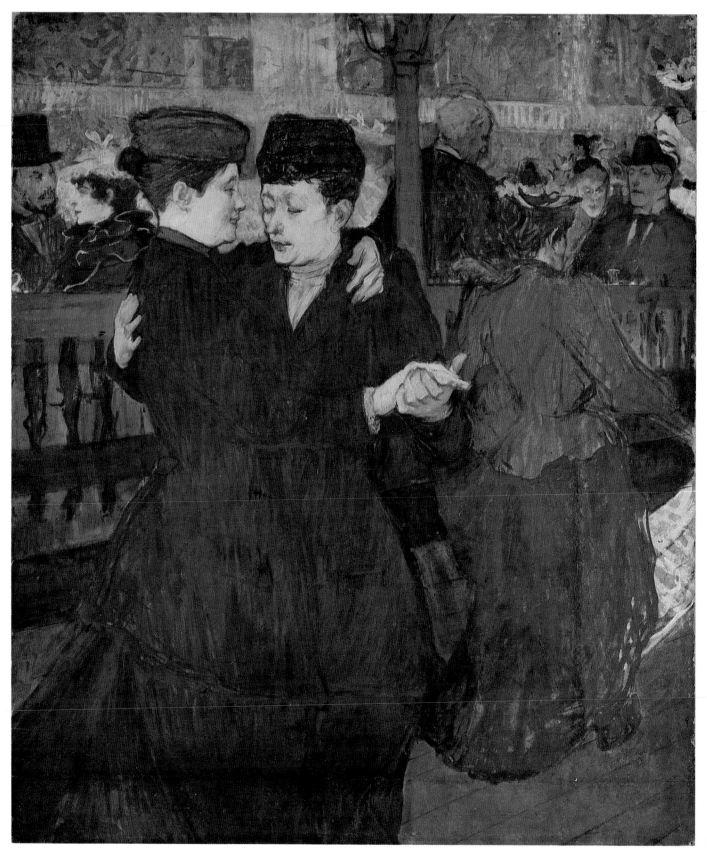

179

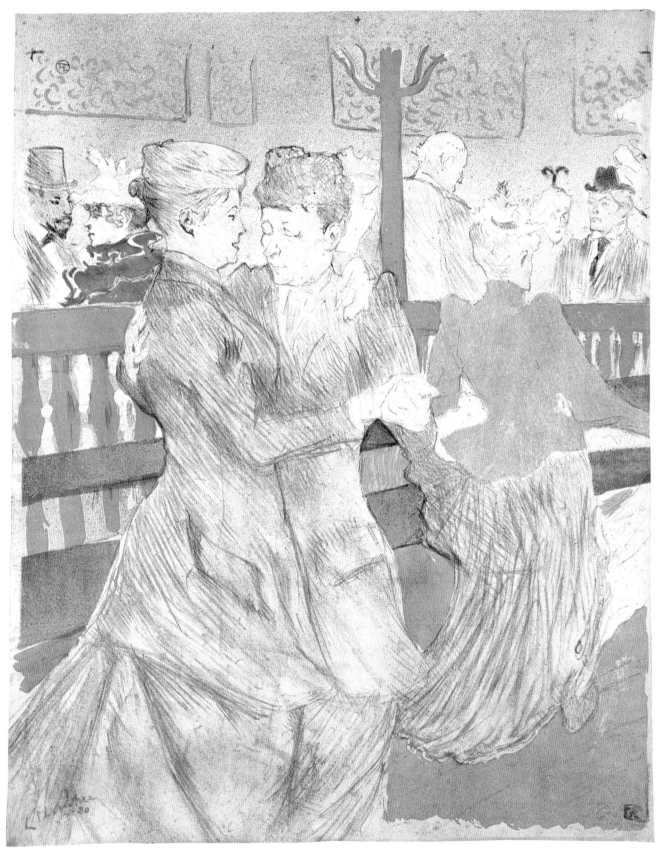

180

181

181. **The Small Theater Box** (La petite loge). 1897.
Lithograph, printed in color, 9½ x 12⁹⁄₁₆″ (24.2 x 32 cm).
Wittrock 182, second state, published edition. Delteil 209,
second state.
The Brooklyn Museum, New York.*

182. **Invitation to a Cup of Milk** (Invitation à une tasse de lait).
1897.
Lithograph, 10½ x 8¹⁄₁₆″ (26.7 x 20.5 cm).
Wittrock 183. Delteil 326.
Staatliche Museen, Preussischer Kulturbesitz,
Kupferstichkabinett, Berlin.

183. **At the Souris—Madame Palmyre** (A la Souris—Madame
Palmyre). 1897.
Lithograph, 14¹⁄₁₆ x 9¹⁵⁄₁₆″ (35.8 x 25.2 cm).
Wittrock 184, published edition. Delteil 210, second state.
Boston Public Library. Albert H. Wiggin Collection.
 The Souris was Madame Palmyre's lesbian café.

184. **In the Bois de Boulogne** (Au bois). 1897.
Lithograph, 13⁹⁄₁₆ x 9⅝″ (34.5 x 24.5 cm).
Wittrock 185, published edition. Delteil 296.
The Museum of Modern Art, New York. Gift of Abby
Aldrich Rockefeller, 1946.*

185. **Au pied du Sinaï** by Georges Clemenceau. Paris, Henri
Floury, 1898 (executed in 1897). 11 lithographs: cover plus
ten illustrations printed on China paper with additional
suite on wove paper, 10⅜ x 8⅛″ (26.4 x 20.4 cm).
Wittrock 188–198, regular edition. Delteil 235–245.
Garvey 302.
The Museum of Modern Art, New York. The Louis E. Stern
Collection, 1964.*

186. Cover for **Au pied du Sinaï** (Couverture pour *Au pied du
Sinaï*). 1897.
Lithograph, printed in color, 10⁵⁄₁₆ x 16¼″ (26.2 x 41.3 cm).
Wittrock 188, book cover edition. Delteil 235, second state.
Collection Mr. and Mrs. Herbert D. Schimmel, New York.

Georges Clemenceau (1841–1929) studied medicine,
traveled, taught, married in America, became mayor of
Montmartre in 1870, and pursued a political career in
the Third Republic. In 1892–93 he was implicated in
the Panama Canal scandal, which disrupted his politi-
cal career. He spent the following decade writing arti-
cles and books and pursuing the review of the Dreyfus
case. He is best known for his role in writing the Ver-
sailles Treaty.

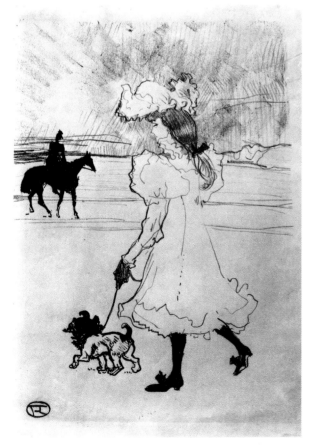

184

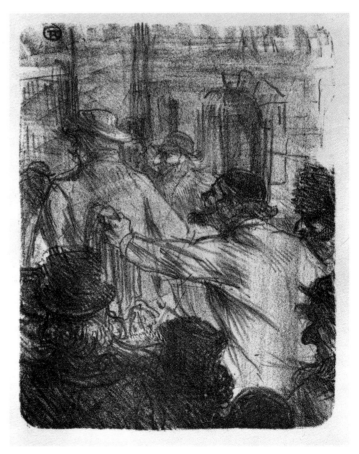

185 *The Cloth Market* (Wittrock 197)

Cover (Wittrock 202)

The Turkey (Wittrock 205)

The Swan (Wittrock 207)

The Stag (Wittrock 219)

187

187. ***Histoires naturelles*** by Jules Renard. Paris, Henri Floury,
1899 (executed 1897). 23 lithographs: cover plus 22
illustrations, 12¼ x 8¾″ (31 x 22 cm).
Wittrock 202–224. Delteil 297–319. Garvey 304.
The Museum of Modern Art, New York. The Louis E. Stern
Collection, 1964.*

188. ***The Horse*** (Le cheval). 1897.
Lithograph, 8⅞ x 7⁹⁄₁₆″ (22.5 x 19.3 cm).
Wittrock 224, proof. Delteil 319, first state.
Graphische Sammlung Staatsgalerie Stuttgart.
Bound into a book with drawings by the artist, formerly
collection M. Loncle, Paris.*

> Jules Renard (1864–1910) was a novelist, playwright,
> and essayist. He wrote *Poil de Carrotte* and *Monsieur
> Vernet*, both successful plays.

Tandem Team (Attelage en tandem). 1897.

189. Lithograph, 10⅜ x 16¼″ (26.4 x 41.2 cm).
Wittrock 227. Delteil 218. Unpublished.
Private collection.*

190. Lithograph and watercolor, 10⅜ x 16¼″ (26.4 x 41.2 cm).
Wittrock 227; inscribed *à Stern*. Delteil 218. Dortu A254.
The Art Institute of Chicago. The Olivia Shaler Swan
Memorial Collection.*

Country Outing (Partie de campagne). 1897.

191. Lithograph, 12¹³⁄₁₆ x 19⅝″ (32.5 x 49.9 cm).
Wittrock 228, trial proof i. Delteil 219.
Bibliothèque Nationale, Paris.*

192. Lithograph, printed in color, 15¹⁵⁄₁₆ x 20½″ (40.5 x 52 cm).
Wittrock 228, published edition. Delteil 219.
Guardsmark, Inc., Collection, Memphis.*

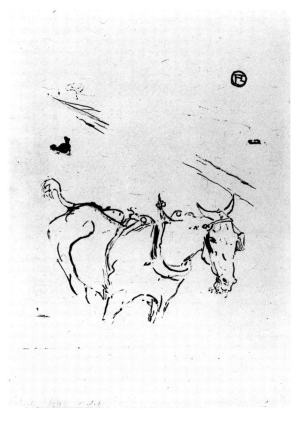

188

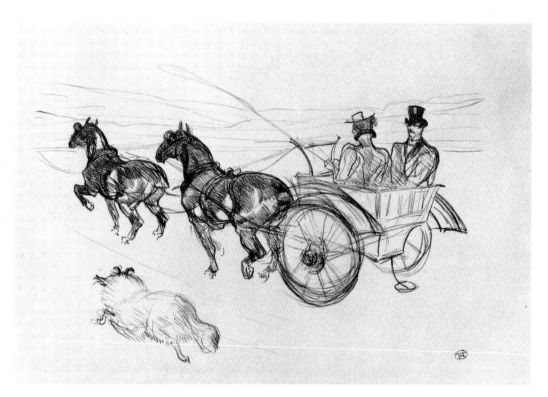

189

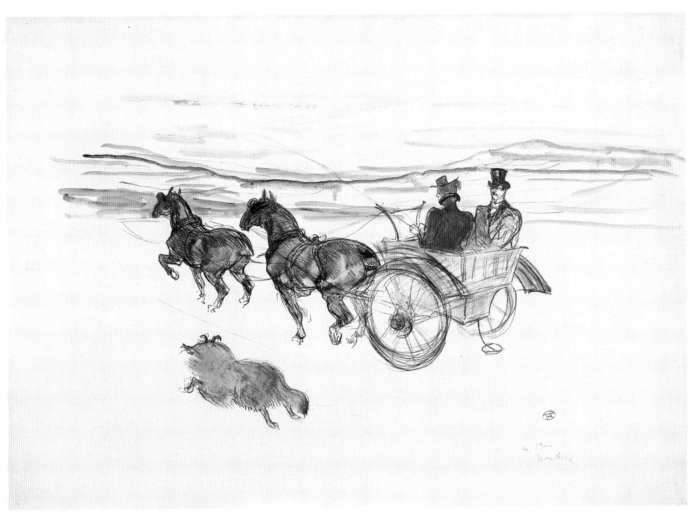

190

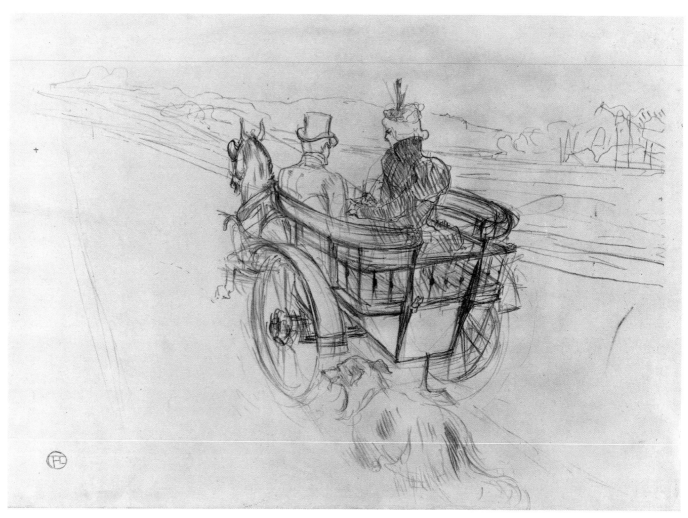

191

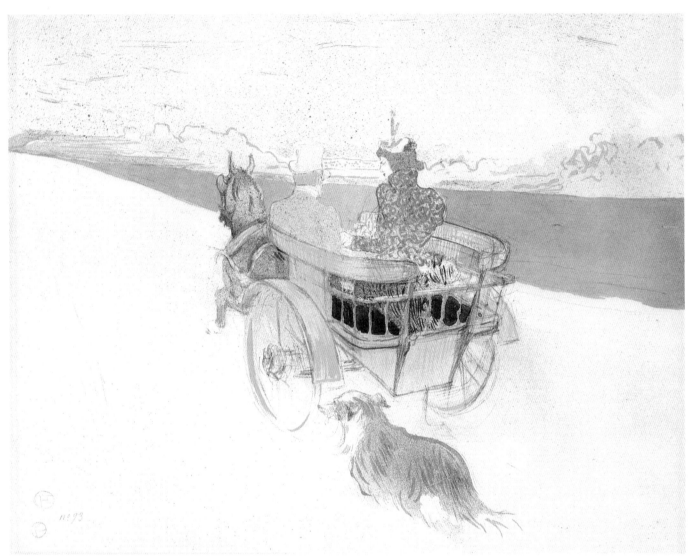

192

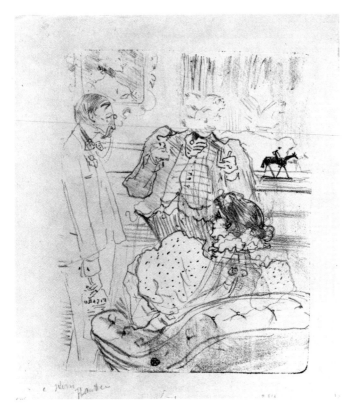

195

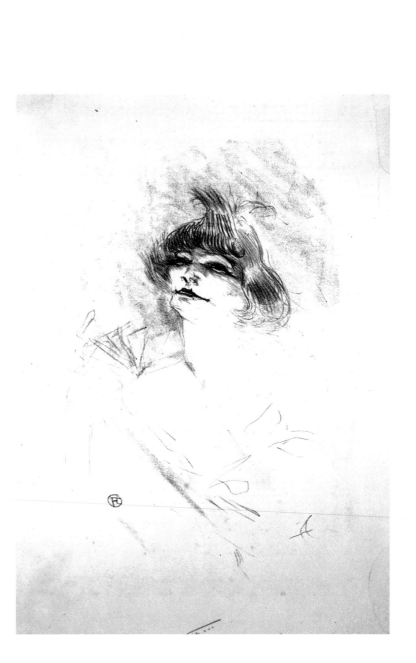

197

202

193. **The Chestnut Man** (Le marchand de marrons). 1897.
Lithograph, 10⅛ x 6⅞″ (25.8 x 17.5 cm).
Wittrock 232, first edition. Delteil 335.
Staatliche Museen, Preussischer Kulturbesitz,
Kupferstichkabinett, Berlin.

194. Cover for **Les courtes joies** (Couverture pour *Les courtes joies*). 1897.
Lithograph, printed in color, 7⅟₁₆ x 9¹³⁄₁₆″ (18 x 25 cm).
Wittrock 236, 1925 edition. Delteil 216.
The Museum of Modern Art, New York. Gift of Emilio
Sanchez, 1961.

> *Les courtes joies* included 115 poems by Julien Sermet
> and a preface by Gustave Geffroy.

195. **Le Gage.** 1897.
Lithograph, 11½ x 9⁷⁄₁₆″ (29.3 x 24 cm).
Wittrock 237, proof; inscribed *à Stern*. Delteil 212,
first state.
The Museum of Modern Art, New York. Gift of Abby
Aldrich Rockefeller, 1946.*

> This image was designed as a theater program for
> *Le Gage* (The Forfeit), a comedy by Frantz Jourdain
> performed at the Théâtre de l'Oeuvre.

196. **New Year's Greetings** (Le compliment du jour de l'an).
1897.
Lithograph, 9¹³⁄₁₆ x 8¹¹⁄₁₆″ (25 x 22 cm).
Wittrock 238. Delteil 217.
National Gallery of Art, Washington, D.C. Rosenwald
Collection, 1952.

197. **Polaire.** 1898.
Lithograph, 17³⁄₁₆ x 8¹⁵⁄₁₆″ (43.7 x 22.8 cm).
Wittrock 248, 1930 edition. Delteil 227.
Collection Mr. and Mrs. Herbert D. Schimmel, New York.*

> Polaire (Emilie-Marie Bouchaud, or Zouzé) was born in
> Algiers in 1879. She began her career at the Ambas-
> sadeurs and sang in many Parisian *cafés concerts* dur-
> ing the 1890s. She became a leading actress in musical
> comedies.

**Portraits of Actors & Actresses—Thirteen Lithographs
by H. de Toulouse-Lautrec** (Portraits d'acteurs &
d'actrices—Treize lithographies par H. de Toulouse-
Lautrec). 1898. [198–210.]
A series of portraits initially conceived by the English
publisher W. H. B. Sands, London, but ultimately not pub-
lished by him. The first edition appeared in Paris c. 1906.
This suite is printed in gray-black on loose beige wove
paper, 15⁷⁄₁₆ x 12⅝″ (39.2 x 32 cm).
Wittrock 249–261. Delteil 150–162.
The Museum of Modern Art, New York. Gift of Abby
Aldrich Rockefeller, 1946.

198. **Sarah Bernhardt.**
Lithograph, 11⅝ x 9½″ (29.5 x 24.2 cm).
Wittrock 249. Delteil 150.

199. **Jeanne Granier.**
Lithograph, 11½ x 9⁷⁄₁₆″ (29.3 x 24 cm).
Wittrock 250. Delteil 154.

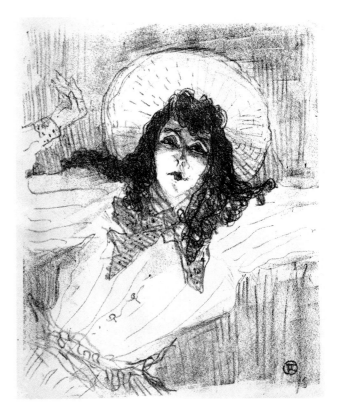

201

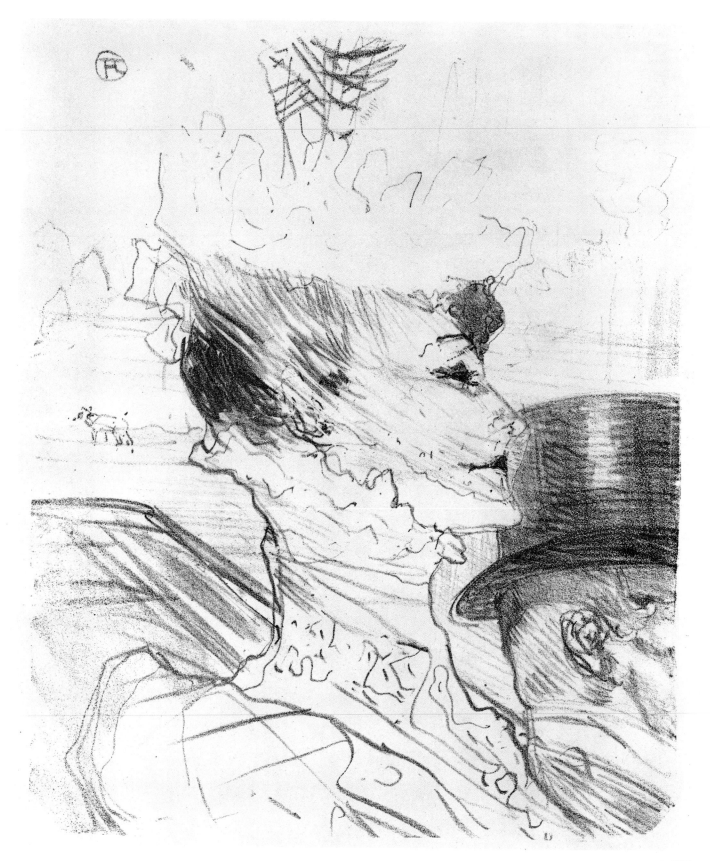

200. *Anna Held.*
Lithograph, 11½ x 9⁹⁄₁₆″ (29.2 x 24.3 cm).
Wittrock 251. Delteil 156.

201. *May Belfort.*
Lithograph, 11⅝ x 9½″ (29.5 x 24.2 cm).
Wittrock 252. Delteil 160.*

202. *Emilienne D'Alençon.*
Lithograph, 11½ x 9⁹⁄₁₆″ (29.3 x 24.3 cm).
Wittrock 253. Delteil 161.

 Emilienne D'Alençon (born 1869) began her career in
 1889 at the Cirque d'Eté. She went on to dance at the
 Folies-Bergère, Casino de Paris, and Menus-Plaisirs.

203. *Coquelin Aîné.*
Lithograph, 11⁷⁄₁₆ x 9½″ (29 x 24.2 cm).
Wittrock 254. Delteil 153.

 Coquelin Aîné (Benoit-Constant Coquelin; 1841–1909)
 was a famous interpreter of Molière. Here he appears as
 Sganarelle in *Le Medecin Malgré Lui.*

204. *Jane Hading.*
Lithograph, 11¼ x 9½″ (28.6 x 24.2 cm).
Wittrock 255. Delteil 162.

205. *Louise Balthy.*
Lithograph, 11⅝ x 9⅝″ (29.5 x 24.4 cm).
Wittrock 256. Delteil 157.*

Louise Balthy (born 1869) made her acting debut at the
Menus-Plaisirs in 1892. She later performed at the
Folies-Dramatiques.

206. *Sybil Sanderson.*
Lithograph, 10¹⁵⁄₁₆ x 9⅝″ (27.8 x 24.4 cm).
Wittrock 257. Delteil 151.

 Sybil Sanderson was born in 1865 in Sacramento, Cal-
 ifornia. She studied music in Paris and made her debut
 in 1889 at the Opéra-Comique in *Esclarmonde.* She
 went on to play Manon, Thaïs, and Gilda in *Rigoletto.*

207. *Cléo de Mérode.*
Lithograph, 11½ x 9⁷⁄₁₆″ (29.3 x 24 cm).
Wittrock 258. Delteil 152.*

 Cléo de Mérode (c. 1875–1966) was born in Belgium
 and was one of the stars of the Paris Opéra. She made
 her American debut in 1897.

208. *Lucien Guitry.*
Lithograph, 11⅝ x 9⅝″ (29.6 x 24.4 cm).
Wittrock 259. Delteil 155.*

 Lucien Guitry (Lucien-Germain Guitry; 1860–1925)
 made his acting debut at the Gymnase in 1878 and
 performed there until 1881. He then spent several years
 acting in Russia and returned to Paris in 1891.

207

208

209. ***Marie-Louise Marsy.***
 Lithograph, 11⁹⁄₁₆ x 9⁹⁄₁₆″ (29.4 x 24.3 cm).
 Wittrock 260. Delteil 158.

 > Marie-Louise Marsy (Anne-Marie-Louise-Joséphine Brochard; 1866–1942) made her debut at the Comédie-Française in 1883. She left the theater in 1886, returned in 1888, and rejoined the Comédie-Française in 1890.

210. ***Polin.***
 Lithograph, 11½ x 9⁵⁄₁₆″ (29.2 x 23.7 cm).
 Wittrock 261. Delteil 159.

 > Polin (Pierre-Paul Marsalès; born 1863) made his *café-concert* debut in 1886 and performed at the Alcazar d'Eté, Nouveautés, and Scala. He was known for his risqué portrayals and sailors' songs.

211. ***Mademoiselle Leconte.*** 1898.
 Lithograph, 11⁹⁄₁₆ x 9⅜″ (29.4 x 23.8 cm).

Wittrock 268. Delteil 225. Unpublished.
Boston Public Library. Albert H. Wiggin Collection.

Yvette Guilbert—On Stage (Yvette Guilbert—Sur la scène). 1898.

212. Lithograph, 11¾ x 9½″ (29.8 x 24.2 cm).
 Wittrock 272, proof; inscribed *à Stern*. Delteil 252.
 Private collection.

213. Lithograph, printed with beige tint stone, 11¾ x 9½″ (29.8 x 24.2 cm).
 Wittrock 272, first edition 1898. Delteil 252.
 The Art Institute of Chicago. The William McCallin McKee Memorial Collection.*

214. Lithograph, printed in sanguine, 11¾ x 9½″ (29.8 x 24.2 cm).
 Wittrock 272, second edition 1930. Delteil 252.
 The Art Institute of Chicago.

213

215

215. **Yvette Guilbert—"Linger, longer, loo."** 1898.
Lithograph, 11¹¹⁄₁₆ x 9½″ (29.7 x 24.2 cm).
Wittrock 278, proof; inscribed *à Stern*. Delteil 259.
Private collection.*

216. **Yvette Guilbert—Taking a Curtain Call** (Yvette
Guilbert—Saluant le public). 1898.
Lithograph, 11¹¹⁄₁₆ x 9½″ (29.7 x 24.2 cm).
Wittrock 279, proof; inscribed *à Stern*. Delteil 260.
Private collection.*

217. **Invitation to an Exhibition** (Invitation à une exposition).
1898.
Lithograph, 8⁹⁄₁₆ x 5⅜″ (21.7 x 13.7 cm).
Wittrock 281. Delteil 232.
Collection Mr. and Mrs. Herbert D. Schimmel, New York.

218. **Philibert the Pony** (Le poney Philibert). 1898.
Lithograph, 14 x 10″ (35.6 x 25.4 cm).
Wittrock 284. Delteil 224.
The Museum of Modern Art, New York. Gift of Abby
Aldrich Rockefeller, 1946.

219. **Picnic** (Pique-nique). 1898.
Lithograph, 8¼ x 7⅞″ (21 x 20 cm).
Wittrock 286. Delteil 174.
Boston Public Library. Albert H. Wiggin Collection.*

220. Cover for **L'Etoile rouge** (Couverture pour L'Etoile rouge).
1898.
Lithograph, 8⅞ x 9⅝″ (22.5 x 24.4 cm).
Wittrock 289, proof; dedicated to Leclercq. Delteil 231,
first state.
The Art Institute of Chicago. The Mr. and Mrs. Carter H.
Harrison Collection.

221. **In Bed** (Au lit). 1898.
Lithograph, 12¼ x 10⅛″ (31.1 x 25.7 cm).
Wittrock 290, published edition. Delteil 226.
The Brooklyn Museum, New York.*

222. **Cabaret Singer** (Chanteuse légère). 1898.
Lithograph, 12⁹⁄₁₆ x 10¼″ (32 x 26 cm).
Wittrock 291, published edition. Delteil 269.
Library of Congress, Washington, D.C.*

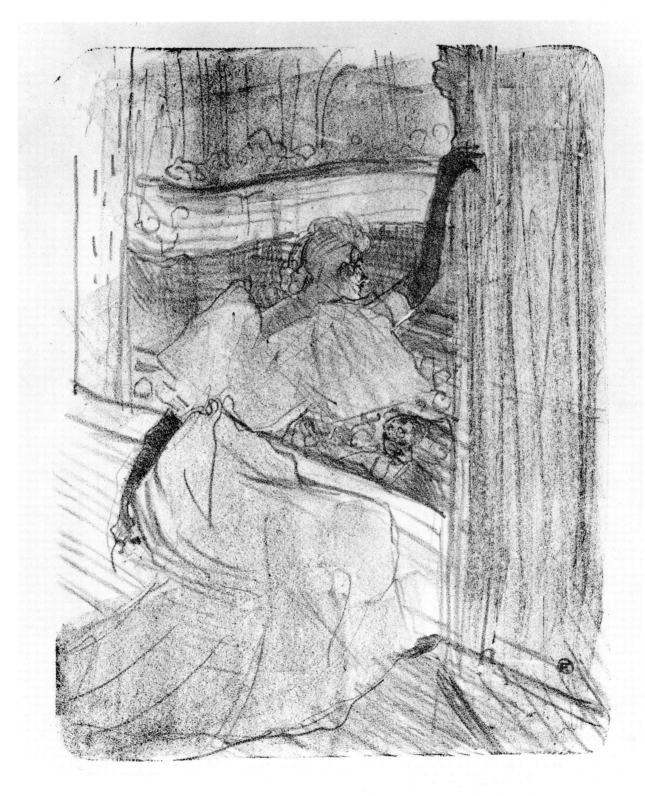

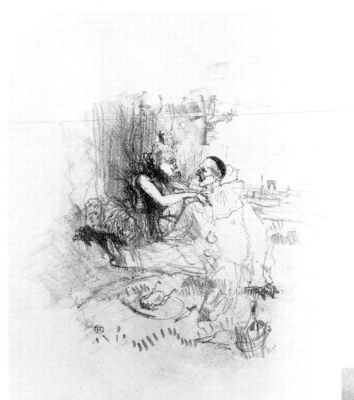

219

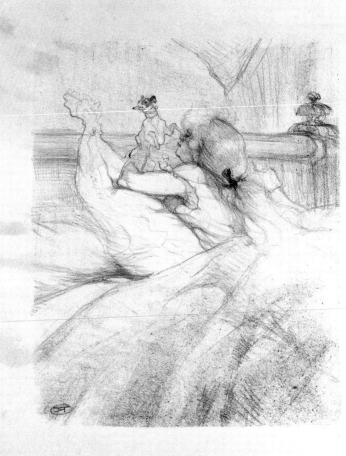

221

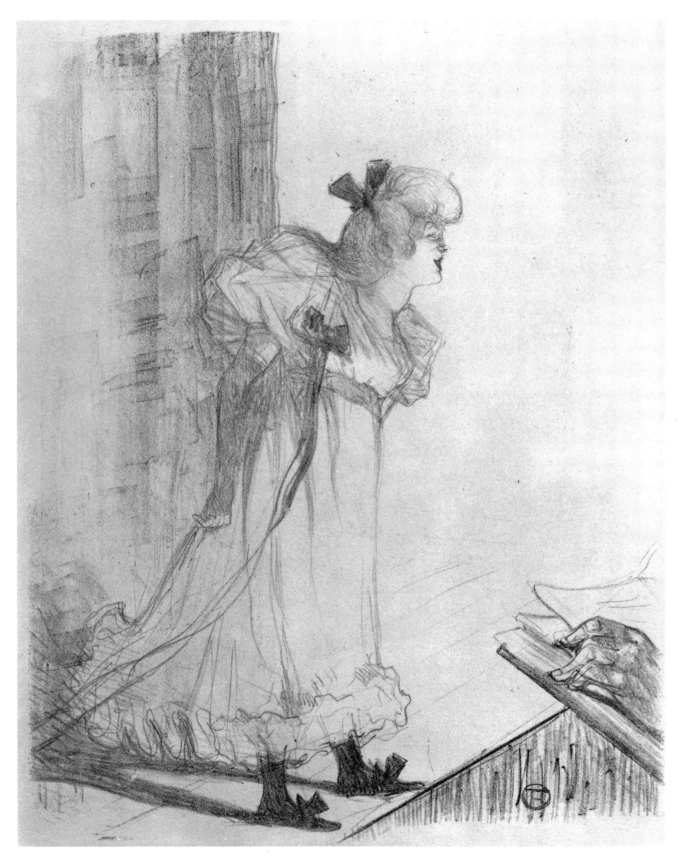

225

223. **The Automobile Driver** (L'Automobiliste). 1898.
Lithograph, 14¾ x 10⁹⁄₁₆″ (37.5 x 26.8 cm).
Wittrock 293, published edition. Delteil 203.
The Museum of Modern Art, New York. Gift of Abby
Aldrich Rockefeller, 1946.*
 Depicted here is Lautrec's cousin, Dr. Gabriel Tapié de
 Céleyran.

224. **Guy and Mealy in Paris qui Marche** (Guy et Mealy dans
Paris qui Marche). 1898.
Lithograph, 10⅞ x 9⅛″ (27.7 x 23.2 cm).
Wittrock 295, published edition. Delteil 270.
Collection Mr. and Mrs. Herbert D. Schimmel, New York.

Georges-Guillaume Guy (1859–1917) made his debut at
the Théâtre Lyrique in 1878 and later performed at the
Folies-Dramatiques, Renaissance, and Variétés.
 Juliette-Josserand Mealy (born in 1867) made her
debut at the Eldorado in 1887 and later performed at
the Menus-Plaisirs, Variétés, and Gaîté. In the 1890s
she performed in London, Austria, Rumania, and
St. Petersburg.

225. **At the Hanneton** (Au Hanneton). 1898.
Lithograph, 14¹⁄₁₆ x 10″ (35.7 x 25.4 cm).
Wittrock 296, published edition. Delteil 272.
The Museum of Modern Art, New York. Gift of Abby
Aldrich Rockefeller, 1946.*

226. **The Fine Printmaker** (Adolphe Albert) (Le bon graveur). 1898.
Lithograph, 13½ x 9⅝″ (34.3 x 24.5 cm).
Wittrock 297, published edition. Delteil 273, second state.
Collection Mr. and Mrs. Herbert D. Schimmel, New York.
 Adolphe Albert was an artist and student at Cormon's studio. Lautrec met him there in the early 1880s.

227. **At the Café** (Au café). 1898.
Lithograph, 9⅜ x 11⅝″ (23.8 x 29.6 cm).
Wittrock 300. Delteil 330. Unpublished.
Private collection.*

228. **Amazon and Carriage** (Amazone et tonneau). 1898.
Lithograph, 9⁵⁄₁₆ x 11½″ (23.7 x 29.3 cm).
Wittrock 301, published edition. Delteil 284.
Staatliche Museen, Preussischer Kulturbesitz,
Kupferstichkabinett, Berlin.

229. **Proposal** (first plate) (Déclaration, première planche). 1898.
Lithograph, 11¾ x 8⅞″ (29.8 x 22.5 cm).
Wittrock 305, re-edition before 1926. Delteil 327.
Boston Public Library. Albert H. Wiggin Collection.

230. **Proposal** (second plate) (Déclaration, deuxième planche). 1898.
Lithograph, 12⅜ x 9³⁄₁₆″ (31.5 x 23.3 cm).
Wittrock 306; inscribed *à Stern*. Delteil 328.
Private collection.*

231. **Promenade** (Promenoir). 1898.
Lithograph, 18⅛ x 13¾″ (46 x 35 cm).
Wittrock 307, published edition. Delteil 290.
The Museum of Modern Art, New York. Gift of Abby
Aldrich Rockefeller, 1946.*

227

230

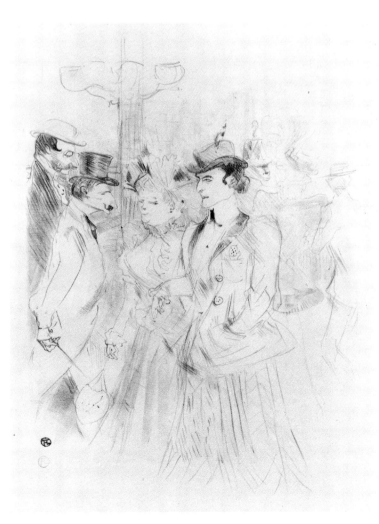

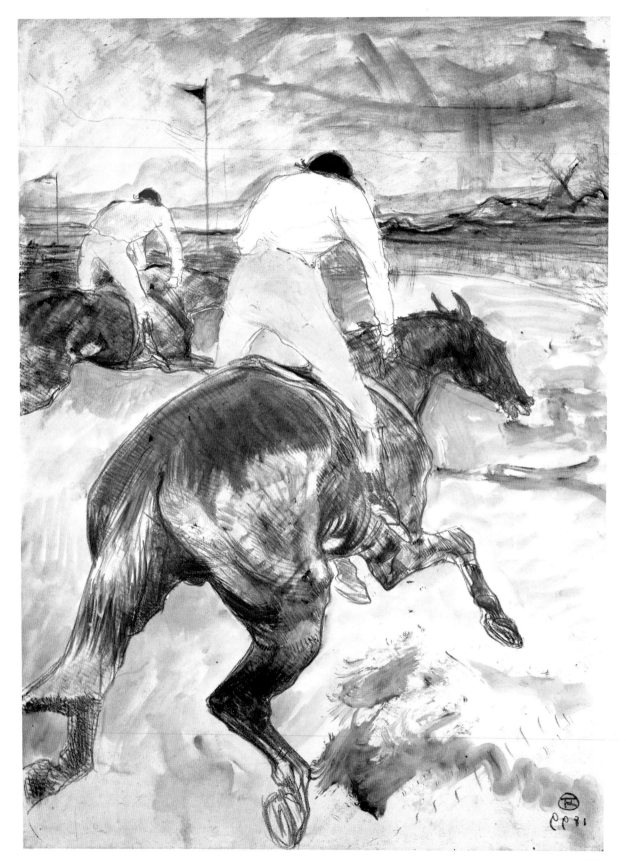

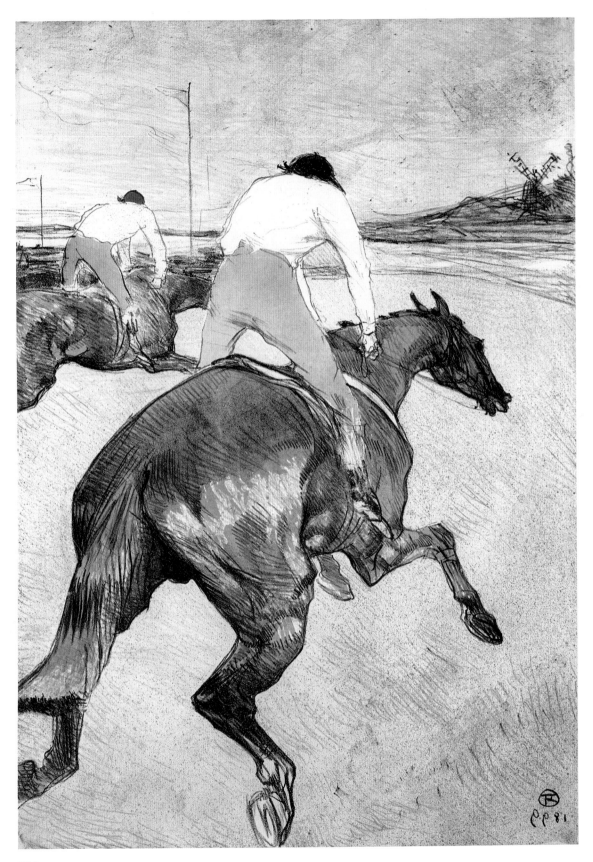

The Jockey (Le jockey). 1899.

232. Lithograph, oil paint, and watercolor, 20¼ x 14⁵⁄₁₆″ (51.5 x 36.3 cm).
Wittrock 308, first state, trial proof. Delteil 279.
Dortu A259.
Private collection.*

233. Lithograph, 20¼ x 14⁵⁄₁₆″ (51.5 x 36.3 cm).
Wittrock 308, first state, first edition. Delteil 279.
The Museum of Modern Art, New York. Gift of Abby Aldrich Rockefeller, 1946.

234. Lithograph, printed in color, 20⅜ x 14¼″ (51.8 x 36.2 cm).
Wittrock 308, second state, trial proof iii. Delteil 279.
National Gallery of Art, Washington, D.C. Rosenwald Collection, 1952.*

235. *The Paddock* (Le paddock). 1899.
Lithograph, 14½ x 12¹¹⁄₁₆″ (36.9 x 32.3 cm).
Wittrock 310. Delteil 280. Unpublished.
Private collection.

236. *Jockey Led to the Post* (Le jockey se rendant au poteau). 1899.
Lithograph and watercolor, 17½ x 13⅜″ (44.5 x 34 cm).
Wittrock 311, second state, proof. Delteil 282, second state.
Dortu A264.
Museum of Fine Arts, Boston. Helen and Alice Colburn Fund.*

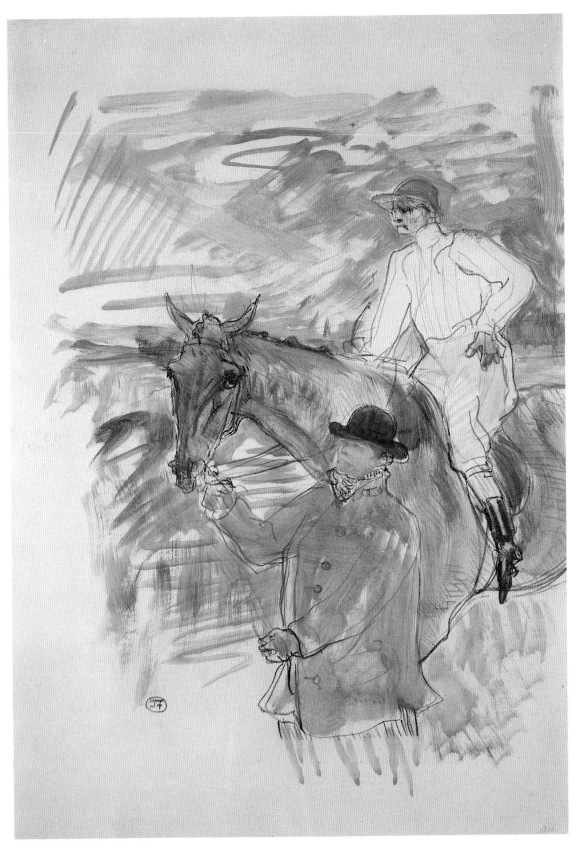

237. **The Dog and the Parrot** (Le chien et le perroquet). 1899.
Lithograph, 12⅛ x 10⁵⁄₁₆″ (30.8 x 26.2 cm).
Wittrock 312, first state. Delteil 277. Unpublished.
The Art Institute of Chicago. The Charles F. Glore
Collection.*

238. **The Trainer** (L'Entraineur). 1899.
Lithograph, 9⁵⁄₁₆ x 17⅞″ (23.6 x 45.4 cm).
Wittrock 313, published edition. Delteil 172.
Sterling and Francine Clark Art Institute, Williamstown,
Massachusetts.

239. **Fantasy** (Fantaisie). 1899.
Lithograph, 11 x 9⁷⁄₁₆″ (28 x 24 cm).
Wittrock 315; inscribed *à Stern*. Delteil 332. Unpublished.
Private collection.*

237

239

240. **The Horse and the Dog with the Pipe** (Le cheval et le chien à la pipe). 1899.
Lithograph, 4½ x 7³⁄₁₆″ (11.4 x 18.3 cm).
Wittrock 321. Delteil 289. Unpublished.
Private collection.*

241. **At the Star** (Le Havre) (Au Star). 1899.
Lithograph, 18¹⁄₁₆ x 14¹¹⁄₁₆″ (45.9 x 37.3 cm).
Wittrock 325, published edition. Delteil 275.
Collection Mr. and Mrs. Herbert D. Schimmel, New York.

242. **The Sailor's Song—Miss X in the Alabamah Coons** (La chanson du matelot). 1899.
Lithograph, printed in color, 13⁹⁄₁₆ x 10⅝″ (34.5 x 27 cm).
Wittrock 326; inscribed *bon à tirer/Miss X in/the alabamah/coons*. Delteil 276.
Collection Ruth Irving, Courtesy Pace Master Prints, New York.*

243. **Couple at the Café Concert** (Couple au café concert). 1899.
Lithograph, 10¼ x 12½″ (26 x 31.8 cm).
Wittrock 327. Delteil 331. Unpublished.
The Art Institute of Chicago. The Mr. and Mrs. Carter H. Harrison Collection.

244. **The Animal Tamer before the Court** (La dompteuse devant le tribunal). 1899.
Lithograph, 11¹¹⁄₁₆ x 9⅝″ (29.7 x 24.5 cm).
Wittrock 329, published edition. Delteil 148.
The Museum of Modern Art, New York. Gift of Abby Aldrich Rockefeller, 1946.

 Depicted here is La Goulue in a trial that followed a dance organized by the journal *Fin de siècle*.

245. **Zamboula-Polka.** 1900.
Lithograph, 8¾ x 9⁷⁄₁₆″ (22.3 x 24 cm).
Wittrock 333, early impression. Delteil 334, first state.
Kunsthalle, Bremen.

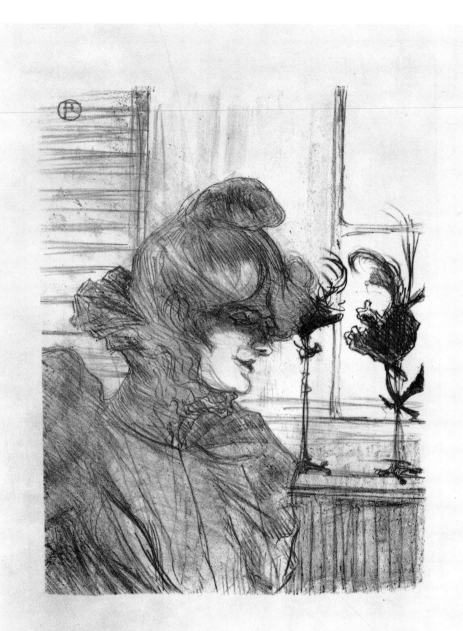

246

246. *Le Margoin* (Mademoiselle Louise Blouet). 1900.
Lithograph, 12⁹⁄₁₆ x 10⅛″ (32 x 25.8 cm).
Wittrock 334, published edition. Delteil 325.
The Museum of Modern Art, New York. Gift of Abby
Aldrich Rockefeller, 1946.*

Le Margoin (often spelled Margouin) worked for the
fashion designer and milliner Renée Vert. Her nickname
is Parisian slang for model. She was a friend of Adolphe
Albert and Maurice Joyant.

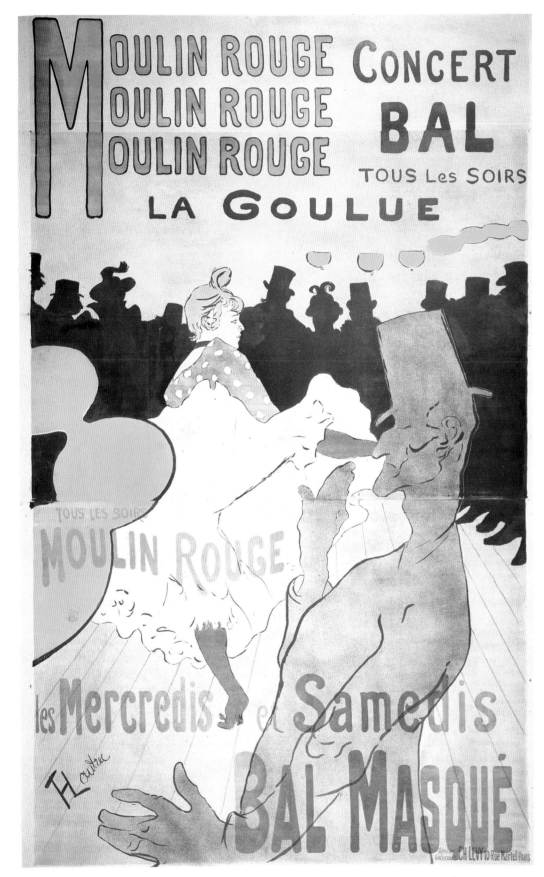

247

Moulin Rouge (La Goulue). 1891.

247. Lithographic poster, printed in color, 75³⁄₁₆ x 46¹⁄₁₆″ (191 x 117 cm).
Wittrock P1/B. Delteil 339.
The Art Institute of Chicago. The Mr. and Mrs. Carter H. Harrison Collection.*

248. Lithographic poster, printed in color, 66⅛ x 46¾″ (168 x 118.8 cm).
Wittrock P1/C. Delteil 339.
Collection Mr. and Mrs. Herbert D. Schimmel, New York.

Reine de joie. 1892.

249. Lithographic poster, printed in color, 53⅝ x 36⅝″ (136.2 x 93 cm).
Wittrock P3. Delteil 342.
Collection Mr. and Mrs. Herbert D. Schimmel, New York.

250. Second copy: The Museum of Modern Art, New York. Gift of Mr. and Mrs. Richard Rodgers. 1961.*

 Reine de joie is a novel by Victor Joze (the Polish writer Victor Dobrski).

251. *Eldorado: Aristide Bruant.* 1892.
Lithographic poster, printed in color, 54⁵⁄₁₆ x 37¹³⁄₁₆″ (138 x 96 cm).
Wittrock P5. Delteil 344.
Collection Mr. and Mrs. Herbert D. Schimmel, New York.*

 Aristide Bruant (1851–1923) founded the Mirliton cabaret in 1885 and performed there until 1905.

252. *Jane Avril Dancing* (Jane Avril dansant). 1893.
Oil on cardboard, 38¹⁵⁄₁₆ x 28⁵⁄₁₆″ (99 x 72 cm).
Dortu P482.
Private collection.*

Jane Avril. 1893.

253. Lithographic poster, printed in color, 48¹³⁄₁₆ x 36″ (124 x 91.5 cm).
Wittrock P6/B. Delteil 345, first state.
Guardsmark, Inc., Collection, Memphis.*

254. Lithographic poster, printed in color, 48¹³⁄₁₆ x 36″ (124 x 91.5 cm).
Wittrock P6/C. Delteil 345, second state.
World-Wide Volkswagen Corp.

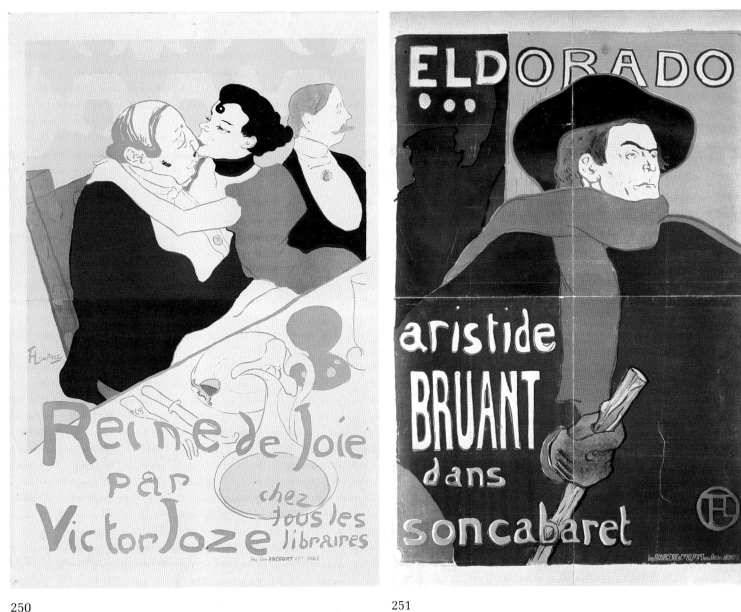

250

251

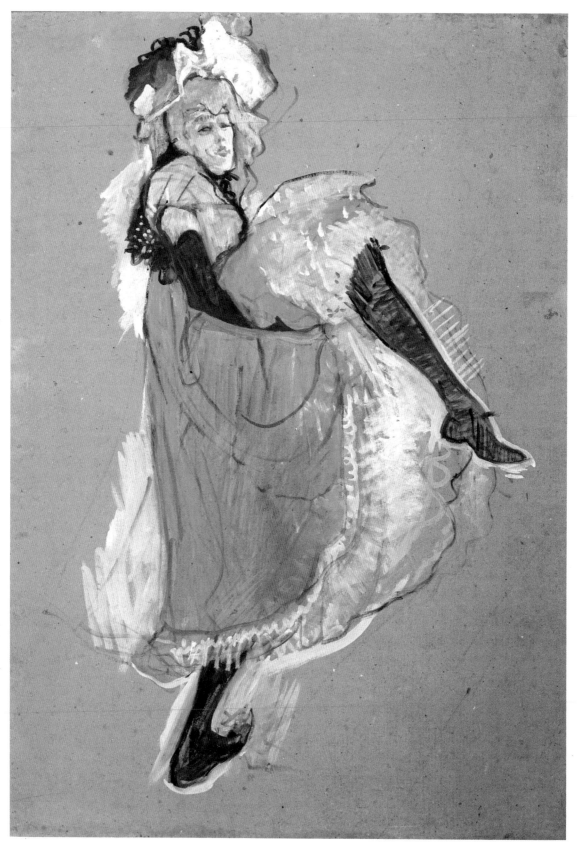

252

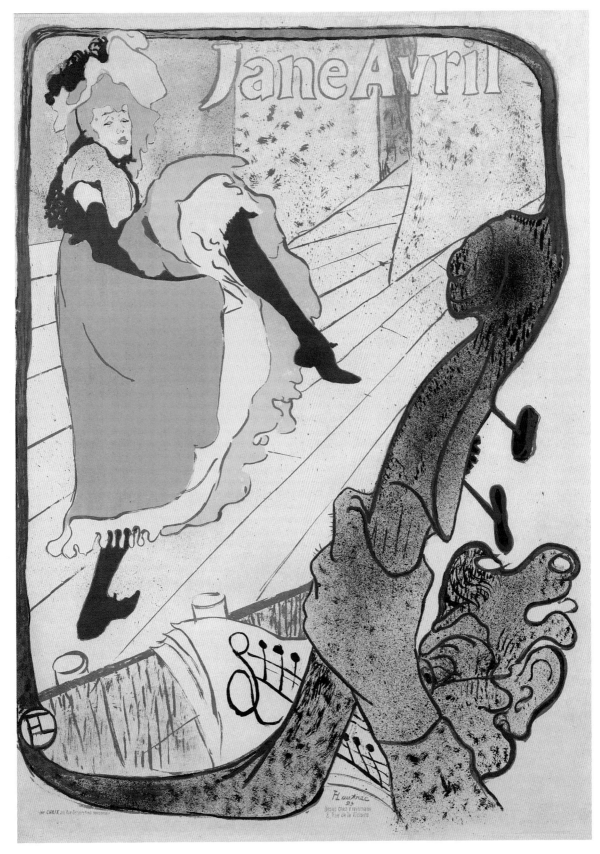

255

255. ***Caudieux.*** 1893.
Lithographic poster, printed in color, 49 1/16 x 35 1/4″
(124.6 x 89.5 cm).
Wittrock P7. Delteil 346.
Collection Mr. and Mrs. Herbert D. Schimmel, New York.*
Caudieux was a popular comedian who performed at
the Petit Casino, Eldorado, and Ambassadeurs.

Aristide Bruant in His Cabaret (Aristide Bruant dans son
cabaret). 1893.

256. Lithographic poster, printed in color, 50 1/8 x 37 3/8″
(127.3 x 95 cm).
Wittrock P9/A. Delteil 348, first state.

The Museum of Modern Art, New York. Gift of Emilio
Sanchez, 1961.*

257. Lithographic poster, printed in color, 50 1/8 x 37 3/8″
(127.3 x 95 cm).
Wittrock P9/C. Delteil 348, second state.
The Metropolitan Museum of Art, New York. Harris
Brisbane Dick Fund, 1932.

258. ***Aristide Bruant.*** 1893.
Lithographic poster, printed in color, 32 3/16 x 21 5/8″
(81.7 x 55 cm).
Wittrock P10/A. Delteil 349, second state.
Collection Mr. and Mrs. Herbert D. Schimmel, New York.

231

259

sporadic closings over the course of two years. Divan Japonais was open to the public only a few short weeks: late 1892–February 1893, October–December 1893, January–February 1894. (There is a note in *L'Escarmouche*, January 1894, about the newly reopened and luxuriously renovated establishment with a reference to Lautrec's poster.) After February 1894 Fournier sold Divan Japonais and it became the Concert Lisbonne.

Portrayed here are Jane Avril, the music critic Edouard Dujardin, and, performing on stage, Yvette Guilbert, who in fact had not appeared there since 1890.

Babylone d'Allemagne. 1894.

262. Lithographic poster, 47¼ x 32¹³⁄₁₆″ (120 x 83.3 cm).
Wittrock P12, proof. Delteil 351.
Collection Mr. and Mrs. Herbert D. Schimmel, New York.

263. Lithographic poster, printed in color, 47¼ x 33¼″ (120 x 84.5 cm).
Wittrock P12/B. Delteil 351, second state.
The Museum of Modern Art, New York. Gift of Abby Aldrich Rockefeller, 1940.*

Confetti. 1894.

264. Lithographic poster, printed in color, 22⁷⁄₁₆ x 15⅜″ (57 x 39 cm).
Wittrock P13. Delteil 352.
Collection Mr. and Mrs. Herbert D. Schimmel, New York.

265. Second copy: Collection Mr. and Mrs. Norman Diamond, Washington, D.C.*

266. **Miss May Belfort.** 1895.
Oil on cardboard, 29⅜ x 16⅜″ (74.6 x 41.5 cm).
Dortu P587.
Private collection, New York.*

267. **Miss May Belfort.** 1895.
Gouache on paper, 32¾ x 24¼″ (83 x 62 cm).
Dortu P589.
Collection Barbara Ginn Griesinger, Gates Mills, Ohio.*

May Belfort. 1895.

268. Lithographic poster, printed in color, 31⁵⁄₁₆ x 24″ (79.5 x 61 cm).
Wittrock P14/B. Delteil 354, second state.
Collection Mr. and Mrs. Ira A. Lipman, Memphis.

269. Lithographic poster, printed in color, 30½ x 23⁹⁄₁₆″ (77.5 x 59.8 cm).
Wittrock P14/C, trial proof. Delteil 354.
Collection Mr. and Mrs. Herbert D. Schimmel, New York.*

270. **The Hanged Man** (second plate) (Le pendu, deuxième planche). 1895.
Lithographic poster, printed in color, 31½ x 23¾″ (80 x 60.3 cm).
Wittrock P15. Delteil 340, second state.
The Museum of Modern Art, New York. Purchase Fund, 1949.

259. *Le Divan Japonais.* 1893.
Black chalk drawing on paper, 31¾ x 24⅝″ (80.5 x 62.5 cm).
Dortu D3223.
Private collection.*

Divan Japonais. 1893.

260. Lithographic poster, printed in color, 31¹³⁄₁₆ x 23¹⁵⁄₁₆″ (80.8 x 60.8 cm).
Wittrock P11. Delteil 341.
Collection Mr. and Mrs. Herbert D. Schimmel, New York.

261. Second copy: The Museum of Modern Art, New York. Abby Aldrich Rockefeller Fund, 1949.*

The Divan Japonais cabaret was taken over by Edouard Fournier from Jehan Sarrazin in late 1892. New fire regulations necessitated building reconstruction and led to

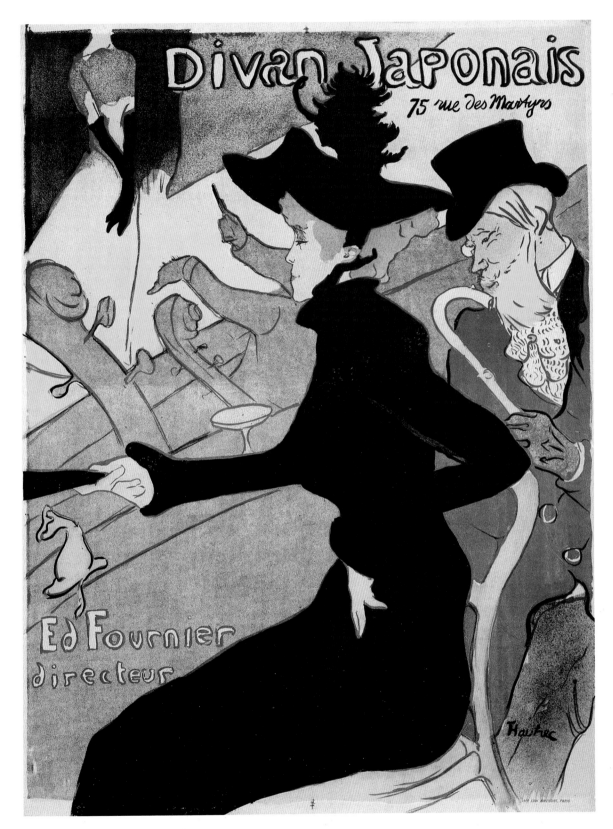

261

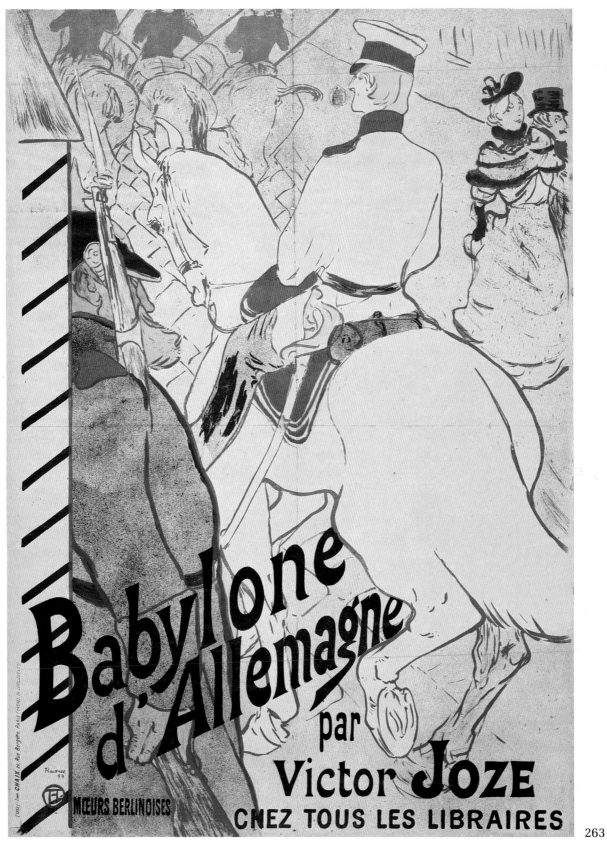

Babylone
d'Allemagne

par
Victor JOZE
CHEZ TOUS LES LIBRAIRES

MŒURS BERLINOISES

263

266

267

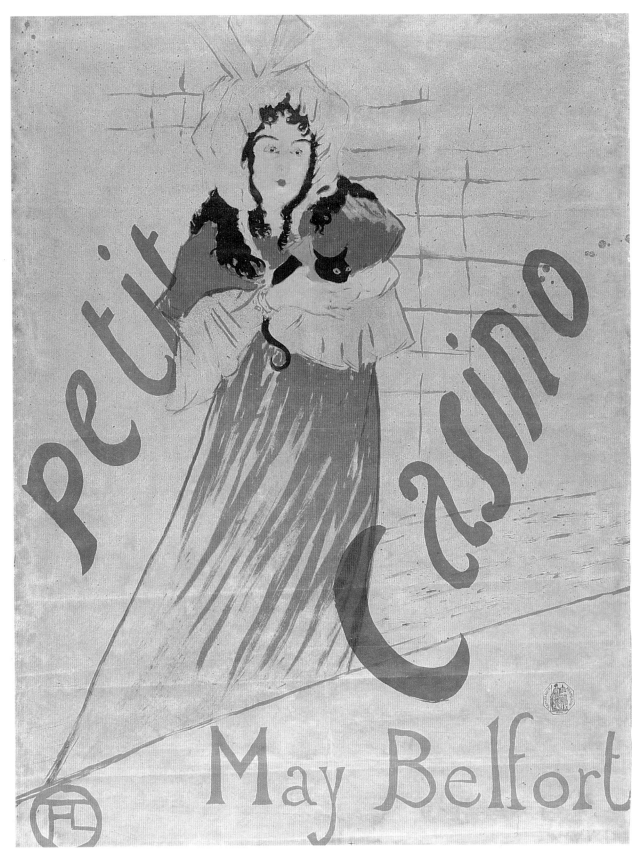

269

271

271. *La revue blanche—Portrait of Madame Misia Natanson.*
1895.
Oil on cardboard, 37 x 28¼″ (94 x 71.8 cm).
Dortu P568.
Private collection.*

La revue blanche. 1895.

272. Lithographic poster, printed in color, 49⅜ x 35⅞″
(125.5 x 91.2 cm).
Wittrock P16/B. Delteil 355, first state.
Collection Mr. and Mrs. Herbert D. Schimmel, New York.

273. Lithographic poster, printed in color, 49⅜ x 35⅞
(125.5 x 91.2 cm).
Wittrock P16/C. Delteil 355, second state.
The Museum of Modern Art, New York. Purchase, 1967.*

La revue blanche was an extremely important intellectual bi-monthly journal published by Alexandre Natanson in 1891–1903. Contributors included his brothers Thadée and Alfred, Lucien Muhfeld, and Paul Leclercq, as well as many of the new literary (André Gide, Marcel Proust, Romain Coolus, Jules Renard, and Tristan Bernard) and artistic talents, especially Felix Vallotton, the Nabis, and Toulouse-Lautrec. Lautrec frequently visited the offices, which became a meeting place for the intellectual avant-garde in Paris.

Misia Godebska (1872–1950) married Thadée Natanson in 1893. Most of their friends were members of the Nabis and included Pierre Bonnard, Félix Vallotton, and Edouard Vuillard, who painted numerous portraits of her. In 1905 she married the publisher Alfred Edwards, and in 1920 the Spanish painter José-Maria Sert.

274

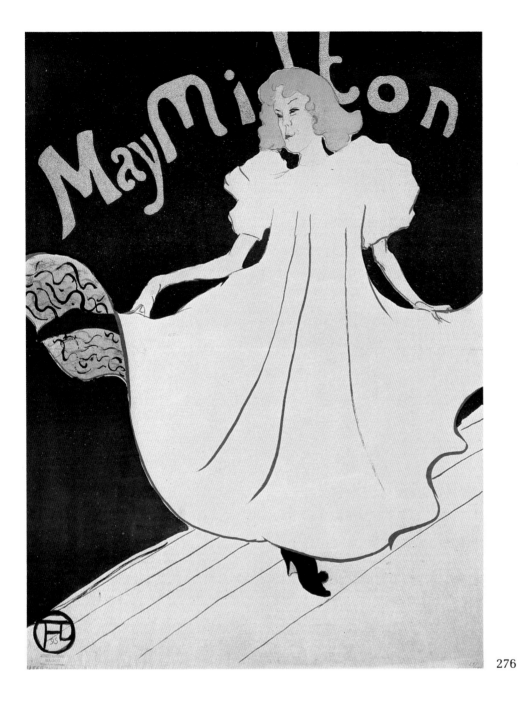

276

274. ***Miss May Milton.*** 1895.
Drawing in blue and black crayon on light brown paper,
29⅛ x 23³⁄₁₆″ (74 x 58.9 cm).
Dortu D3887.
Yale University Art Gallery, New Haven. Gift of Walter
Bareiss.*

May Milton. 1895.

275. Lithographic poster, 29⅛ x 23⅞″ (74 x 60.6 cm).
Wittrock P17, trial proof. Delteil 356.
Collection Mr. and Mrs. Herbert D. Schimmel, New York.

276. Lithographic poster, printed in color, 31⁵⁄₁₆ x 24″
(79.5 x 61 cm).
Wittrock P17/B. Delteil 356, second state.
Collection Mr. and Mrs. Herbert D. Schimmel, New York.*

277. Second copy: Guardsmark, Inc., Collection, Memphis.

May Milton, an English dancer and close friend of Jane
Avril, frequented the Irish and American Bar. She
appeared on a tiny stage at the rue Fontaine for only one
season and then went to the United States.

Irish and American Bar, rue Royale—The Chap Book.
1895.

278. Lithographic poster, printed in color, 16¼ x 24⁵⁄₁₆″
(41.2 x 61.8 cm).
Wittrock P18/A. Delteil 362, first state.
The Museum of Modern Art, New York. Gift of Abby
Aldrich Rockefeller, 1946.

279. Lithographic poster, printed in color, 16¼ x 24⁵⁄₁₆″
(41.2 x 61.8 cm).
Wittrock P18/B. Delteil 362, second state.
Guardsmark, Inc., Collection, Memphis.*

> *The Chap Book* was an American magazine. This scene
> takes place in the Irish and American Bar in Paris,
> frequented by English horseracing fans, trainers, and
> grooms. Tom, the Rothschilds' coachman, is seated
> at the right, and Ralph, a San Franciscan, tends
> the bar.

280. ***The Passenger from Cabin 54*** (La passagère du 54). 1896.
Pencil drawing on paper, 21 x 15½″ (53.3 x 39.4 cm).
Dortu D4254.
Private collection.

The Passenger from Cabin 54—Sailing in a Yacht
(La passagère du 54—Promenade en yacht). 1896.

281. Lithograph, crayon, and gouache, 22¹⁵⁄₁₆ x 16⅛″
(58.2 x 41 cm).
Wittrock P20, first state, proof. Delteil 366. Not in Dortu.
The Art Institute of Chicago. The John H. Wrenn Memorial
Collection.*

282. Lithograph, 23⅝ x 15¾″ (60 x 40 cm).
Wittrock P20, first state, first edition. Delteil 366, first state.
Boston Public Library. Albert H. Wiggin Collection.

283. Lithograph, printed in color, 24 x 17⁹⁄₁₆″ (61 x 44.7 cm).
Wittrock P20, second state, second edition. Delteil 366.
The Art Institute of Chicago. The Mr. and Mrs. Carter H.
Harrison Collection.*

284. Lithographic poster, printed in color, 23¹¹⁄₁₆ x 15¾″
(60.2 x 40 cm).
Wittrock P20, third state. Delteil 366, second state.
The Metropolitan Museum of Art, New York. Gift of Mrs.
Bessie Potter Vonnoh, 1941.

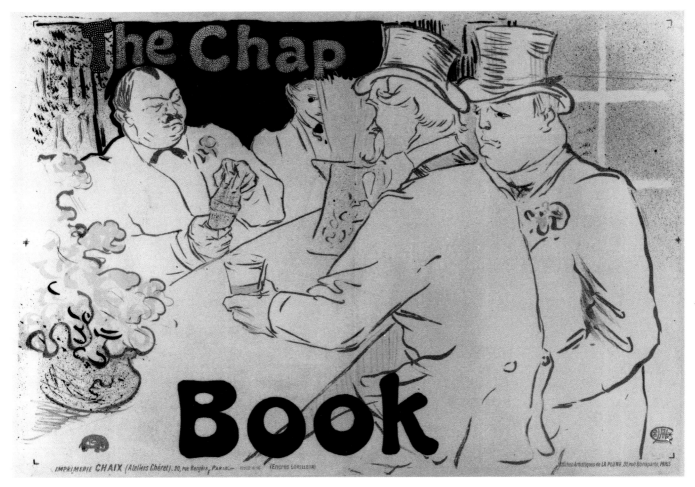

279

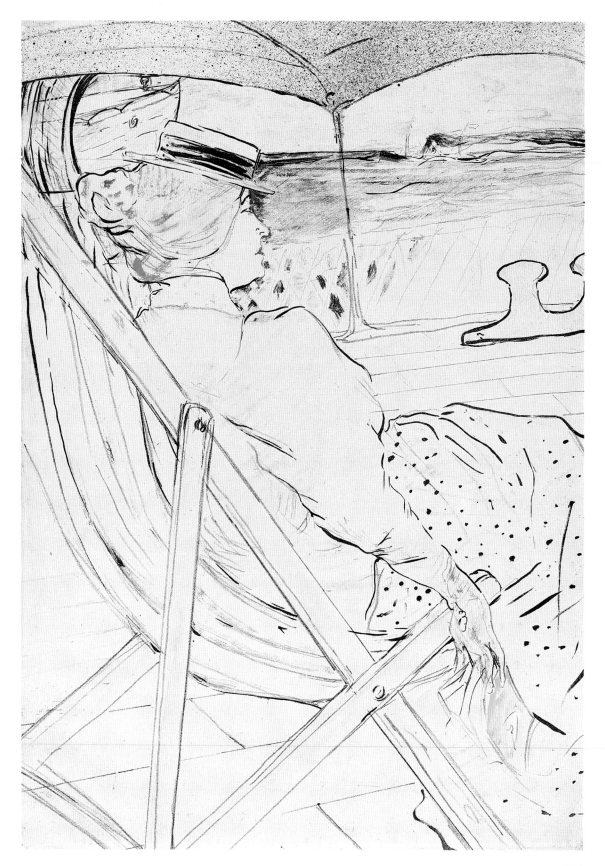

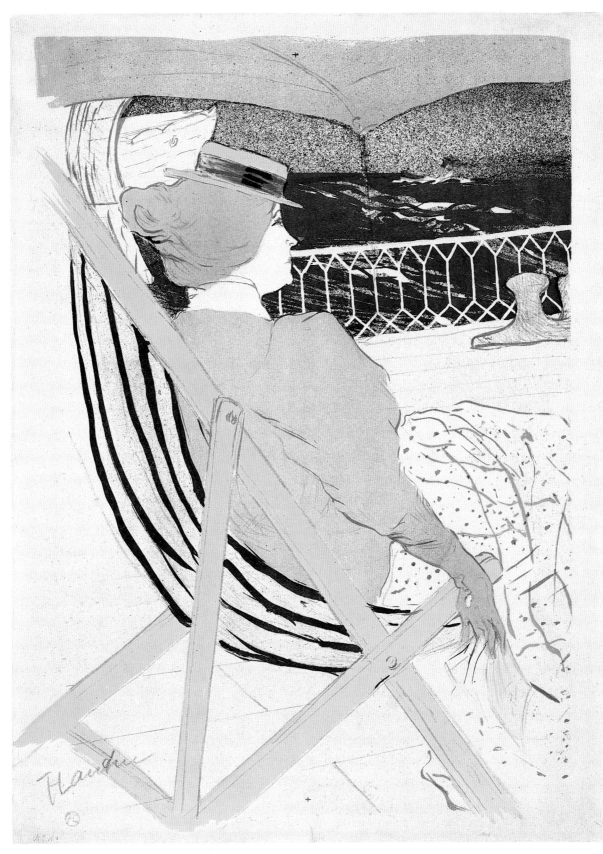

283

285. **Mademoiselle Eglantine's Company** (Troupe de Mademoiselle Eglantine). 1896.
Charcoal drawing and gouache on cardboard, 29⅛ x 36⅝" (74 x 93 cm).
Dortu P631.
Private collection.*

Mademoiselle Eglantine's Company (La troupe de Mademoiselle Eglantine). 1896.

286. Lithographic poster, printed in color, 24⁵⁄₁₆ x 31⅝" (61.7 x 80.4 cm).

Wittrock P21/A. Delteil 361, first state.
Harvard University Art Museums, Fogg Art Museum, Cambridge, Massachusetts. Purchase Francis H. Burr Memorial Fund.

287. Lithographic poster, printed in color, 24⁵⁄₁₆ x 31⅝" (61.7 x 80.4 cm).
Wittrock P21/C. Delteil 361, third state.
Maxwell Davidson Gallery, New York.

288. Second copy: The Museum of Modern Art, New York. Gift of Abby Aldrich Rockefeller, 1940.*

285

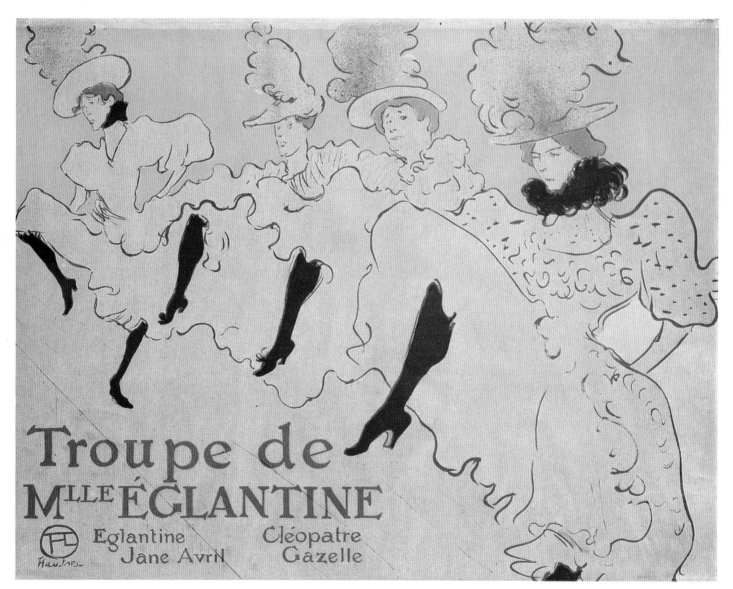

288

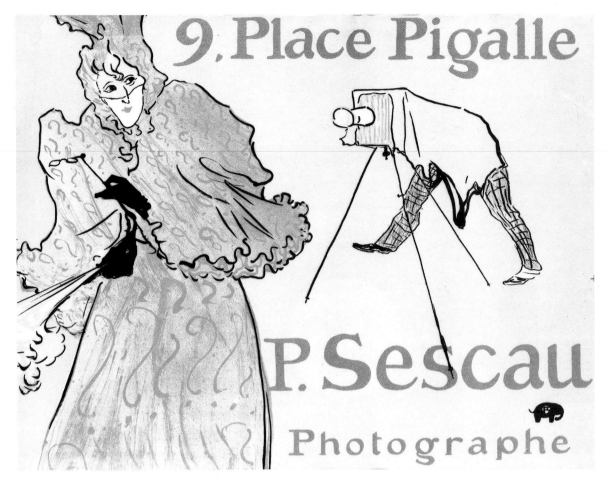

9. Place Pigalle

P. Sescau

Photographe

289

Sescau, Photographer (Le photographe Sescau). 1896.

289. Lithographic poster, printed in color, 23⅞ x 31½″
(60.7 x 80 cm).
Wittrock P22/B. Delteil 353.
Collection Mr. and Mrs. Herbert D. Schimmel, New York.*

290. Lithographic poster, printed in color, 23⅞ x 31½″
(60.7 x 80 cm).
Wittrock P22/C. Delteil 353.
Boston Public Library. Albert H. Wiggin Collection.

291. **L'Aube.** 1896.
Lithographic poster, printed in color, 24 x 31½″
(61 x 80 cm).
Wittrock P23. Delteil 363.
The Museum of Modern Art, New York. Gift of Abby
Aldrich Rockefeller, 1940.*

292. **L'Artisan Moderne.** 1896.
Lithographic poster, printed in color, 35⁷⁄₁₆ x 25³⁄₁₆″
(90 x 64 cm).
Wittrock P24/B. Delteil 350, second state.
Collection Mr. and Mrs. Herbert D. Schimmel, New York.

293. **The Simpson Chain** (La Chaîne Simpson). 1896.
Lithographic poster, printed in color, 32⁹⁄₁₆ x 47¼″
(82.8 x 120 cm).
Wittrock P26. Delteil 360.
Collection Mr. and Mrs. Herbert D. Schimmel, New York.*

La Chaîne Simpson was a bicycle chain company man-
aged by Louis Bouglé ("Spoke"), an amateur racing
cyclist who organized races in London and Paris to
demonstrate his products. (The poster had to be
redrawn because Spoke noticed that the pedals were
incorrectly placed.)

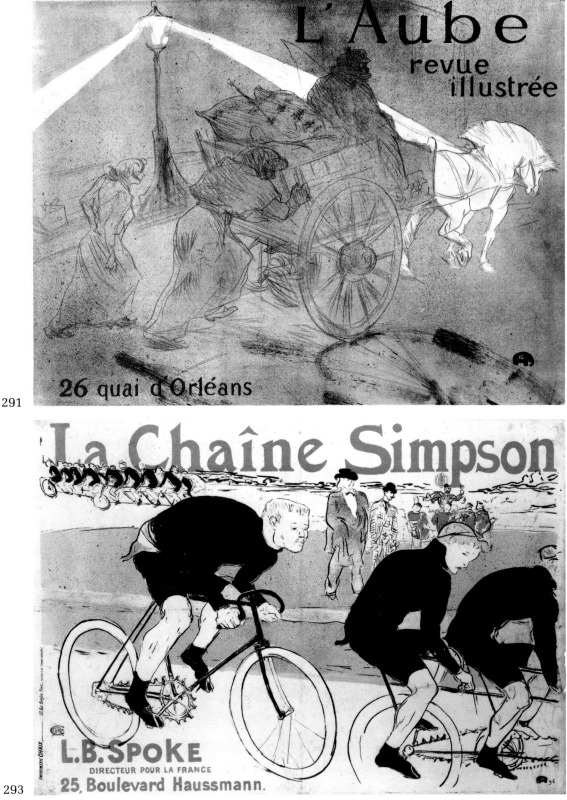

291

293

294

294. *La vache enragée.* 1896.
Lithographic poster, printed in color, 31⅛ x 22⅝″
(79 x 57.5 cm).
Wittrock P27/B. Delteil 364, second state.
Collection Mr. and Mrs. Herbert D. Schimmel, New York.*

> *La vache enragée* was a journal founded by the artist Léon-Adolphe Willette. The first issue appeared March 11, 1896, and it was published until 1897. The festival of La Vache Enragée was held annually in Montmartre by the bohemian artists and writers.

At the Concert (Au concert). 1896.

295. Lithographic poster, printed in color, 12⁹⁄₁₆ x 9¹⁵⁄₁₆″
(32 x 25.2 cm).
Wittrock P28/C. Delteil 365, third state.
Collection Mr. and Mrs. Herbert D. Schimmel, New York.*

296. Second copy: Collection Dr. and Mrs. George E. Paley, Torrington, Connecticut.

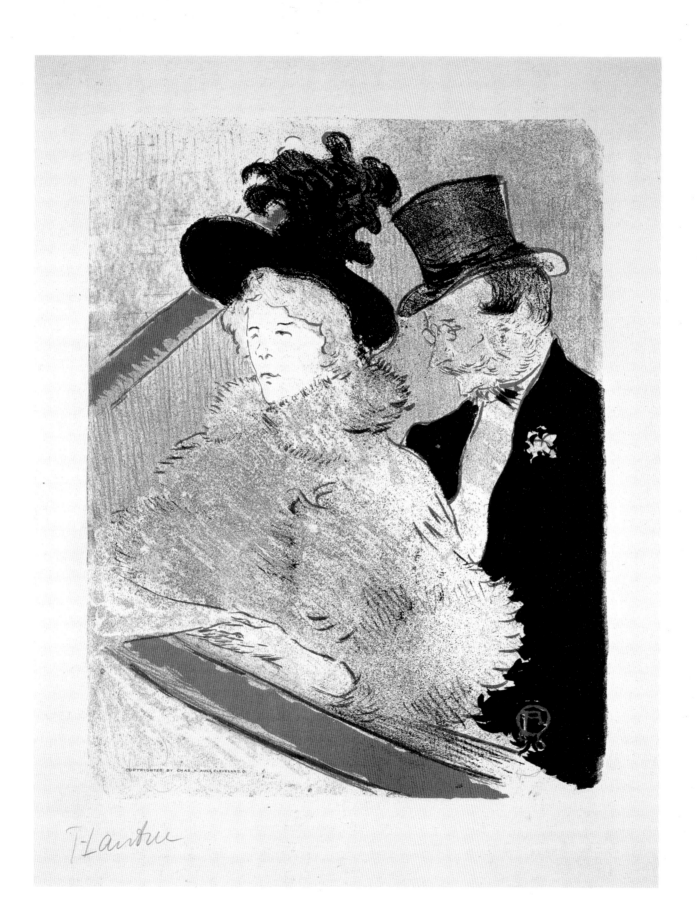

COPYRIGHTED BY CHAS. H. AULS CLEVELAND, O.

T-Lautrec

295

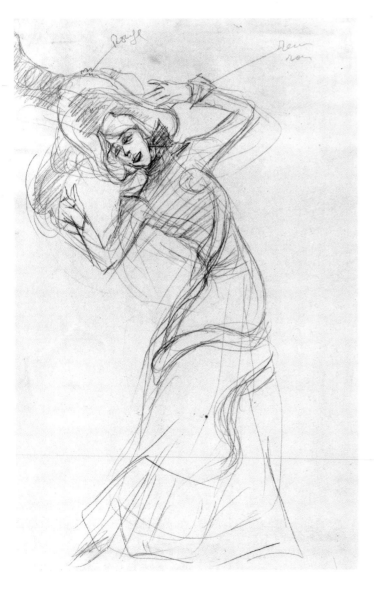

297. ***Jane Avril.*** 1899.
Pencil drawing on white wove paper, 22⅛ x 15″
(56 x 37.8 cm).
Dortu SD29; inscribed *rouge/bleu roi/noir.*
Private collection.*

298. ***Jane Avril.*** 1899.
Lithographic poster, printed in color, 22¹⁄₁₆ x 11¾″
(56 x 29.8 cm).
Wittrock P29/A. Delteil 367, first state.
The Museum of Modern Art, New York. Gift of Abby
Aldrich Rockefeller, 1946.*

299. ***La Gitane.*** 1899.
Lithographic poster, printed in color, 35¹³⁄₁₆ x 25″
(91 x 63.5 cm).
Wittrock P30. Delteil 368.
The Art Institute of Chicago. The Mr. and Mrs. Carter H.
Harrison Collection.*

> *La Gitane*, by Jean Richepin, made its debut at the Thé-
> âtre Antoine on January 22, 1900. Depicted is Marthe
> Mellot, actress and wife of Alfred Natanson.

300. Ten autograph letters:
A. From Lautrec (*Harry*) to his mother, the Countess Adèle
de Toulouse-Lautrec, September 1891.
B. From Lautrec (*H.*) to his mother, September 1891.
C. From Lautrec (*H. T. Lautrec*) to the print dealer and pub-
lisher Edouard Kleinmann, February 9, 1894.
D. From Lautrec (*H. T. Lautrec*) to the art critic and author
of *Yvette Guilbert,* Gustave Geffroy, June 21, 1894.
E. From Lautrec (*Lautrec*) to the editor of the literary and
artistic periodical *La plume,* Léon Deschamps, October
11, 1895.
F. From Lautrec (*Henri*) to his mother, Summer 1897.
G. From Lautrec (*H. de Toulouse Lautrec*) to the publisher
and print dealer Gustave Pellet, November 30, 1898.
H. From Lautrec (*H. de Toulouse Lautrec*) to the publisher
W. H. B. Sands, March 27, 1898.
I. From Lautrec's printer Henry Stern to W. H. B. Sands,
April 1, 1898.
J. From Yvette Guilbert to Lautrec, May 6, 1898.
Collection Mr. and Mrs. Herbert D. Schimmel, New York.

301. Various items related to Yvette Guilbert, including sheet
music, photographs, theater programs, letters, publication
announcement, magazine article, and books.
Collection Mr. and Mrs. Herbert D. Schimmel, New York.

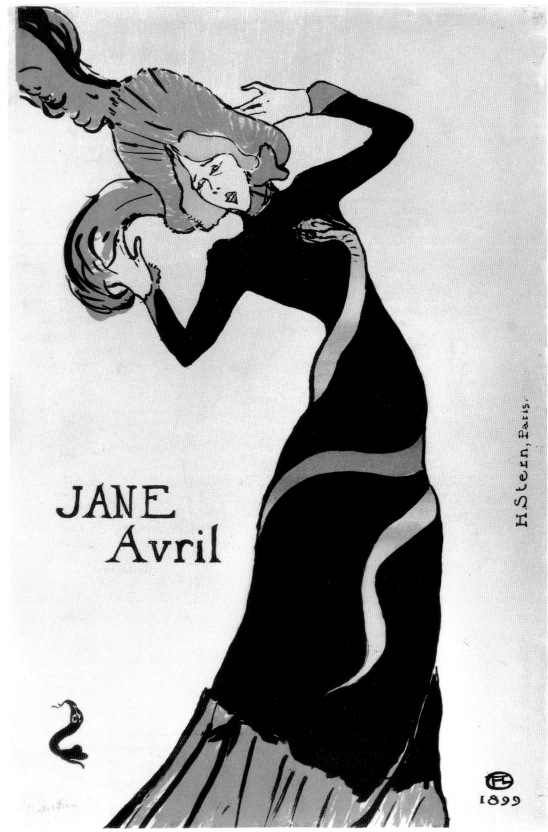

JANE
Avril

H. Stern, Paris.

1899

298

253

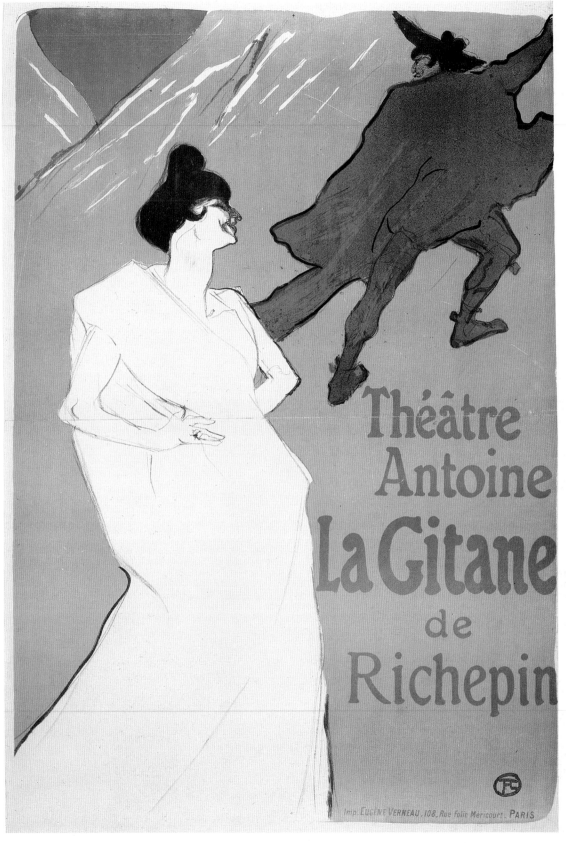

Théâtre
Antoine
La Gitane
de
Richepin

Imp. EUGÈNE VERNEAU, 108, Rue Folie Méricourt, PARIS

299

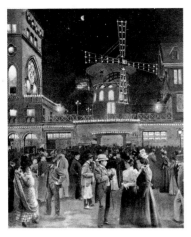

The Moulin Rouge, from a period painting by Ducourtiou

La Goulue

Loie Fuller

Chronology 1891–1901

This chronology is limited to the ten years in which Henri de Toulouse-Lautrec made lithographs and posters, and provides a sampling of cultural and political events of the final decade of the nineteenth century.

France	The World

1891

Henri de Toulouse-Lautrec creates his first poster, *Moulin Rouge*, depicting La Goulue and her dancing partner Valentin Le Désossé

The journal *La revue blanche* is founded by Alexandre Natanson

Claude Monet exhibits Haystack paintings at Durand-Ruel gallery

James McNeill Whistler's *Portrait of My Mother* is bought by the French government

General Georges Boulanger commits suicide

Former prefect of the Seine Baron Georges-Eugène Haussmann dies in poverty, January 11

Painter Jean-Louis-Ernest Meissonier dies, January 31

Painter Georges Seurat dies, March 29

Poet Arthur Rimbaud dies, November 10

Beginning of wireless telegraphy

Theo van Gogh dies in Holland, only one year after the death of his brother Vincent

International Copyright Act passed by United States Congress

Opening of London-to-Paris telephone line

Painter Paul Gauguin arrives in Tahiti, June 8

1892

Henri Matisse begins studies with Gustave Moreau at Ecole des Beaux-Arts

First Salon des Rose + Croix, founded by Sâr Péladan, opens with fanfare by composer Erik Satie

Claude Monet begins Rouen Cathedral paintings

Debut of dancer Loie Fuller at the Folies-Bergère

Paul Gauguin paints *Manao Tupapua (Spirit of the Dead Watching)* in Tahiti

Pan-German League founded

Young Turk Movement formed in Geneva

George Bernard Shaw begins writing plays

Bombing on the rue de Clichy

Sarah Bernhardt in *Phèdre*

Aristide Bruant

France	The World
Claude Debussy composes *L'Après-midi d'une faune*	
Bombs explode on the rue de Clichy; subsequent arrest and execution of anarchist bomber Ravachol, March–July	
Cholera epidemic, July–October	

1893

France	The World
Prints by Kitagawa Utamaro and Ando Hiroshige shown at Durand-Ruel gallery	*Les Vingts*, the Belgian avant-garde group begun in 1884, is disbanded and succeeded by Libre Esthétique
Sarah Bernhardt appears in *Phèdre* at the Théâtre Renaissance	Chicago World Exhibition
Paul Gauguin returns from Tahiti	Henry Ford builds his first automobile
Aristide Bruant appears in his cabaret, the Mirliton	Grover Cleveland begins second term as 24th president of the United States
Ambroise Vollard opens first gallery in Paris	Painter Joan Miró born in Barcelona, April 20
Aurélien-François Lugné-Poë founds Théâtre de l'Oeuvre	
Ferdinand and Charles de Lesseps and Charles Eiffel receive prison sentences for their roles in the Panama Canal scandal	
Lautrec depicts dancer Jane Avril on cover of *L'Estampe originale*	
Novelist Guy de Maupassant dies, July 6	

1894

France	The World
First Salon des Cent poster exhibition	*The Yellow Book*, a British review, begins publication
Lautrec paints *The Salon on the rue des Moulins*	Thomas Alva Edison opens kinetoscope theater in New York
Gustave Caillebotte's Impressionist collection rejected by the Luxembourg Museum	The Dual Alliance is signed by France and Russia
Lumière brothers invent the cinematograph	
Captain Alfred Dreyfus convicted of treason	
Lautrec illustrates *Yvette Guilbert* by Gustave Geffroy	
President Sadi Carnot assassinated	

Jane Avril

Brothel at 5, rue des Moulins

Captain Alfred Dreyfus degraded

France	The World
1895	
Paul Cézanne paints portrait of Gustave Geffroy	*Pan*, a German review, begins publication
Marcelle Lender appears in the operetta *Chilpéric*	H. G. Wells writes *The Time Machine*
First public film showing in Paris held at Hôtel Scribe	Physicist Wilhelm C. Roentgen discovers X rays
Dreyfus sent to Devil's Island	Publication of *Studies of Hysteria* by Sigmund Freud
Scandal caused by death of Max Lebaudy	Bulgarian premier Stephan Stambulov assassinated
Chemist Louis Pasteur dies, September 28	Paul Gauguin returns to Tahiti
1896	
Lautrec's print series *Elles* shown at Salon des Cent	Marchese Guglielmo Marconi receives first patent for radio-telegraphy
S. Bing shows first exhibition of work by Edvard Munch at Maison de l'Art Nouveau	Publication of *The Jewish State* by Theodor Herzl
Marcel Proust's first book of short stories is published	Nobel Prize established
Oscar Wilde's play *Salomé* is performed in Paris	Giacomo Puccini composes *La Bohème*
France annexes Madagascar	Revolution in Nicaragua precipitates landing of United States Marines, March 20
Czar Nicholas II visits Paris	Poet and artist William Morris dies, October 3
Jimmy Michael, English bicyclist, races at Tristan Bernard's velodrome	
Poet Paul Verlaine dies, January 8	
Novelist Edmond de Goncourt dies, July 16	
1897	
Lautrec moves to his last studio on avenue Frochot	Queen Victoria's Diamond Jubilee
Henri Rousseau paints *The Sleeping Gypsy*	United States annexes Hawaii
Physicist Antoine Henri Becquerel discovers the electron	Brussels World Exhibition
Rodolphe Salis, owner of the Chat Noir cabaret, dies	William McKinley becomes 25th president of the United States

Yvette Guilbert

Marcelle Lender

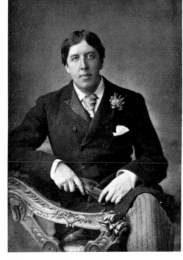

Oscar Wilde

France	The World
1898	
Emile Zola writes *J'Accuse,* is tried and convicted of libel, and flees to England	Empress Elizabeth of Austria is assassinated
Colonel Henry admits to having forged a document in the Dreyfus case and commits suicide	United States battleship *Maine* explodes in Havana harbor, February 15
	United States declares war on Spain, April 25
Chemists Marie and Pierre Curie discover radium	Artist Aubrey Beardsley dies, March 16
Sculptor Auguste Rodin finishes *Monument to Balzac*	Statesman Otto von Bismark dies, July 30
Poet Stéphane Mallarmé dies, September 9	
Painter Pierre Puvis de Chavannes dies, October 24	
Treaty of Paris signed by Spain and the United States, December 10	
1899	
Lautrec is treated in a sanatorium for eleven weeks	Boer War between the British and Dutch begins in South Africa
Painter Alfred Sisley dies, January 29	First Peace Conference meets at The Hague and establishes permanent court of arbitration among 26 nations
Painter Rosa Bonheur dies, May 25	
	First magnetic recording of sound
	Novelist Ernest Hemingway born
1900	
Universal Exhibition opens and is visited by over 50 million people	Publication of *Interpretation of Dreams* by Sigmund Freud
Pablo Picasso goes to Paris for the first time, paints *Le Moulin de la Galette*	Max Planck postulates quantum theory
Inauguration of the Paris Métro, with entrances designed by Hector Guimard	Boxer Rebellion in China against Europeans
	Umberto I of Italy assassinated
Oscar Wilde dies, November 30	Philospher Friedrich Wilhelm Nietzsche dies, August 25
1901	
Pablo Picasso's first exhibition at Ambroise Vollard gallery	Queen Victoria dies and is succeeded by Edward VII

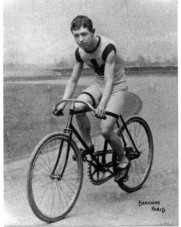

Jimmy Michael, English bicyclist

France	The World
Paul Gauguin's book *Noa-Noa* is published	Massacre of students in St. Petersburg
Painter Jean Dubuffet born	Composer Giuseppe Verdi dies, January 27
René F. A. Sully Prudhomme wins first Nobel Prize for literature	President William McKinley assassinated, September 6
Lautrec dies, at Malromé, near Bordeaux, September 9	Theodore Roosevelt becomes 26th president of the United States, September 14

Compiled with the assistance of Herbert D. Schimmel

Lautrec's studio at 14, avenue Frochot

Malromé

Lenders to the Exhibition

Staatliche Museen, Preussischer Kulturbesitz,
 Kupferstichkabinett, Berlin
Boston Public Library
Museum of Fine Arts, Boston
Kunsthalle Bremen
Harvard University Art Museums, Fogg Art Museum,
 Cambridge, Massachusetts
The Art Institute of Chicago
The Minneapolis Institute of Arts
Yale University Art Gallery, New Haven
The Brooklyn Museum, New York
The Metropolitan Museum of Art, New York
Smith College Museum of Art, Northampton, Massachusetts
The Ashmolean Museum of Art and Archeology, Oxford
Bibliothèque Nationale, Paris
The National Gallery, Prague
Museum of Art, Rhode Island School of Design, Providence
Museum Boymans–van Beuningen, Rotterdam
Staatsgalerie Stuttgart
Library of Congress, Washington, D.C.
National Gallery of Art, Washington, D.C.
Sterling and Francine Clark Art Institute, Williamstown,
 Massachusetts

Nelson Blitz, Jr., New York
Henry W. Bloch, Shawnee Mission, Kansas
Maxwell Davidson Gallery, New York
Mr. and Mrs. Norman Diamond, Washington, D.C.
Mr. and Mrs. Heinz Friederichs, Frankfurt
Dr. and Mrs. Martin L. Gecht, Chicago
Barbara Ginn Griesinger, Gates Mills, Ohio
Guardsmark, Inc., Collection, Memphis
Ruth Irving, Courtesy Pace Master Prints, New York
Eberhard W. Kornfeld, Bern, Switzerland
Mr. and Mrs. Ira A. Lipman, Memphis
Mr. and Mrs. Jeffrey H. Loria, New York
Dr. and Mrs. George E. Paley, Torrington, Connecticut
Mr. and Mrs. Gilbert Rothschild
Mr. and Mrs. Herbert D. Schimmel, New York
Dr. Henry M. Selby, New York
Thyssen-Bornemisza Collection, Lugano, Switzerland
World-Wide Volkswagen Corporation, Orangeburg, New York
Mr. and Mrs. Edward M. M. Warburg, New York
Mrs. John Hay Whitney, New York
Eight anonymous lenders

Trustees of The Museum of Modern Art

William S. Paley
 Chairman of the Board
Mrs. Henry Ives Cobb
David Rockefeller
 Vice Chairmen
Mrs. John D. Rockefeller 3rd
 President
Mrs. Frank Y. Larkin
Donald B. Marron
 Vice Presidents
John Parkinson III
 Vice President and Treasurer

Lily Auchincloss
Edward Larrabee Barnes
Mrs. Armand P. Bartos
Sid Richardson Bass
H.R.H. Prinz Franz von Bayern**
Gordon Bunshaft
Shirley C. Burden
Thomas S. Carroll
Frank T. Cary
Anne Cox Chambers
Ivan Chermayeff
Gianluigi Gabetti
Miss Lillian Gish**
Paul Gottlieb
Mrs. Melville Wakeman Hall
George Heard Hamilton*
Barbara Jakobson
Sidney Janis**
Philip Johnson
Ronald S. Lauder
John L. Loeb*
Ranald H. Macdonald*

Dorothy C. Miller**
Mrs. G. Macculloch Miller*
J. Irwin Miller*
S. I. Newhouse, Jr.
Stavros S. Niarchos
Richard E. Oldenburg
Peter G. Peterson
Gifford Phillips
Mme Jacqueline Picasso**
John Rewald**
David Rockefeller, Jr.
Agnes Gund Saalfield
Richard E. Salomon
Mrs. Wolfgang Schoenborn*
Mrs. Constantine Sidamon-Eristoff
Mrs. Bertram Smith
Jerry I. Speyer
Mrs. Alfred R. Stern
Mrs. Donald B. Straus
Walter N. Thayer
R. L. B. Tobin
Edward M. M. Warburg*
Mrs. Clifton R. Wharton, Jr.
Monroe Wheeler*
Richard S. Zeisler

Trustee Emeritus
**Honorary Trustee*

Ex Officio
Edward I. Koch
Mayor of the City of New York
Harrison J. Goldin
Comptroller of the City of New York

Photograph Credits

The photographers and sources of the illustrations in this book are listed alphabetically below, followed by the number of the page on which each illustration appears.

Jörg P. Anders, Berlin: 143 right, 156, 202 right; Matthias Arnold, Munich: 42, 55, 58; © The Art Institute of Chicago, all rights reserved: 13, 51, 103 left, 127, 133 right, 148 bottom left and right, 155, 158, 163 top, 167, 183 bottom left and right, 199, 211, 220, 225, 244, 245, 254; The Ashmolean Museum, Oxford: 170; Museé des Beaux-Arts, Lyon: 49 right; Bibliothèque Nationale, Paris: 100, 118, 136, 137, 145, 151 right, 153, 175 bottom, 200; Boston Public Library, Print Department: 115, 116, 134 left, 141, 154, 157, 182 top, 210 left; The Brooklyn Museum: 54 top, 112 left, 117, 164, 194, 210; The Cleveland Museum of Art: 236 right; A. C. Cooper Ltd., London: 130 top, 228, 238; Farbfoto Harz, Düsseldorf: 207; Museum of Fine Arts, Boston: 47 left, 111 right, 219; The Fogg Art Museum, Cambridge, Mass.: 174, 177 left; A. Frequin, Museum Boymans–van Beuningen: 40 left, 124, 168; Hauptzollmt, Munich: 183 top right; Kate Keller, The Museum of Modern Art: cover, 16, 96, 107, 110, 119, 161, 171, 187, 195 right, 196, 202 left, 204, 205, 213, 224, 227 left, 231, 233, 234, 239, 249 top; Kimball Art Museum, Fort Worth: 69 bottom; Kunsthalle, Hamburg: 43; Kunstmuseum, Basel: 59; Musée du Louvre, Paris: 47 right, 49 left, 50 left, 56 bottom, 61 right; Michael Marsland, Yale University Art Gallery: 240; James Mathews, The Museum of Modern Art: 62 left; The Metropolitan Museum of Art, all rights reserved: 99, 113, 132, 138, 139, 148 bottom, 151 left; The Museum of Modern Art: 18, 28, 65 top, 128, 143 left, 147 left, 173, 177 right, 179, 215, 247, 255 bottom, 257 top, 258 bottom; The Museum of Modern Art, from Charles Terrasse, *Bonnard*, Paris, 1927: 63; Mali Olatunji, The Museum of Modern Art: 97, 152, 176, 178, 237; The Phillips Collection, Washington, D.C.: 66 top; Rolf Peterson, The Museum of Modern Art: 70 bottom; Eric Pollitzer, Hempstead, N.Y.: 108 left, 236 left, 246; Nathan Rabin, New York: 64 top, 78, 79, 80, 83, 84, 109 top, 114, 250; Nathan Rabin, New York, courtesy Herbert D. Schimmel: 255 top, 256 top and bottom, 257 center and bottom; National Gallery of Art, Washington, D.C.: 106, 108 right, 129, 159, 166, 182 bottom; Museum of Art, Rhode Island School of Design, Providence: 144; Rijksmuseum, Amsterdam: 53 top left; Gordon H. Robertson, A. C. Cooper Ltd., London: 184; Smith College Museum of Art, Northampton, Mass.: 142 top; Soichi Sunami, The Museum of Modern Art: 48 left, 72, 130 bottom, 140, 195 left, 203, 212, 253; Staatsgalerie, Stuttgart: 197; Stedelijk Museum, Amsterdam: 53 top right, 56 top, 57, 60, 61 left; Galerie Thomas, Munich: 70 top; Musée Toulouse-Lautrec, Albi: 10, 40 right, 48 right, 50 right, 53 bottom, 66 bottom; Victor's Photography, Piscataway, N.J., courtesy Phillip Dennis Cate: 41, 62 right, 76, 87; Von Voithenberg: 54 bottom; J. Warnod: 12; Wolfgang Wittrock, Düsseldorf: 39, 65 bottom.